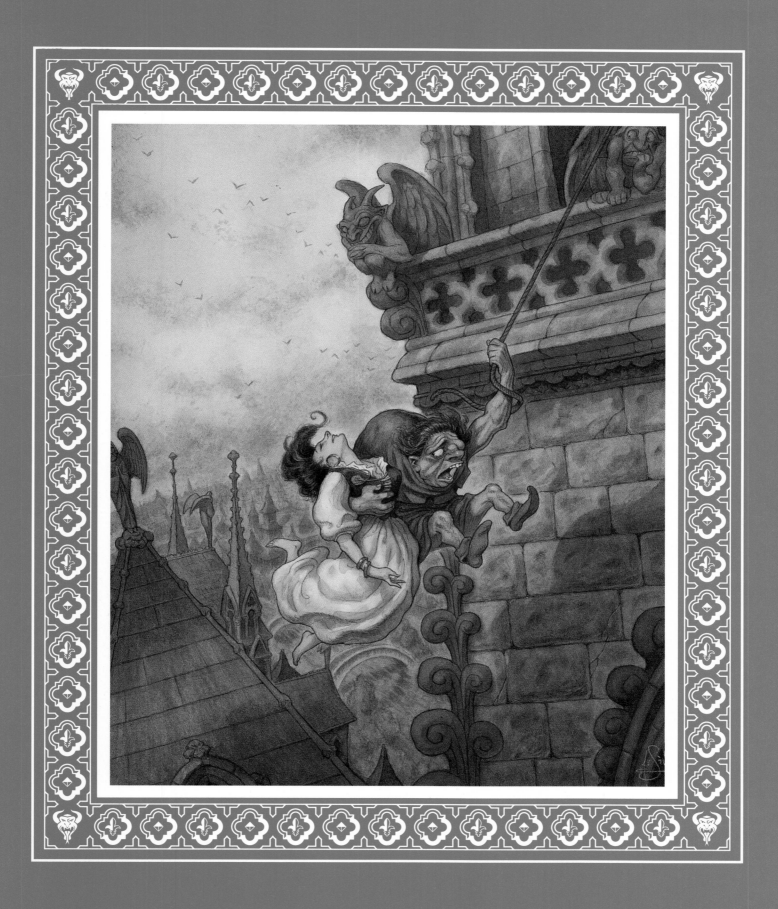

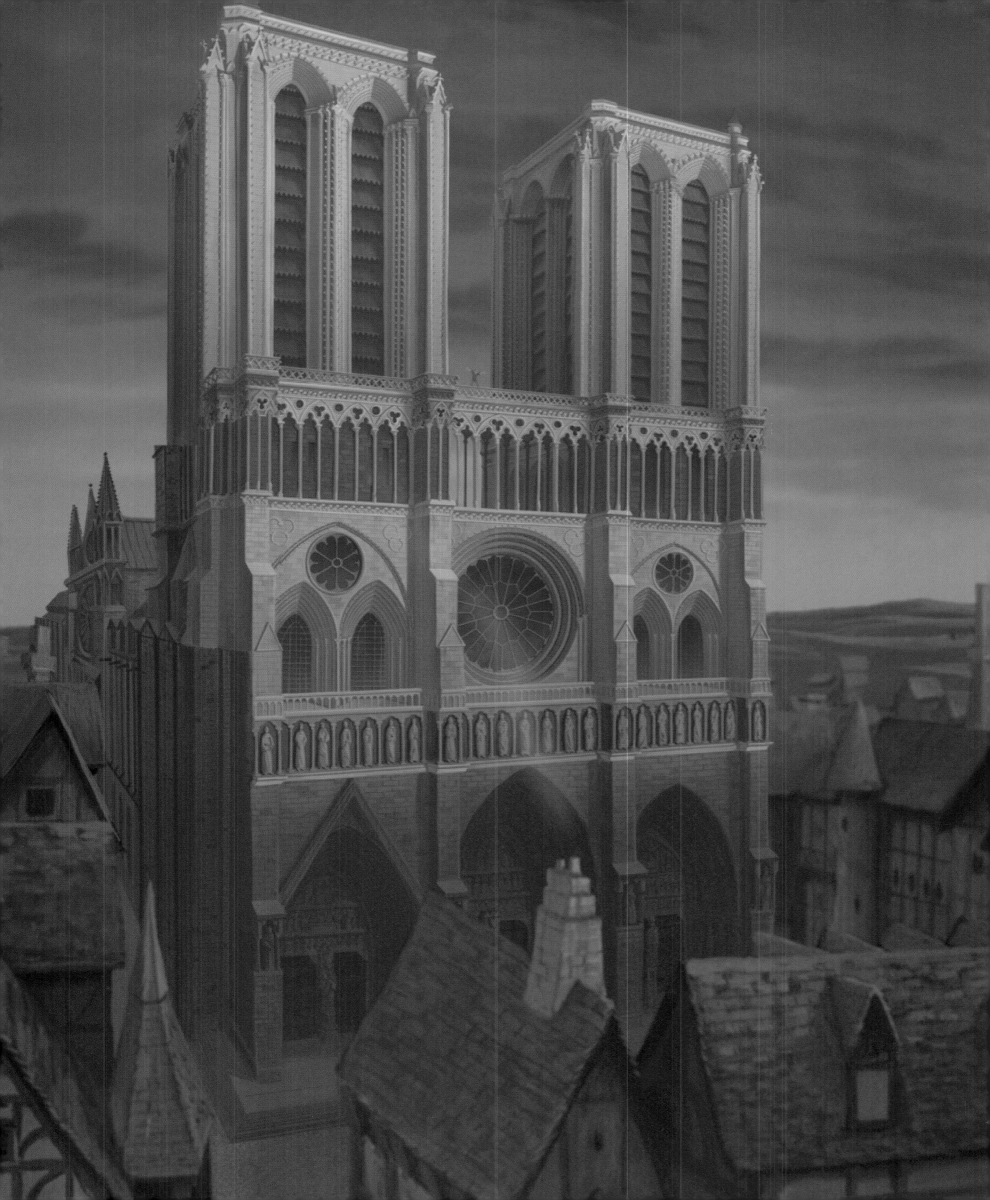

The Art of
THE HUNCHBACK OF NOTRE DAME

TEXT BY
STEPHEN REBELLO

A WELCOME BOOK

HYPERION

NEW YORK

ENDPAPER: *Value study by Fred Craig.*
PAGE 1: *Concept art by Peter DeSève.*
PAGES 2–3: *Color key by David Goetz.*
PAGES 4–5: *Production still.*
THESE PAGES: *Layout art by Sam Michlap.*

PAGES 22 BOTTOM, 118 TOP, 168 BOTTOM:
Courtesy Art Resource
PAGES 118 BOTTOM LEFT, 149 TOP RIGHT:
Courtesy Dover Publications, New York
PAGES 18 TOP LEFT, 44 TOP TWO, 168 TOP:
Courtesy Maison de Victor Hugo, Paris
PAGES 33, 40, 41: Courtesy New York Public
Library, New York
PAGE 17: Courtesy Pierpont Morgan Library,
New York, gnr fr 180
PAGES 23 TOP, 120 TOP: Courtesy Photothèque
des Musées de La Ville de Paris, Paris

Rebello, Stephen.
 The art of The Hunchback of Notre
 Dame / text by Stephen Rebello.
 p. cm.
 "A Welcome book."
 ISBN 0-7868-6208-4
 1. Hunchback of Notre Dame (Motion
 picture : 1996) I. Title
 IN PROCESS
 791.43'72—dc20
 96-967
 CIP

For information address:
Hyperion
114 Fifth Avenue
New York, New York, 10011

Produced by:
Welcome Enterprises, Inc.
575 Broadway
New York, New York, 10012

Directors: *Lena Tabori, Hiro Clark*
Project Director: *Ellen Mendlow*
Hyperion Editor: *Wendy Lefkon*
Designer: *Gregory Wakabayashi*
Art Coordinator: *Rachel Balkcom*

Printed and bound in Japan by
Toppan Printing Co., Inc.

10 9 8 7 6 5 4 3 2 1

Contents

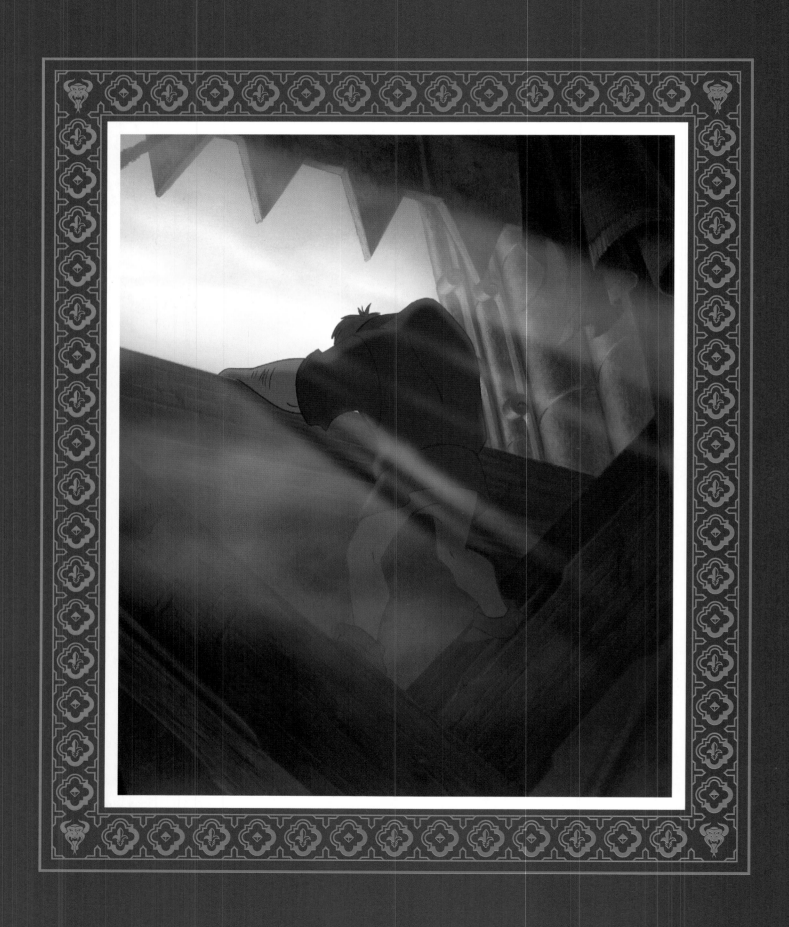

Preface

WHEN WALT AND ROY DISNEY CAME TO HOLLYWOOD AND began making feature-length animated films, their desire was to tell great stories with magic and heart. The artists they gathered around them used the fledgling medium of animation to create new interpretations of familiar, well-loved stories, from fairy tales like *Snow White and the Seven Dwarfs* and *Cinderella*, to classic works of children's literature like *Alice in Wonderland* and *Pinocchio*. An entire generation grew up on the movies of Walt Disney.

Today the tradition of adapting classic stories for the screen in animated form lives on for a whole new generation of viewers and artists. *The Art of The Hunchback of Notre Dame* follows the journey of a group of people who took inspiration from a classic work of literature written over a century ago and set out to interpret it for today's audience.

At the heart of Victor Hugo's complex tale, the filmmakers found a simple and compelling story. It is the story of an outsider—a frightening visage with a beautiful soul—one who wants to be accepted by the world around him but must tackle his own inner fears in order to do so. It is an eloquent affirmation of the human spirit.

That same spirit has motivated an extraordinary group of filmmakers to bring this classic story to the screen. These artists from different backgrounds and cultures have come together as a collaborative team to create a unique human expression through the magic of motion pictures. Their work resonates with style and craftsmanship, integrity, and insight.

I hope that in these pages you can feel not only the brilliance of Hugo's masterpiece as it translates to the screen, but also the quiet, passionate energy of the individual artist. An artist who somehow magically creates drawings on a blank piece of paper that move us to laugh or cry, that entertain and inspire us, and even make us forget that we are looking at drawings at all.

When the lights go down and the film begins to roll, it is the spirit of that artist that shines through the darkness. That is the magic of *The Hunchback of Notre Dame*.

—DON HAHN, Producer

THIS PAGE: *Layout drawings by Scott Caple.*
OPPOSITE: *Production still.*

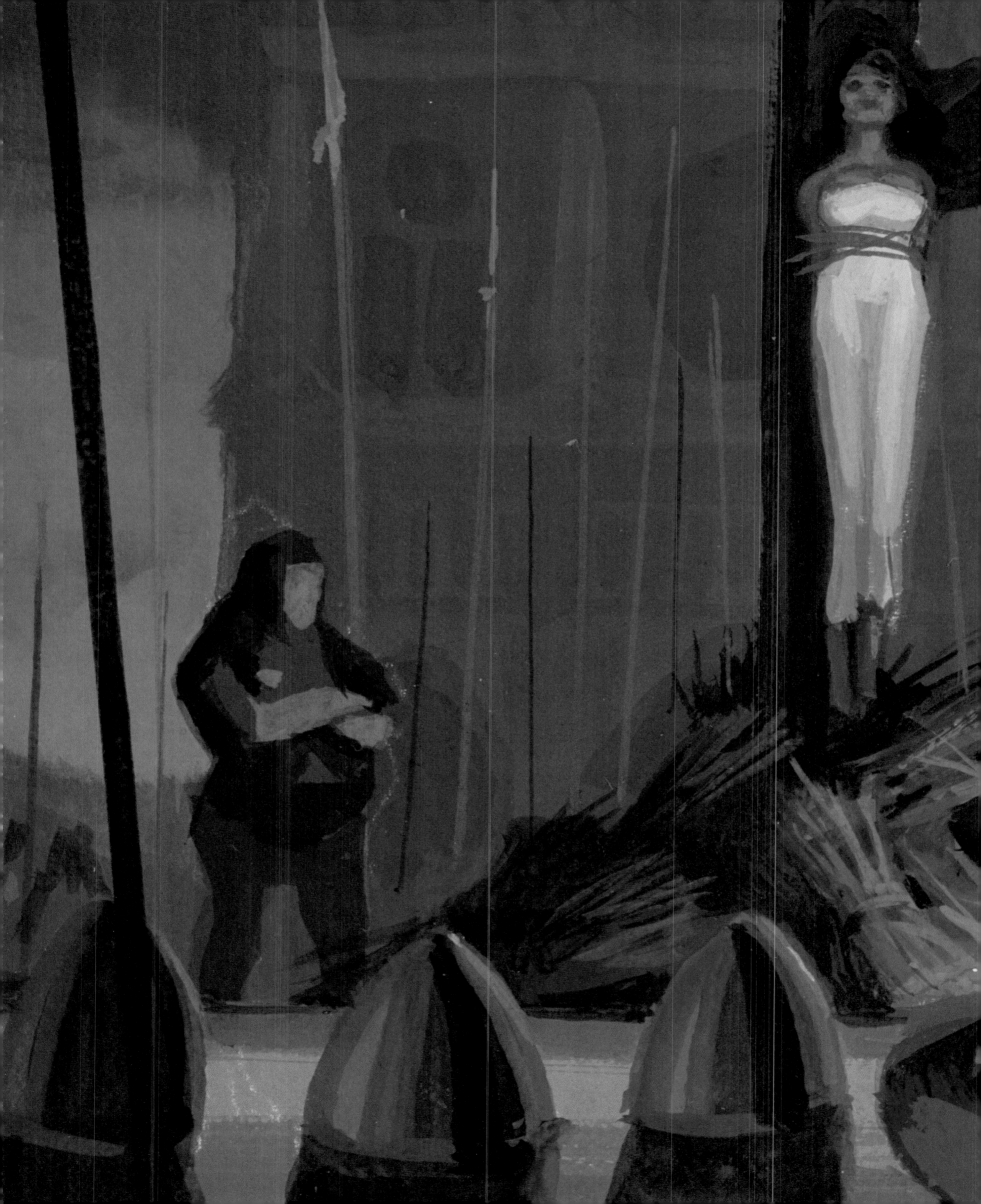

ABOVE AND OPPOSITE: *Color keys by David Goetz.*

Color key by David Goetz.

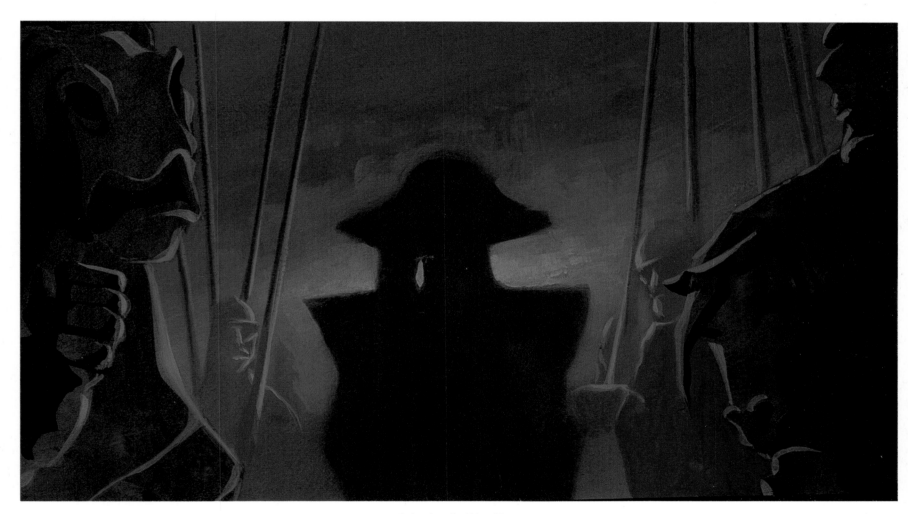

Color key by Lisa Keene.

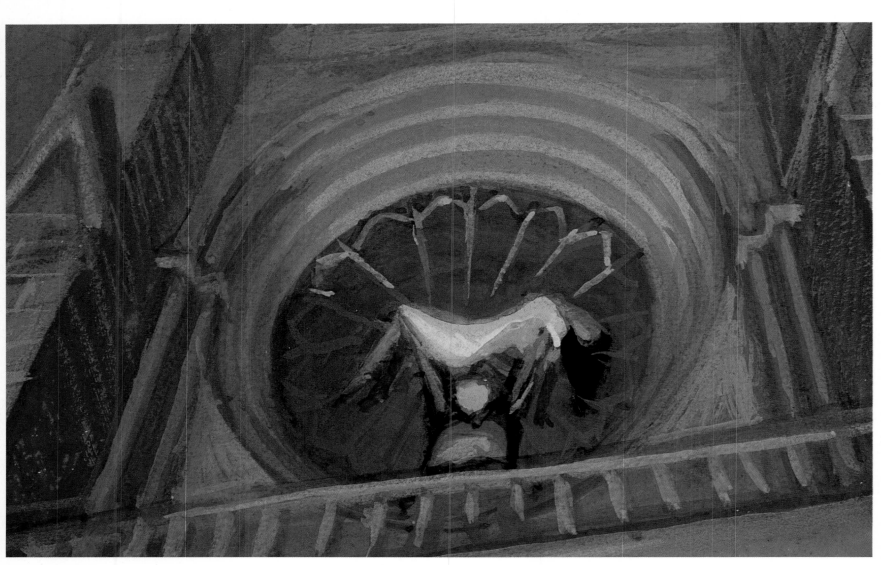

Color key by David Goetz.

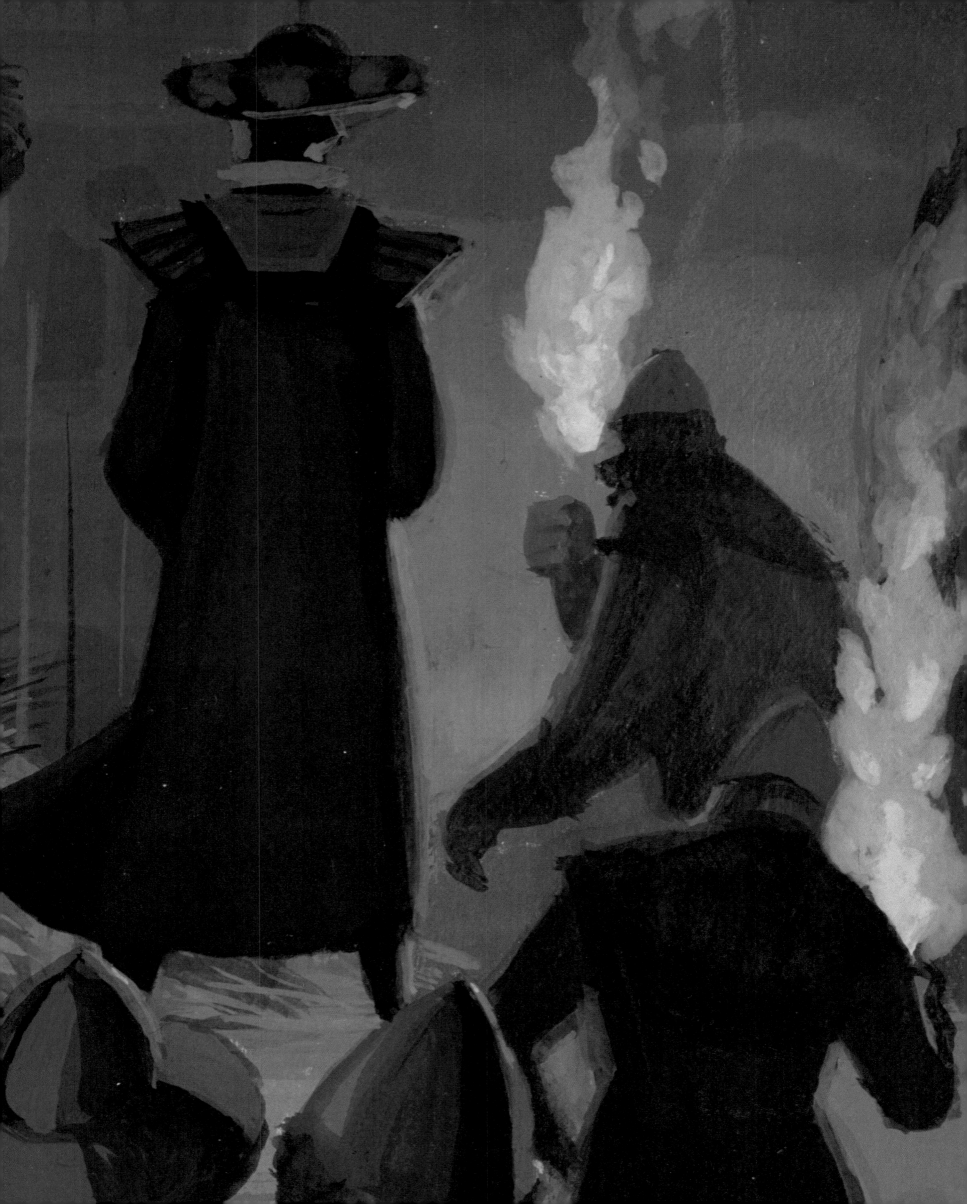

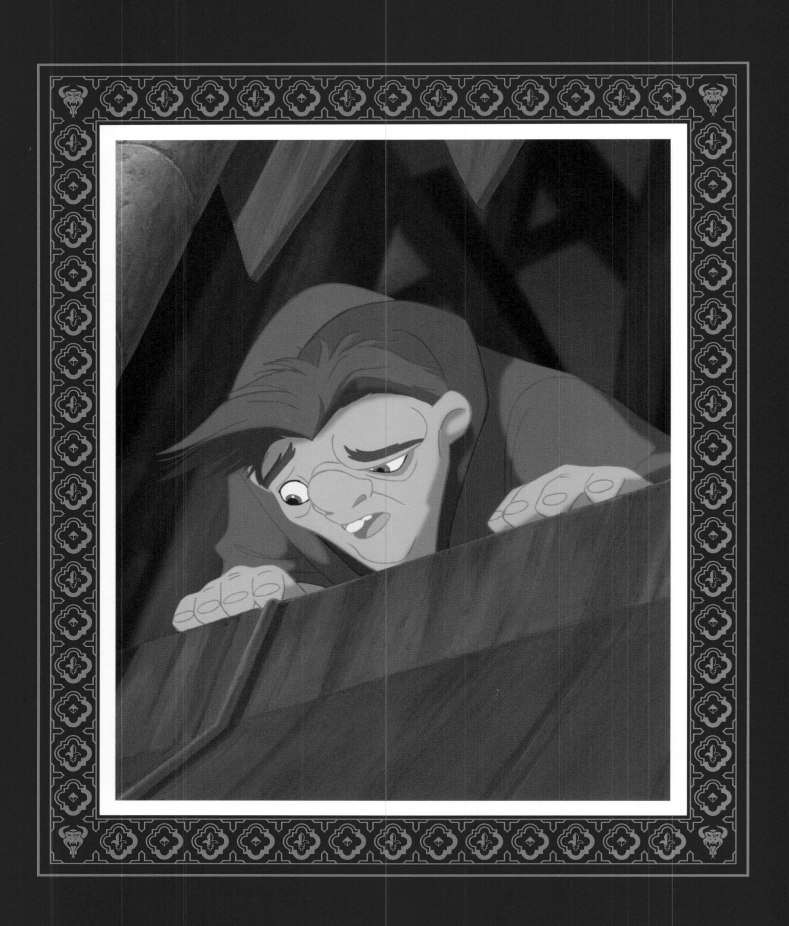

I.

What There Is in a Bottle of Ink

"I was born in my time for glory. I was born astride two centuries."
—VICTOR HUGO

ABOVE: *Frontispiece by Celestin Nanteuil from an 1832 edition of* Notre-Dame de Paris.
OPPOSITE: *Production still.*

Victor Hugo was riveted by the Greek letters he saw carved deep into a stone wall of a tower in Notre Dame cathedral. They read, translated, as: Fate. Why was that cryptic inscription chiseled there? By whom? What did it signify? Hugo brooded over such questions, as was true to his nature. But, as was also true to his nature, his brooding led him to research, dream, dig down into himself, and to write like fury. The end result was the publication in March 1831 of *Notre-Dame de Paris*, his much-read, much-beloved, much-argued-about, and, what was to become a century later, much-filmed novel. In the preface to the first edition, he revealed that the impulse to create the sprawling saga had sprung from a desire to re-create medieval Paris and to envision the events that might have led to someone's having carved in stone that one-word message to eternity.

Most modern readers are familiar with the aspect of the novel that involves the adoration the misshapen bell-ringer Quasimodo

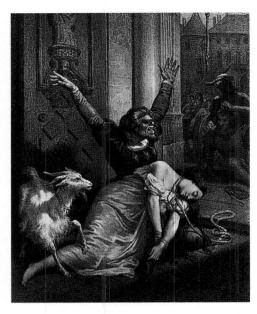

The Disney filmmakers used pivotal moments of the novel to tell a story about universal emotions, such as feelings of exclusion and the desire for acceptance by others.

ABOVE: *Illustration by Nicolas Maurin from a 19th-century edition of* La Esmeralda. RIGHT: *Rough animation of Esmeralda by Anne Marie Bardwell and of Quasimodo by James Baxter.* BELOW: *Value studies by Tom Shannon.*

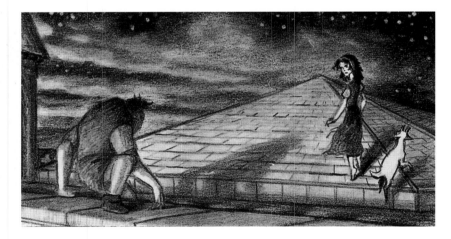

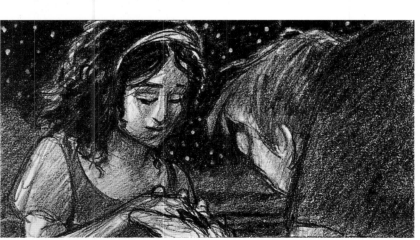

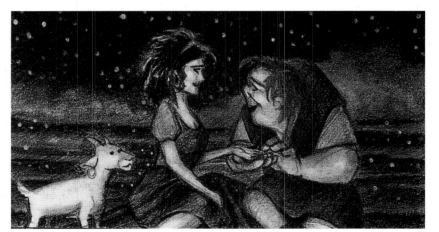

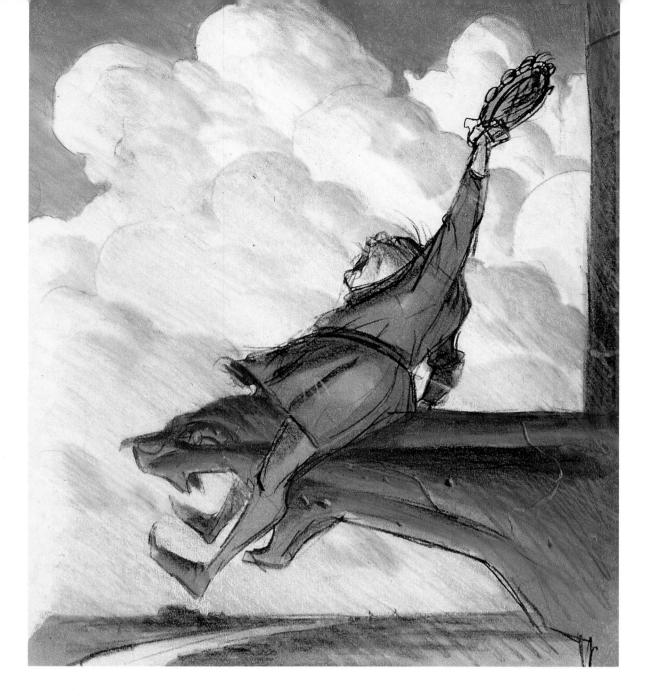

feels for Esmeralda, the beautiful gypsy girl. Many know the book, too, for such epic moments as the hunchback being crowned King of Fools by an orgiastic, celebratory festival crowd, and his being pitilessly ridiculed, tortured, and humiliated by that same crowd on the pillory. There is Quasimodo's acrobatic scaling of the heights of the cathedral and his swinging ecstatically from the gargoyles and the bells. There is his rescue of Esmeralda from the captors who would hang her as a witch, as he hoists her in his arms out of harm's way, crying triumphantly, "Sanctuary!" There is the mob storming the cathedral and Quasimodo raining molten lead down on the crowd, which Hugo so powerfully brings to life that it simultaneously evokes the storming of the Bastille and anticipates his own gripping handling of the political upheaval in *Les Misérables*.

Yet, what perhaps remains most memorable are Quasimodo's extraordinary physical challenges, his self-sacrificing love for Esmeralda, and the lengths to which he will go to justify that love. Certainly these aspects have been persuasively dramatized in previous screen versions of the work in

19

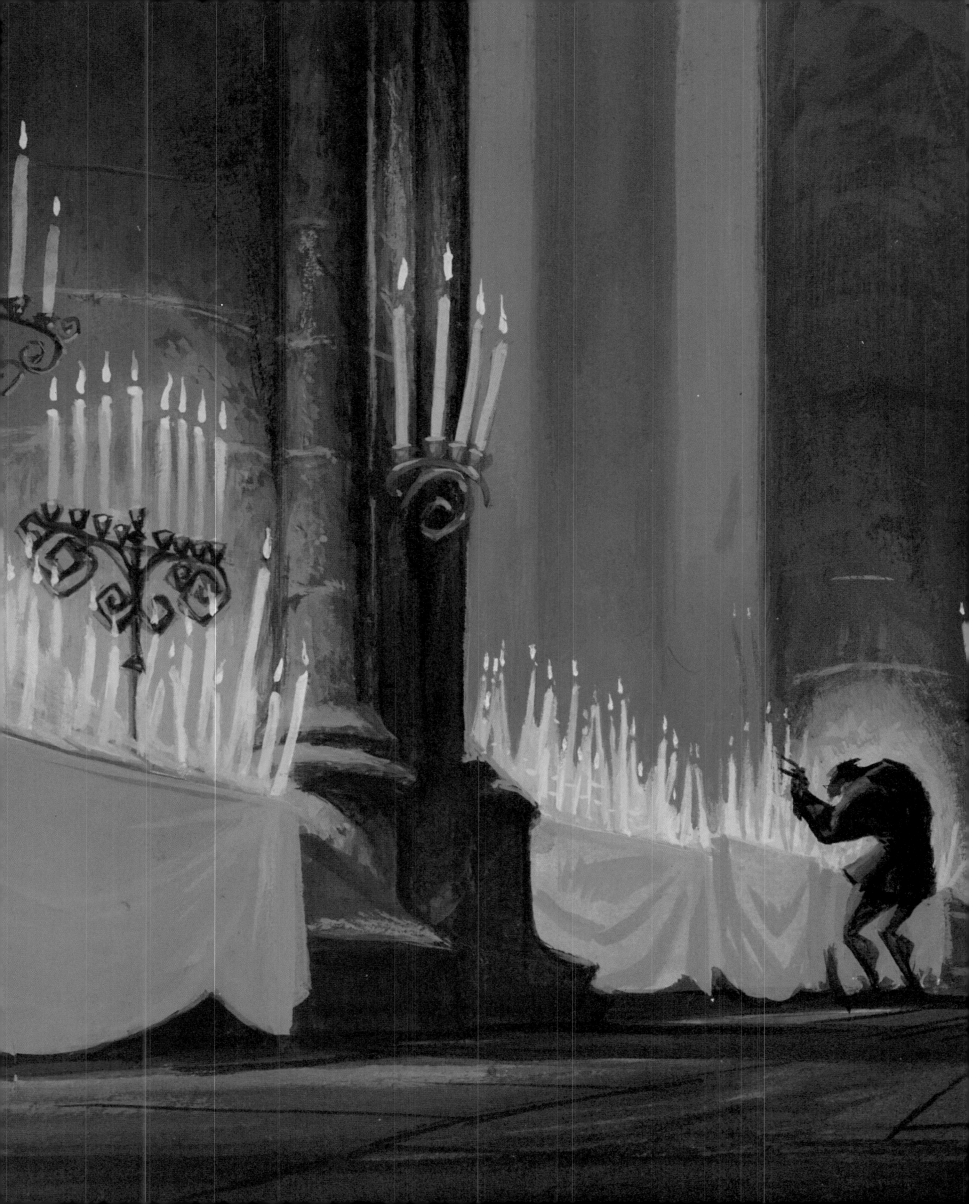

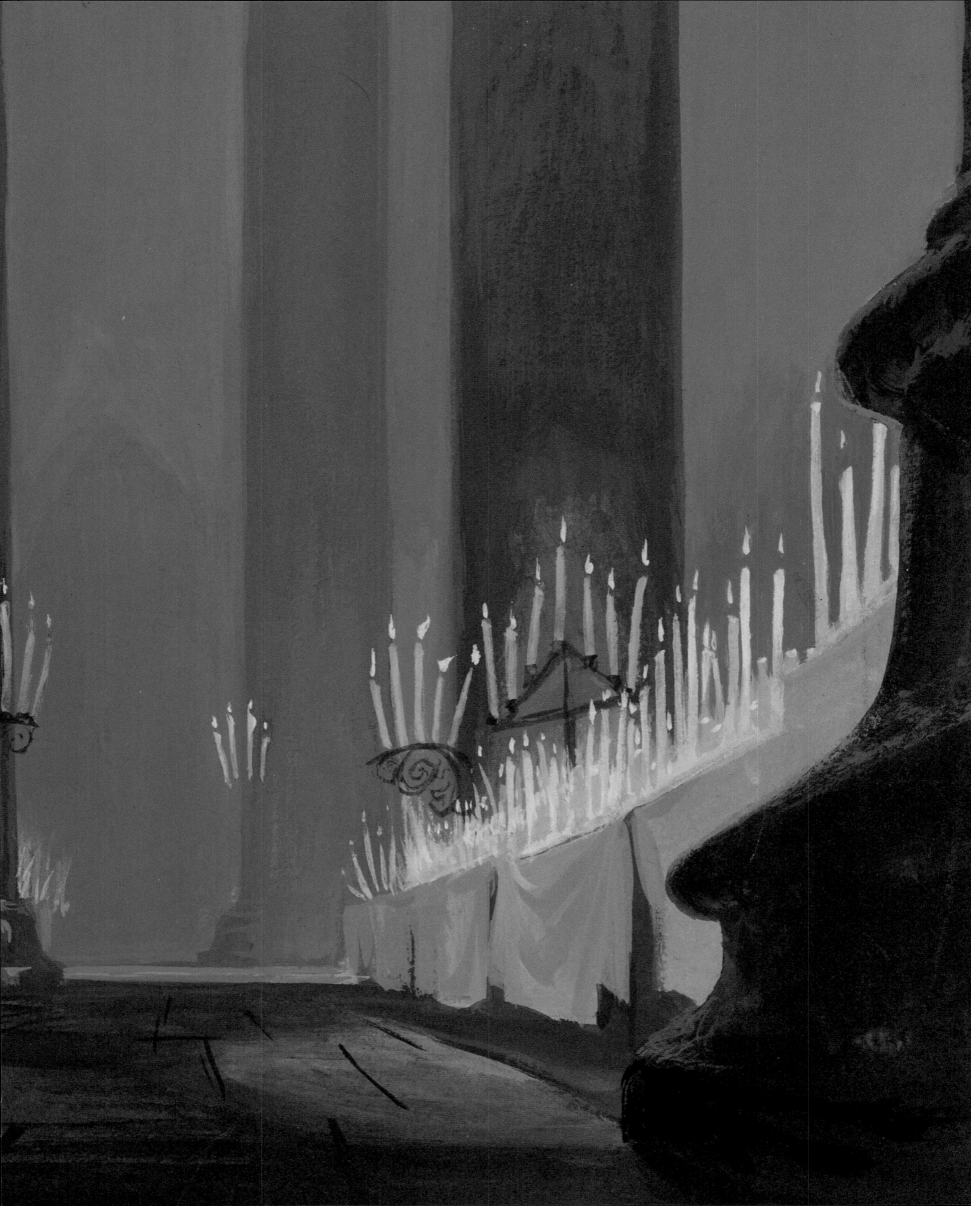

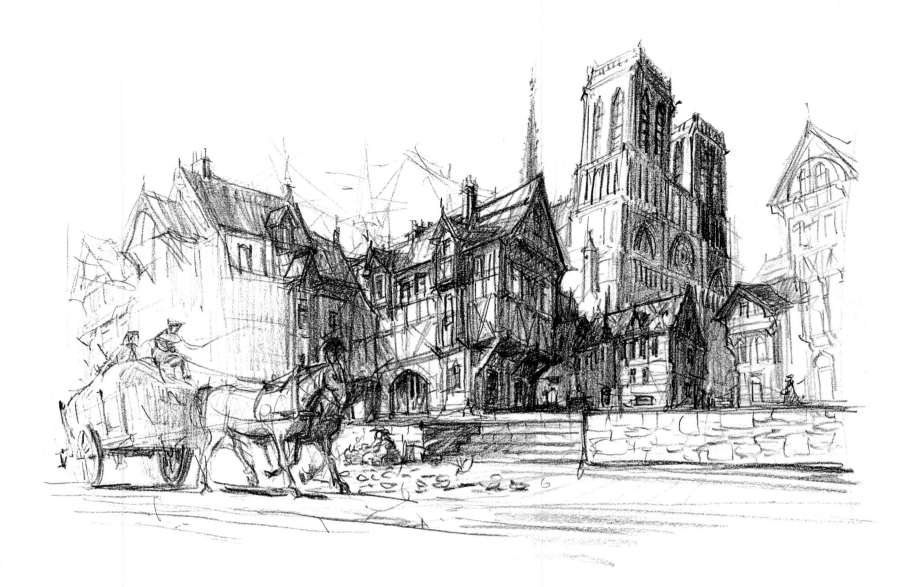

which Quasimodo has been played, over the decades, by Lon Chaney, Charles Laughton, Anthony Quinn, and Anthony Hopkins. But Hugo's novel, which, among other things, is vehemently anticlerical and anti-aristocratic, is concerned with far more than Quasimodo, who, in the book, is virtually peripheral.

Central to the novel is the cathedral itself, which Hugo describes with an ever-shifting play of light and shadow, sounds and silences, even moods that invest the grand structure with a character, and a moral force, of its own. Throughout the novel Hugo plays out a literary conceit of visual, aural, and moral contrasts and opposites: the hushed silence of Notre Dame spotlighted against the tumult of the streets, light played against dark, appearance versus reality, good against evil, piety opposed to true faith, outward beauty contrasted with ugliness of the soul. He envisions the medieval world of Paris as hierarchical and three-layered: Heaven is represented by the glory of Notre Dame; Hell is symbolized by the life of the everyday Parisian in the filthy, hectic streets; Quasimodo's realm, his station in life, is to remain poised halfway between. Hugo's pre-Freudian, pre-Jungian notions of a "shadow" self give the novel a tension and edge that connect with the lives of modern readers.

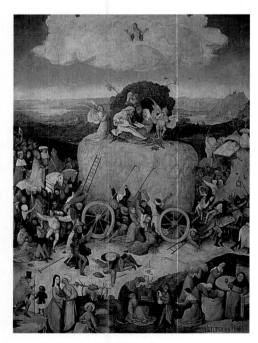

ABOVE: The Hay Cart (1500–1502), by Hieronymus Bosch, seems to evoke the three-layered medieval view of the universe that inspired Hugo's vision of the city in Notre-Dame de Paris. TOP: Concept art by Marek Buchwald.

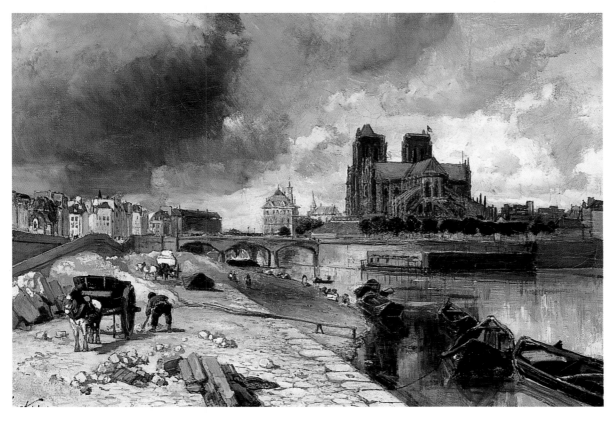

The Disney artists looked at art by Hugo and his contemporaries for inspiration for the art direction of the film.

LEFT: Notre-Dame, quai de la Tournelle, by Johan Jongkind, 19th century.
BELOW: Background art by Justin Brandstater.
OVERLEAF: Concept art by Lisa Keene.

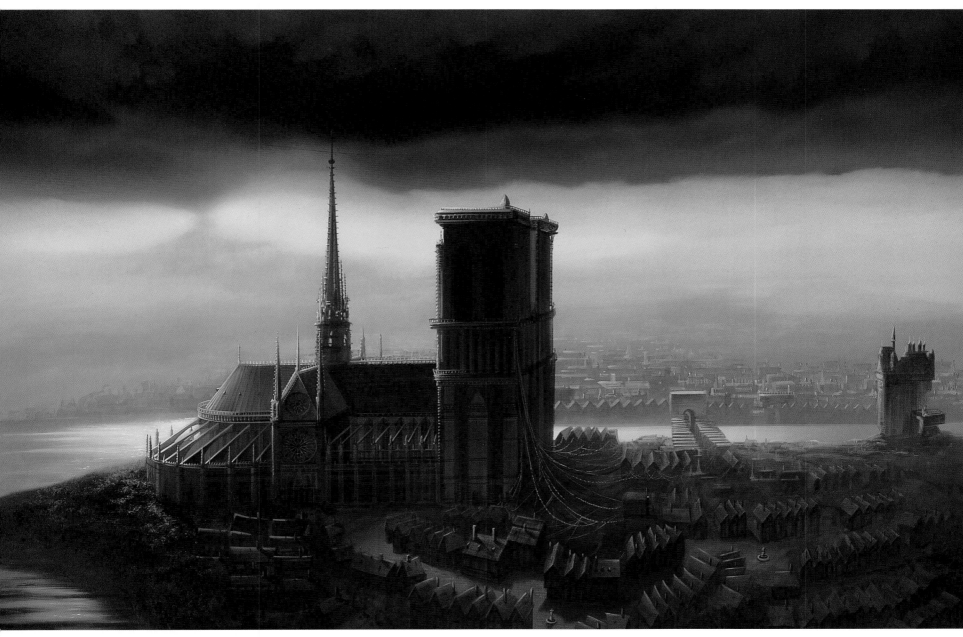

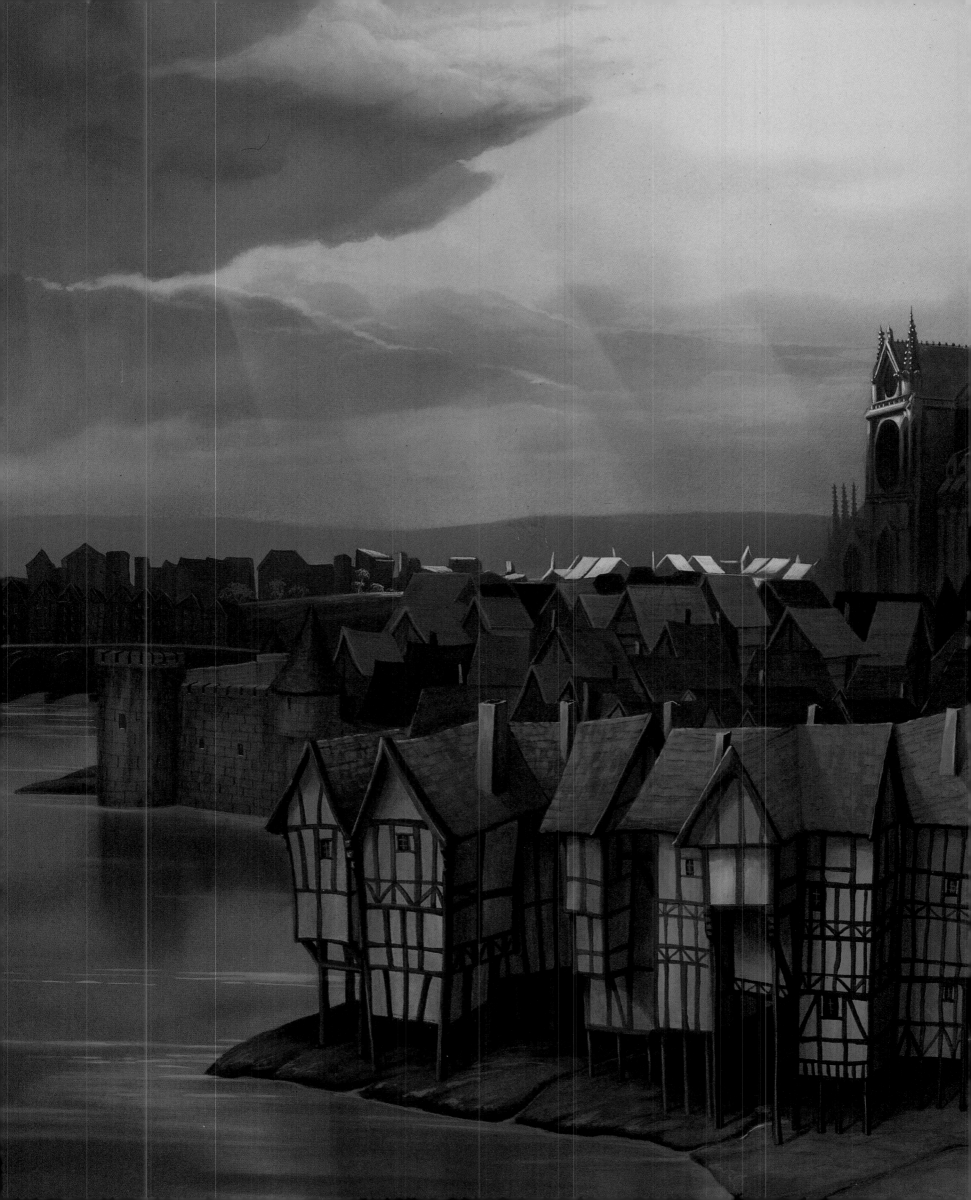

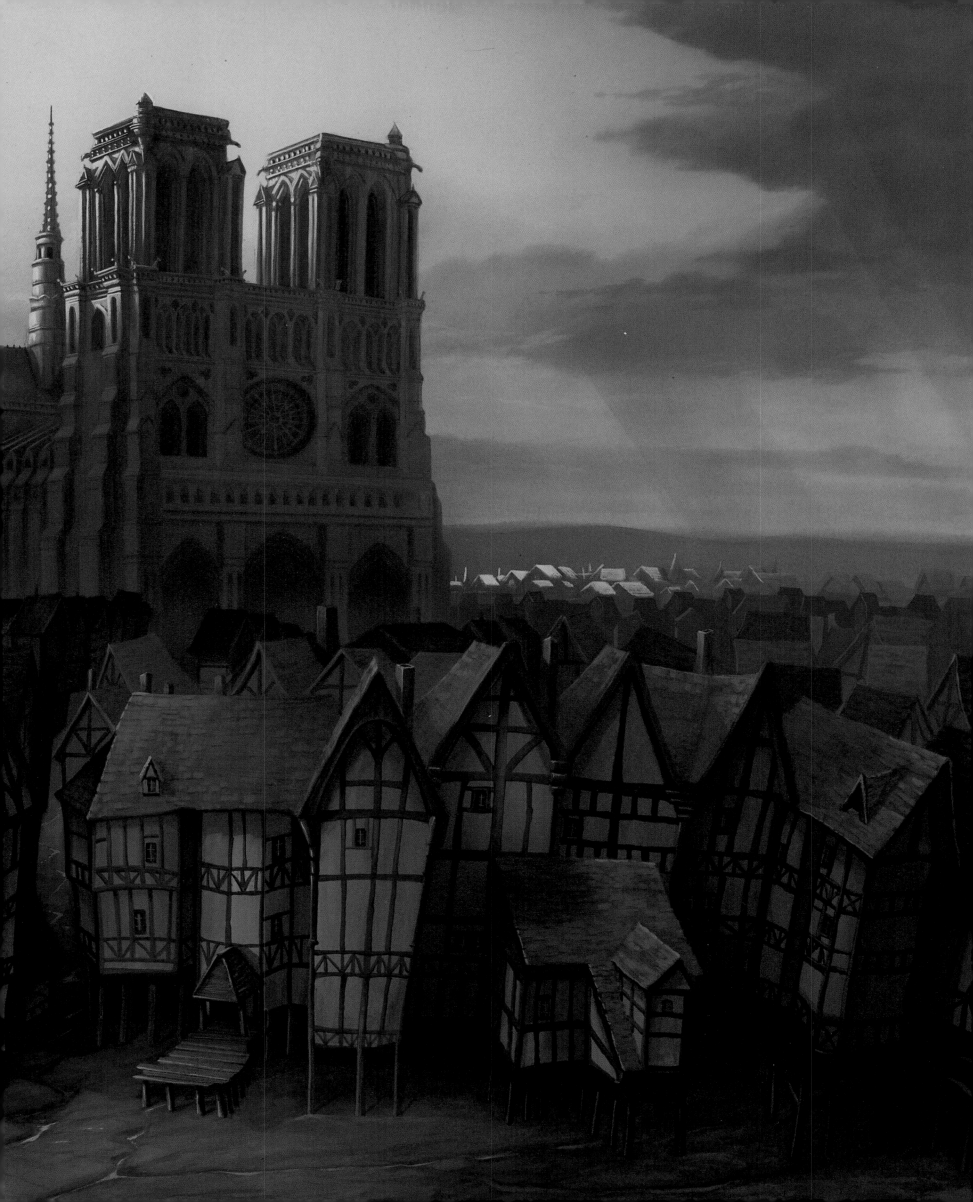

In the novel, the complex interplay of light and dark, good and evil, piety and carnality is epitomized in the character of the self-righteous and powerful Claude Frollo, Quasimodo's protector, whose hatred of gypsies and thwarted desire for Esmeralda push him to further and further extremes. Hugo's Quasimodo can also be viewed as a physical manifestation, an outward projection, of the sick, twisted soul of Frollo. He can be seen, as well, as a projection of the fears, ignorance, and conflicts of a society obsessed with guilt and sin. Esmeralda represents, in part, a Romantic's idealization of the exotic, the mysterious, the untamed.

Within the context of a rousing historical romance and psychodrama, Hugo uses the book as a forum to air his views on the "modernization" of Gothic buildings, on alchemy, Satanism, gypsies, and French history. The novel is also a hymn to the Gothic style. Vividly emotional, ferociously impassioned, dark and ruminative, it is rife with Hugo's fascination with history, the arcane, mysterious, and occult. A model of Romanticism, it overflows with

ABOVE: *Concept art by Sue Nichols.*
BELOW: *Concept art by Vance Gerry.*

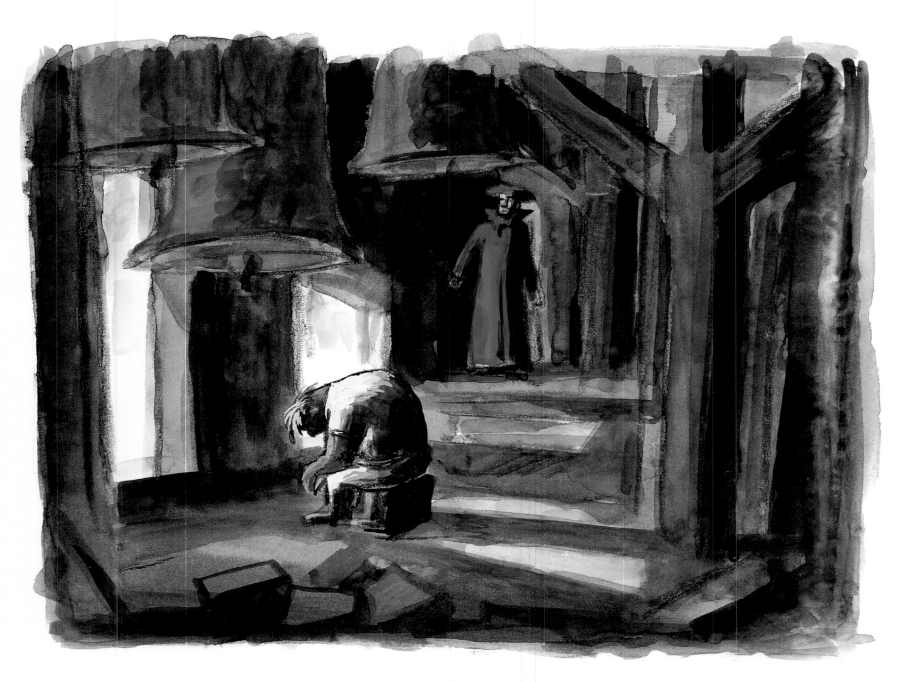

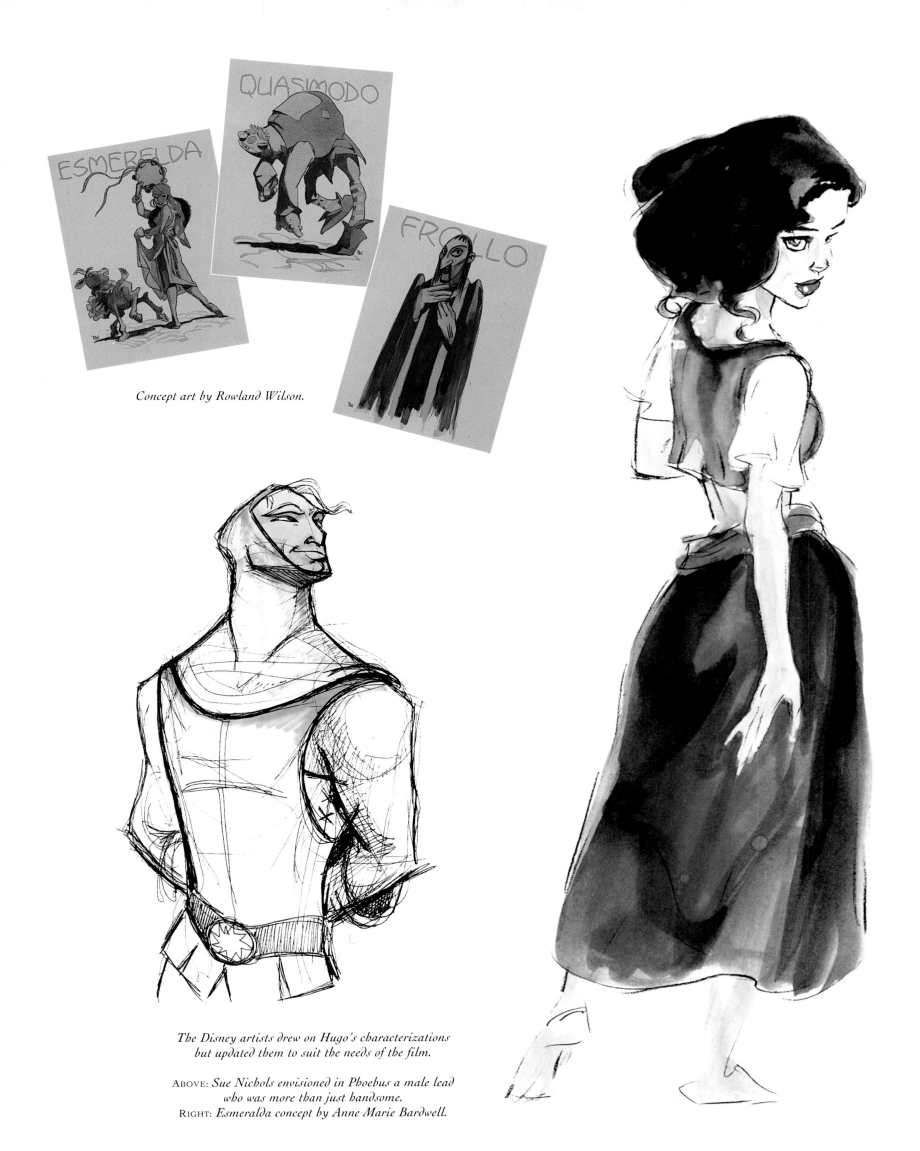

ESMERELDA

QUASIMODO

FROLLO

Concept art by Rowland Wilson.

The Disney artists drew on Hugo's characterizations
but updated them to suit the needs of the film.

ABOVE: Sue Nichols envisioned in Phoebus a male lead
who was more than just handsome.
RIGHT: Esmeralda concept by Anne Marie Bardwell.

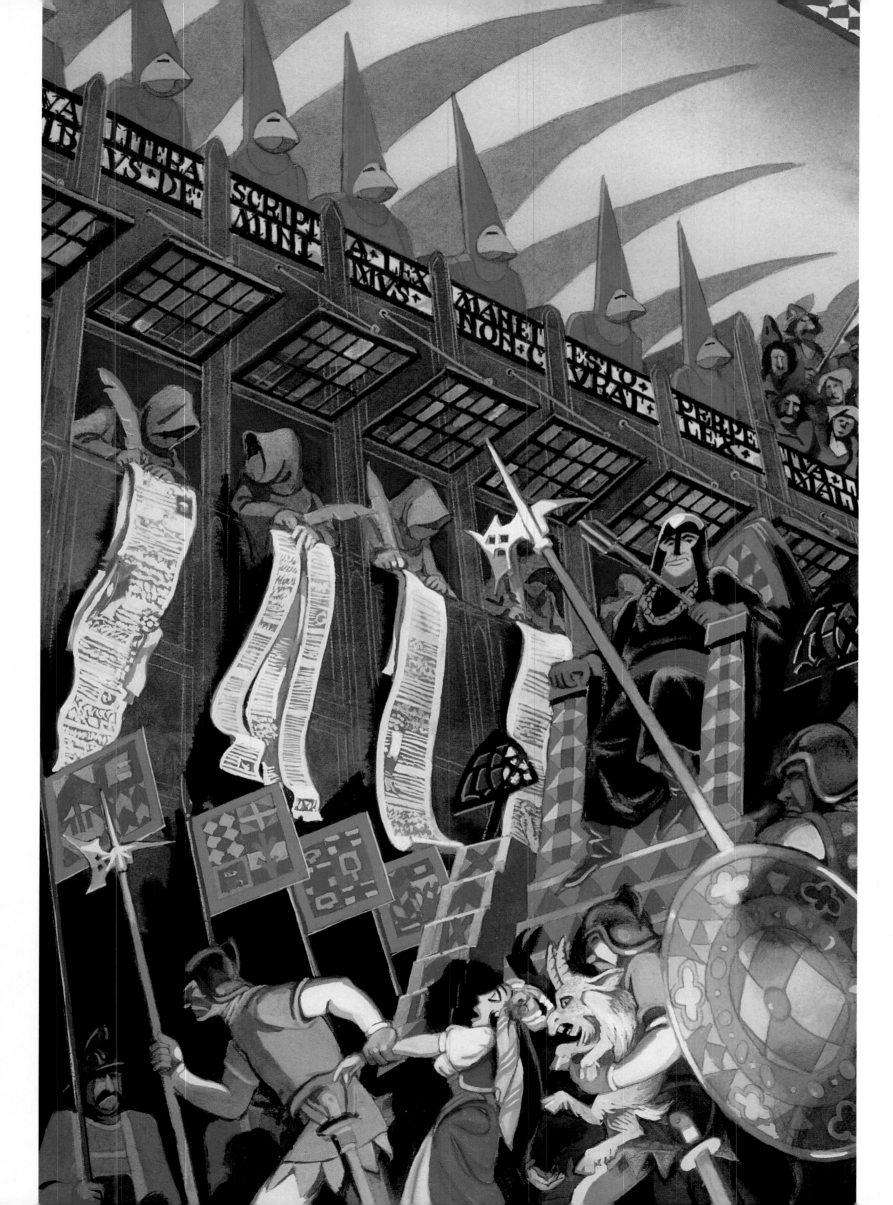

intense images, and finds Hugo thumbing his nose at the traditions of Classicism and embracing humanity, particularly the common man.

As befits the Romantic spirit, swirls of myth and melodrama surround the writing of *Notre-Dame de Paris*—perhaps a result of Hugo's having done everything in his considerable power to create that swirl. *Victor Hugo Recounted by a Witness of His Life*, a memoir written by Adèle Hugo, then his wife of seven years, details his creation of the novel. Many historians and critics insist that Hugo himself dictated the memoir, in which the artist is described as having "bought himself a bottle of ink and a huge gray knitted shawl, which swathed him from head to foot, locked his formal clothes away so that he would not be tempted to go out and entered his novel as if it were a prison."

Whatever his state of mind, Hugo had begun making notes for just such a historical novel three years earlier. He probed archives, chronicles, charters, inventories, and dusted-off histories of Paris. No inscription at Notre Dame (reading "Fate," or anything else) went unnoticed, no spiral staircase was not climbed, no arcane passageway nor closet carved of stone not investigated. In this regard, he is much like Quasimodo, who knows the cathedral's every secret, every nook and cranny, so much so that he speaks to its architectural

Concept art by Marek Buchwald.

To realize the epic scope and teeming chaos of the streets of Paris, the filmmakers created computer-generated three-dimensional crowds.

BELOW: *Color key by Doug Ball.*
OPPOSITE: *Concept art by Rowland Wilson.*
OVERLEAF: *Concept art by Lisa Keene.*

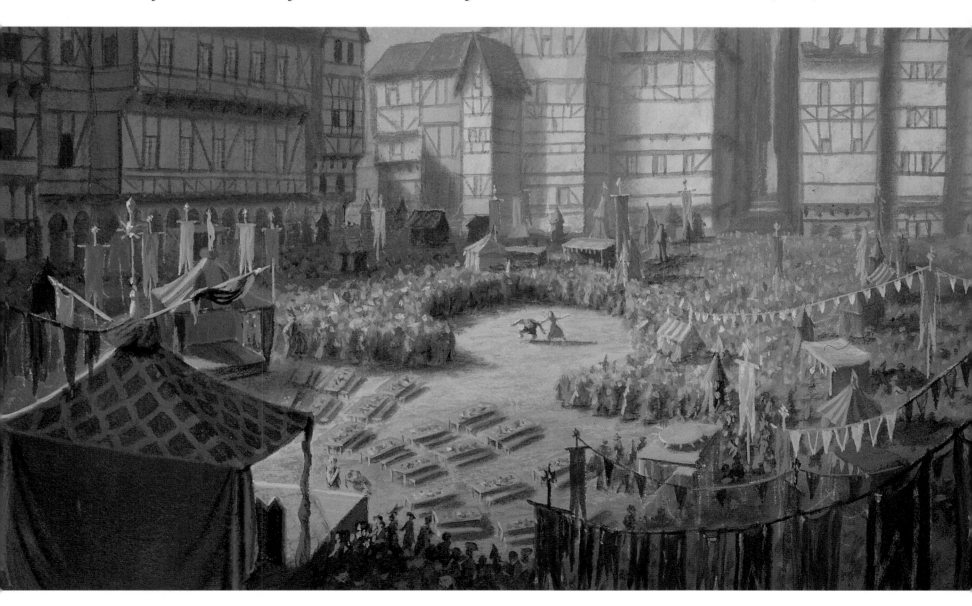

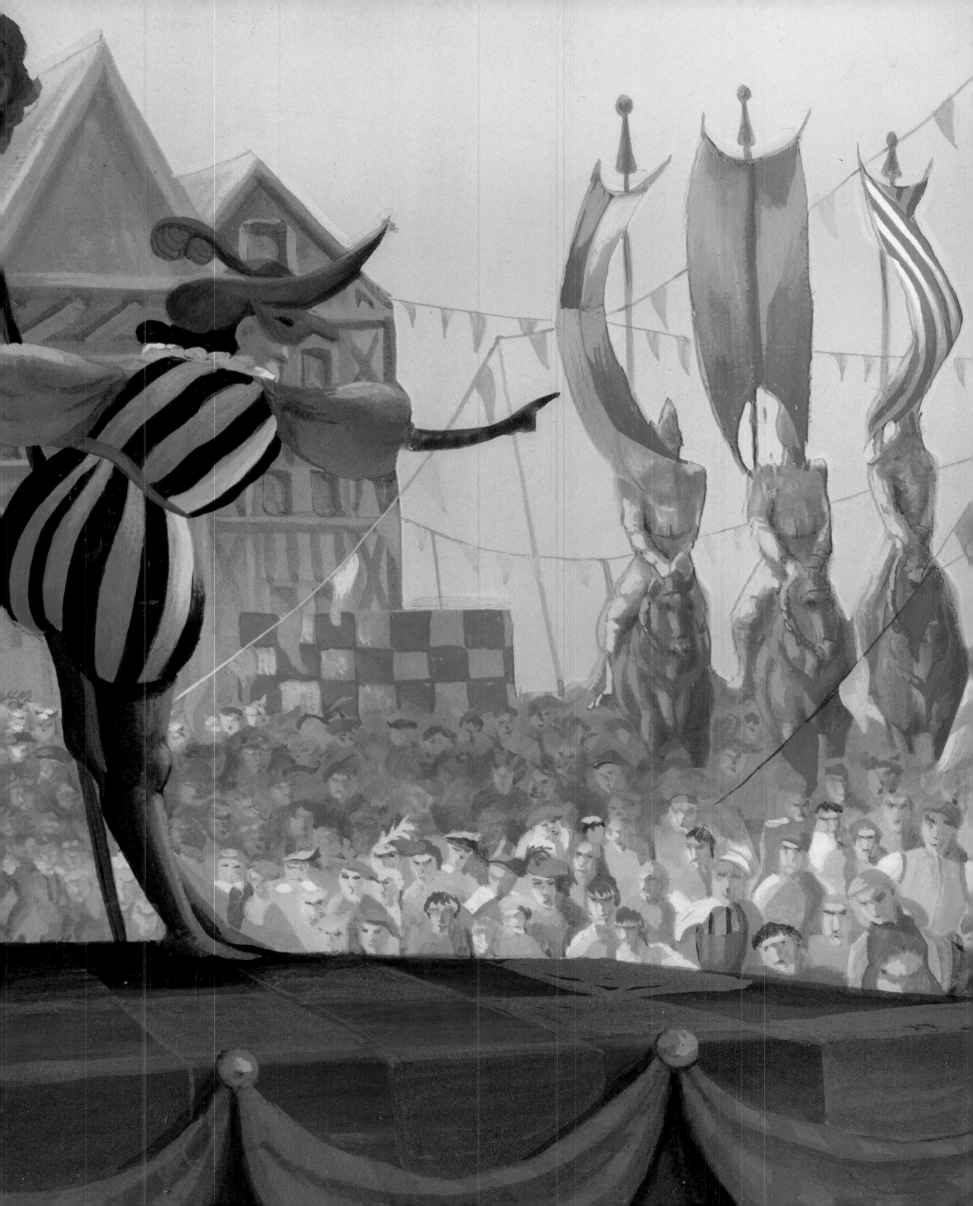

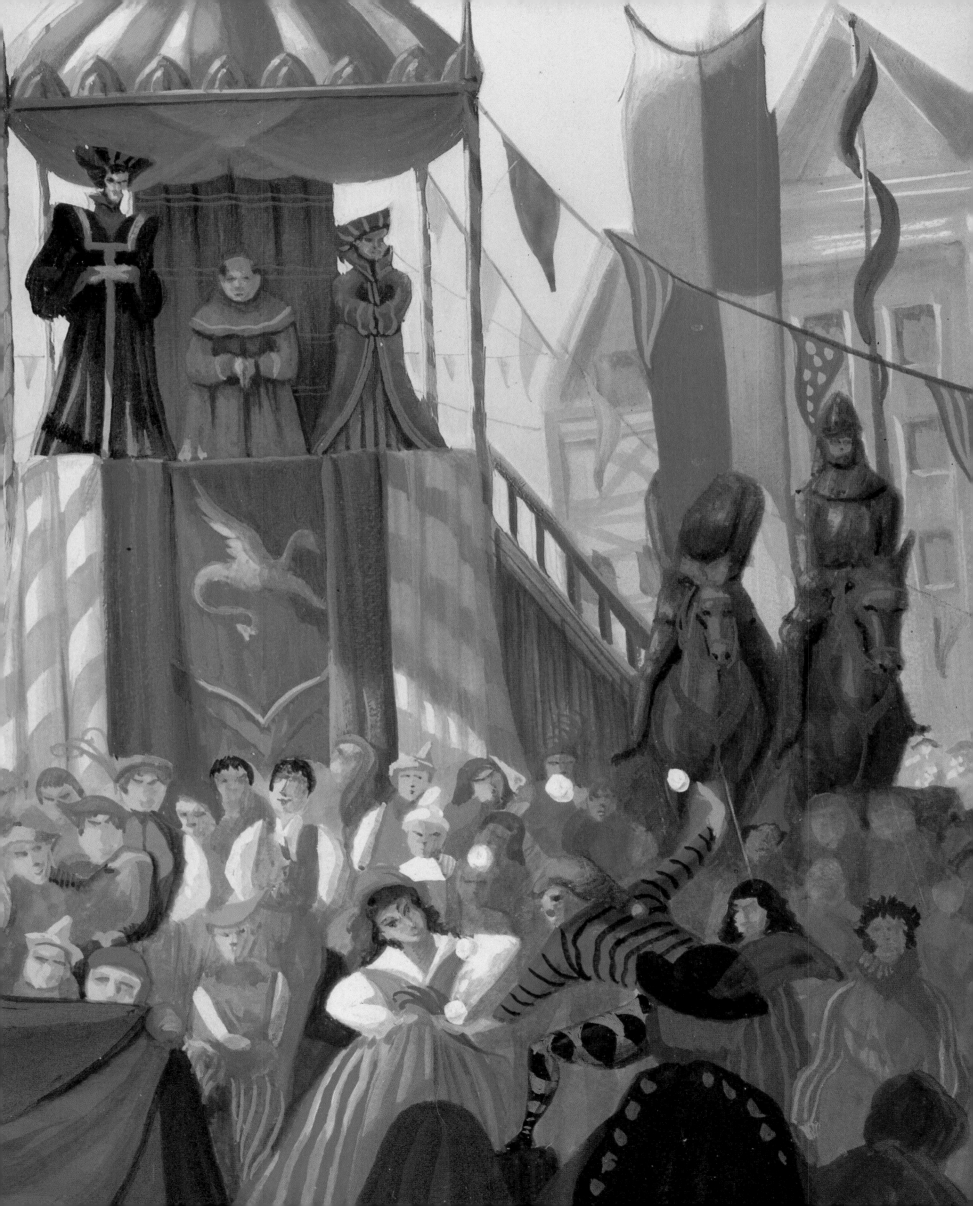

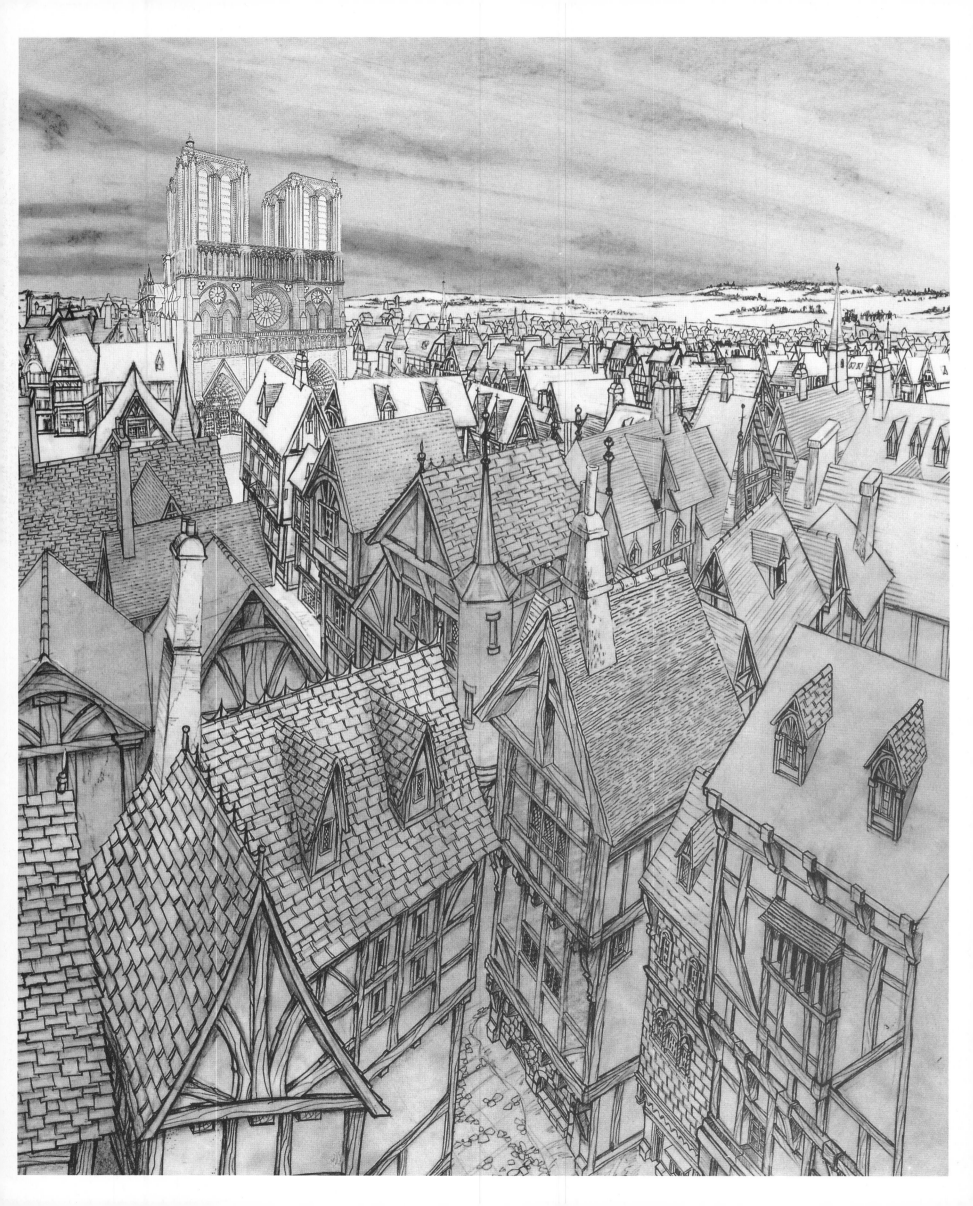

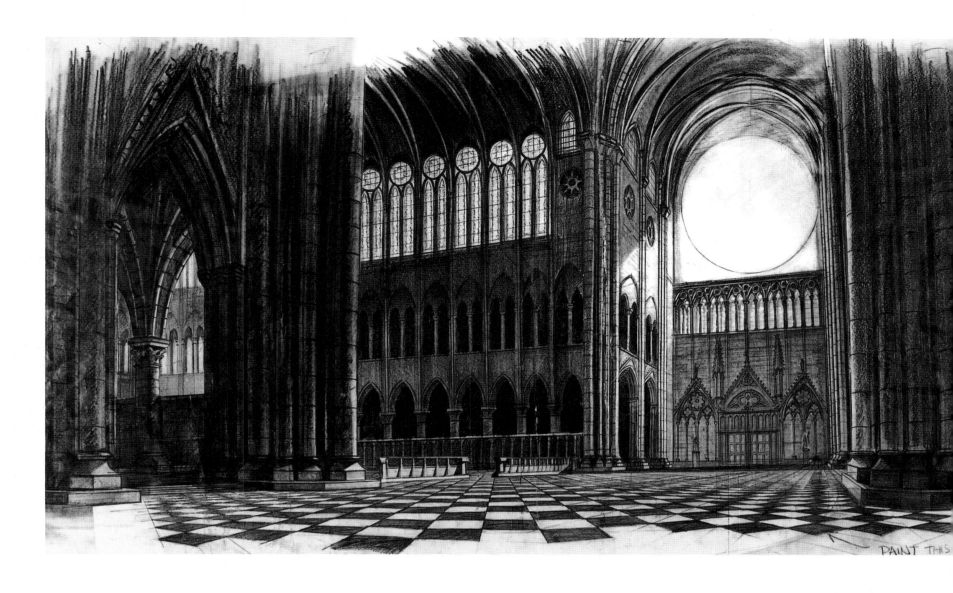

elements and calls the bells by names. August Vacquerie observed that Hugo so identified himself with the cathedral and its preeminence as a symbol of Paris and all that is Parisian, the 'H' formed by the cathedral towers was virtually synonymous with the 'H' in Hugo. For Hugo, all such research "is what matters least," as he wrote in his preface to the novel. "Its sole merit, if it has one, lies in the fact that it is a work of imagination, whim, and fancy."

Because Hugo was feverishly ambitious and productive, spreading his energies and gifts among multiple projects, hoisting the banner for many crusades and causes, the publisher of the long-delayed *Notre-Dame de Paris* inserted a contractual clause demanding Hugo forfeit 1,000 francs for each week the book was late. It proved an effective ploy; with four children and another on the way, Hugo badly needed the money. He began writing the book in September and finished the nearly 200,000-word manuscript six months later. Mme Hugo claimed in *Victor Hugo as Recounted by a Witness of His Life* not only that her husband completed the book and ran out of ink simultaneously but that he also wrote the entire book from a single bottle of ink and considered titling the novel *What There Is in a Bottle of Ink*.

The cathedral's preeminence in the landscape of medieval Paris inspired the layout artists to use a graphic language of elongated verticals to emphasize the relationship of Notre Dame with Paris and of the characters with their surroundings.

ABOVE: *Illustration by Eugène Viollet-le-Duc from an 1877 edition of* Notre-Dame de Paris.
TOP: *Layout art by Sam Michlap*
LEFT: *Concept art by Joe Grant.*
OPPOSITE: *Layout art by Ed Ghertner.*

33

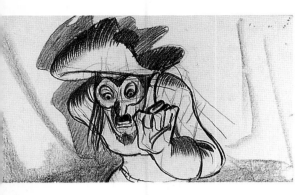

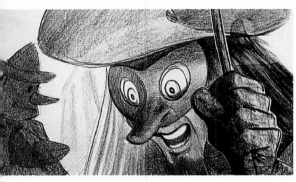

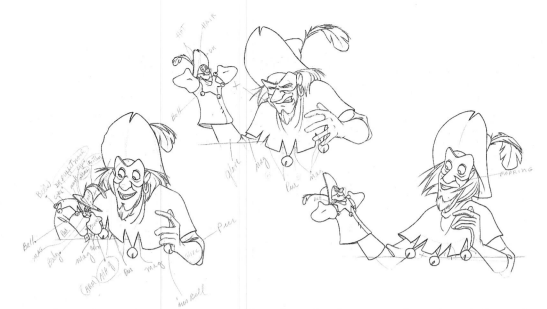

What there was in Hugo's bottle of ink proved to be rich and rousing indeed. Yet on publication, *Notre-Dame de Paris* drew mixed reviews. One critic may have praised Hugo as "the Shakespeare of prose," but Prosper Mérimée wrote he would be "in despair if that were the sort of thing this century wants." Goethe thought the book too schematic, its characters merely Hugo's puppets. Others said worse. No matter. The novel sold a highly profitable three thousand copies-plus in its first eighteen months of publication and underwent four separate translations into English between 1833 and 1839. Beyond that, it secured Hugo's reputation in England where, on its second translation in 1833, it was retitled *The Hunchback of Notre Dame*, the

A prologue sung by the self-proclaimed gypsy king Clopin was devised to communicate the relationship between Quasimodo, Frollo, and the cathedral. This sequence, along with another five minutes of the film, was conceived, produced, and animated in Disney's Paris Studio.

ABOVE: *Storyboard art by Paul Brizzi and Gaëtan Brizzi.*
TOP: *Cleanup of Clopin by Margie Daniels, animation by Michael Surrey.*
RIGHT: *Cleanup of Quasimodo's mother and father by Vera Lanpher, animation by Stéphane Sainte Foi. Cleanup of the soldier by Lieve Miessen, animation by Stéphane Sainte Foi.*
BELOW: *Workbook drawing by Ed Ghertner.*

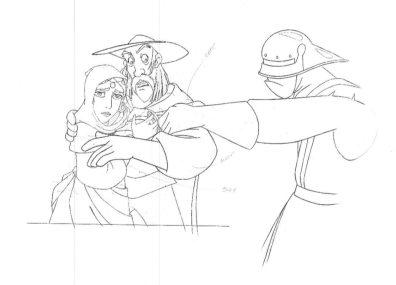

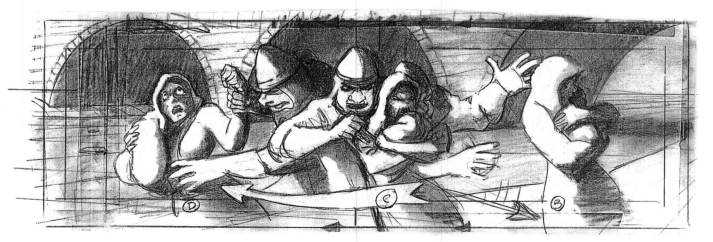

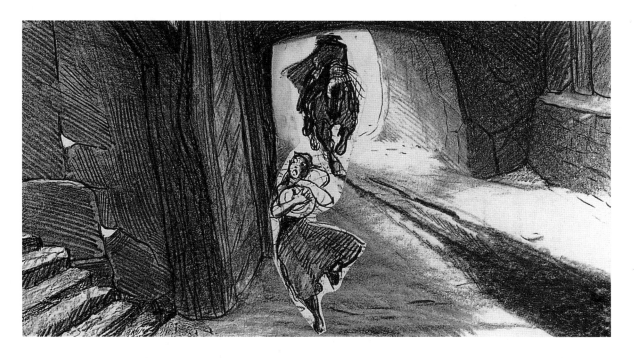

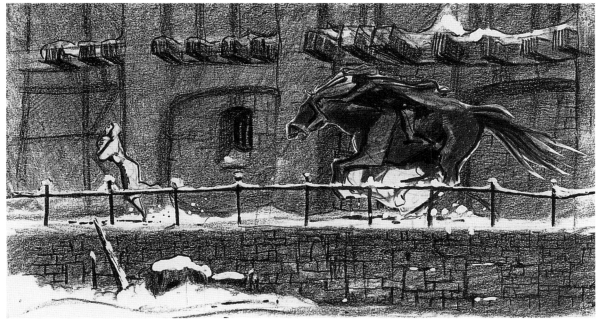

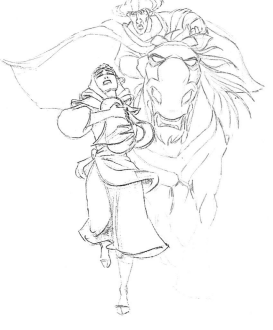

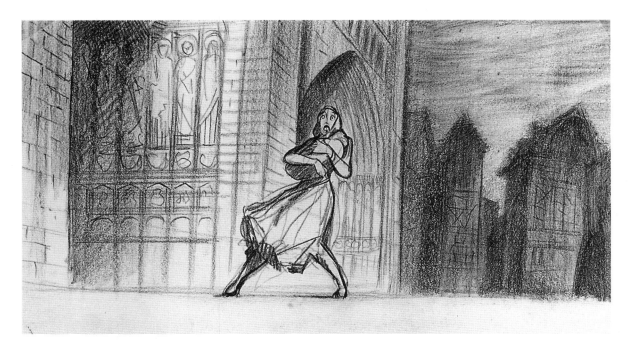

ABOVE: *Rough animation by Stephane Sainte Foi and Bolhem Bouchiba.*
LEFT: *Storyboard art by Paul Brizzi and Gaëtan Brizzi.*
BELOW: *Rough animation of the Archdeacon by Dave Burgess.*
OVERLEAF: *Production still.*

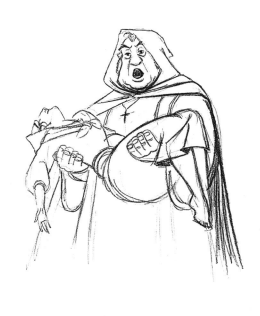

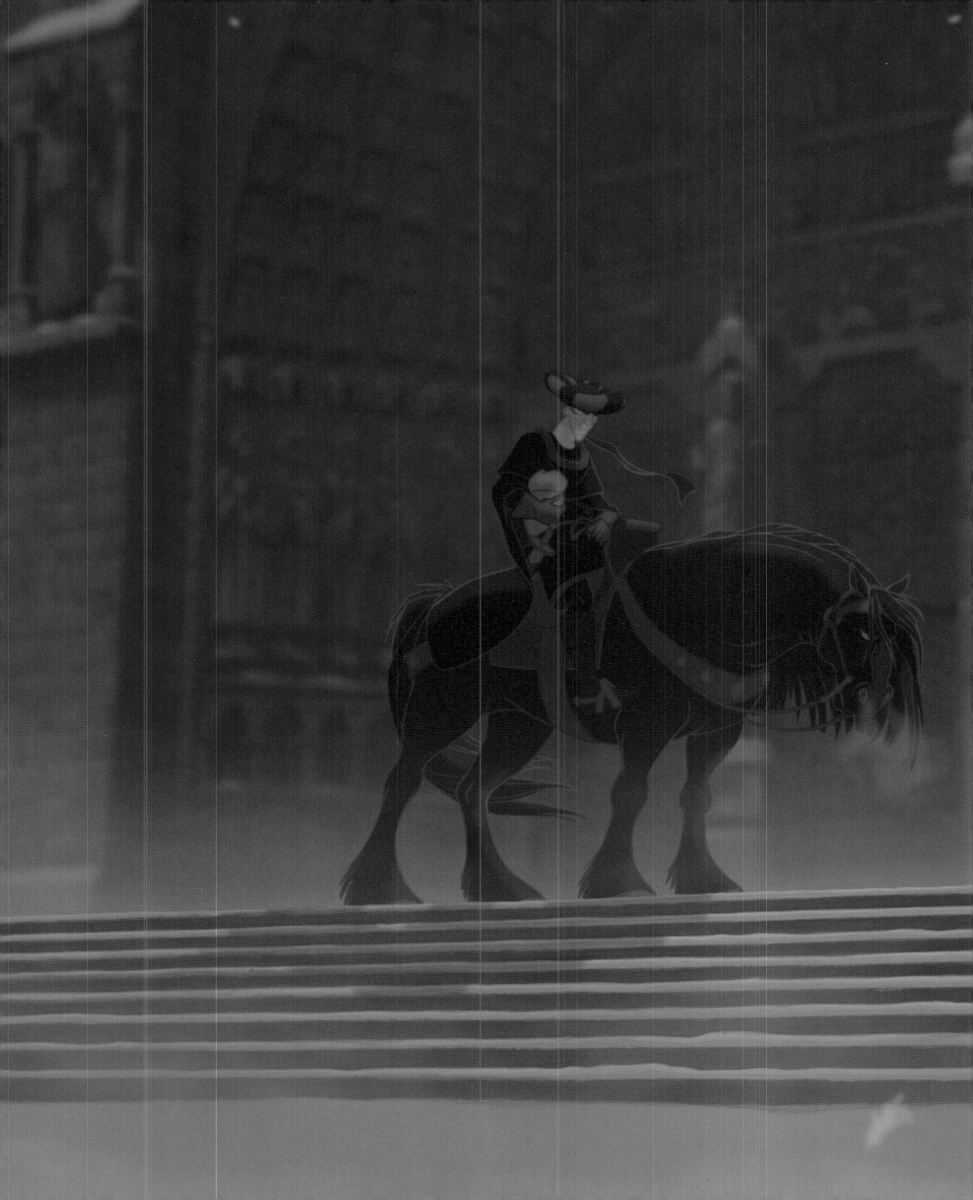

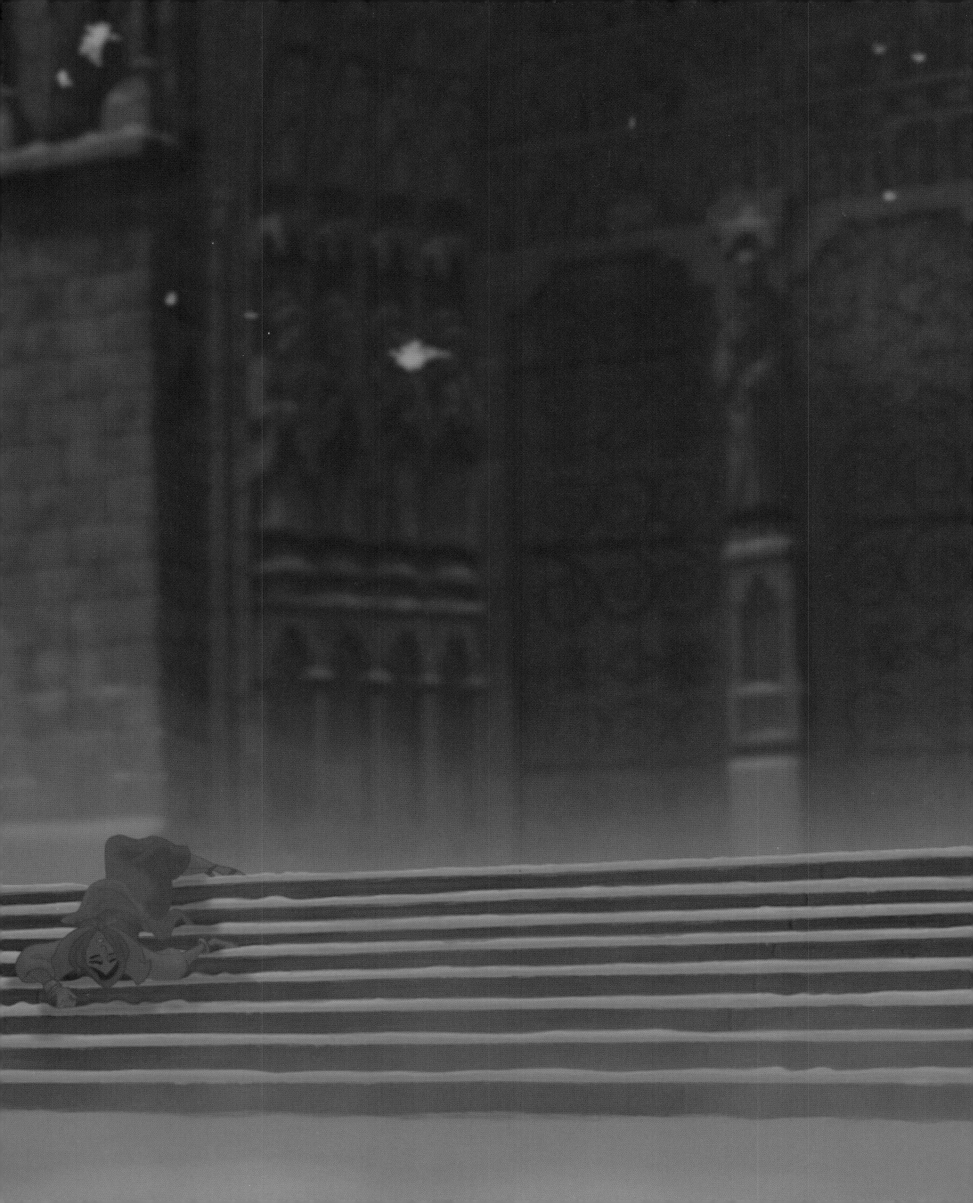

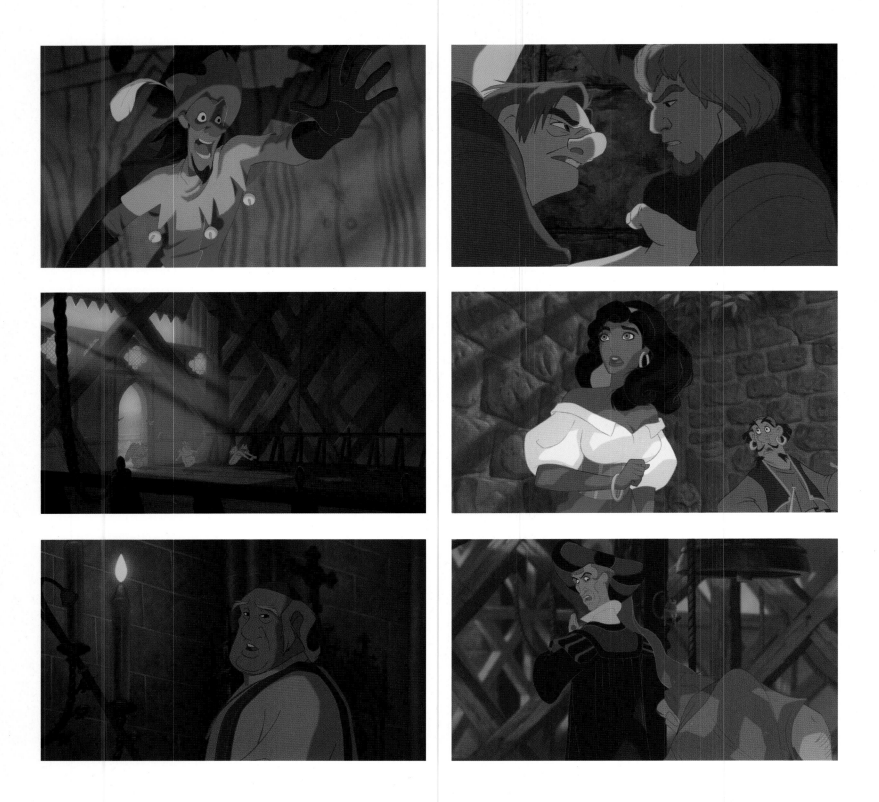

Hugo's metaphorical interplay of light and shadow inspired the effects department to create dramatic lighting that would both create a cohesive environment for the characters and subtly enhance the emotions and storytelling.

THESE PAGES: *Production stills.*

title by which English readers have known it ever since. Of the British critics who reviewed the book, even those who judged it as an uncommonly well-done tearjerker, one wrote: "The concluding passages offer some of the most pathetic pages we ever remember to have bedewed with (irresistibly flowing) tears." No less than Swinburne, Robert Louis Stevenson, and Rudyard Kipling championed it. One of the popular successes of Hugo's lifetime, the book has enthralled readers from the first. With so much raw material and subtext, small wonder that Hugo's novel has been filmed four times previously. Small wonder, too, that the filmmakers at The Walt Disney Company recognized in it many wonderful and challenging elements for a powerful animated musical.

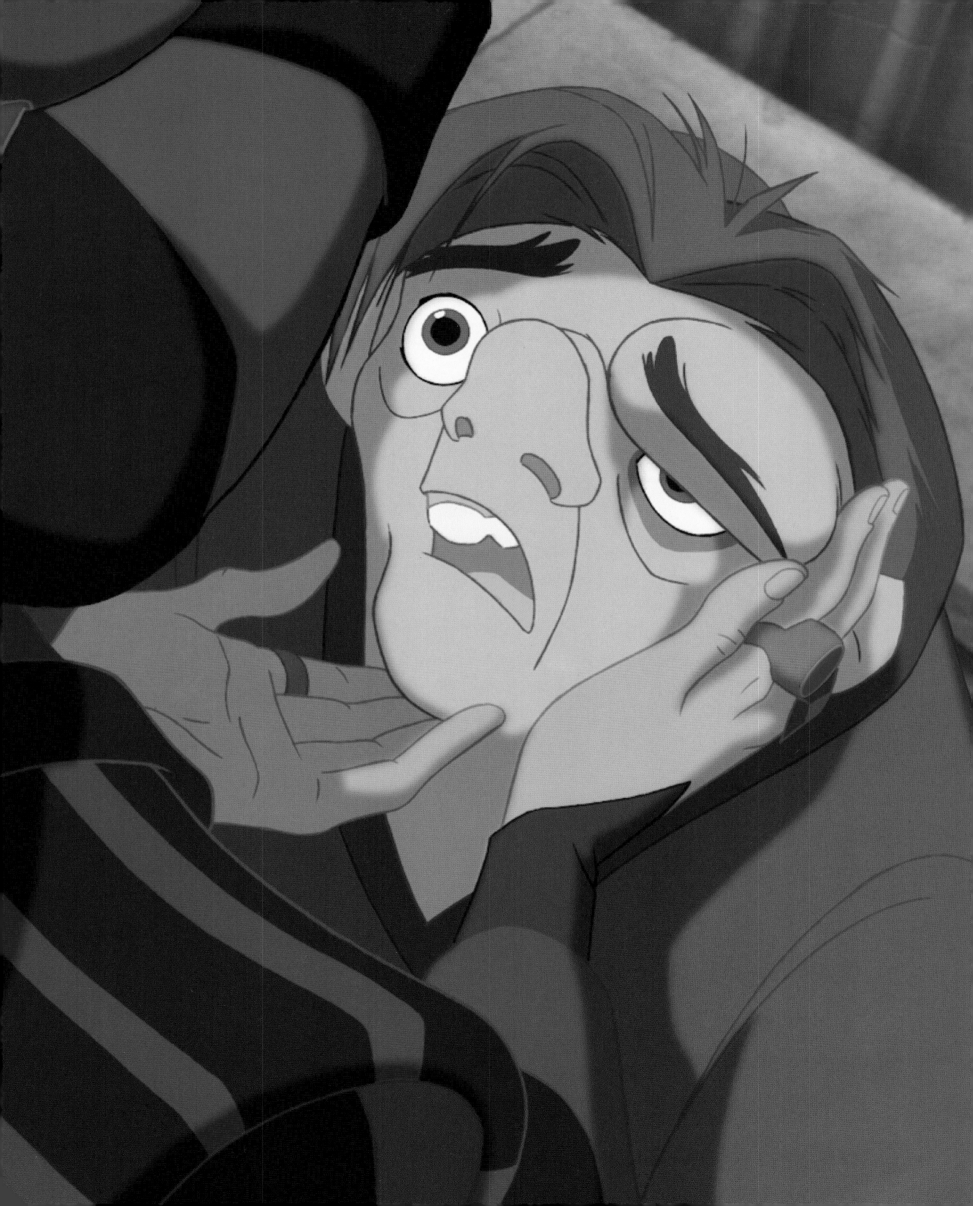

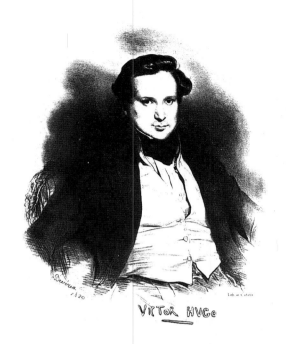

"Born for Glory"

ictor Hugo (1802-1885) attained near-
ly mythic stature in his lifetime, having
dominated French culture as the coun-
try's foremost Romantic novelist and poet, as
well as one of its most gifted painters and play-
wrights. He lived expansively, powering through
his life with bravura style, passion, and human-
ism. Not surprisingly for someone who declared,
at fourteen, "I must be Chateaubriand, or noth-
ing!" he would continue throughout his life to out-
rage and enthrall audiences and critics. He loved
several women, fathered many children, and
made legions of enemies and admirers. His oeuvre
inspired no less a talent than Paul Verlaine. Rodin
sculpted his head.

For a canon of work that includes the greatly
admired *Les Misérables* and *Odes et Poésies diverses*,
Hugo and, particularly *Notre-Dame de Paris*, came
to symbolize the Romantic literary movement and
helped spur a widespread architectural preserva-
tion movement that accounts for many of France's
extant Gothic structures. Controversy surrounded

much of his work. His historical play *Marion de
Lorme* sparked a censorship battle, and the pref-
ace to his play *Cromwell* was adopted as the man-
ifesto of Romantic literary theory. Another of his
historical plays, *Hernani*, provoked a full-out riot
between the Classicists, who favored formal rigor
and respect for the artistic conventions of the day,
and the radical Romanticists, who espoused revo-
lution in formal ideals, life, and art.

About to be banished from France for his
political views by Napoleon III, Hugo fled the
country rather than be hounded. He would later
be invited back to his beloved country where, at
age 83, he died and was laid in state under the Arc
de Triomphe before being buried in the Panthéon.
He inspired admiration, consternation, exaspera-
tion. When asked to name the supreme French
poet, André Gide replied, "Victor Hugo, hélas!"

As critics and biographers have contended,
certain defining events and moments in the life of
Victor Hugo could surely have influenced his cre-
ation of *Notre-Dame de Paris*. Accounts of his birth

in Besançon in 1802 report that he was so frail his chances for survival were considered marginal; an abnormally large head made him resemble a misshapen dwarf. At twenty-eight, he would create, with infinite empathy and wry humor, Quasimodo, the malformed, soulful bell-ringer of Notre Dame, in whose ears seem to whisper both angels and devils, and who is shunned and feared merely for his appearance.

The young Hugo also grew up with the awareness that his mother loved a man other than his soldier father. Some blame his mother's infidelity for a melancholy that apparently shadowed Hugo from infancy. "The poor devil's melancholy," Hugo would later write of Quasimodo, "became as complete and incurable as his deformity." At age nine, while in Spain with his mother and brothers, Hugo developed an infatuation with the exotic Pepita, the fourteen-year-old daughter of the Marquise de Monte-Hermoso. Later, he would create the exotic young gypsy street entertainer Esmeralda, whose beauty inflames Quasimodo and whose unexpected compassion he poignantly misinterprets.

Biographers believed Hugo derived further inspiration for Esmeralda's idyllic, otherworldly aspects from Adèle, the childhood sweetheart he married at twenty and whom he called "the angel" in the dedication of his first book, *Odes et Poésies diverses*. Childhood sweetheart or no, their relationship was fraught with miscommunication, jealousies, betrayals, and reprisals. At the wedding, Hugo's brother Eugène went mad, venting anguish and frustration that not only had Victor outstripped him as a poet but had also won Adèle, his unrequited, secret love. Later in their marriage, Hugo proved to be a prodigious sire of children but a self-absorbed, distracted husband; he came to learn that the prominent critic Charles-Augustin Saint-Beuve had become Adèle's lover. Perhaps in this triad, he found inspiration for his theme of "tres para una"—three in love with the same woman— as Esmeralda inspires very different forms of admiration in Quasimodo, Frollo, and the rakish, shallow soldier Phoebus. André Marois, Hugo's biographer, detected in the character of Frollo, a man torn between desire and denial, something of the artist himself.

ABOVE: *Cover of the first edition of* Notre-Dame de Paris, *1851.*
TOP: *Concept art by Jean Gillmore.*
OPPOSITE: *Lithograph of Victor Hugo by Achille Devéria, 1829.*

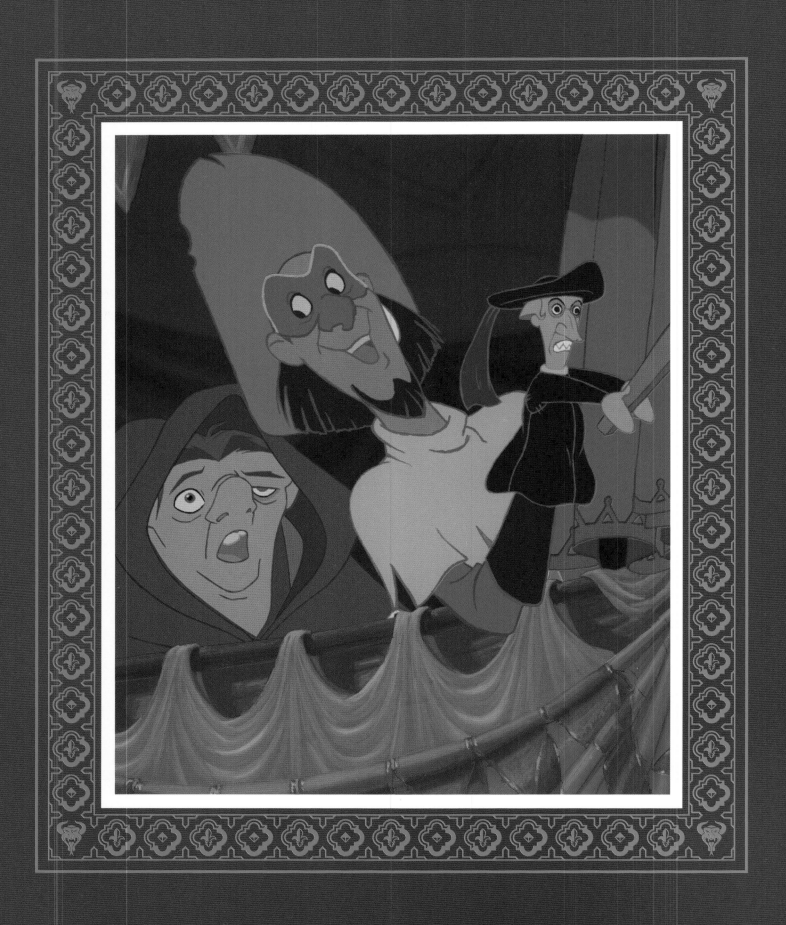

II.

The Corner of Avenue Victor Hugo and Dopey Drive

"Every character in the film is an outcast. Quasi is an outcast because of his looks, Phoebus comes to town to do his duty and becomes a fugitive, Esmeralda is an outcast by virtue of being a gypsy. The gargoyles were supposedly carved and discarded by the stone masons because they were imperfect. Even Frollo through his zealotry makes himself an outcast."

—TAB MURPHY, Writer

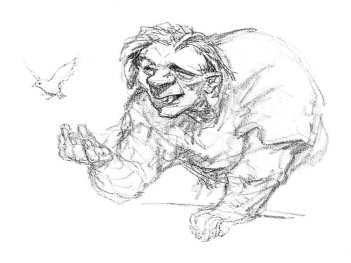

ABOVE: *Concept art by Peter DeSève.*
OPPOSITE: *Production still.*

t could be argued that, were Walt Disney alive and making films today, he would be culling material for animated films from literary classics. After all, during his lifetime, he was attracted to film versions of books by such storytellers as Lewis Carroll, Sir James Barrie, and Jules Verne. He also initiated the innovative *Fantasia*, which wedded abstract imagery with more traditional animated designs to create visual tone poems inspired by orchestral compositions of Bach, Schubert, Beethoven, and Stravinsky. Innovative and intrepid, Disney might well have gone on to realize the film potential of works by Twain, London, Dickens, Hawthorne, Hemingway, and others.

It can be argued that there are elements of inevitability in the intersecting of Hugo and Disney. Both artists were strongly in

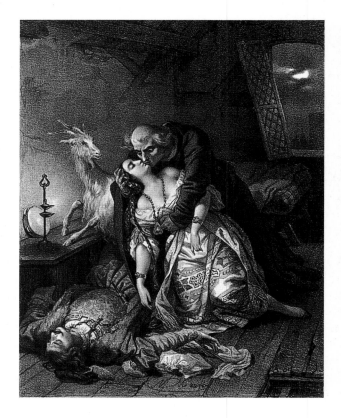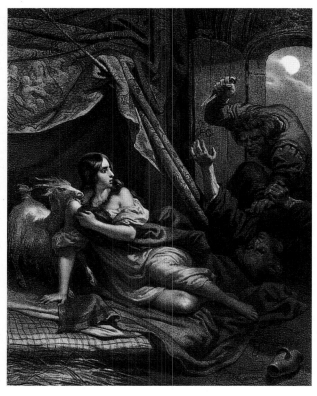

tune with and responsive to popular taste. Neither shied away from universal themes and strong, archetypal characters. Both understood the power of publicity; their works, even the men themselves were larger-than-life "events." Both evoked admiration and envy.

Creative Affairs Vice President David Stainton initiated *The Hunchback of Notre Dame* in 1993, impressed as he was by "the truly great scenes and affecting storyline" he had encountered on first reading as a child the Classics Illustrated comic book version and, later, in high school, the novel. When considering potential material for an animated musical, he re-read the book and found it "thrilling, because of the challenge it so clearly presented for a streamlined, restructured treatment in animation."

Taking up that challenge was the province of co-directors Kirk Wise and Gary Trousdale, who had collaborated previously as codirectors on Oscar®-nominated *Beauty and the Beast*, and who were searching for a new project that would expand their artistic horizons. "One of the criteria for each new Disney animated film is to do something we've never done before," notes Kirk Wise. The directors were excited by the possibility of tackling in animation a mature-minded international classic by a literary master. With such familiar and well-respected material, could the moviemakers adapt Hugo's novel to the needs of the screen and still please literary purists? Then, too, with such serious source material, where might the Disney magic and joy come from? "Hugo's novel is a brooding and dramatic tale," says Gary Trousdale, "and that's the very thing that drew us to it."

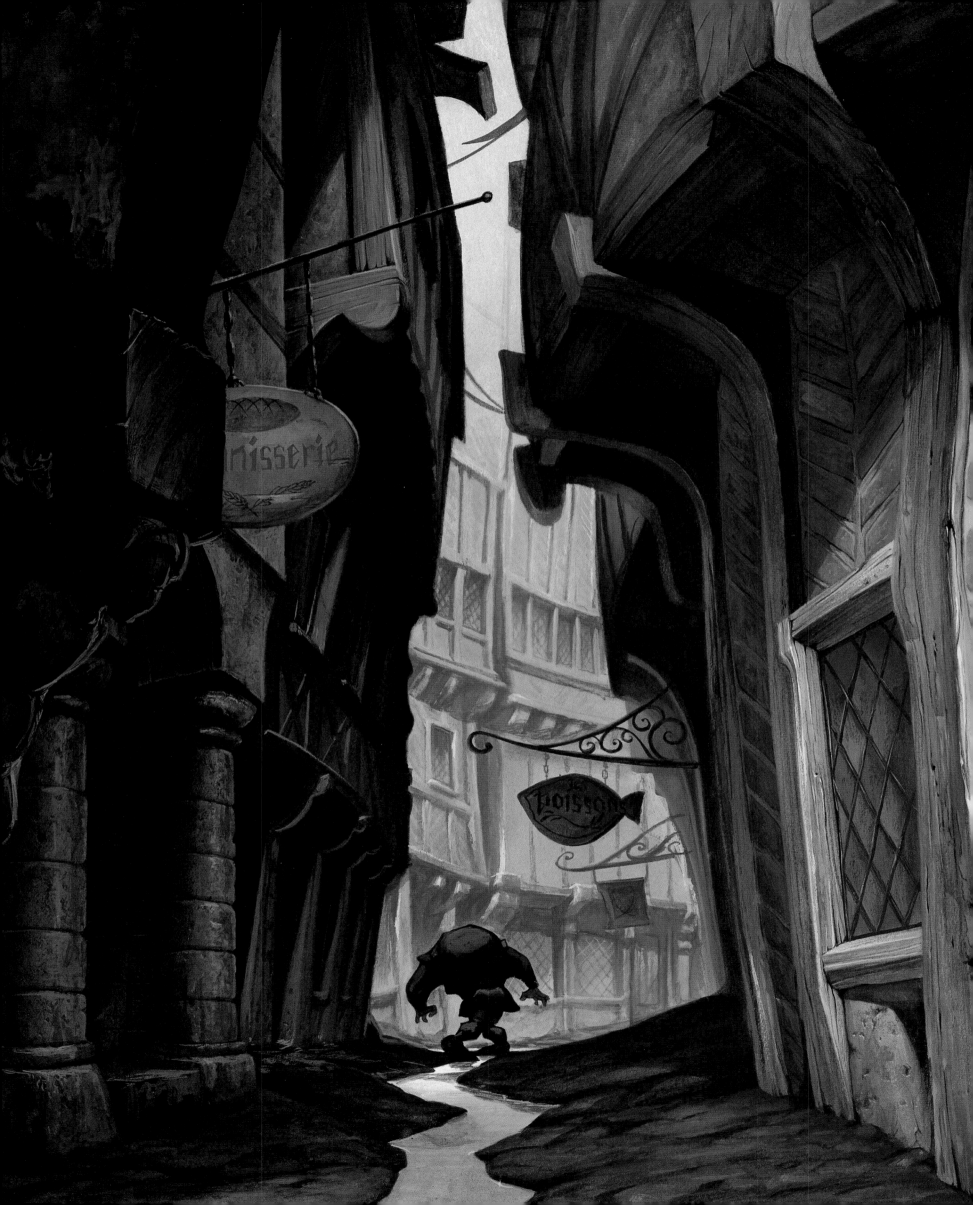

In the novel, Quasimodo's misguided love and gratitude for Esmeralda is matched by Esmeralda's equally misguided, impassioned love for Phoebus. More importantly, it is Frollo—a racist, psychologically tormented, conflicted soul, as well as a cleric—whose inability to love sets the dark juggernaut of the novel in motion.

Hugo's novel provided a vast sprawling tale, as twisting and complicated as its medieval Paris setting. The filmmakers' initial challenge was to sift through the complicated storyline and evershifting focus, the complex relationships and numerous points of view, and the various philosophical

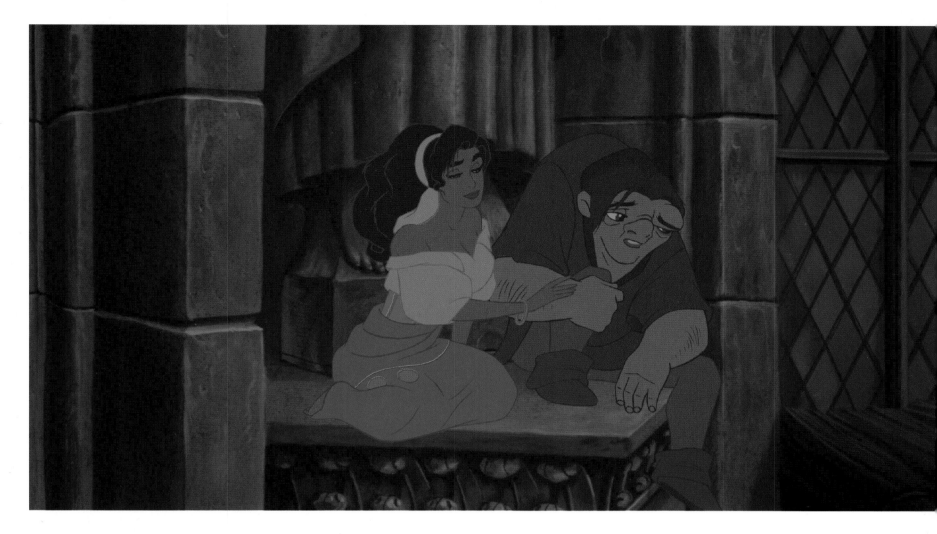

and historical references, until the heart of the story remained. Over time, it became clear to everyone that, as Vice Chairman Roy Disney asserts, the story "contains a message of hope and optimism that says: 'It's what's inside that counts.'" "The story translates well into this medium because Hugo tended to paint in very broad strokes," says Kirk Wise. "His characters were either the most ugly or the most beautiful or the most evil, they're archetypes." Gary Trousdale concurs, "You're dealing with big iconic characters and huge emotions. Every character in the book hinges on the idea of duality. The most ugly creature has the most beautiful spirit, and the most pious man has the ugliest soul." Hugo's compelling characters, scenarios, and themes attracted Disney's moviemakers, particularly the overarching idea that the power of love can open a window that allows one to see beyond appearances straight to the essence of the soul. Love breaks down the dichotomies between such superficial categories as beautiful and ugly, good and evil, permitting people to reach their full potential. It is through belief in that potential that each character in the tale can break the chains that society or fate—*anankè* as Hugo evokes it—prescribe for them.

"We chose to make a *Hunchback of Notre Dame* which for the first time truly focuses on Quasimodo. Through his transcendent love for Esmeralda, he forges his first connection with the wide world outside the cloistered cathedral," says head of story and supervising animator Will Finn.

ABOVE: *Rough animation by James Baxter.*
TOP: *Production still.*

"Esmeralda learns through her love for Phoebus that not all soldiers are persecutors, just as Quasimodo comes to understand that gypsies are not supernatural creatures of evil and cunning." The strongest appeal for the project, claims Thomas Schumacher, Executive Vice President of Feature Animation, lay in its message. Schumacher asserts, "Our earlier movies say things like 'It's okay to be you . . . ' but that usually meant 'it's okay to be you *if* you're a really handsome, winning, young street urchin or you're a frightening, ill-tempered beast who in the end becomes handsome.' This movie says, 'It's okay to be you if you're not necessarily "normal" or "beautiful" to the rest of the world,' which I call a big step forward."

The Misshapen Bell-ringer

Taking that step forward required the filmmakers to extract the essence of some of literature's more memorable and sharply etched characters. Hugo evokes Quasimodo, for instance, as "a giant broken in pieces and badly reassembled," with "a huge head sprouting red hair; between the two shoulders an enormous hump, the repercussions of which were evident at the front; a system of thighs and legs so strangely warped that they met only at the knees and looked, from the front, like two scythe-blades joined at the handle; broad feet and monstrous hands." Still, beneath the surface, "There was a radiance about that somber and unhappy face."

In the novel Quasimodo may be viewed as a symbol of the unacknowledged evil of his guardian, Claude Frollo, as well as a scapegoat for the fears and superstitions of the medieval populace. Yet the Disney filmmakers saw that behind these misconceptions lay another Quasimodo entirely. Observes concept artist Jean Gillmore, "Quasimodo was limited not so much by his own physical restrictions as by people's opinions of him. People of that time feared anything out of the ordinary, and Quasimodo

ABOVE: *Concept art by Thom Enriquez.*
TOP: *Concept art by Joe Grant.*
ABOVE RIGHT: *Concept art by Peter DeSève.*

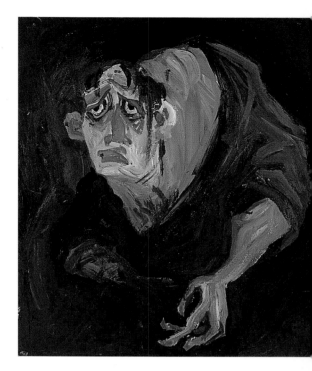

ABOVE: *Concept art by Geefwee Boedoe.*
LEFT: *Concept art by Rick Maki.*
BELOW: *Concept art by Vance Gerry.*
OVERLEAF: *Production still.*

embodied those fears, fueled by the superstitions and dogma of the church. To them something that hideous on the outside must also be hideous inside."

Rather than dwell solely on the physical qualities of the character, whom Hugo variously describes as "a living chimera," and "hunchbacked, one-eyed, and lame," and with a "dome for a back and twisted columns for legs," the Disney moviemakers chose to dramatize Quasimodo's internal struggle with the shame, insecurities, and self-loathing Frollo has created in him. Don Hahn, who previously produced *Beauty and the Beast* and *The Lion King* before being asked to produce *The Hunchback of Notre Dame*, views Quasimodo as "an abused child who has to struggle far less with his physical challenges than with the huge oppression of being told by his father figure, Frollo, that he is a monster, a freak unfit to venture out into the world." Kirk Wise terms the relationship of Quasimodo and Frollo "classically dysfunctional. Frollo constantly reminds Quasimodo of how ugly, how worthless, he is and whenever the poor kid gets his hopes up, Frollo

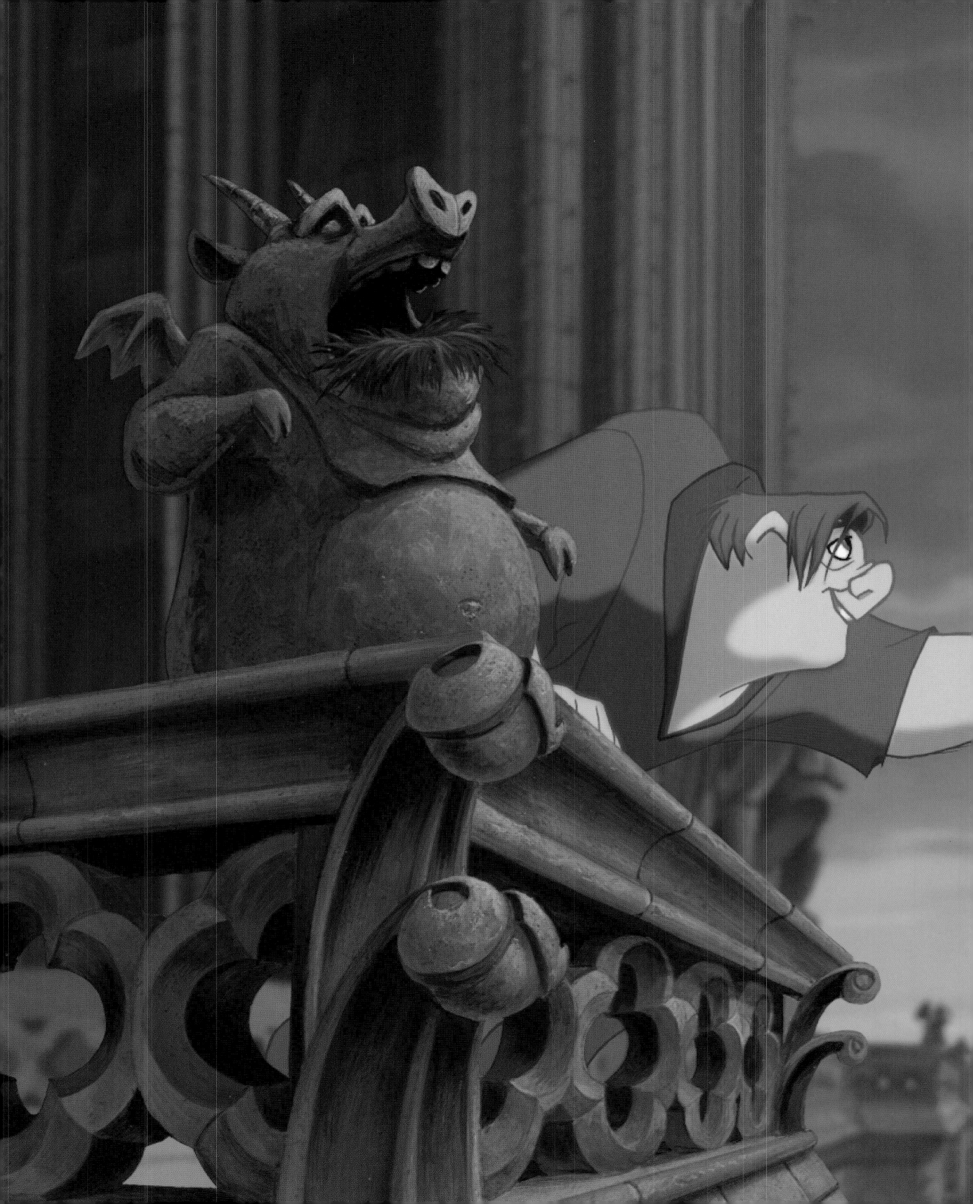

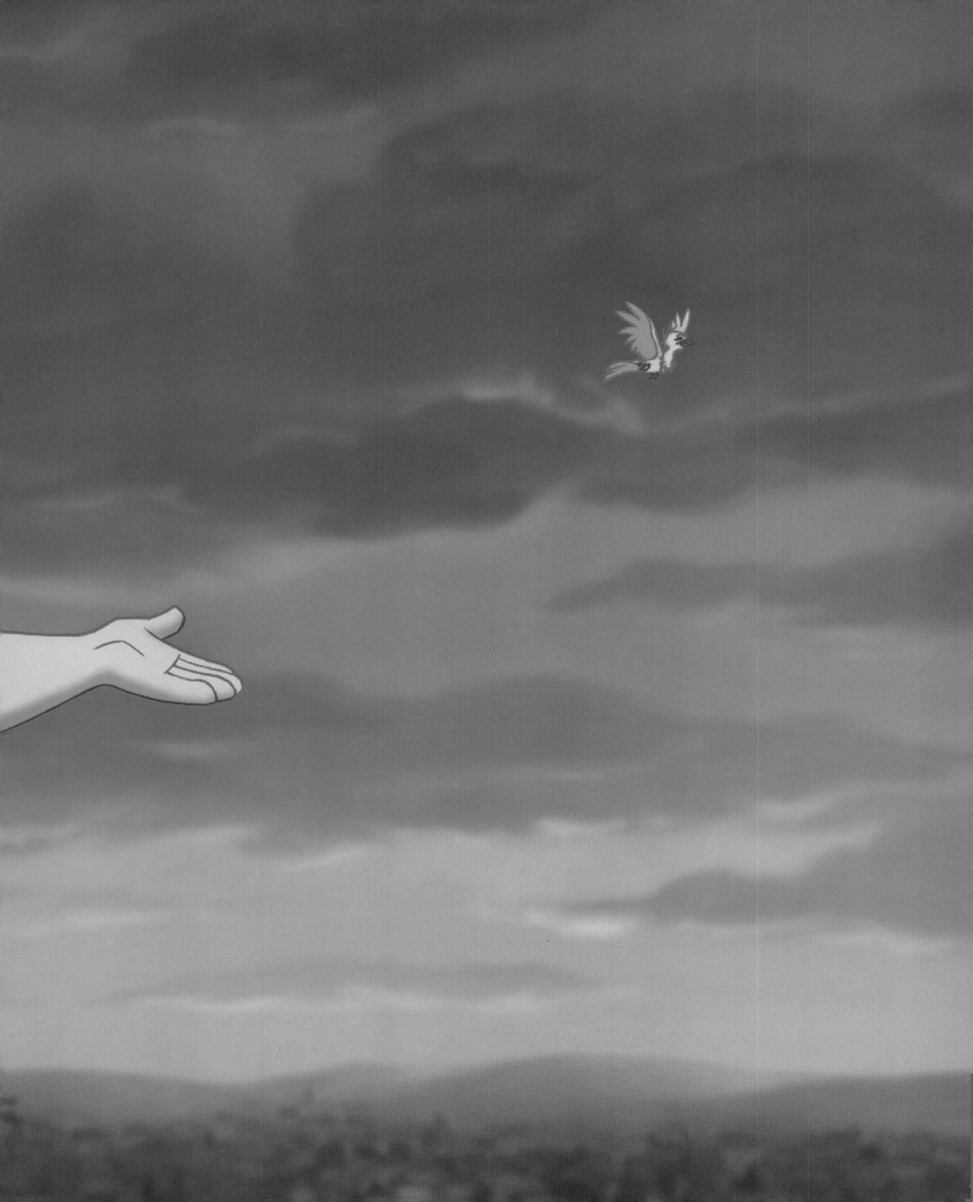

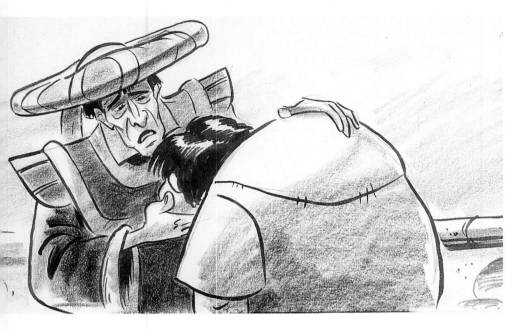

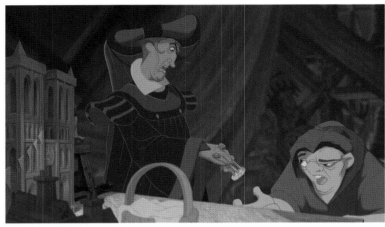

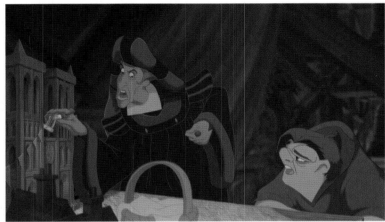

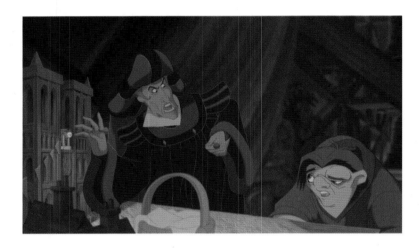

ABOVE: *Rough animation of Frollo by Kathy Zielinski. Rough animation of Quasimodo by James Baxter.*
TOP: *Storyboard art by Ed Gombert.*
ABOVE RIGHT: *Frollo tells Quasimodo to stay safe within the confines of Notre Dame. Production stills.*

smashes them down. It's almost like some insidious form of brainwashing that keeps Quasimodo in a trance."

The moviemakers determined that their Quasimodo should hew close to the age Hugo ascribes to him, about twenty, rather than the fortyish man he appears to be in previous film versions. The choice lends him an innocent appeal. Hugo's conception that Quasimodo was "vicious in fact because he was anti-social; he was anti-social because he was ugly" evolved in the filmmakers' minds to a more modern conceit. Gary Trousdale maintains that it was crucial for Quasimodo to not be "malevolent, bitter, and vicious, but a put-upon guy who, beneath his surface appearance and his being emotionally stunted, has a loving heart of gold." "It's not so much how he looks, it's really his inner soul trying to break free," concurs Kirk Wise.

No Disney animated character, from Mickey Mouse to Captain John Smith or from Snow White to Pocahontas, has sprung easily into existence. Few could have presented more challenges than Quasimodo, whose transcendent spirit can be glimpsed only by those willing to see beyond his unconventional outward appearance. Key decisions were required as to how he would look and move, and how great his physical challenges should be. It had been suggested, for instance, that half his face might be deformed, but hidden under a cascade of beautiful hair. The filmmakers vetoed that notion because, as writer Bob Tzudiker put it, "This is a story of someone who must overcome his perception of his own deformity. If we hid his deformity, we'd be avoiding telling the story." Many of the Studio's most gifted artists—among them Joe Grant, Burny Mattinson, Ed Gombert,

BELOW: *Cleanup of Frollo by June Fujimoto, animation by Roger Chiasson.*
BOTTOM: *Rough animation of Quasimodo by Shawn Keller.*
LEFT: *When Quasimodo is ridiculed by the crowd after being crowned King of Fools, the color palette of the scene begins to shift dramatically. Production stills.*

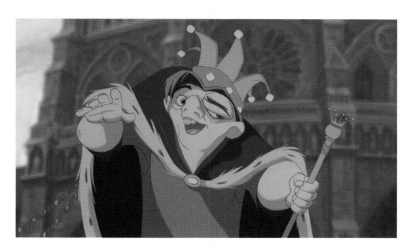

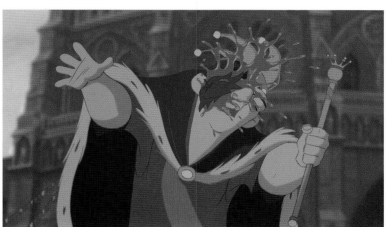

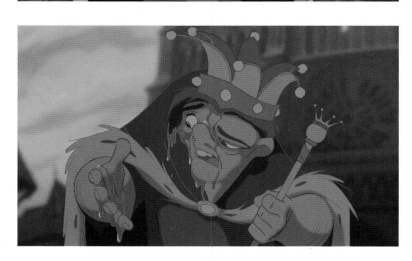

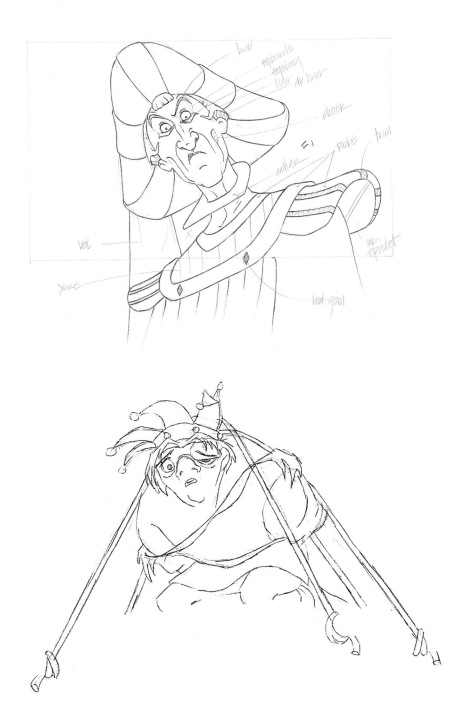

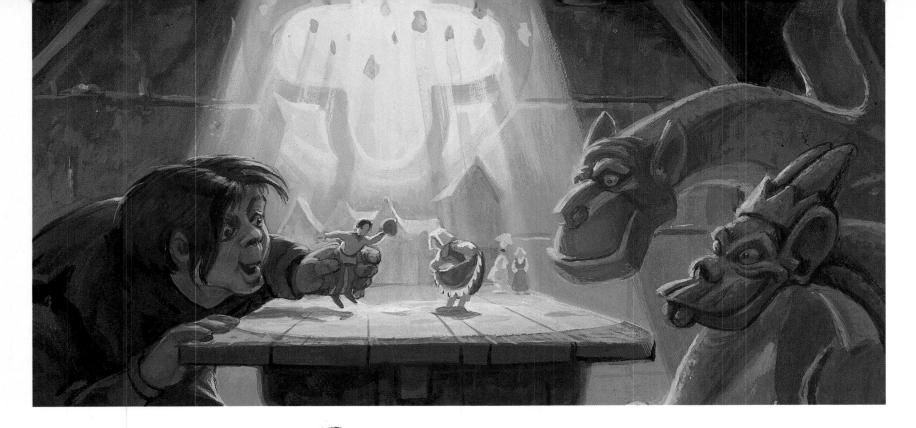

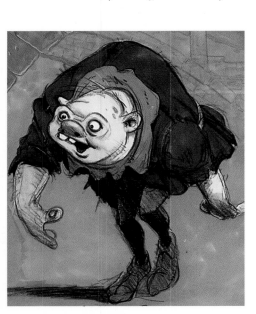

Jean Gillmore, Thom Enriquez, Rick Maki, Geefwee Boedoe, Kevin Harkey, James Baxter, and Rowland Wilson—created prototypical inspirational approaches to the character that ranged from nightmare creatures to singular-looking boys. In the end, a blend of the designs of illustrator Peter DeSève, whose surrealistic style is perhaps known best from his *New Yorker* work, and animator James Baxter, best known for his work on *Beauty and the Beast* and *The Lion King*, were chosen to balance Hugo's Quasimodo with Disney's. From the first moment Quasimodo appears on screen, lovingly urging a hesitant, frightened young pigeon to at last fly free of Notre Dame, the character, as animated by Baxter, appears sympathetic, psychologically battered, winsome, a full-hearted and appealing underdog. "James Baxter's animation of Quasimodo is so moving, that it's

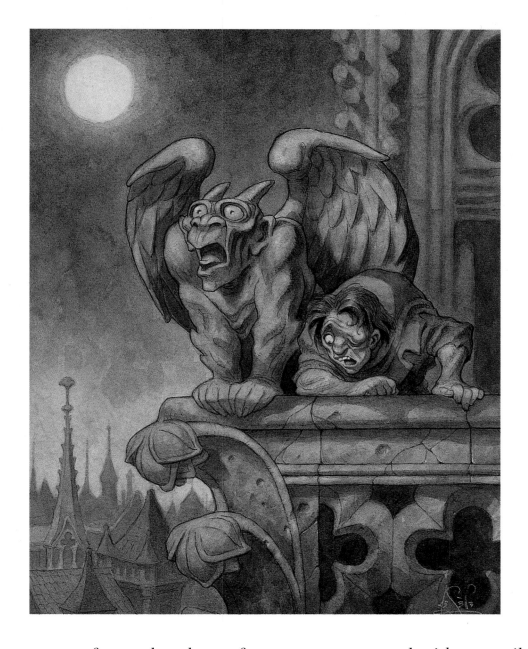

easy to forget that the performance was created with a pencil and paper," producer Don Hahn says. "The energy from his animation is something audiences can feel when they look at the screen."

Baxter designed Quasimodo with a stress on horizontal shapes rather than vertical ones. Says Baxter, "His shape contrasts deliberately with the other major characters, especially Frollo, who is very tall and Gothic. Frollo seems to fit in with the Gothic architecture while Quasi doesn't." Despite Quasimodo's physical appearance, he had to be designed to be very adept and active. "He's deformed but not disabled," says Baxter. "His being bent over was a metaphor for his wanting to hide. We wanted him wrapped in on himself, able to bend over and cower in his most oppressed moments."

The artists of the layout, background and effects departments worked to create an environment for Quasimodo which reflected his character and his moods. Psychologically, the cathedral is, in Baxter's words, "Quasi's comfort zone. When he's on his own or with the gargoyles he's at ease; it's very different from when he's in the square." Says head of layout Ed Ghertner, "There are places in the belltower where Quasimodo has all these

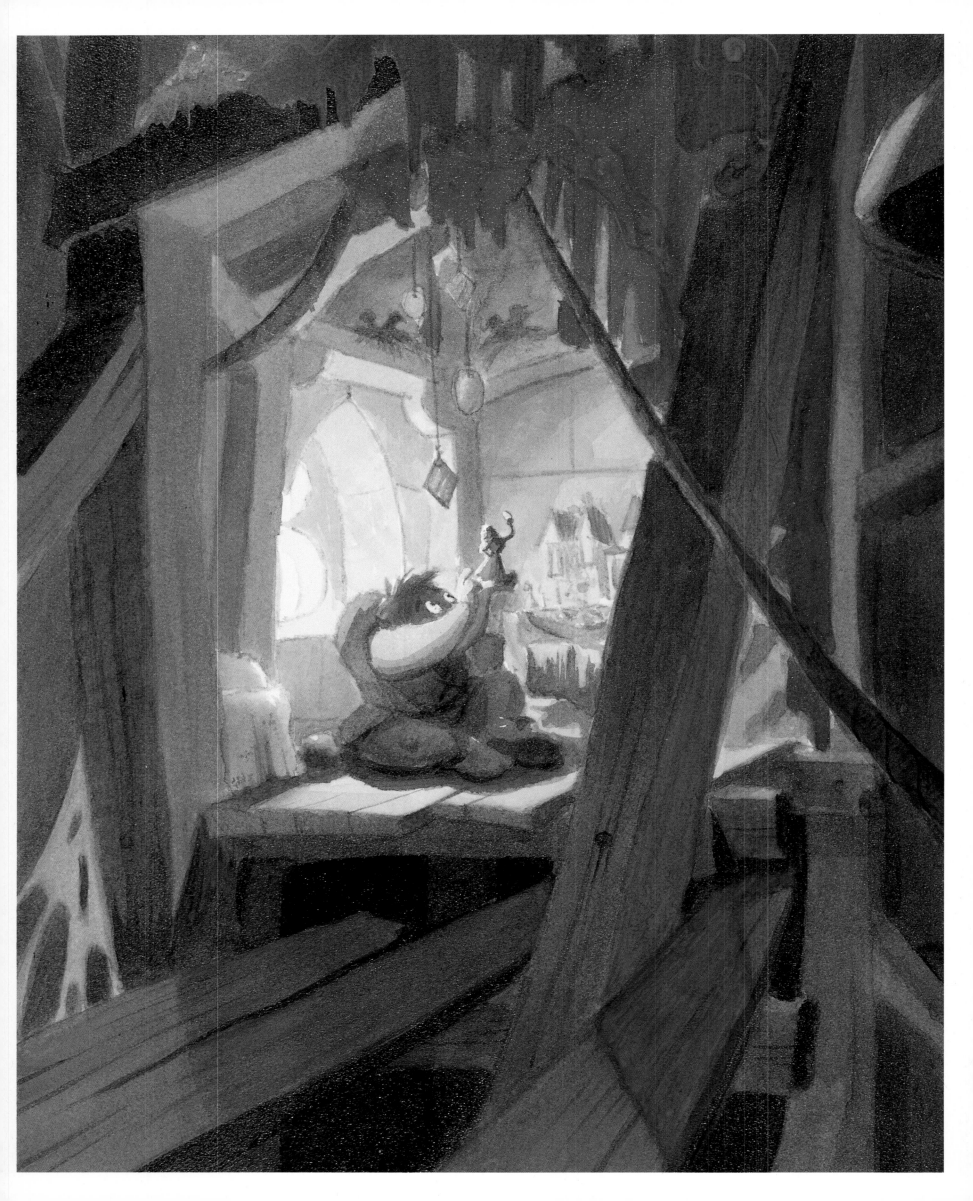

found and manufactured objects and they really tell you a lot about who he is, what his preoccupations are." As the movie progresses the color and the environment change subtly to suggest changes in Quasi's mood, "Though his environment starts out cold, it becomes warmer when he shows his space to Esmeralda and magical and ethereal when he dreams of heaven's light," says head of backgrounds Lisa Keene.

It is through his relationship with another element of the cathedral, the gargoyles Hugo, Victor, and Laverne, that the directors chose to reveal an important aspect of Quasimodo's character. Voiced by Jason Alexander, Charles Kimbrough, and Mary Wickes, respectively (Jane Withers took on the role of Laverne after Mary Wickes passed away in October 1995), "the gargoyles help us see the warm and funny side of Quasi that shuts down when Frollo's around," says Gary Trousdale. "Not only does this add humor and lightness to the film, it shows an aspect of his character you wouldn't otherwise see, an aspect that he isn't allowed to express to others."

The character and his journey from oppression to freedom aroused empathy in many key contributors to the project. Marshall Toomey, the cleanup key for the character and an African-American, asserts, "I've lived Quasimodo's life. I was one of the first people to get bussed in the early 1960s. I got called all kinds of names. I felt so inferior and so ugly. I know what's in Quasimodo's heart because of what

TOP: *Cleanup of Frollo by June Fujimoto, animation by Roger Chiasson. Cleanup of Quasimodo by Marshall Toomey, animation by James Baxter.*
LEFT: *Rough animation of Laverne by Will Finn.*
BELOW: *Rough animation of Hugo and Victor by Dave Pruiksma. Rough animation of Quasimodo by Doug Frankel.*
OPPOSITE: *Concept art by Ed Ghertner.*

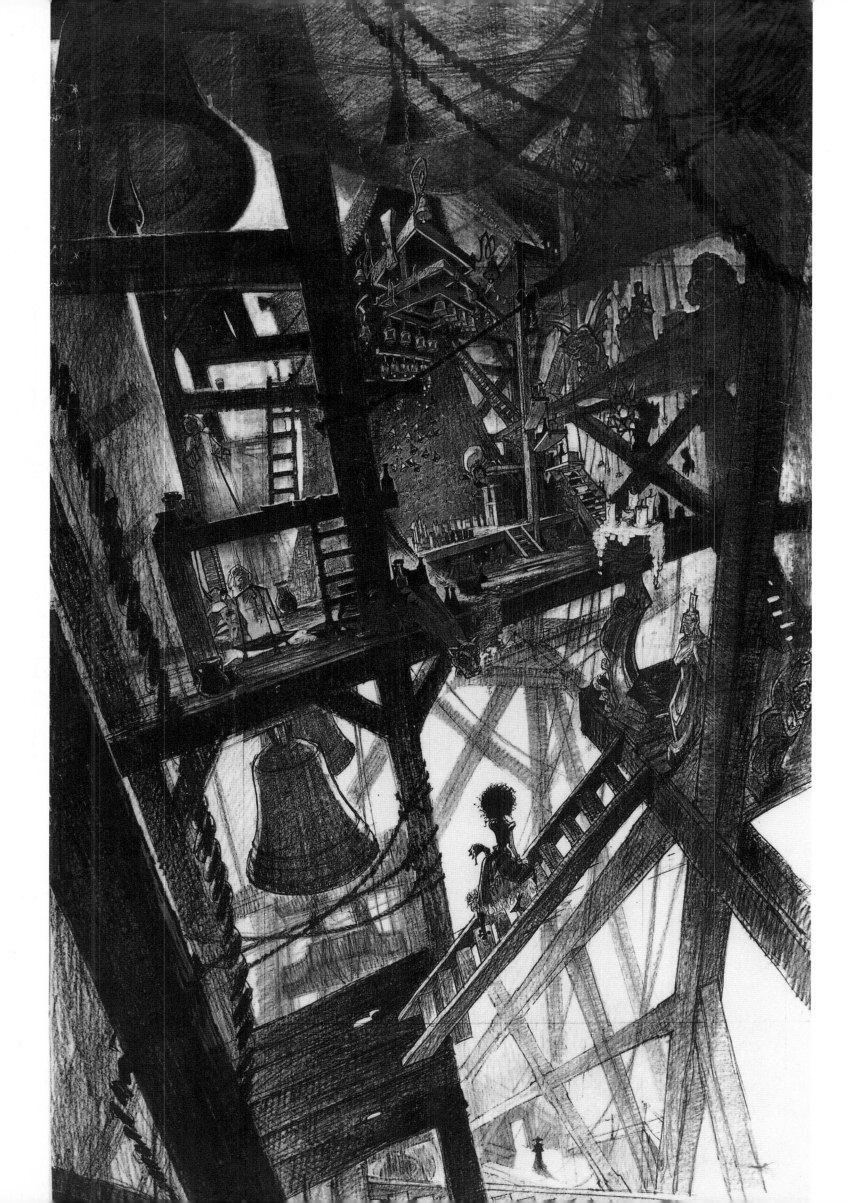

OVERLEAF: *Except for a small pool of light cast over the table where Quasimodo keeps his toys, the environment in the belltower starts out in cold tones and in darkness. The coldness of the belltower and the shadows cast by the cross beams suggest that Quasi's home is really a prison.*

LEFT: *Concept art of the gargoyles by Peter DeSève.*
BELOW: *Background art by Patricia Palmer-Phillipson.*
BOTTOM LEFT: *Concept art of Quasimodo's table by Tom Shannon.*
BOTTOM RIGHT: *Layout drawings of the dolls on Quasimodo's table. Esmeralda, Quasi, and Frollo dolls by Anne Marie Bardwell, two townspeople dolls by Johan Klingler.*
OPPOSITE: *Layout art by Darek Gogol.*

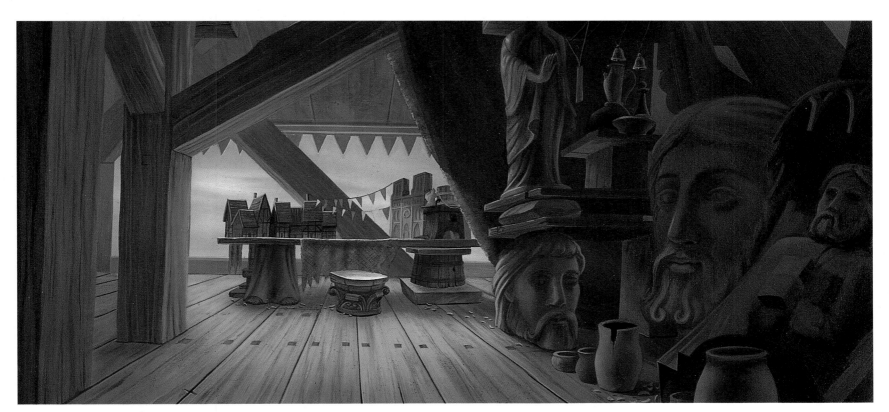

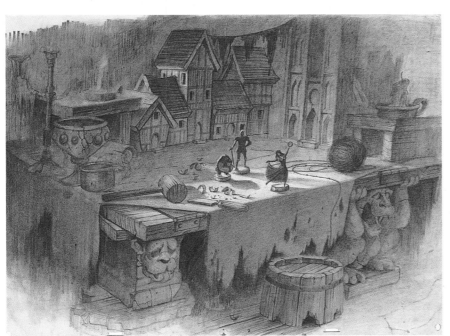

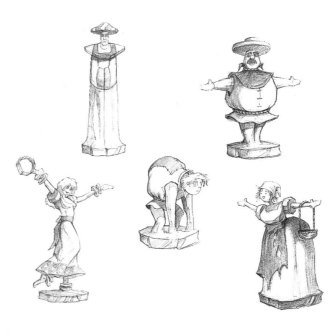

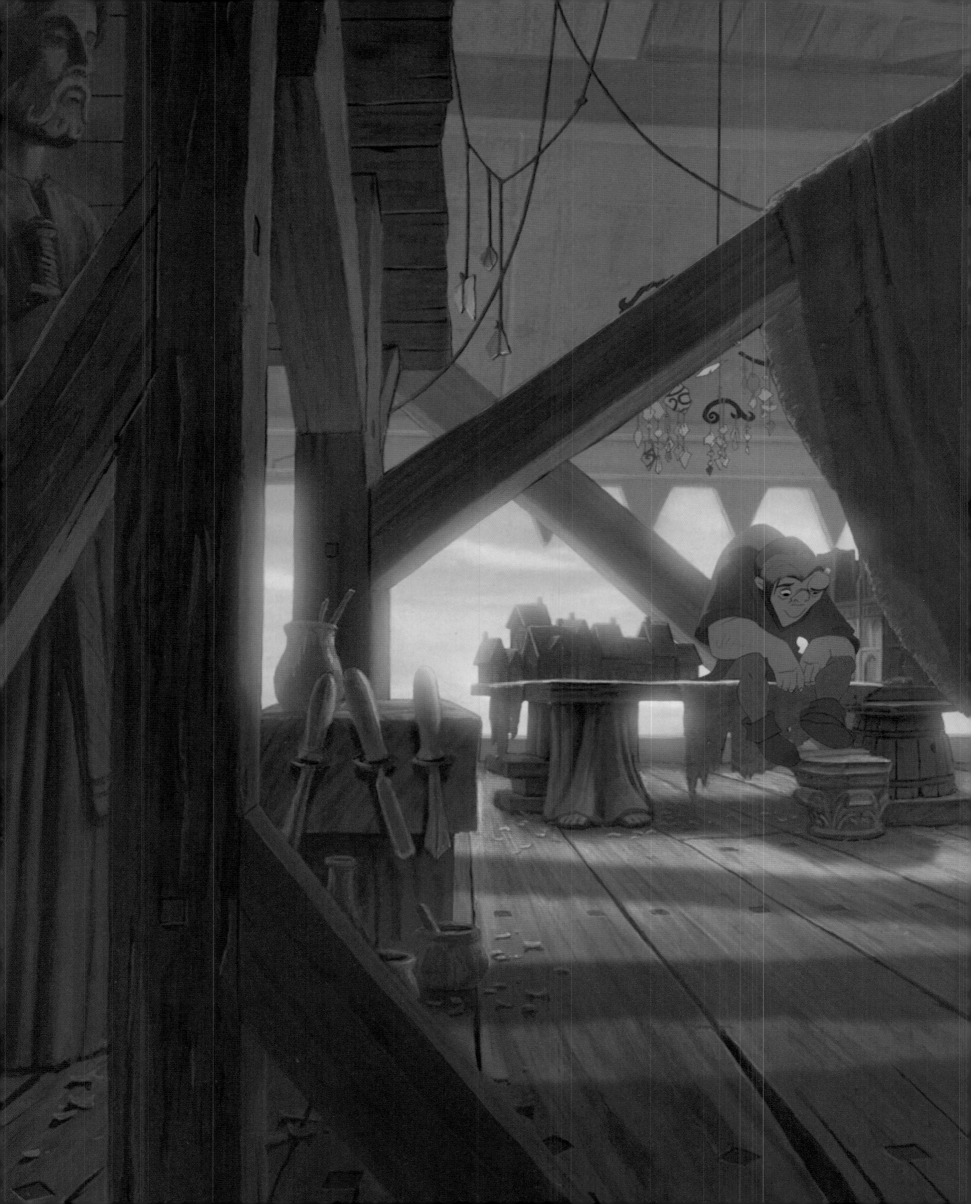

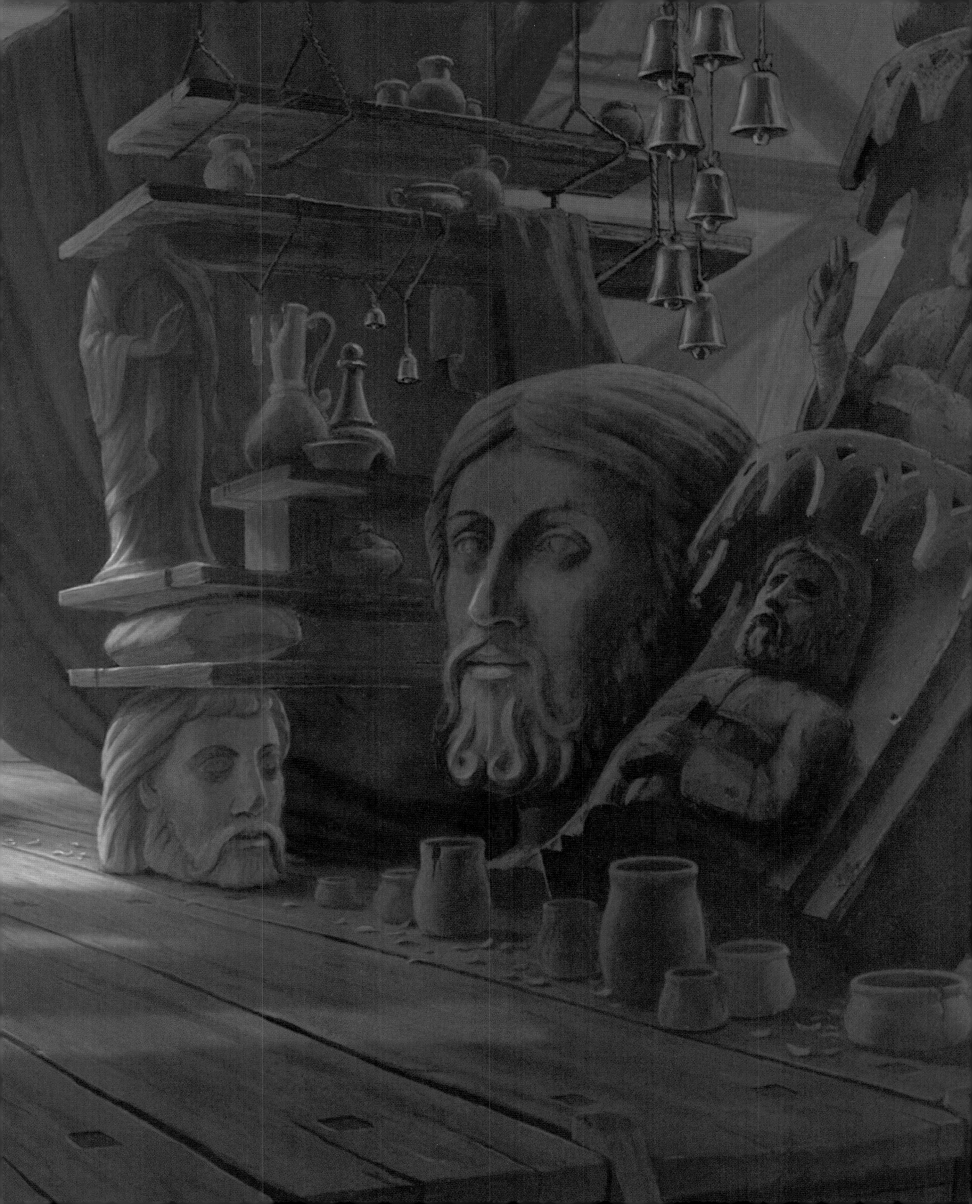

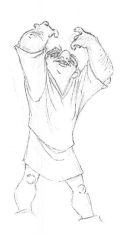

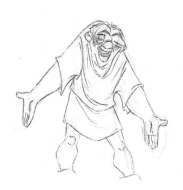

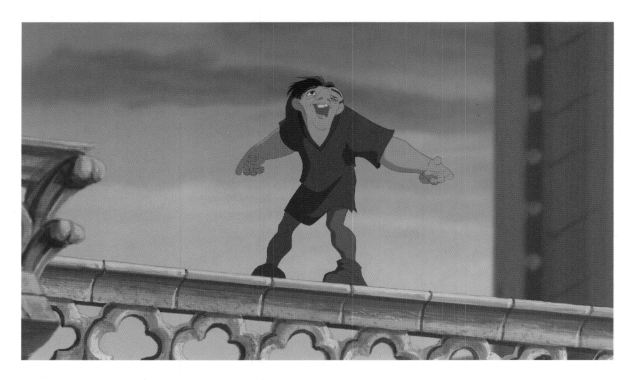

I've been through in my life." Writer Noni White asserts, "Someone once said that anti-Semitism is a light sleeper. All bigotry is a light sleeper. Because Quasimodo and the gypsies are outcasts, the story touches a universal theme: Why can't we see each other as human beings and not judge one another based on looks, beliefs, or race?"

To voice and sing the character, Tom Hulce, an Oscar® nominee for his role as Mozart in *Amadeus*, was, according to coproducer Roy Conli, "*the* guy as soon as we heard him sing because he has this wonderful, innocent quality to his voice, yet it still has the kind of power and depth you'd expect from Quasimodo." Hulce got put to the test on "Out There," the song written for Quasimodo by composer Alan Menken and lyricist Stephen Schwartz in which the character's feelings well up, compelling him to express his longing for one single day amid the throngs he watches from the distant heights of the belltower:

> All my life I wonder how it feels to pass a day,
> Not above them,
> But part of them. . .

For Gary Trousdale, the song "defines Quasimodo as a yearning, child-like guy watching life pass him by from the belltower, as frustrated as anyone might be if the Tournament of Roses Parade or Macy's Thanksgiving Day Parade passed by your window, but you could never go." Victor Hugo probably never imagined his malformed, melancholy creation breaking forth into song. Yet, Baxter's animation, Menken's melody, and Schwartz's lyrics speak powerfully of the character's lonely isolation, oppression, and feeling of being an outsider.

ABOVE: *Rough animation by James Baxter.*
ABOVE RIGHT: *Production still.*

A Celestial Creature

o that's what La Esmeralda is," Hugo writes. "A celestial creature! A dancer off the streets! So much and so little!" Hugo draws the heroine of *Notre-Dame de Paris* sketchily and one takes away from the book an impressionistic sense of her. Innocent, mysterious, beautiful, exotic, impulsive, ethereal—Esmeralda is fated to be the pawn in Frollo's cruel and obsessive game and the victim of her own naive, unwise attraction to the vain soldier Phoebus. Described by one character as "a nymph, a goddess!" Hugo paints Esmeralda in constant motion, as "some

ABOVE: *Concept art by Jean Gillmore.*
ABOVE LEFT: *Rough animation of Esmeralda by Anne Marie Bardwell and of Frollo by Kathy Zielinski.*
BELOW: *Production still.*

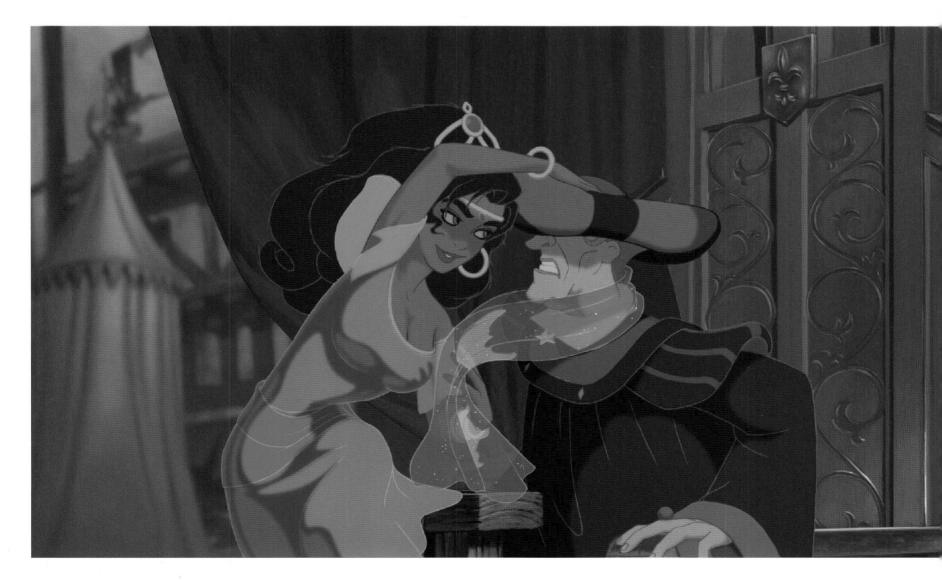

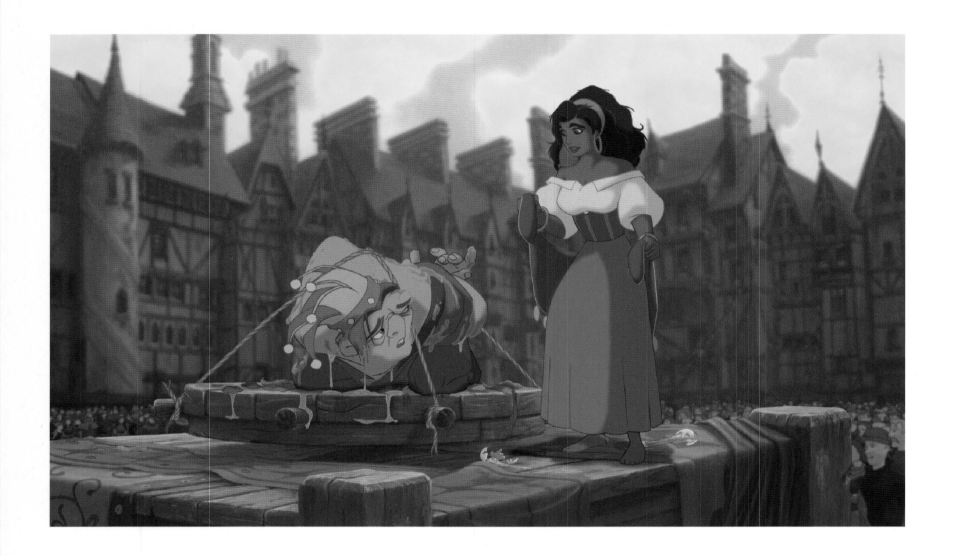

sort of supernatural creature, with her billowy, multicolored dress, her bare shoulders, her shapely legs, which her skirt revealed from time to time, her jet-black hair and her fiery eyes." More a collection of ideal attributes than a flesh-and-blood creation, Esmeralda in Hugo's novel is a character whose outsider status sets her apart from the constricted medieval caste system inhabited by Frollo. Although she pays dearly for being a member of an oppressed and despised group, her status allows her to slip back and forth between both worlds.

While Hugo skewers many of his characters with pointed satire and irony, Esmeralda is essentially sympathetic from the first. She delivers Quasimodo from his thirst and torment on the pillory by braving the derision of the mob to offer him a kind word and a drink of water. Hugo writes of the impact her simple act of human kindness has upon Quasimodo: "A big tear welled up in his eye, which until then had been so dry and fiery, and slowly trickled down his deformed face. It was perhaps the first tear the unfortunate man had ever shed. His emotion was so great that he forgot to drink." But the ramifications of her simple, loving act run deep. Unaccustomed to kindness, Quasimodo's gratitude toward Esmeralda turns to blind devotion, just as Esmeralda's gratitude to the soldier Phoebus

ABOVE: *Concept art by Thom Enriquez.*
TOP: *Production still.*

64

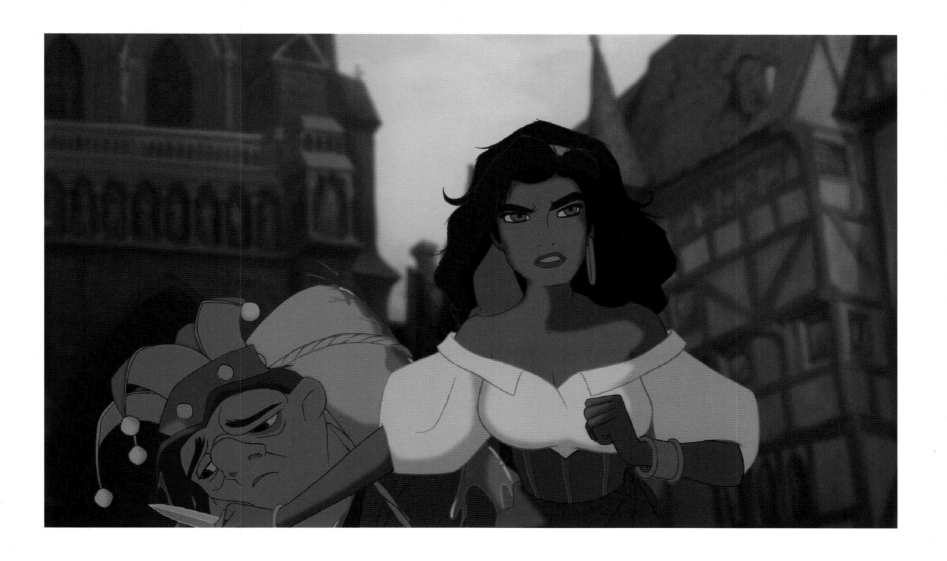

for rescuing her from the clutches of Quasimodo, doing the bidding of Frollo, turns to love.

Like Notre Dame itself, Esmeralda inspires, intoxicates, comforts, pains Quasimodo. Like Quasimodo, she has lost her parents, is judged and persecuted for her looks and her station in life. Like her physical counterpoint Quasimodo, she has a kind of freedom that keeps her refreshingly innocent and childlike. Although in the novel Esmeralda inspires tragic devotion from Quasimodo, the Disney moviemakers softened the passion, says Gary Trousdale, to "puppy love and gratitude for being the first person to treat Quasimodo like a human being. Our story is more about 'Will Quasimodo get out from under Frollo and become part of the outside world?' than 'Does he get the girl?' He has to accept the fact that the woman he has a terrible crush on belongs with someone else."

The Disney writers and animators re-imagined Esmeralda as more forthright and assertive than Hugo did. To writer Irene Mecchi, she is "a snappy, wise, vital gal, quick with her wits, physical resources, and a zingy comeback, one who has been knocked around in life and is all the stronger for it." "We wanted to create a sense of spontaneity for her character," says supervising animator Tony Fucile. "In a dangerous situation she doesn't

ABOVE: *Production still.*
BELOW: *Cleanup of Esmeralda by Ginny Parmele, animation by Duncan Marjoribanks.*
OVERLEAF: *Production still.*

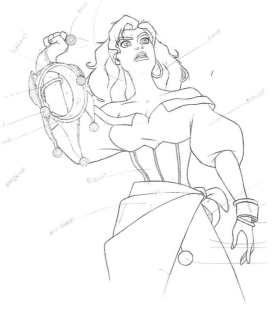

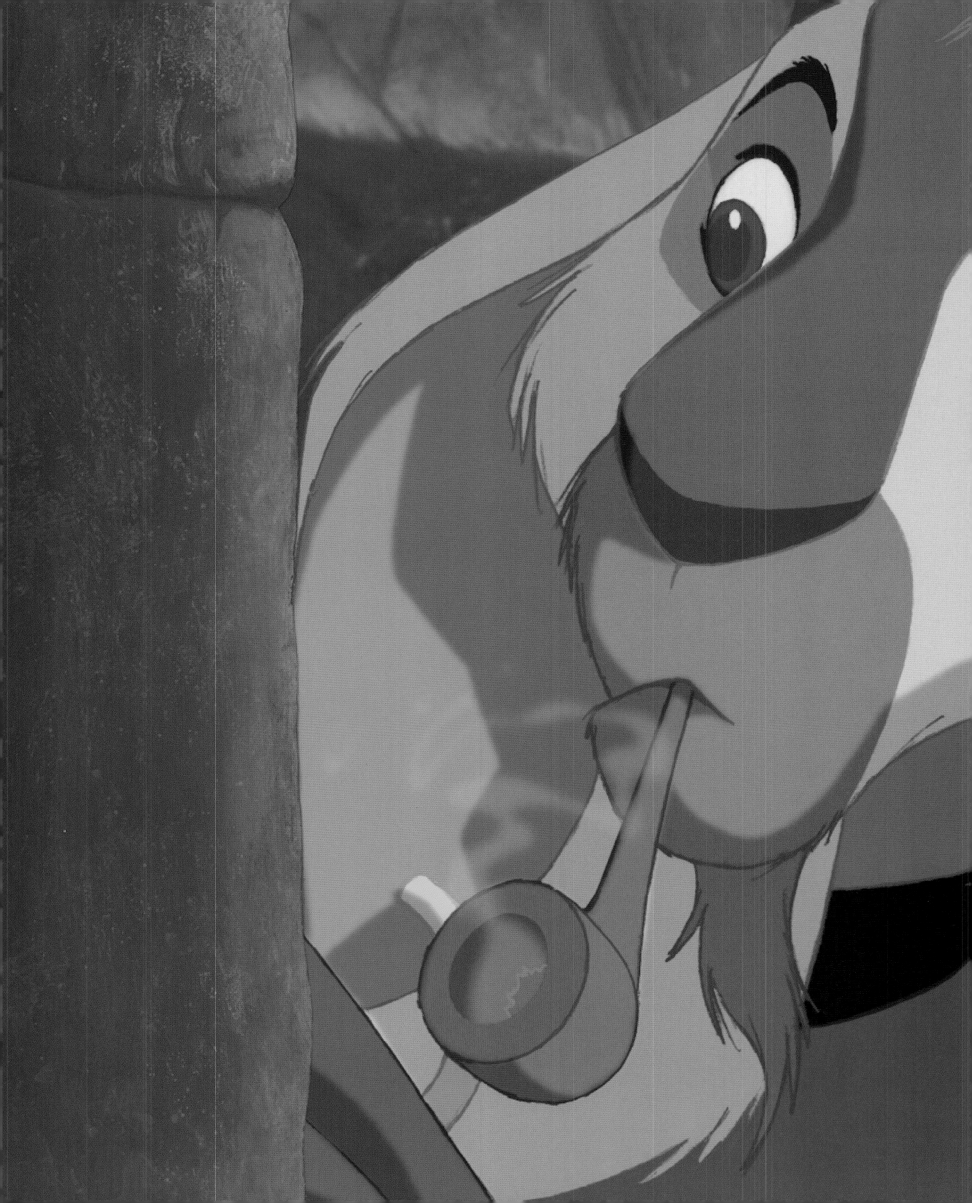

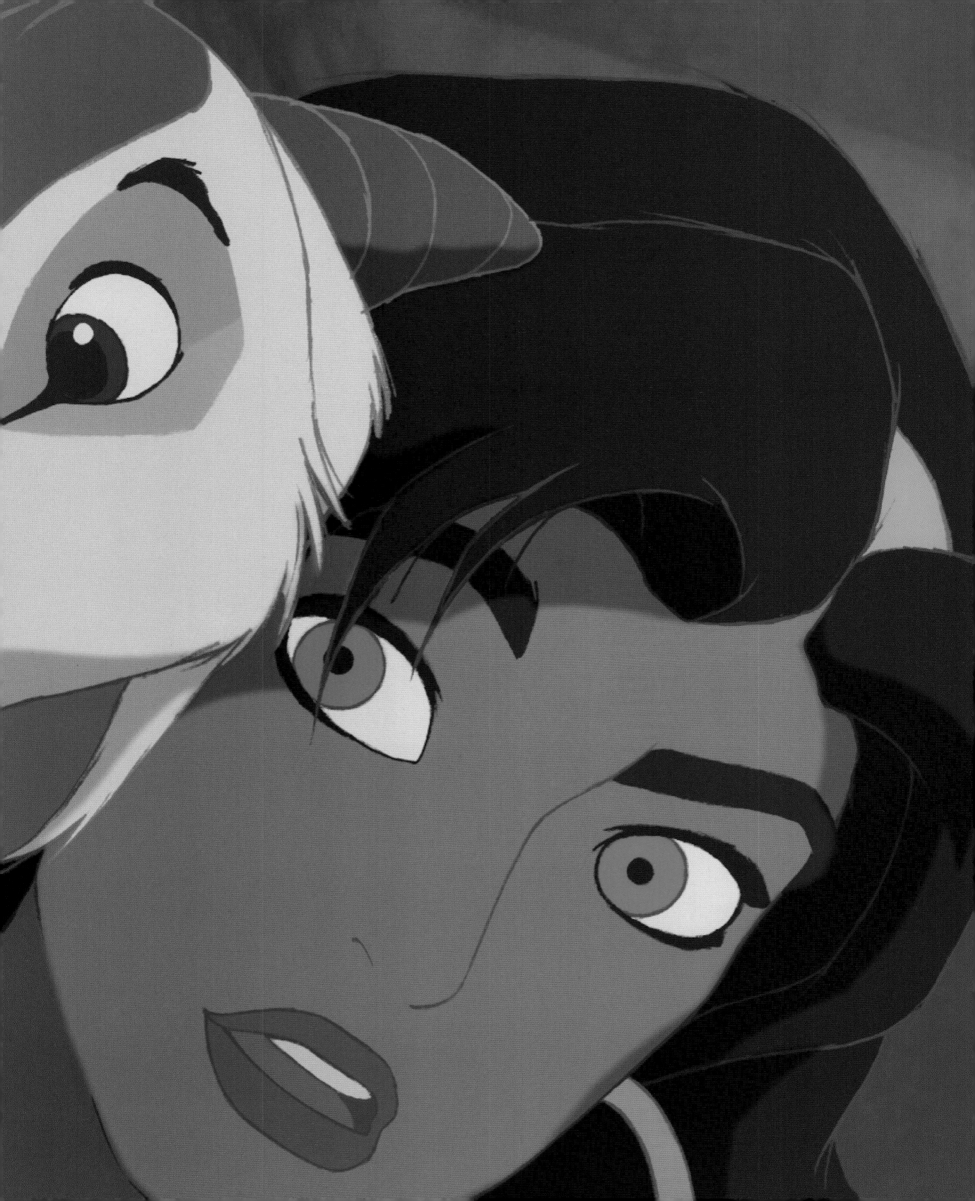

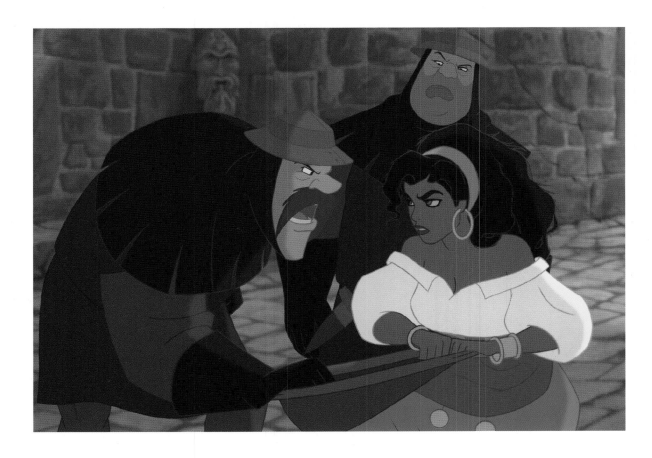

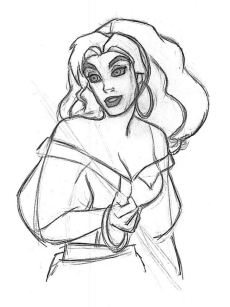

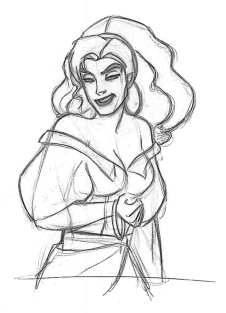

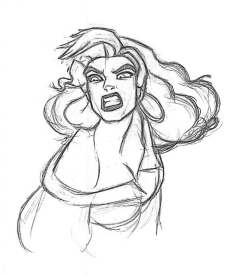

ABOVE: *Rough animation by Dave Brewster.*
ABOVE RIGHT: *Production still.*

really think about what she's doing because she's developed her instincts over years of surviving tough situations."

As another of the film's outsiders and fugitives, her motivations extend beyond love: she wants to end the persecution of her people. Kirk Wise asserts, "She sees inequality and wants justice. She just wants what's right for her people. She identifies with Quasimodo when she witnesses the crowd's mistreatment of him. That incident galvanizes her to take a stand against authority that says, 'You do this to him, you do this to us. Why do people have to be so cruel and terrible?'" According to Fucile, "she's seen a lot, she has a lot to be angry about, but at her core she's a wonderfully heartfelt, emotional person."

The animators designed Esmeralda to appear fully prepared to stand up to the brutal, persecutory environment and social conditions under which she lives. Her character design stresses curves and round shapes contrasted with sharp angles. These, coupled with her loose, free-flowing, and exotically colored garments, suggest a freedom and vivacity that contrast with the Gothic pallor and rigidity of such other characters as Frollo. Although Don Hahn asserts that the animation medium "requires, by its very nature, a caricature of reality," he also observes that, in Esmeralda's case, the caricature quite deliberately embodies

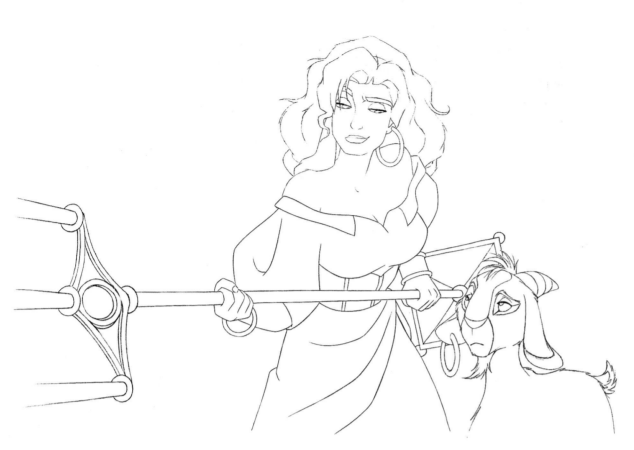

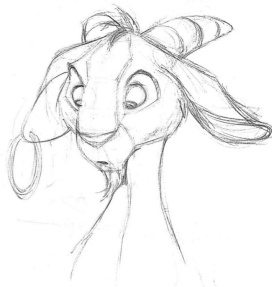

ABOVE: *Rough animation of Djali by Ron Husband.*
LEFT: *Trying to maintain both graphic subtlety and realism was a challenge for Ginny Parmele and other cleanup artists working on Esmeralda. Cleanup of Esmeralda by Ginny Parmele, animation by Tony Fucile. Cleanup of Djali by Scott Anderson, animation by Tony Fucile.*

"a combination of qualities cited by world culture as beautiful. She is not only an object of affection but also represents life and joy and happiness." The Disney Esmeralda's dusky coloring, sultry beauty, proud carriage, and flamboyant costuming suggest less Hugo's ethereal conception than the moviemakers' homage to a saucy, hands-on-her-hips heroine of zingy Technicolor historical adventure epics of the forties.

ABOVE: *Concept art by Geefwee Boedoe.*
BELOW AND OPPOSITE RIGHT: *Cleanup of Djali by Scott Anderson, animation by Ron Husband.*

Although Hugo makes Esmeralda age sixteen in the novel, the Disney moviemakers matured her to somewhere in her twenties. Designed with an unruly mane of jet-black hair, a quality of having survived a hardscrabble life, and the carriage of a born leader, she marks a refinement and maturation of what writer Jonathan Roberts terms "the sentimental Disney heroine with big eyes."

Artist Jean Gillmore, whose early research and designs for the character were adapted almost unaltered for the film, conceptualized the heroine and the Gypsy population as "nomadic people, true survivors, from various ethnic groups who grabbed a little bit from every culture. Esmeralda has an energy that says, against very tough odds, 'I can beat this.'" Ginny Parmele, cleanup

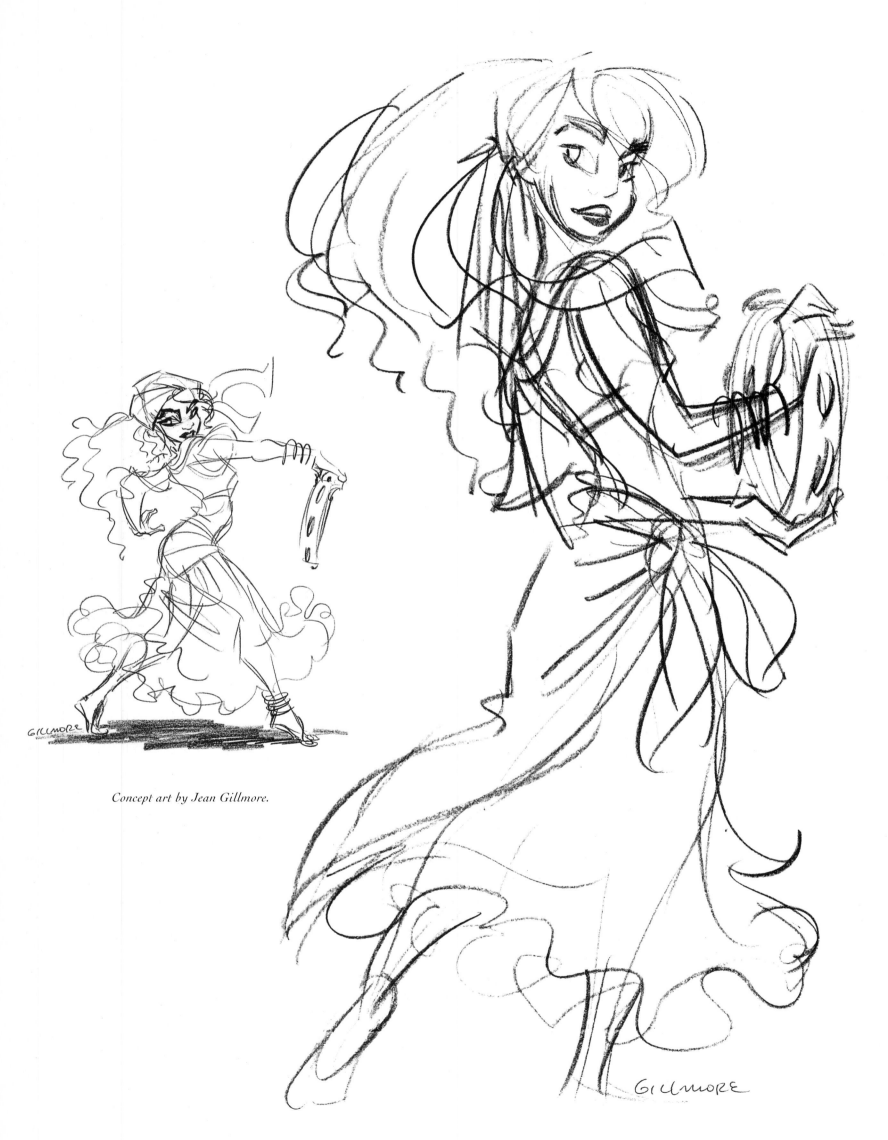

Concept art by Jean Gillmore.

70

lead for the character, recalls, "I studied with a yoga instructor once who always said, 'Keep a balance between strength and softness.' That's what Esmeralda has."

To voice this combination of self-reliance, beauty, vulnerability, and smarts, the moviemakers secured the services of Demi Moore, who is best known for starring in such films as *Ghost*, *Indecent Proposal*, and *About Last Night*. The directors particularly liked the combination of maturity and warmth that Moore's voice lent the character. "The fact that she doesn't sound like a typical clear-voiced Disney heroine immediately makes me understand that this is a gal raised on the streets, not a castle," says Kirk Wise. Adds Gary Trousdale, "Her voice also has tremendous warmth to it. There are intimate moments with Quasimodo when you feel on hearing the voice that this is a character with a past, this is someone who's seen a lot."

ABOVE: *Rough animation by Tony Fucile.*
ABOVE LEFT: *Rough animation by Ron Husband.*
BELOW: *Production still.*

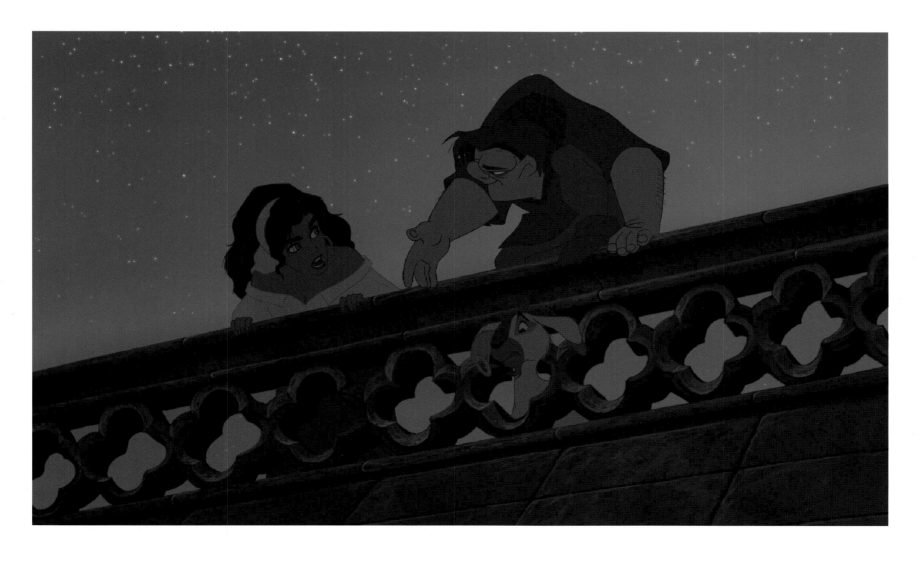

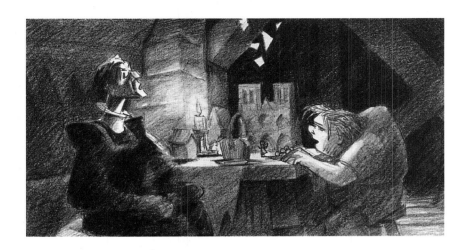

A Twisted Soul

his was the face of a man, austere, calm and saturnine," Victor Hugo wrote of Claude Frollo, the darkly motivated, conflicted archdeacon of the church whom Hugo renders with great psychological precision and intensity. Hugo describes Frollo, a man who cannot reconcile the animal and angelic forces within himself, as "a somber and awe-inspiring personage who made the choirboys and inferior priests tremble as he walked . . . his arms crossed and his head bowed so low that no part of his face was visible except his bald, broad forehead." On the surface, Quasimodo's revered and feared guardian is rigorously pious, unflinchingly righteous. Underneath, however, he is pitiless, cruelly manipulative, consumed by desire. Hugo writes: "What was that inner fire which sometimes flashed in his eyes, making them seem like two holes in the wall of a furnace?"

The novel introduces Frollo watching Esmeralda making her living dancing with her tambourine: "He followed the nimble young gypsy girl's every movement and as she danced and capered to the pleasure of the crowd his reverie seemed to grow more and more gloomy. . . ." Although Esmeralda is utterly innocent of Frollo's dark designs on her, Frollo firmly believes that, by destroying the gypsies and Esmeralda, he can purify Paris and himself. Others, however, recognize the terrible and destructive conflict in his nature. As Hugo describes the reaction of a Paris citizen watching Frollo and Quasimodo pass by together: "'There they go—one's soul is as twisted as the other's body.'"

Hugo wrote *Notre-Dame de Paris* during a personal crisis of faith. Even in re-creating a time of growing disaffection with the church, he jolted readers by portraying in Frollo a purportedly holy man who psychologically terrorizes Quasimodo and who willfully persecutes gypsies while being consumed by desire for the gypsy Esmeralda.

ABOVE: *Costume development art by Jean Gillmore.*
ABOVE RIGHT: *Value study by Tom Shannon.*

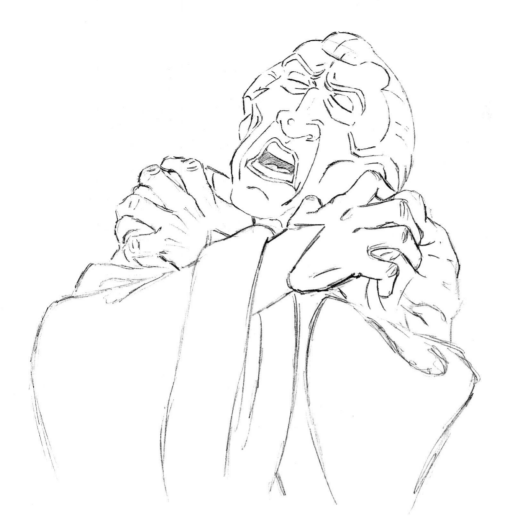

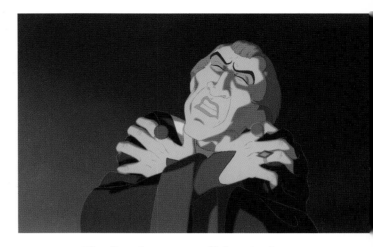

The effects department added sculpted tones to the animation of Frollo to emphasize the contortion of the character and to underscore the emotions Frollo is feeling inside.

ABOVE: *Effects animation by David Lyons.*
LEFT: *Rough animation by Kathy Zielinski.*

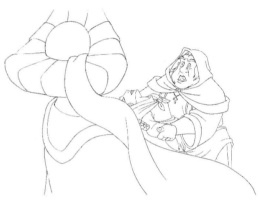

Frollo is confronted by the Archdeacon on the steps of Notre Dame as he prepares to kill the infant Quasimodo. Animated by Dave Burgess, the Archdeacon lends a voice to the cathedral.

ABOVE: *Cleanup of Frollo by June Fujimoto, animation by Catherine Poulain. Cleanup of the Archdeacon by Randy Sanchez, animation by Dave Burgess.*
BELOW: *Storyboard art by Paul Brizzi and Gaëtan Brizzi.*
OVERLEAF: *Production still.*

The Disney moviemakers chose to make Frollo a feared and powerful judge rather than a cleric as Hugo did. He is introduced in the film preparing to toss the infant Quasimodo in a well after causing the death of Quasimodo's gypsy mother, when he is opposed by the Archdeacon of Notre Dame. It is the confrontation on the steps of the cathedral between these two antithetical characters which sets the events of the story in motion and establishes the relationships among Quasimodo, Frollo, and the cathedral. Dave Burgess, who animated the Archdeacon, sees that character as "representative of the positive aspects of the church, with the strength to stand up to Frollo and stop him from the evil he is about to commit." With the voice of veteran character actor David Ogden Stiers,

73

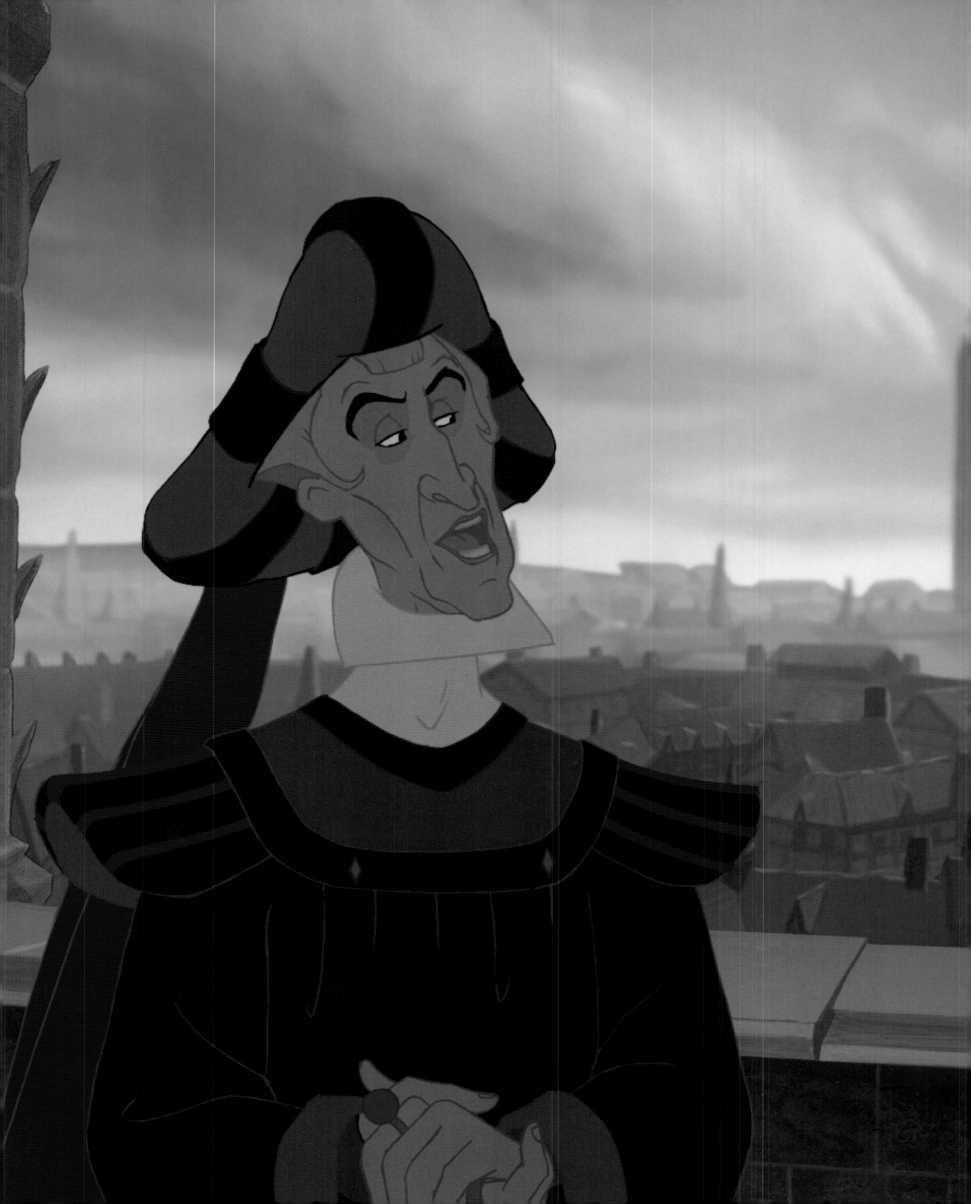

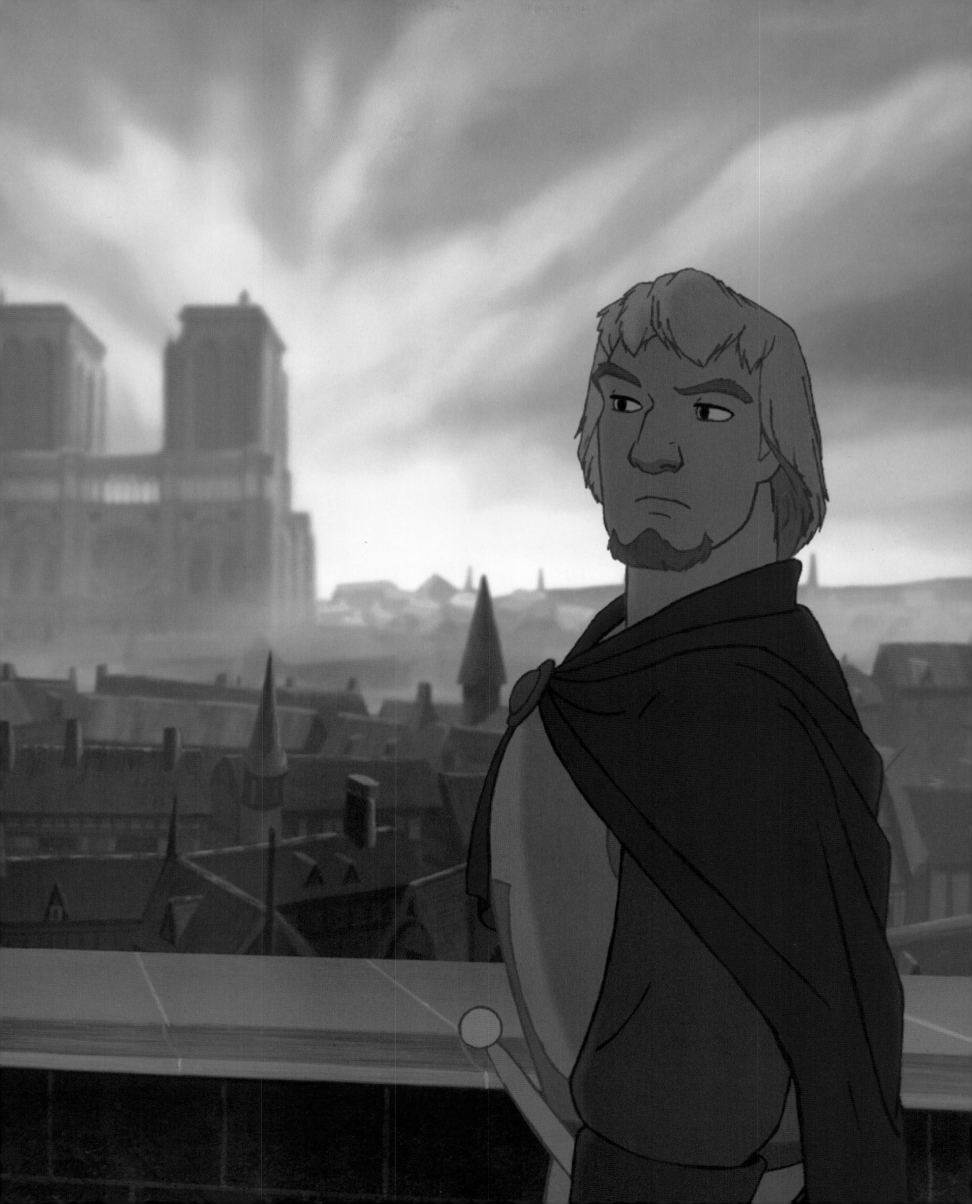

"the Archdeacon has the power and the position to tell Frollo that his soul could be damned forever if he killed this child," according to head of cleanup Vera Lanpher. "Both Frollo's chance for redemption and the entire throughline of the film are established in the moment the bond is created between him and Quasimodo."

Alongside his racism, and inability to love, Frollo's passion for Esmeralda remains, much as it does in the book, a powerful motivation for his despicable actions. Hugo writes: "The thought of her haunted him incessantly, tortured him, gnawed at his brain and twisted his entrails. . . . Toward sundown he examined himself once again and found that he was nearly mad." Don Hahn asserts that the character was one of the most challenging and intriguing to translate to the screen: "The book is rife with psychosexual tension and Frollo is a large source of that tension. He wants to abolish the gypsies from Paris, yet falls in love with one of them in spite of his hatred and revulsion. The very thing he wants to do away with is what haunts and destroys him." Concurs head of story and supervising animator Will Finn, "When he responds to Esmeralda and finds her beautiful and attractive and all the things that he naturally would, the feeling is so unnatural for him that it becomes something tortured and twisted and something he is afraid of. He's a very tragically warped character who is almost entirely ashamed of any human quality he might possess, so he projects this persona of a holy figure to repel his own humanity."

From a design standpoint, the filmmakers conceived Frollo as spindly, elongated, and severely angular, qualities which serve as apt visual

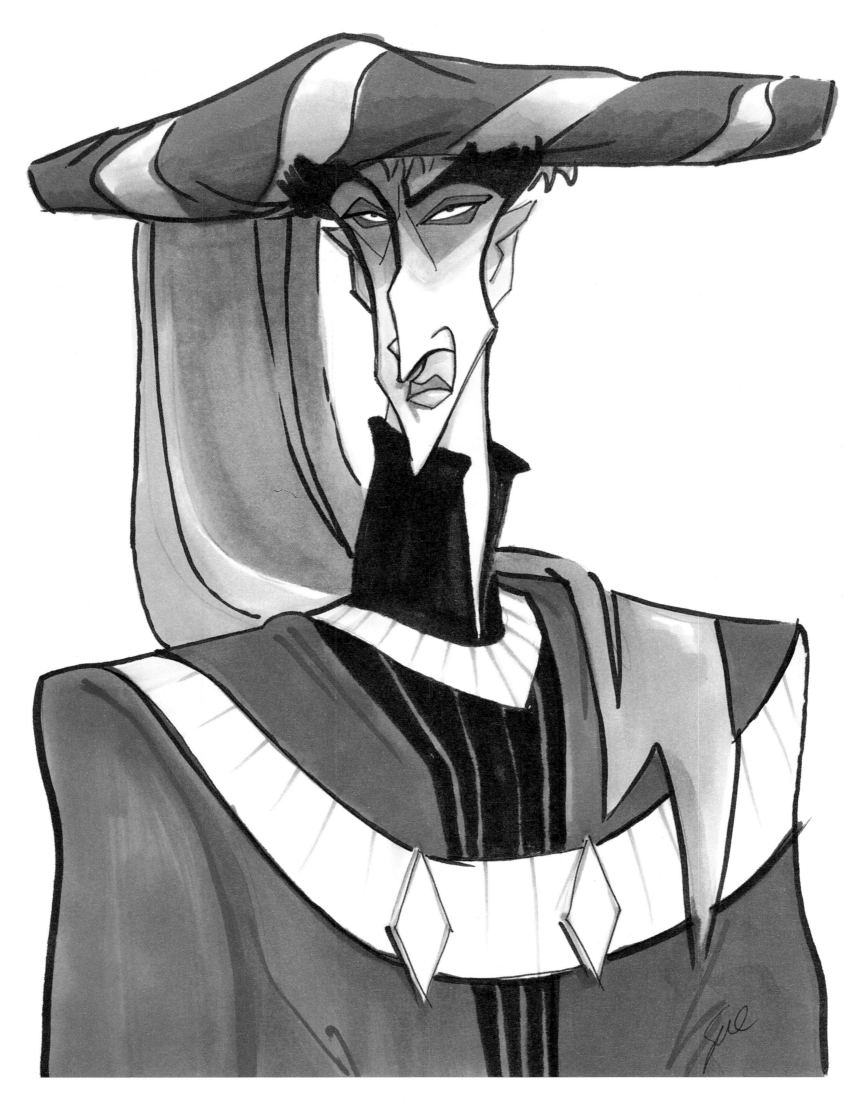

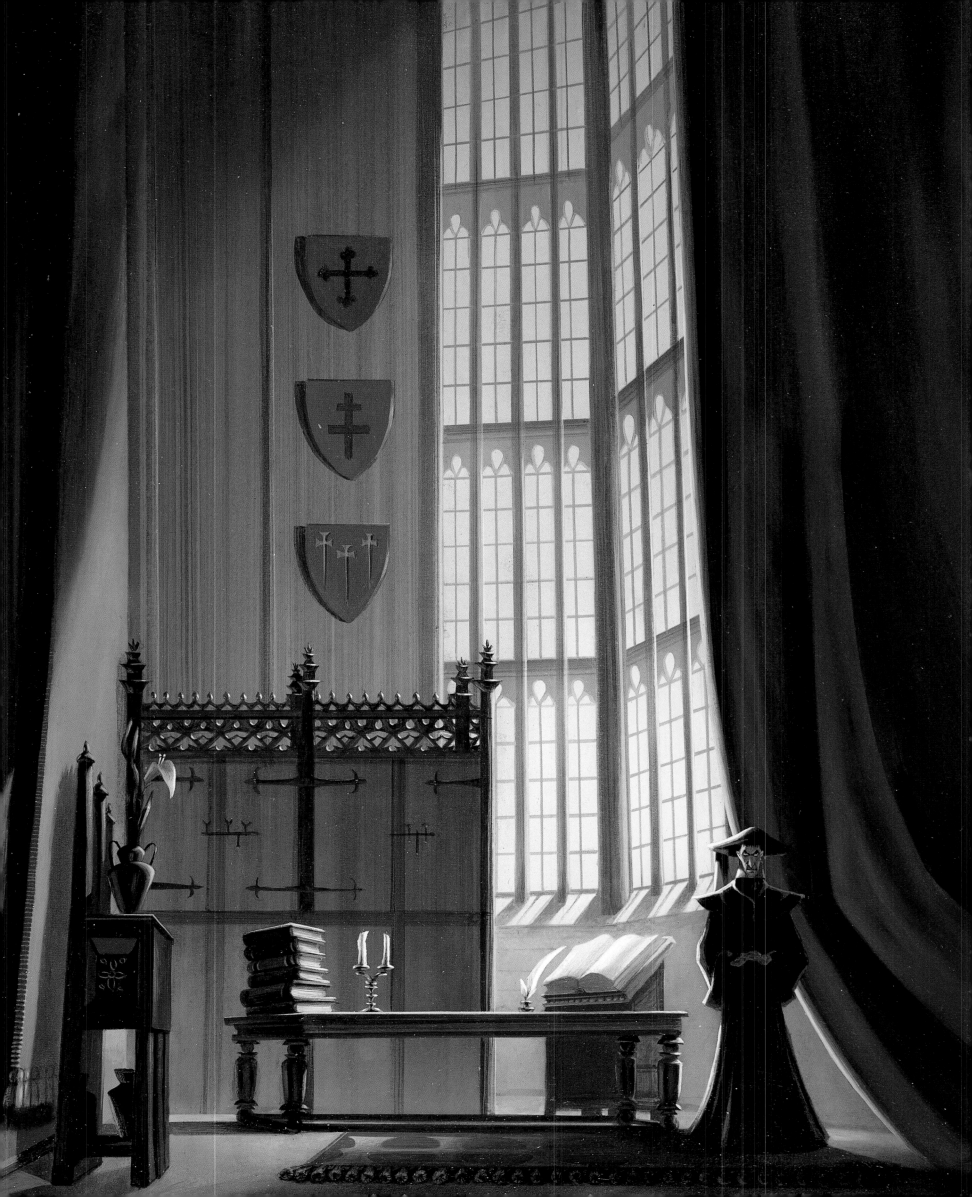

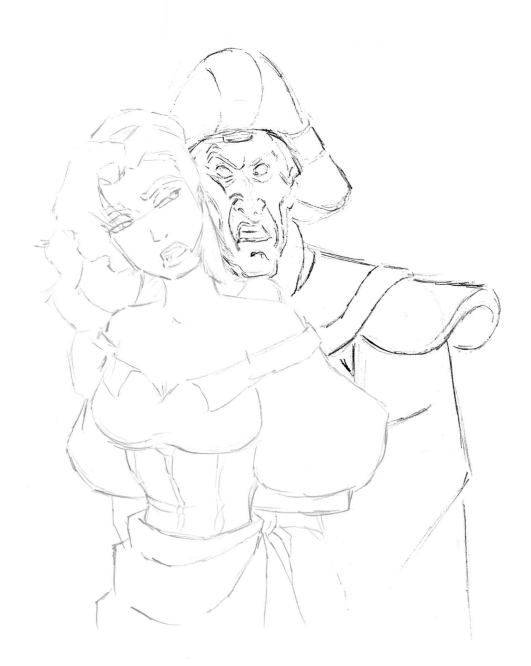

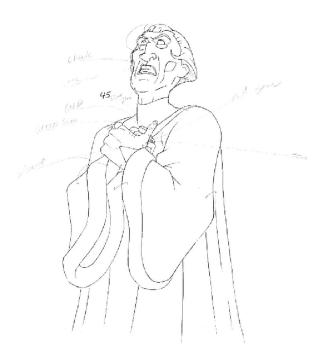

ABOVE: *Frollo's complexity as a character extends to his animation. According to cleanup lead June Fujimoto, Frollo is among the most difficult characters to draw in the Disney pantheon. Cleanup by June Fujimoto, animation by Kathy Zielinski.*
LEFT AND ABOVE: *Rough animation of Frollo by Kathy Zielinski and of Esmeralda by Mark Koetsier.*
OPPOSITE: *Hugo originally imagined an alchemist's den for Frollo's study. The Disney artists instead made his environment stark, spare and unyielding, like his character. Concept art by Darek Gogol, painted by Justin Brandstater.*

metaphors for his authoritarianism and austerity. His design also nicely complements the vertical composition of Paris architecture and environment stressed in the background paintings and layout designs supervised respectively by *Beauty and the Beast* contributors Lisa Keene and Ed Ghertner. Despite Frollo's apparent self-denial and piety, his costume is deliberately the single most finely detailed and materially sensuous of any in the film, subtly suggesting the character's inherent arrogance, narcissism, hypocrisy, and corruption.

While Quasimodo inspired strong empathy from the moviemaking team, Frollo commanded a fascinated antipathy. Kirk Wise comments that, unlike earlier villains in Disney animated features, "Frollo is not about one thing, like wanting power, revenge, or gold. He's multilayered, truly sinister, divisive." Codirector Gary Trousdale sees him as "the ultimate abusive parent." For supervising animator Kathy Zielinski, Frollo is "mean, elegantly sinister, fascinating to watch, and he has this hold on you. I got so involved with him emotionally that I found myself thinking what it would

Concept art by Sue Nichols.

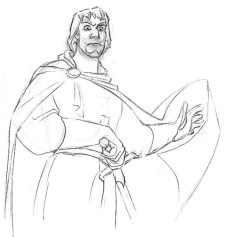

be like to be him. I found I had to listen to upbeat music just to try to get him out of my system." June Fujimoto, cleanup key for Frollo, views him as "a true villain, sick and twisted inside, with a design as complicated as his inner character." The voice of Frollo, British actor Tony Jay, who also voiced the asylum keeper in *Beauty and the Beast*, characterizes the Minister of Justice as a tragic figure: "Frollo is guided by the zealous belief that he has right on his side and, of course, a person whose zeal becomes fanatical is almost always doomed." Gary Trousdale concurs: "Frollo represents unexamined, self-justifying evil incarnate."

A Very Handsome Archer

Neither Hugo's novel nor Disney's film presents a traditional romantic hero. In both, the soldier Phoebus enchants, beguiles, and challenges Esmeralda much the way Esmeralda enchants, beguiles, and challenges Quasimodo. The author, referring to the character's name, writes: "It was the name of a very handsome archer, who was a god." The novel's Phoebus is not only handsome and, as a soldier, something of an

ABOVE: *Rough animation of Phoebus by Russ Edmonds.*
ABOVE RIGHT: *Cleanup by Brian Clift, animation by Russ Edmonds.*
RIGHT: *Production still.*

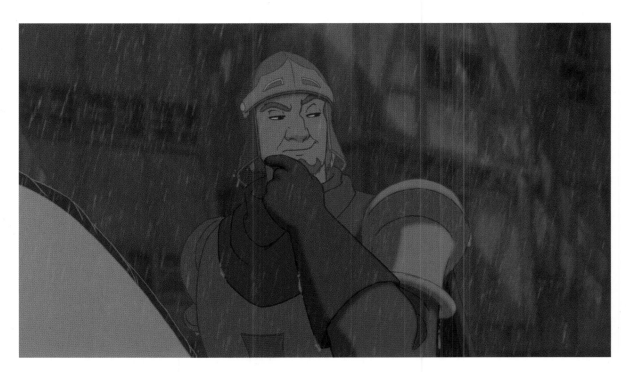

80

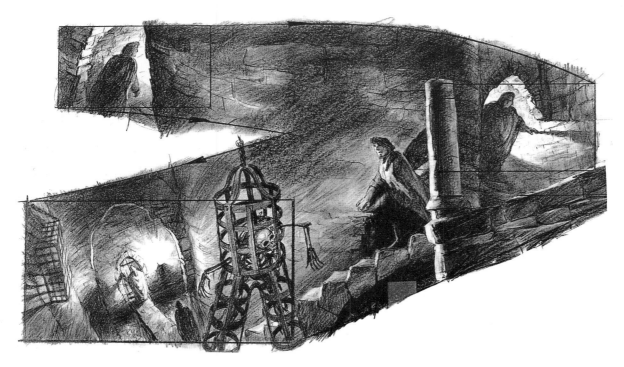

archer, but also a vain, dimwitted, untrustworthy, womanizing, shallow cad. In a defining moment, Hugo's Phoebus meets Esmeralda for a nighttime assignation and listens, unmoved, as she pours out her heart. Later, Phoebus watches without emotion the preparations for Esmeralda's public execution on trumped-up charges of witchcraft and murder—his own murder.

In the animated film, Phoebus is far less the cad. A mercenary soldier in the employ of Frollo, Phoebus was originally conceived as an amalgam of two characters from the novel. The writers and directors grafted onto the vain soldier Phoebus qualities of the bohemian character of Pierre Gringoire, a hapless, callow, self-admiring inept playwright who is bewitched by Esmeralda. In the end, the writers, directors, producer, and animators conspired to design and characterize a mature and down-to earth Phoebus unlike either of these original models. Explains Kirk Wise, "We had to create a character who would seem worthy of Esmeralda's love and be loved and accepted by the audience."

THIS PAGE: *Phoebus descends into the dungeon beneath the Palace of Justice. Value studies by Fred Craig.*

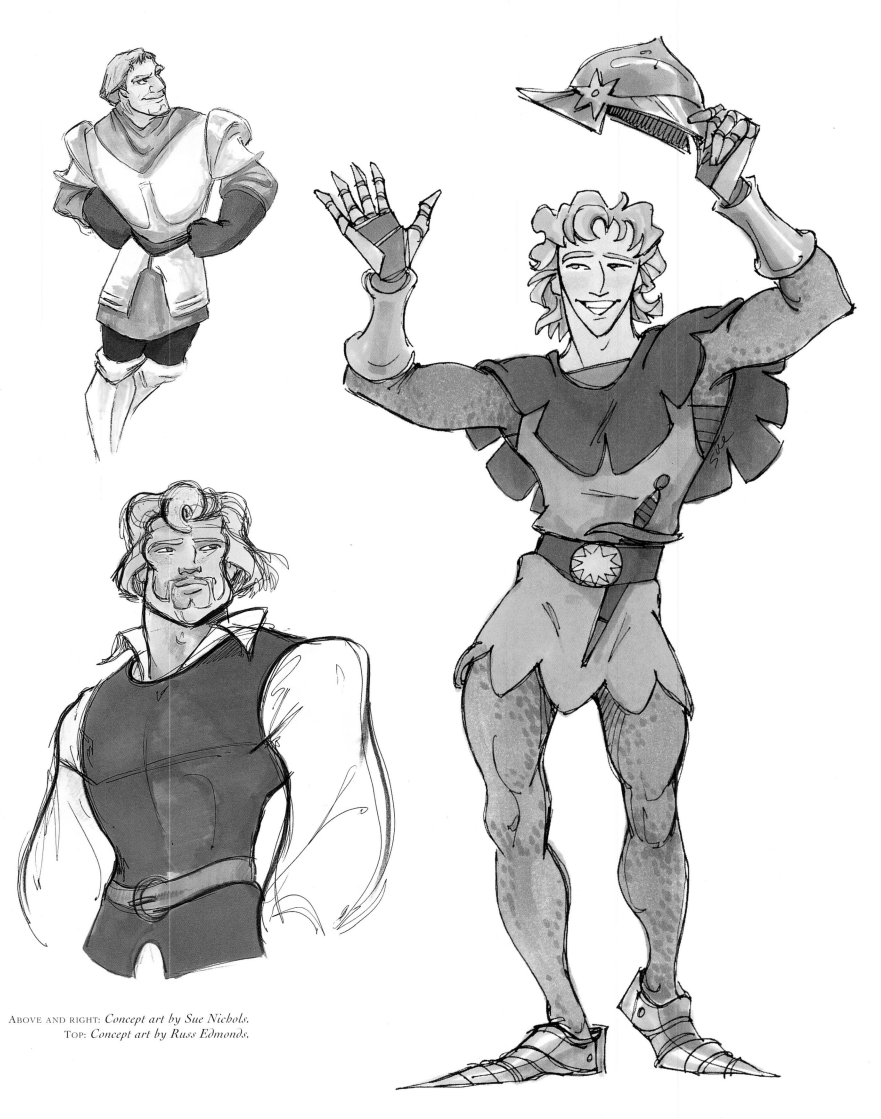

ABOVE AND RIGHT: *Concept art by Sue Nichols.*
TOP: *Concept art by Russ Edmonds.*

Don Hahn calls the Disney Phoebus "an Everyman, a good cop in a bad town. He's the kind of guy who sees Esmeralda and thinks, 'She's cute.' He provides the audience's point of view, though, because he sees through Frollo quickly and becomes a fugitive, an outcast himself, when he rejects Frollo's corruption."

Gary Trousdale admits, "I want to be like Phoebus when I grow up. He's a dashing soldier, witty, brave, sure, yet what I most like is that although he can keep a straight face when it's required of him, you can tell deep down, he'd rather tell a joke." Animated by Russ Edmonds, some of whose mannerisms and expressions found their way into the character, Phoebus emits self-deprecating charm and a winning lack of pretense. He is a big, strapping galoot, a gallant doofus. According to Edmonds, "He's not some young kid who has to decide what's happening in his life. He's already done. He's been through the ropes, he's been through a war. He has a broken nose, and he's had battle wounds. Because he's been through his life experiences already, he has a sense of humor about life. He's a mature hero with a heart."

By refusing to carry out Frollo's genocidal orders to set fire to the home of a family suspected of harboring gypsies, Phoebus makes himself an outcast but also breaks the chains of blind, soldierly obedience fate has forged for him. Voiced by Kevin Kline, who in *A Fish Called Wanda* and *I Love You to Death* revealed himself a master at kidding his matinee idol looks with witty self-spoofing, Phoebus represents a rough-around-the-edges animated leading man.

ABOVE: *Storyboard art by Jeff Snow.*
ABOVE LEFT: *Rough animation by Russ Edmonds.*
OVERLEAF: *Production still.*

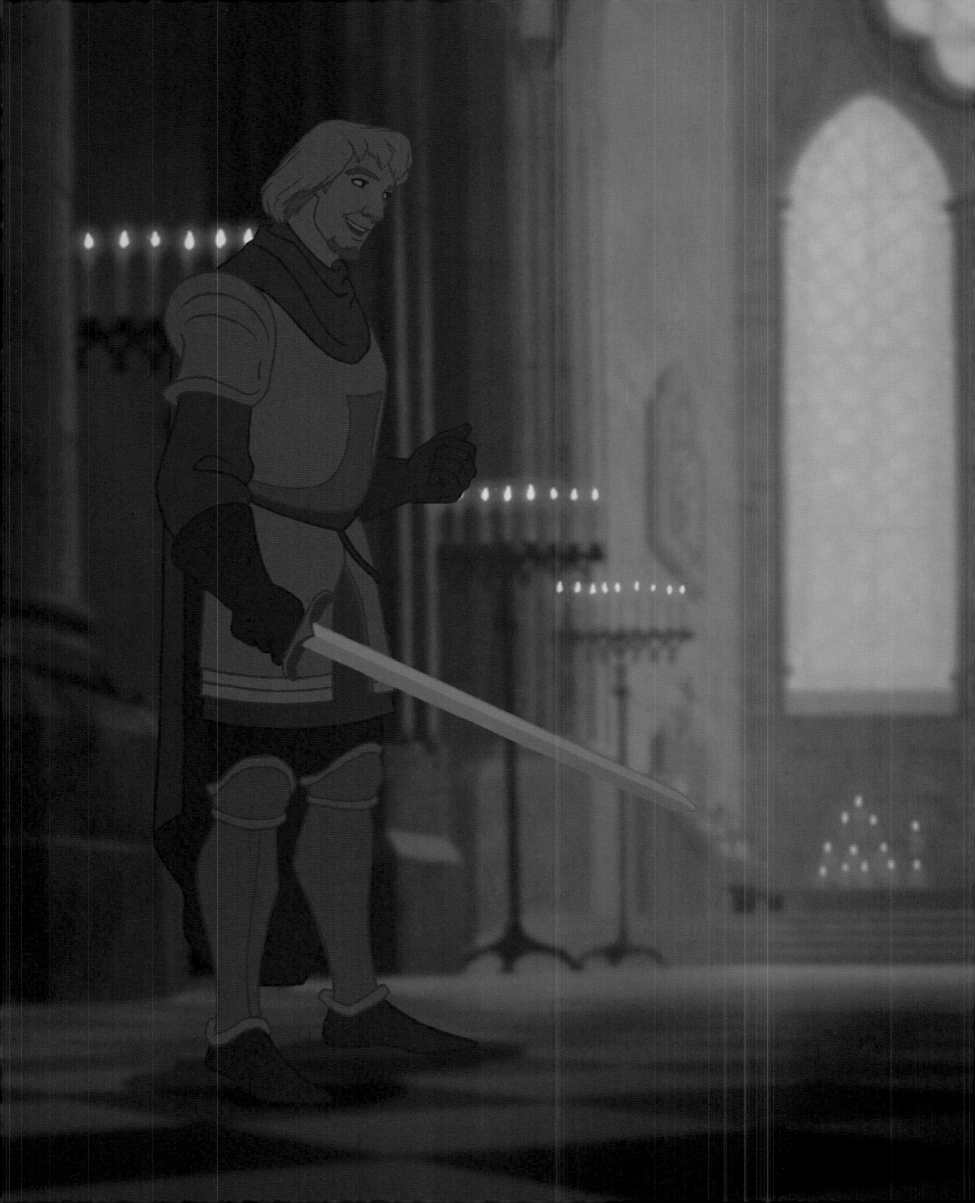

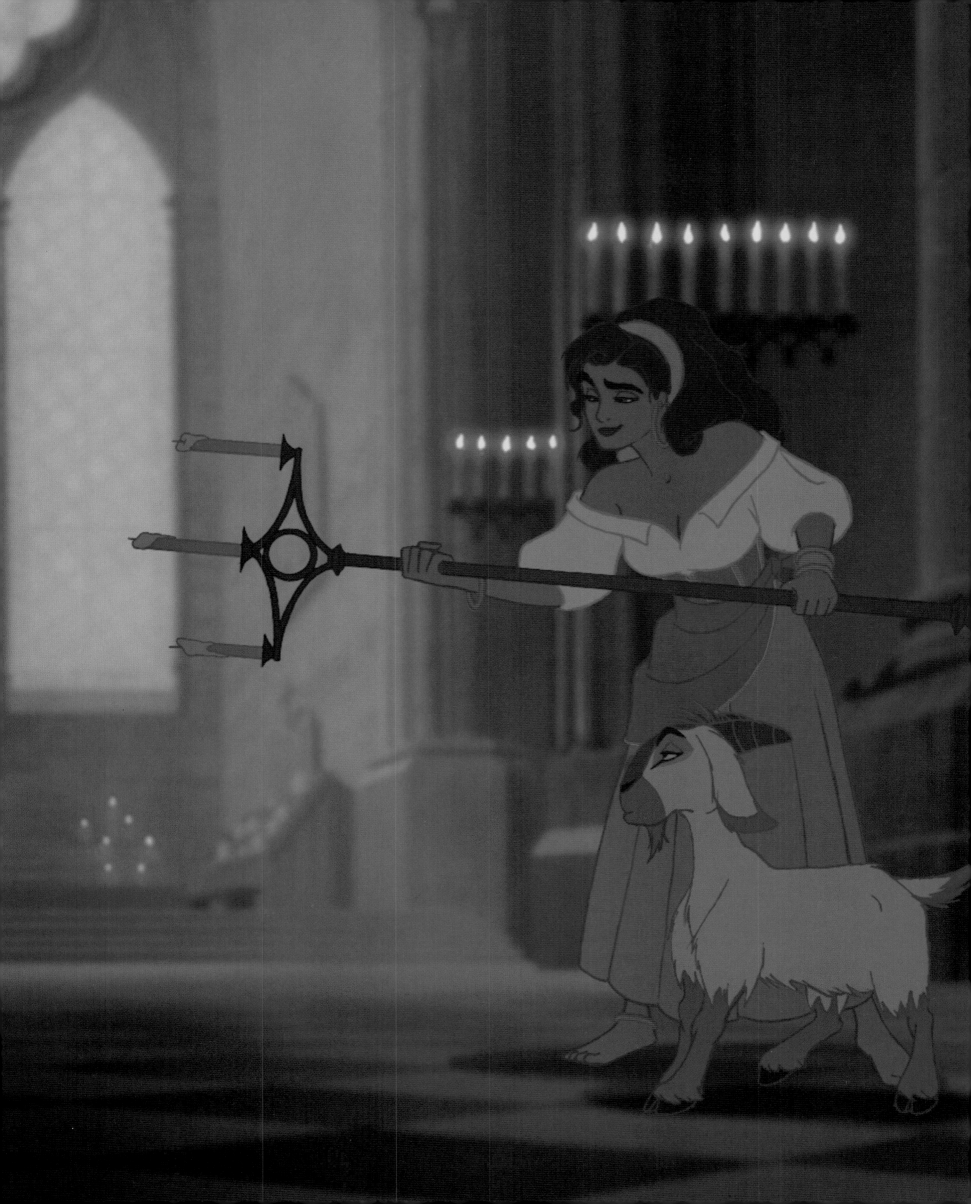

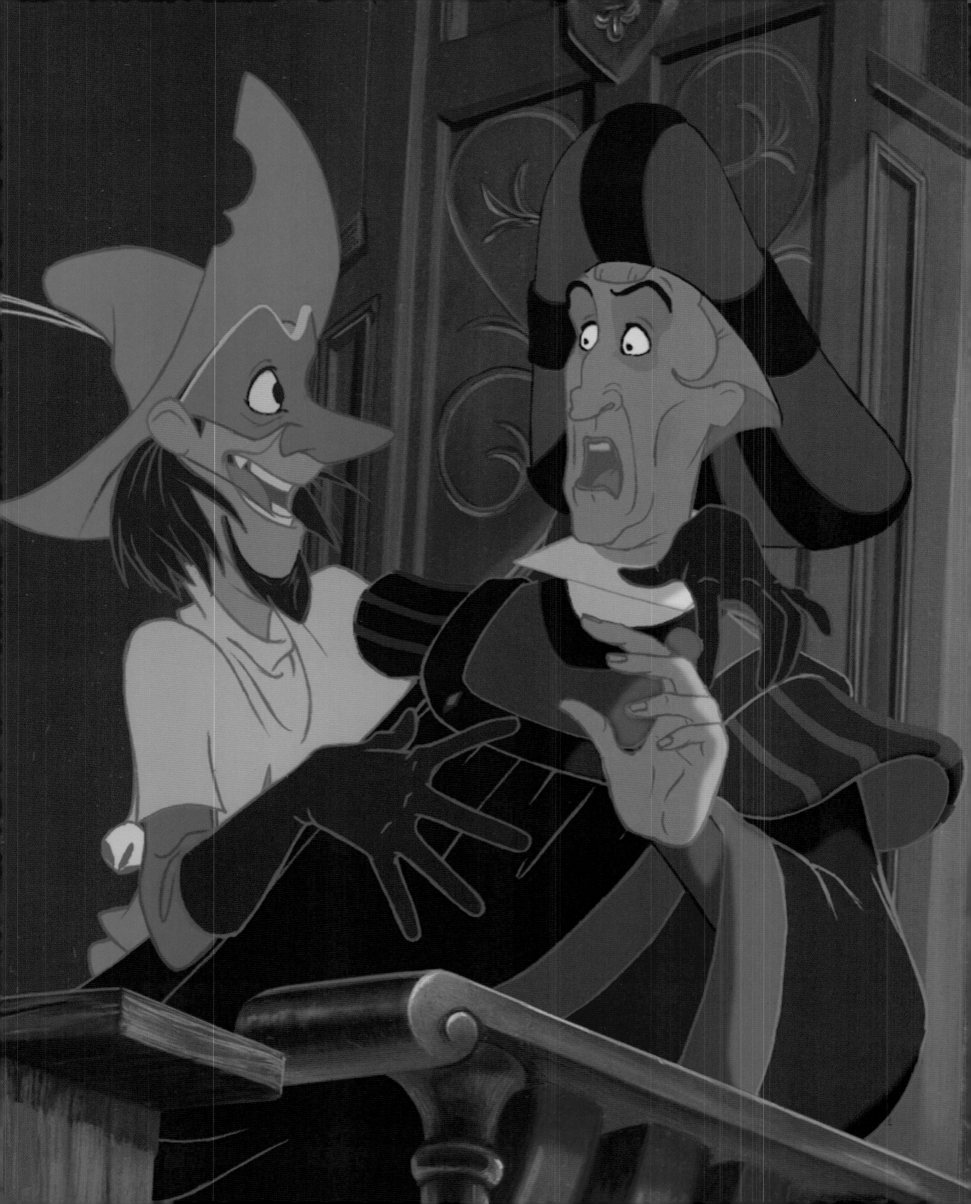

The Master of Ceremonies

Victor Hugo likens Clopin, the seedy, opportunistic, showboating beggar and charlatan Gypsy King, to "a caterpillar on an orange" and "a boar's head amidst the snouts of pigs." Clopin makes his first noteworthy appearance in the novel when he presents himself, along-side Quasimodo, as a nominee for King of Fools. As Hugo writes of Clopin in an aside, "God knows the intensity of ugliness his face was capable of attaining." A withering mimic, a trickster, a pricker of the balloon of pretense, a light-fingered master of disguises, Clopin is another persecuted outsider who has learned to survive in the margins of society. Hugo character-izes him as one of the beggars at the Palace of Justice and the de facto lord of the Court of Miracles, that shad-owy, sinister lair where gypsies, outcasts, and scoundrels rub elbows.

Equal parts narrator and entertainingly unsavory master of ceremonies, Clopin shares qualities with the duplicitous ringmasters played, respectively, by Joel Grey in *Cabaret* and by Jonathan Pryce in *Miss Saigon*. True to the tradition of *commedia dell'arte*, those 16th- to 18th-century theatrical troupes in which largely improvisational actors specialized in such roles as "Arlecchino" or "Scapino," Clopin skewers hypocrisy and class distinctions, is irreverent, even vulgar and farcical. The *commedia* tradition and spirit live in the

87

character, just as they do in Punch and Judy puppet shows, Charlie Chaplin, and various contemporary political and satirical European and American acting companies.

Another outsider and fugitive from society, Clopin moves and speaks with a freedom, a license, and a class-free ease that contrasts starkly with Frollo. Clopin, observes the character's supervising animator Michael Surrey, "could have stolen the shoes off someone who just died in the streets. Although he belongs to the lowest group in society, he tries to keep himself a tad above the rabble and wants attention and respect. That's what

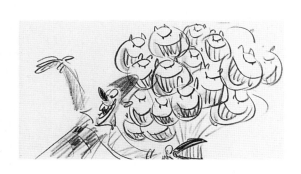

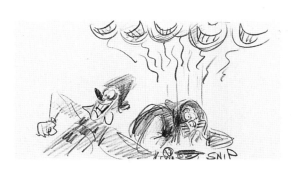

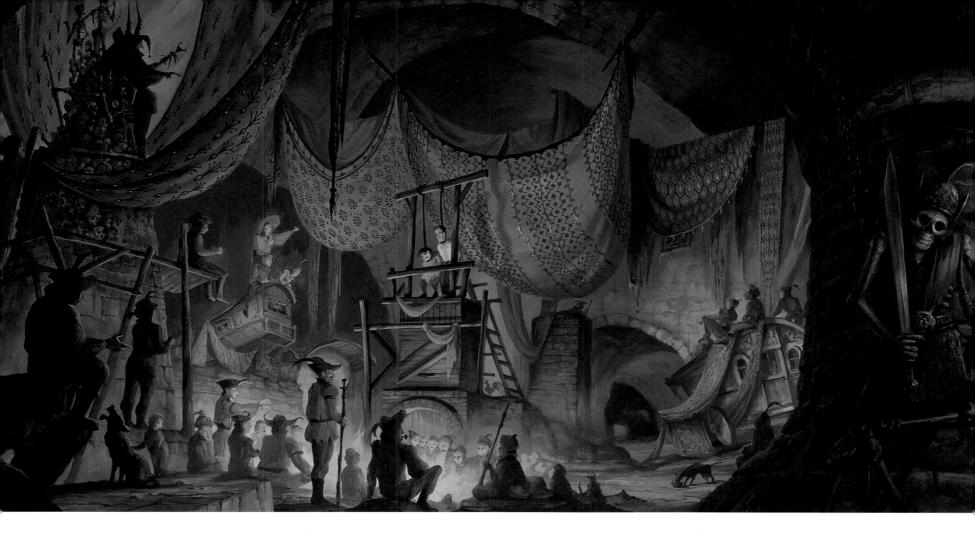

helps set him apart, and makes him believe he can change his fate." For Surrey, Clopin's indomitable spirit, quickness, and resourcefulness is the gift that comes from his outsider status. "It's always interesting when you see somebody who might not be as fortunate as others, but who just does incredible things with the little they have," says Surrey. Clopin's design reflects the litheness and agility necessary for Gypsy survival. "Where Frollo and his world are designed to be straight and vertical, Clopin and the Gypsies are curvy, rhythmic, featuring a lot more odd-looking shapes." Actor Paul Kandel, who sings and voices Clopin, worked closely with animator Surrey to help add some of his own personal dimensions to the character. Kandel observes, "This is a story set in a time when people were stratified by their looks, clothing, race. Clopin and the gypsies, as a despised race, are a societal representation of where Quasimodo falls on the spectrum. That's why he and the gypsies, both outcasts, become allies by the end of the film."

The chaotic, creative Court of Miracles, temporary home of the outcast, freedom-loving gypsies, contrasts sharply with Frollo's spindly Palace of Justice.

ABOVE: *Concept art of the Palace of Justice by Marek Buchwald.*
TOP: *Concept art of the Court of Miracles painted by Don Moore, layout by Marek Buchwald.*
LEFT AND ABOVE LEFT: *Concept art by Jean Gillmore.*
OVERLEAF: *Production still.*

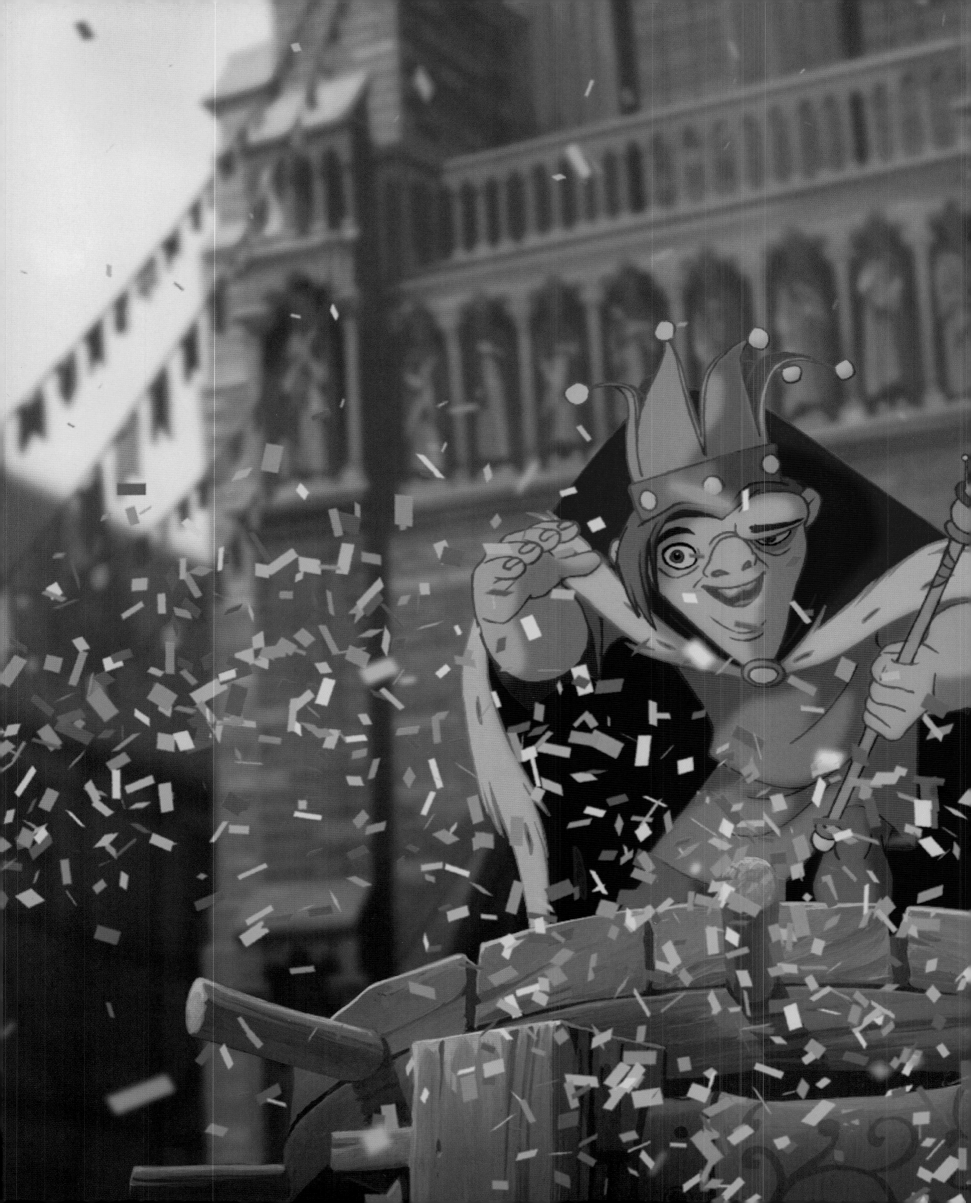

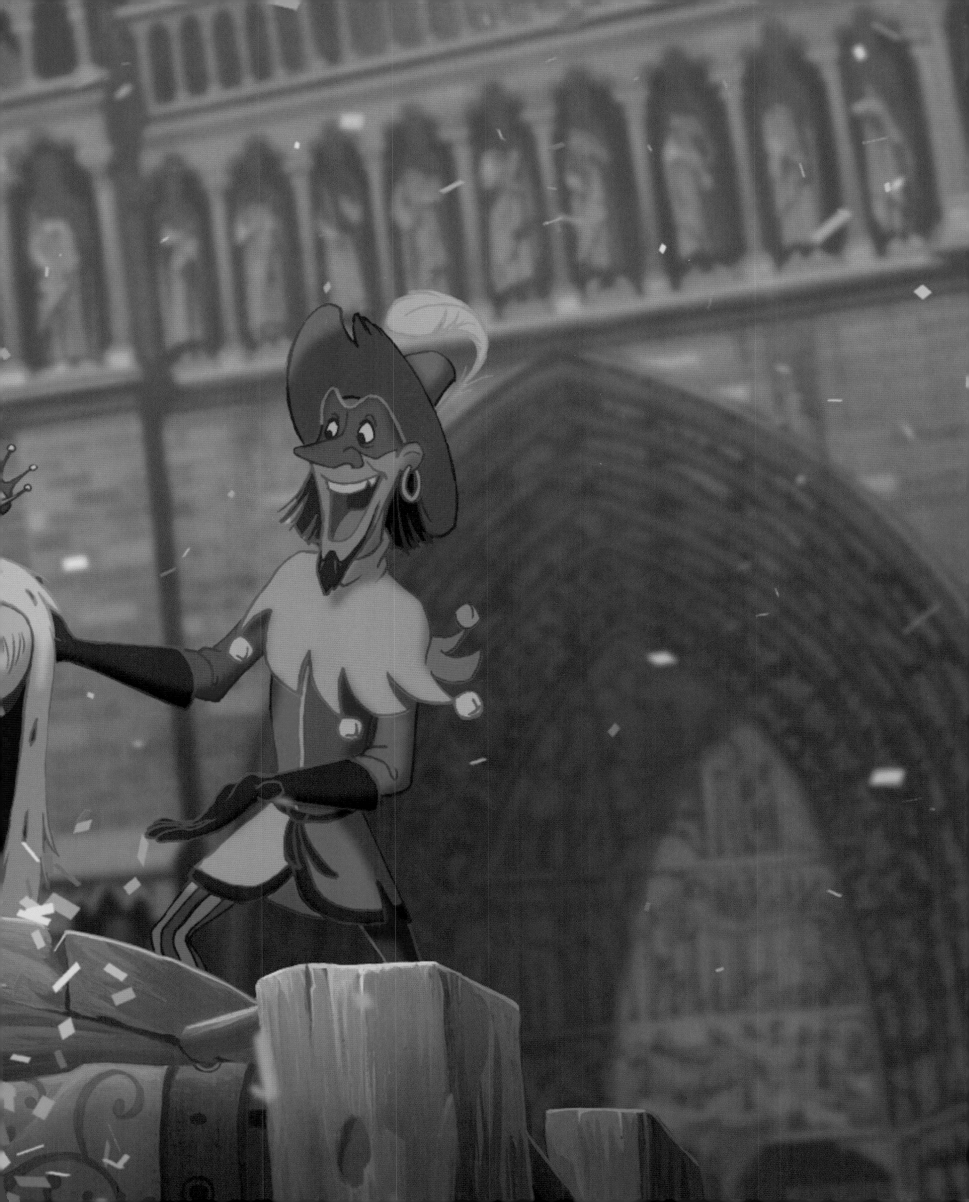

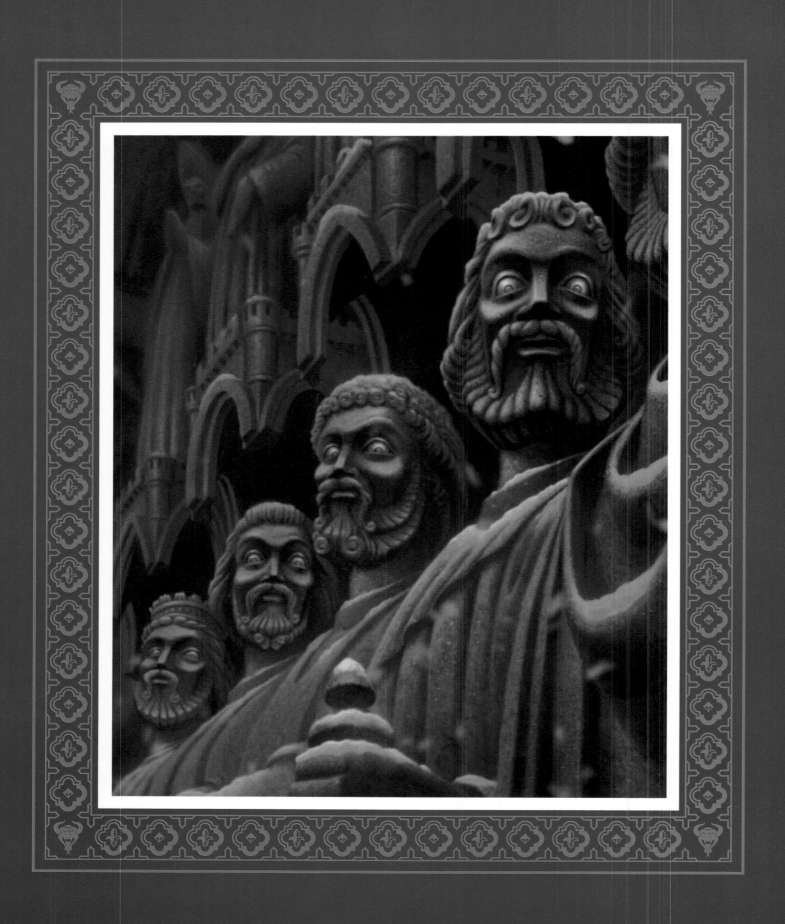

III.

Angels in the Architecture

"Notre Dame rises in the middle of the city of Paris, and when it was first built, you could see it for miles around. The cathedral is a symbol of strength to Quasimodo and the gypsies and the townsfolk but a threat to Frollo. In this story, it's really God's presence on earth."

—ED GHERTNER, Head of Layout

Hugo's treatment of Notre Dame inspired the filmmakers to give the cathedral a character of its own.

ABOVE: *Layout art by Lam Hoang.*
OPPOSITE: *Production still.*
OVERLEAF: *Background art by Greg Drollette.*

The sweeping, grand-scale historical scope of *Notre-Dame de Paris* at times conveys a documentary-like sense of Parisian life during the Middle Ages. Meticulous in describing the form and function of the interiors and exteriors of many of the city's most impressive buildings, the novel is no mere time travelogue;

its sense of time, place, incident, and event is accomplished with intense, boldly impressionistic language and carefully selected details. Because Hugo intends Notre Dame, the centerpiece of the tale, to emerge as a character in all respects as lively, multifaceted, complex and ever-changing as any other, the novel conveys

sense impressions of the cathedral that are completely visceral. It rises above its surroundings, inspiring awe and wonder in those who revere its spectacular architecture and status as a religious icon.

Hugo dramatizes the extraordinary spirit of Notre Dame largely through Quasimodo's unique relationship to the

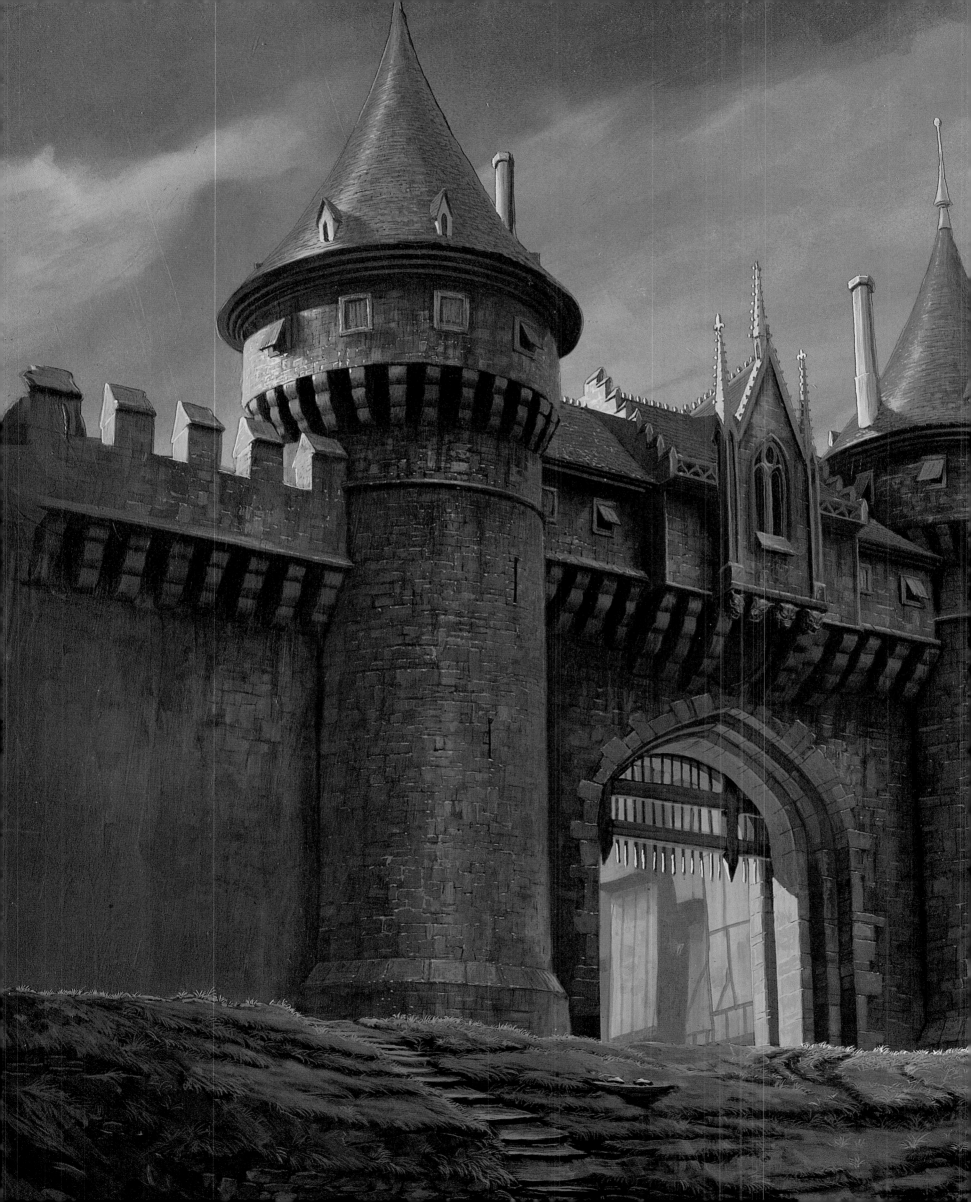

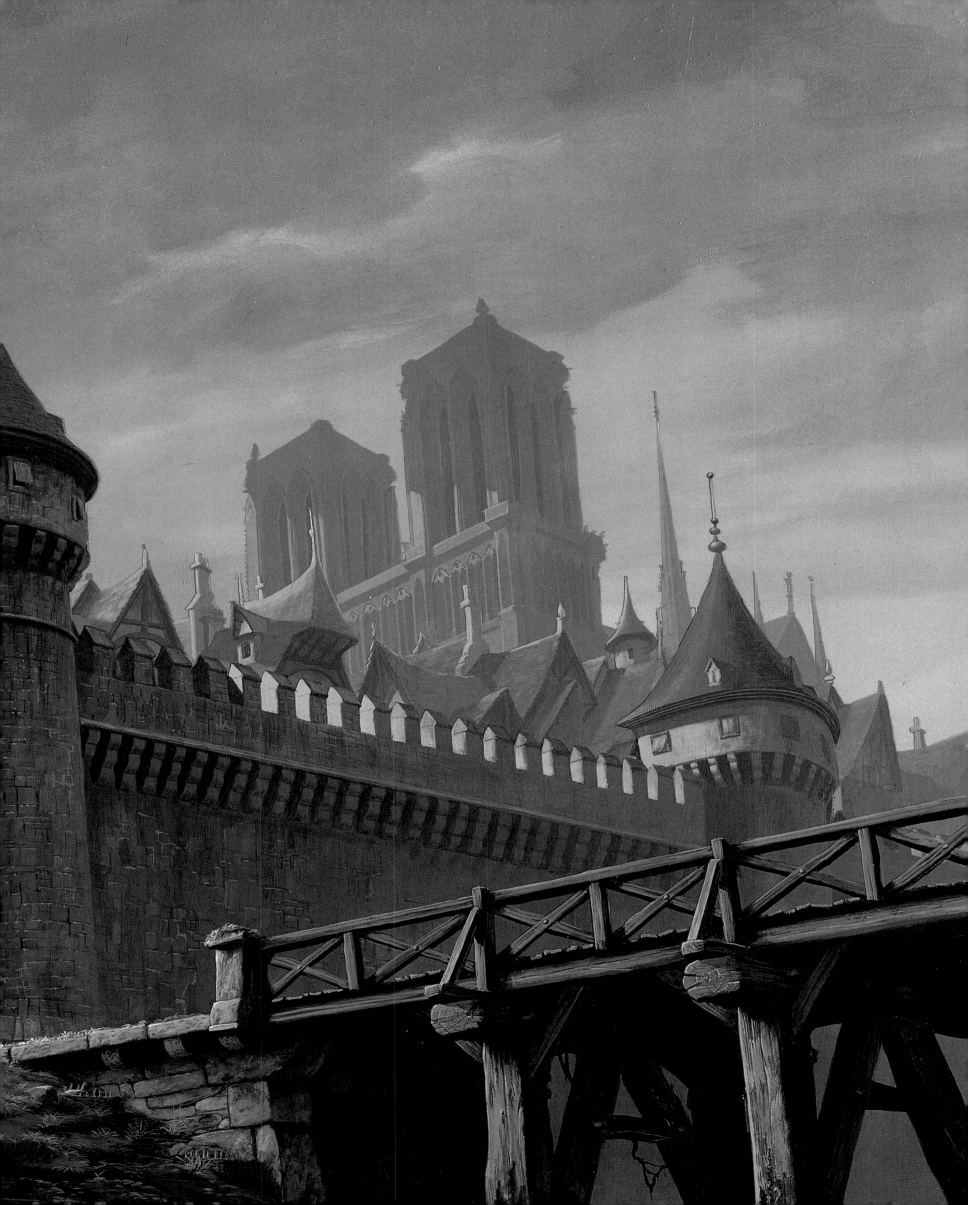

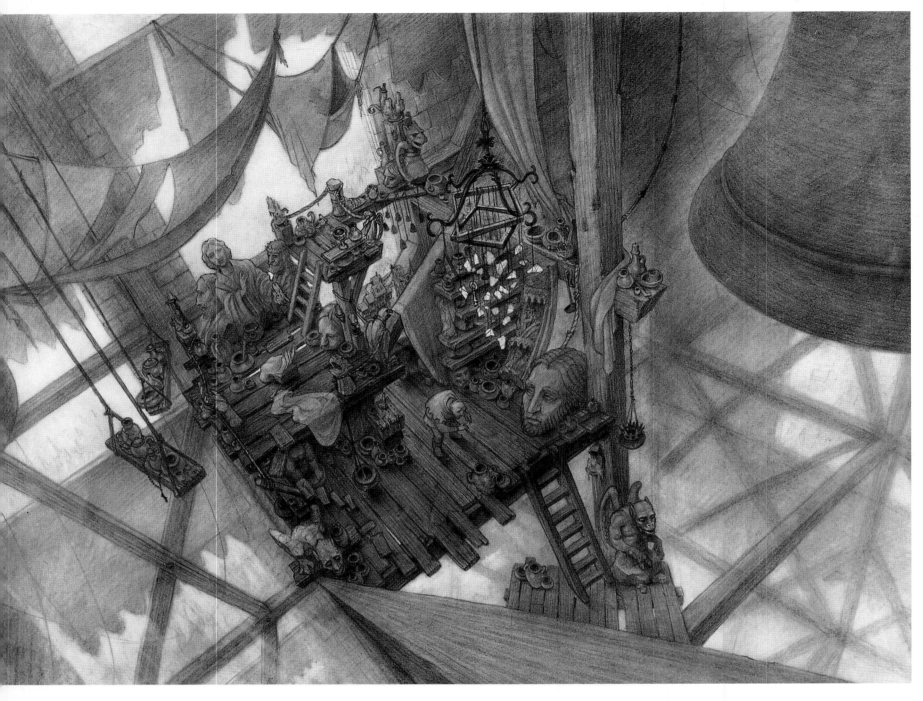

ABOVE: *The Belltower. Layout art by Tom Shannon.*
RIGHT: *Concept art by Thom Enriquez.*

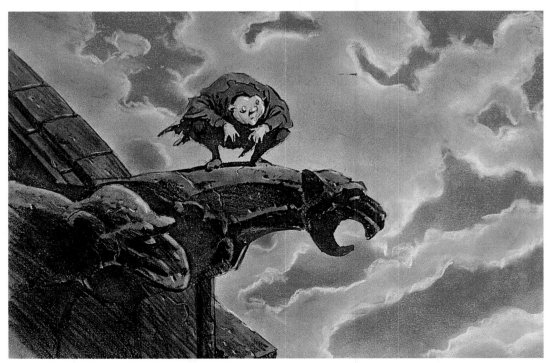

place. Quasimodo personifies the bells by invoking the popular names by which Parisians knew them, names that signify the bells' unique personalities. Even the stones seem to share Quasimodo's feelings and characteristics. "The presence of this extraordinary being," Hugo writes, referring to the bell-ringer, "seemed to breathe life into the whole cathedral. There seemed to come from him, at least according to the exaggerated superstitions of the people, a mysterious emanation which animated all the stones of Notre Dame and made the old church quiver to its very entrails. Knowing that he was there was enough to make the hundreds of statues along the galleries and over the doorways seem to live and move."

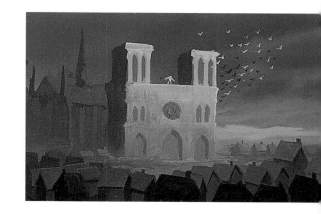

Describing sightings of Quasimodo atop the towers "climbing, twisting, crawling on all fours, coming down the wall high overhead, hopping from one projection to another," Hugo writes "the whole cathedral took on a fantastic, supernatural and frightening aspect; eyes and mouths would open here and there; strange noises could be heard coming from the stone dogs, serpents and monsters which day and night kept watch around the edifice with outstretched necks and gaping jaws." Hugo, describing the cathedral long after the death of Quasimodo, calls it "deserted and lifeless. That immense body is empty, nothing but a skeleton; the spirit has vanished. It is like a skull in which there are still two sockets, but no eyes."

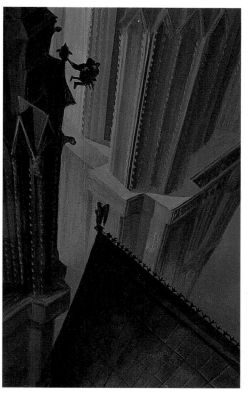

ABOVE: *Color key by Lisa Keene.*
TOP: *Color key by Kathy Altieri.*
LEFT: *Background art by Don Moore.*

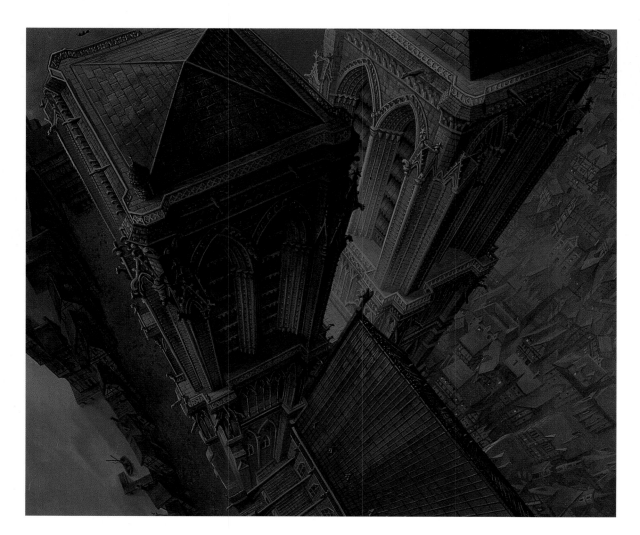

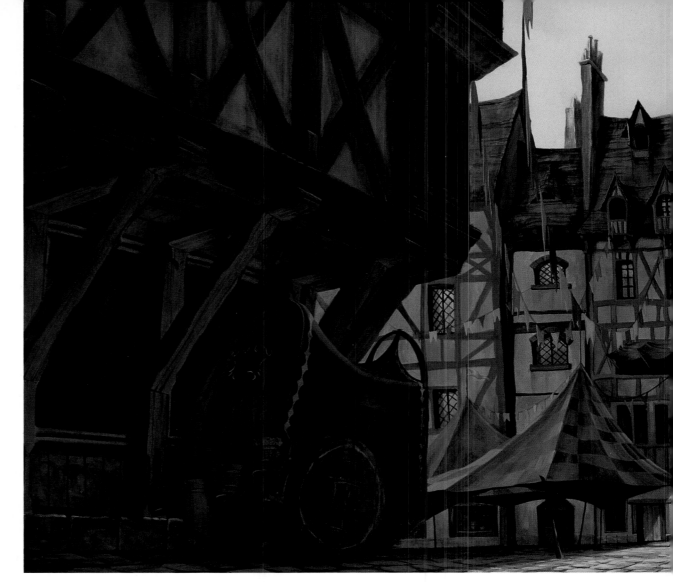

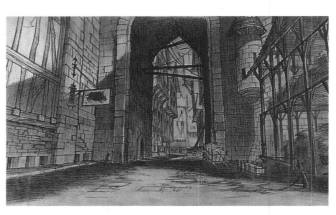

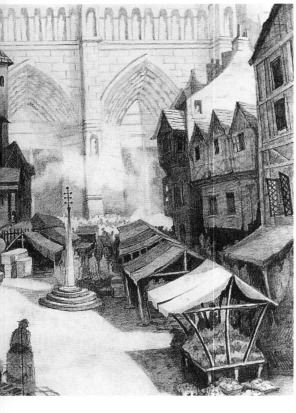

The filmmakers created a realistic, grimy medieval Paris, contrasting the squalor of the city streets with the reverential hush of the cathedral interior.

ABOVE AND TOP: *Art by Lisa Keene.*
ABOVE RIGHT: *Layout art by Jim Alles.*
OPPOSITE: *Layout art by Scott Caple.*

Americans in Paris

he makers of *The Hunchback of Notre Dame* were inspired by Hugo's passion for accurate, dramatic, and highly evocative rendering of Gothic architecture. Many of the film's collaborators flew to Paris in October of 1993, to immerse themselves for ten days in the heady, gritty atmosphere of Hugo's beloved city. Directors Gary Trousdale and Kirk Wise, art director David Goetz, coproducer Roy Conli, head of layout Ed Ghertner, head of story and supervising animator Will Finn, composer Alan Menken, and lyricist Stephen Schwartz were among those on the first trip, while others made additional visits. These trips were also vital because *The Hunchback of Notre Dame* was chosen, fittingly enough, to

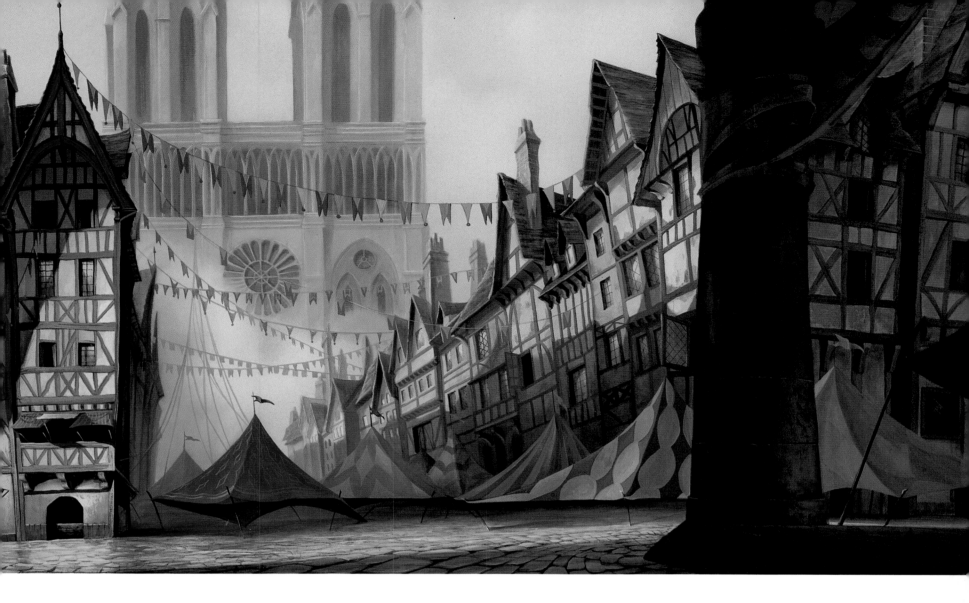

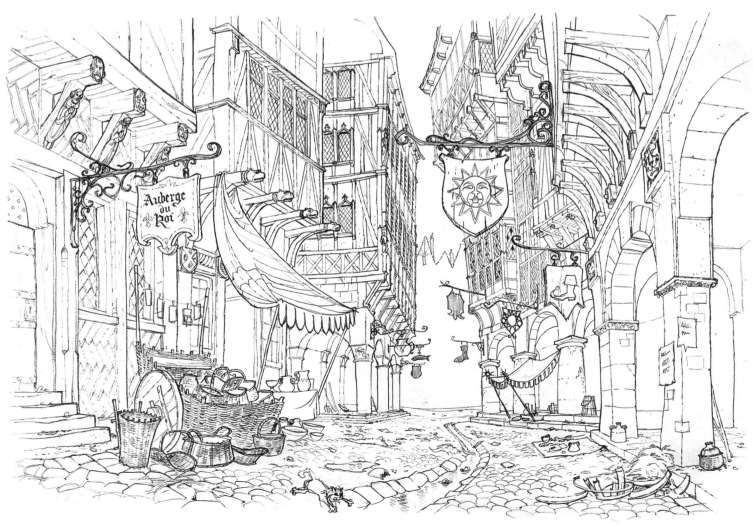

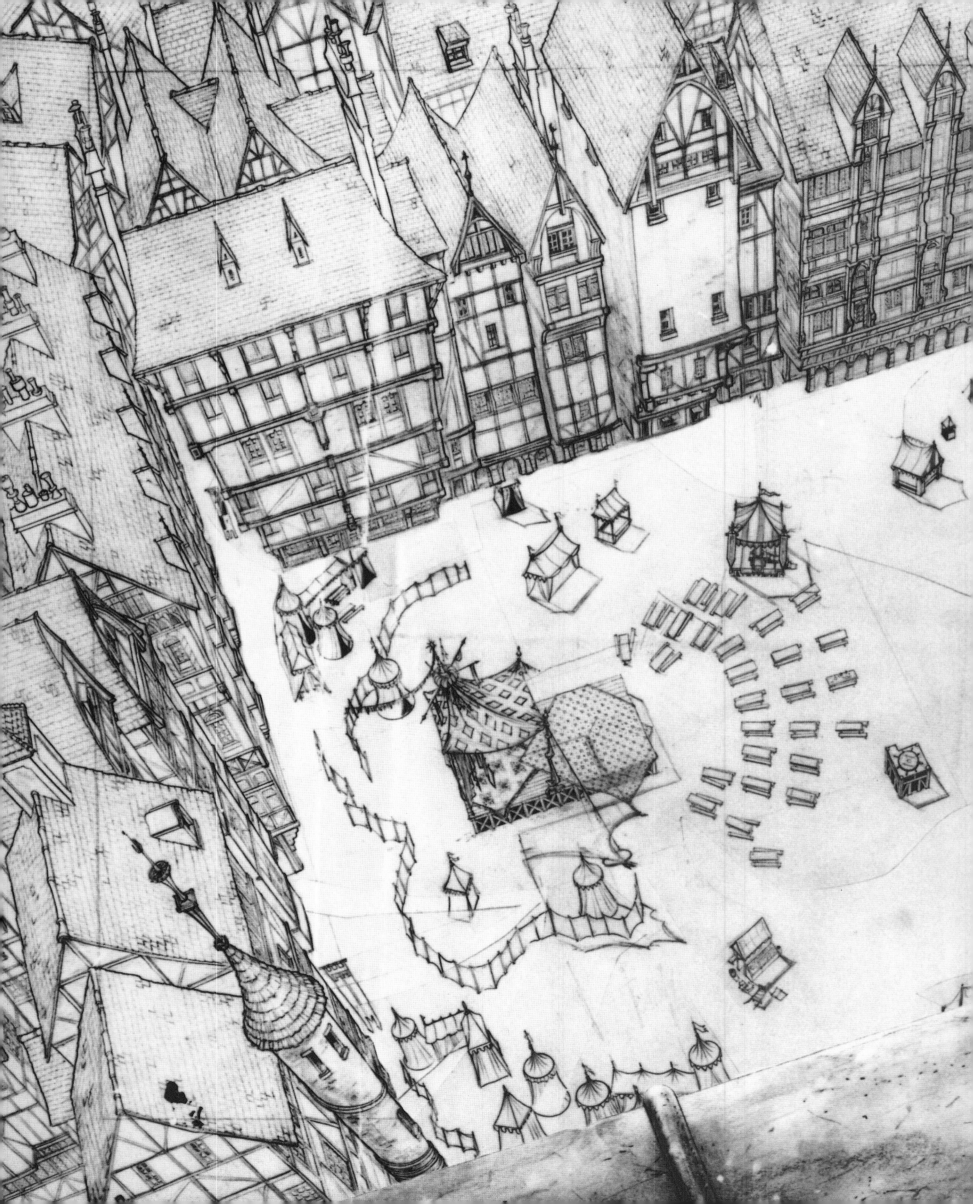

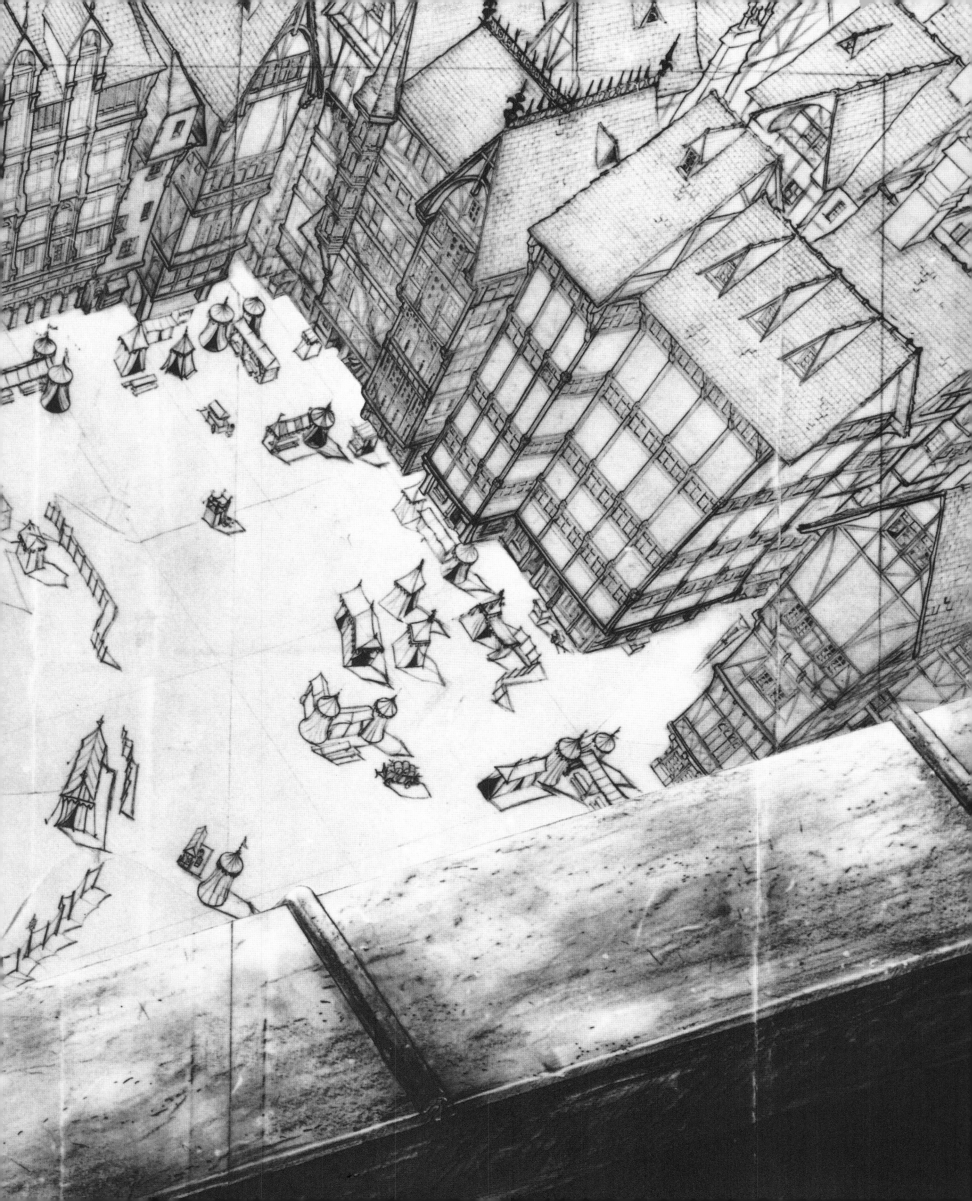

inaugurate the collaboration of the Studio's American filmmaking contingent with the roughly one hundred moviemakers at its new Paris Studio. Led by Paul Brizzi and Gaëtan Brizzi, who also storyboarded and acted as sequence directors for several parts of the film, "the Parisian artists brought a European sensibility and familiarity with Hugo and his work that were indispensable," asserts Don Hahn.

The moviemakers devoted three days to exploring Notre Dame itself, including a private tour of such rarely glimpsed sites as actual passageways, stairwells, towers, and hidden rooms within which Hugo set his action. The trip also included visits to the Palace of Justice and to the likely original location of the Court of Miracles, that hotbed of black-market chicanery. On these exploratory excursions, writer and historian Pascal Payen-Appenzeller provided the filmmakers with a running discourse on topics ranging from the Catholic symbolism of Notre Dame's statuary to the differences between how moderns view the medieval world and how Hugo and his contemporaries would have viewed it.

Unlike the idyllic, stylized depiction of the medieval era appropriate to such Disney romantic fables as *Sleeping Beauty* or *Beauty and the Beast*, *The Hunchback of Notre Dame* would immerse its audience in what David Goetz terms "a grungy, dusty, used Middle Ages," inspired by real-world settings and encrusted with a rich, "old world" patina. As Kirk Wise

ABOVE: *Color key by Lisa Keene.*
BELOW: *Layout art of the Court of Miracles by Loïc Rastout.*
OPPOSITE: *Concept art of the Palace of Justice by Marek Buchwald.*
PRECEDING PAGES: *Layout art by Lam Hoang.*

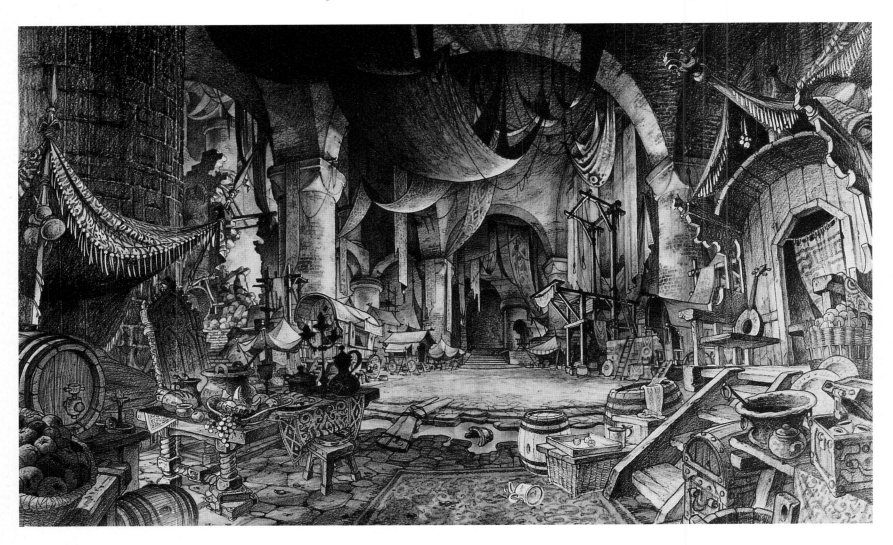

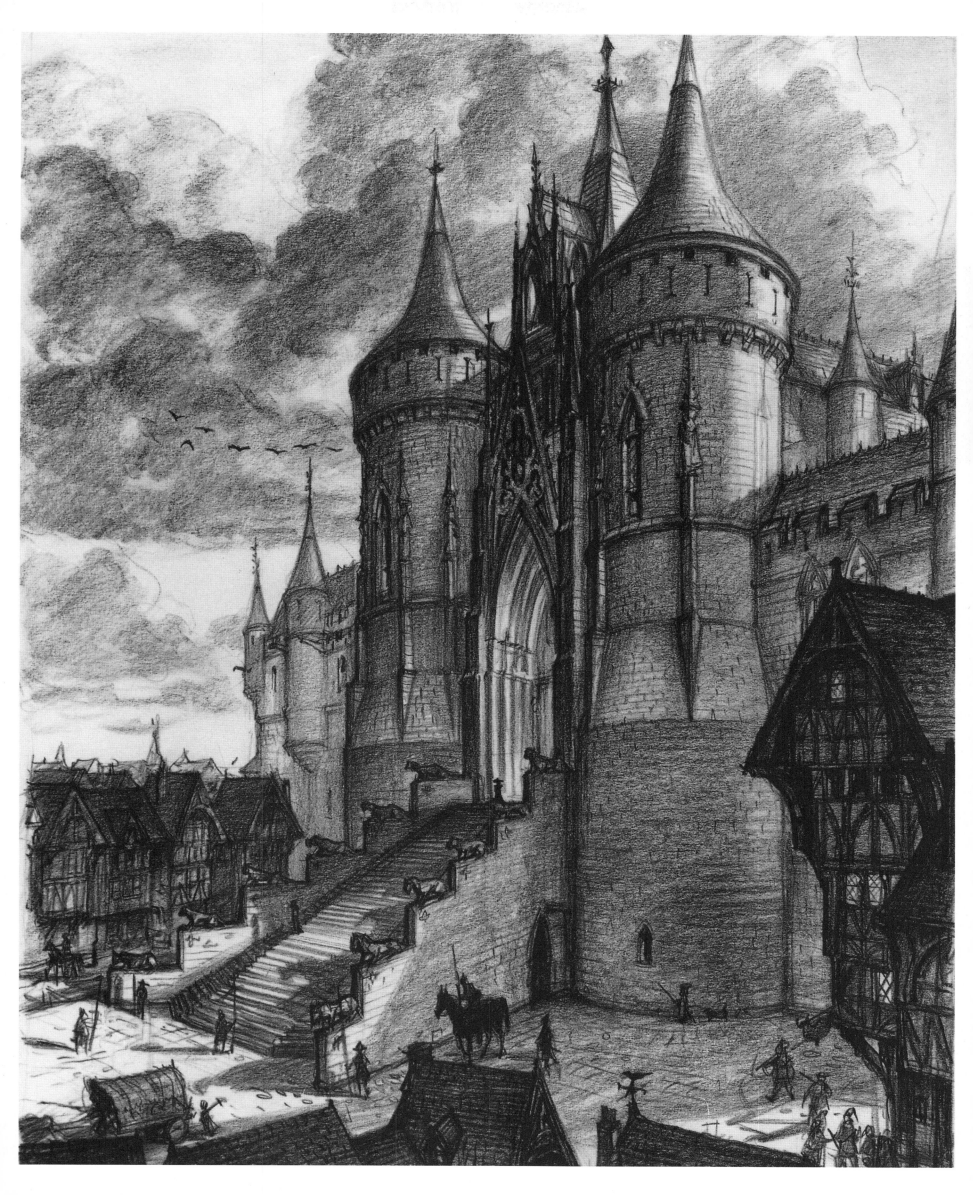

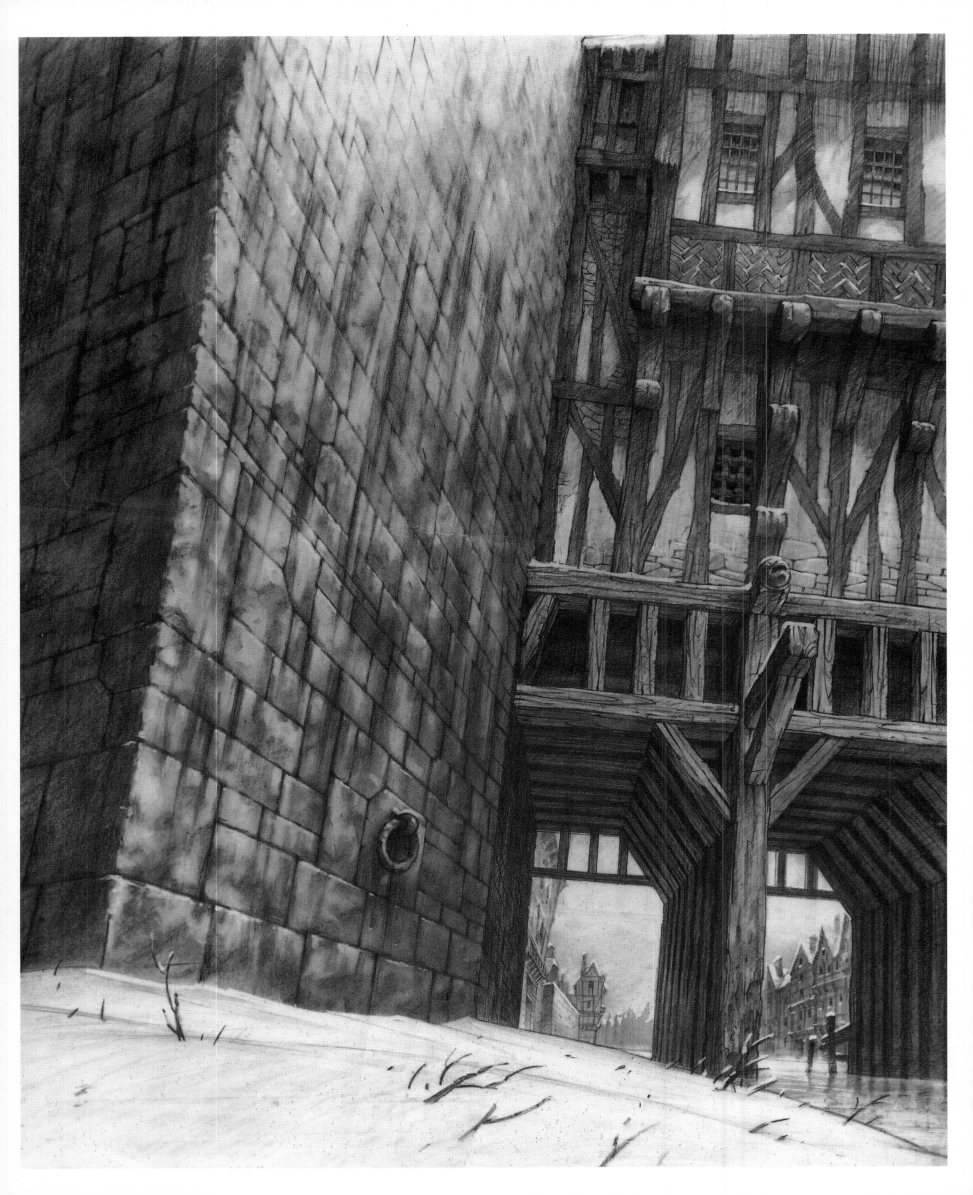

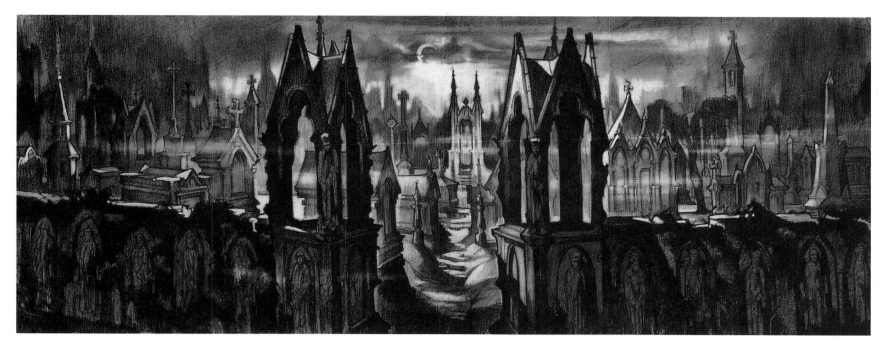

recalls, "Being able to climb the towers Hugo says Quasimodo lived in, to use the door Frollo supposedly walked in and out of every day," inspired the movie-makers to create a realistic medieval architectural environment complete with dust, grime, and edge. Given the number of *Hunchback* team members who had earlier worked together on the French medieval *Beauty and the Beast*, this approach marked a radical departure. Roy Conli asserts that the goal was not to alter what Disney had traditionally done best but to bring to the movie some of the incontrovertibly "French" world Hugo describes so passionately. "We definitely didn't want to do the 'picture book' version of the era." Kirk Wise describes the film's visual universe as "cyberGothic, as opposed to the manicured country club look that the medieval era has in *Sleeping Beauty*."

ABOVE: *Concept art by David Martin.*
BELOW: *Gargoyle concepts by Rick Maki.*
BELOW LEFT: *Concept art by Vance Gerry.*
OPPOSITE: *Layout art by Olivier Adam.*

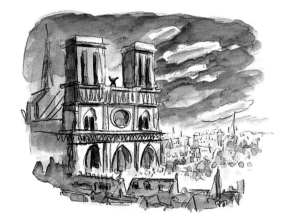

A Sublime and Majestic Building

o convey the impression of the cathedral's possessing as much life, attitude, and force as Hugo imagines in the novel required the Disney artists to make deliberate choices in terms of lighting, design, staging, and use of music. These choices make it seem as if the

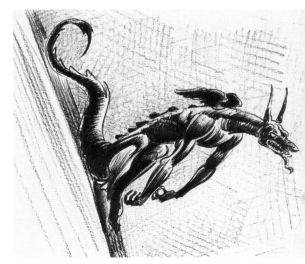

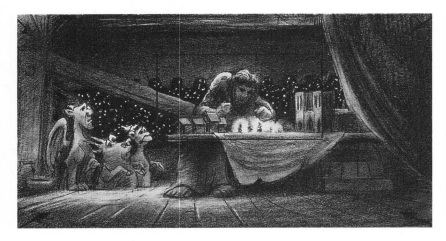
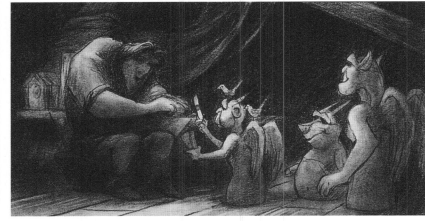
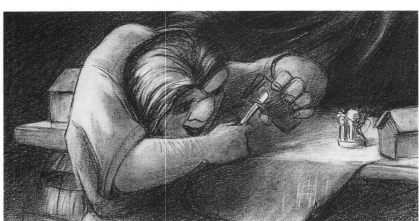
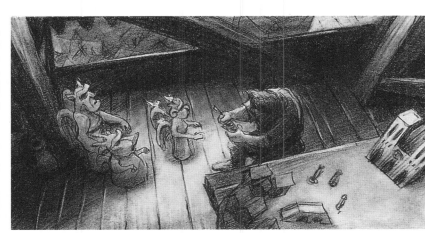

Snow is used to emphasize the chasm between Frollo and God by providing a cold atmosphere and an actual physical barrier between the character and the cathedral.

cathedral reacts differently to each character in the film. When Quasimodo navigates the belltower of Notre Dame, the only home he has ever known, the shadows cast by the cross beams and the filtered light that streams in from the Paris skies seem welcoming and encompassing. "The church embraces and nurtures Quasimodo," explains Kirk Wise. "This is contrasted with scenes where the eyes of the tall statuary of the saints in the cathedral seem to follow and glare reproachfully at Frollo, who sees the church as watching and judging him for his actions." Conversely, when Esmeralda enters the church, with wonder, respect, and perhaps a bit of fear, despite whatever her religious beliefs might be, the light through the stained glass windows seems to envelop and encourage her. And, in the conclusion, when Quasimodo must stave off the siege of the cathedral by Frollo's men, Notre Dame literally spits fire.

To underscore musically the power of such moments, the filmmakers went to Europe to record the peal of bells, choruses, and chants. To complete these moments visually, they relied on the subtle use of effects including special lighting, tonal shadows, dustbeams, fire and other elements to create an enveloping atmosphere for the characters. According to head of effects Chris Jenkins, "We're transmitting a feeling, translating a memory. The deep sense of spiritual awe we feel in the cathedral is only completed by the misty beams of light that wrap around Esmeralda's tentative footsteps when she first enters Notre Dame."

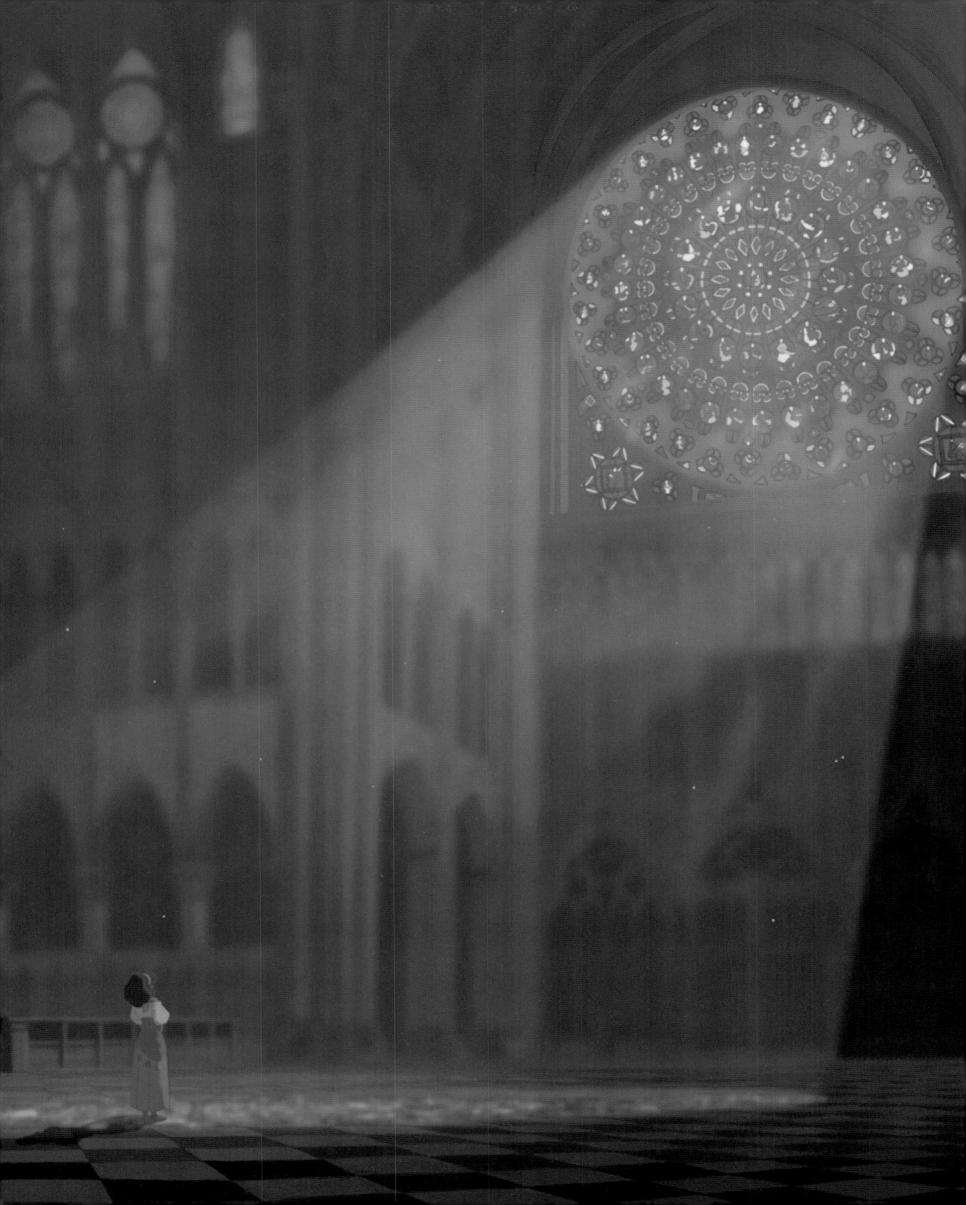

In the Gutters of Paris

For Hugo, Paris is also a living, breathing, complex character. If Notre Dame emanates the tranquillity, hush, and fortress-like quality of a sanctuary, the city on the street level pulses with the noise and squalor of the teeming masses, and the subterranean city below suggests the bottomless pit of Hell. On any level, Hugo's Paris lives. He pulls out the moody, Gothic stops in describing the lair of Frollo: It is a "dimly lit room. There were also a large armchair and table, compasses, alembics, animal skeletons hanging from the ceiling, a sphere lying on the floor, glass jars containing gold leaves, skulls lying on sheets of vellum covered with letters and figures, thick piles of manuscripts—in short, all the rubbish of medieval science and all covered with dust and cobwebs." By contrast, evoking the Palace of Justice he writes: "And right away, our ears are dinned and our eyes dazzled. Above our heads, a double Gothic vault, with carved wood paneling painted sky-blue with gold fleur-de-lys; beneath our feet, a pavement of alternate black-and-white marble." Setting the scene for Esmeralda's imprisonment in the catacombs below the Palace, he writes: "The further the stories of these prisons plunged into the ground, the narrower and darker they became; there were so many zones pervaded by different shades of horror. Dante was unable to find anything better for his hell."

The twisting streets and alleyways of medieval Paris suggest a labyrinth in direct contrast to the cathedral. Layout supervisor Ed Ghertner, who handled the same assignment on *Beauty and the Beast*, asserts that he and his collaborators "went after a dramatic, almost film noir quality to the environs surrounding the cathedral. Through lighting, camera angles, and shapes, we wanted to convey the impression that this was a very tough place in which to survive—too many people, too little space, too little money. You'd have to go to Notre Dame to escape the clamor of the streets."

The layouts and backgrounds designed for the film subtly convey a no-way-out claustrophobia, which serves as an apt visual equivalent for a society stratified by convention, social rigidity, feudalism, or by fate. This

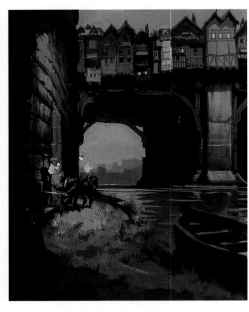

ABOVE: *Concept art by David Goetz.*
TOP: *Concept art by Marek Buchwald.*
OPPOSITE: *The low angle of this shot, coupled with narrow depth of field and smoke turbulence effects created on the Computer Animation Production System (CAPS), helped convey a feeling of claustrophobia and griminess in the Paris streets. Production still.*

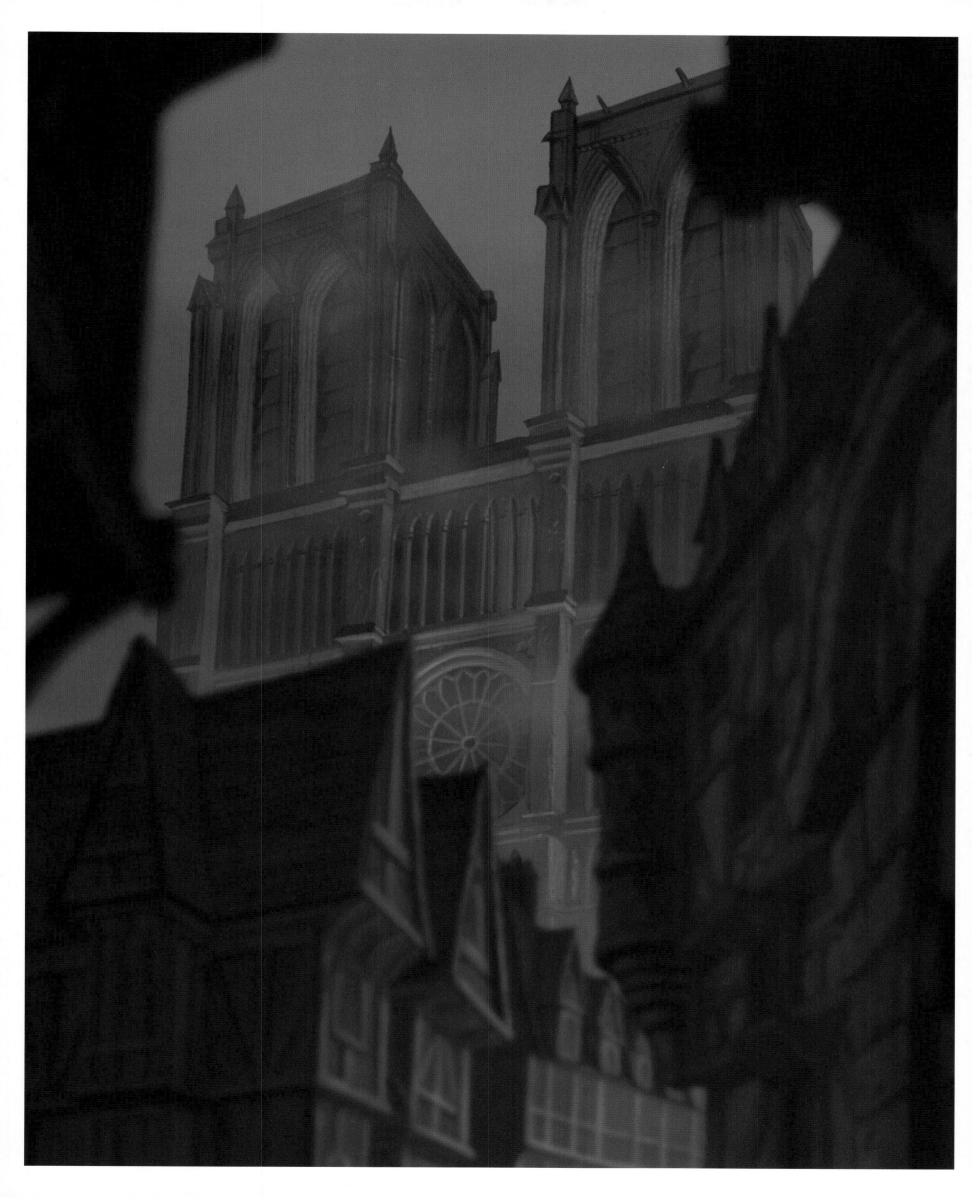

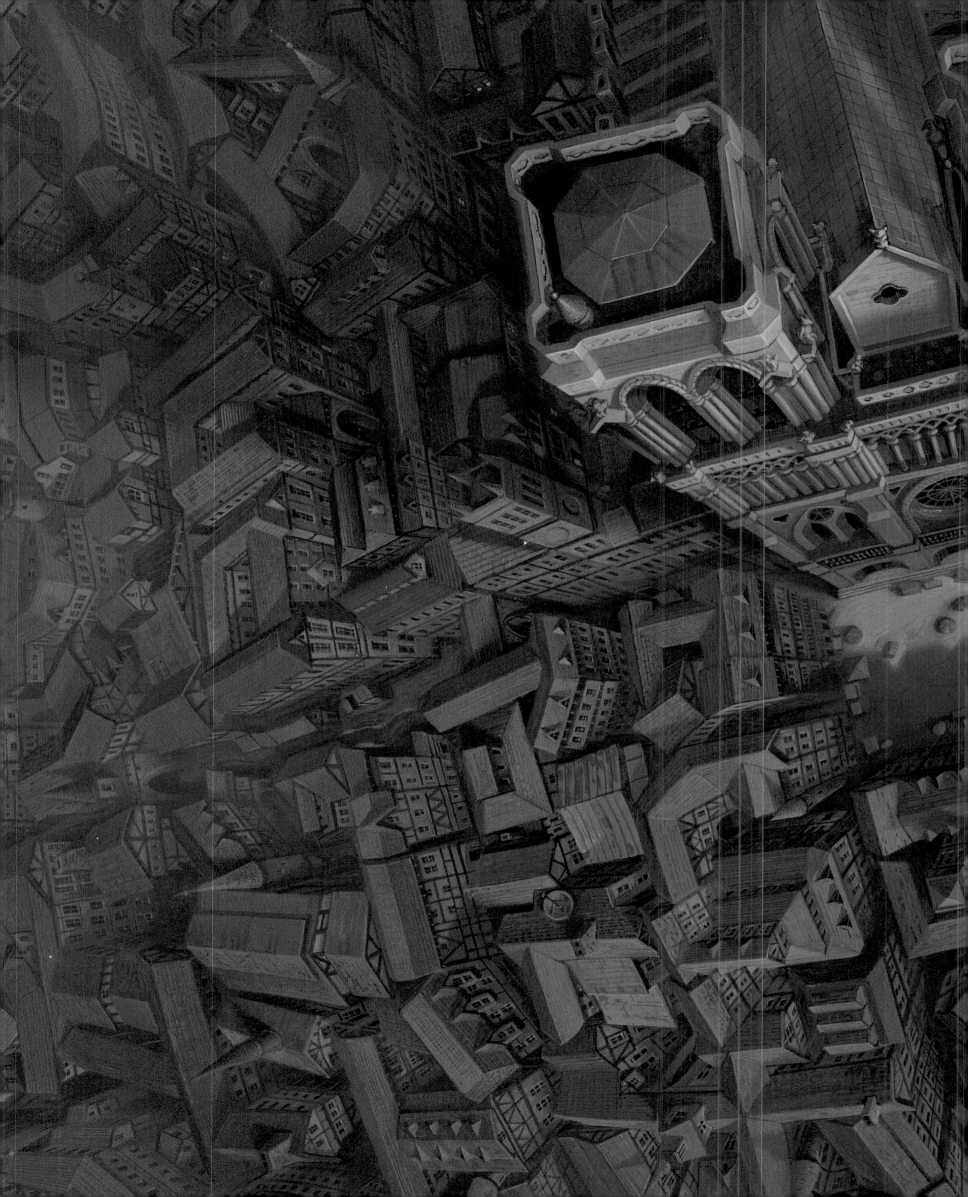

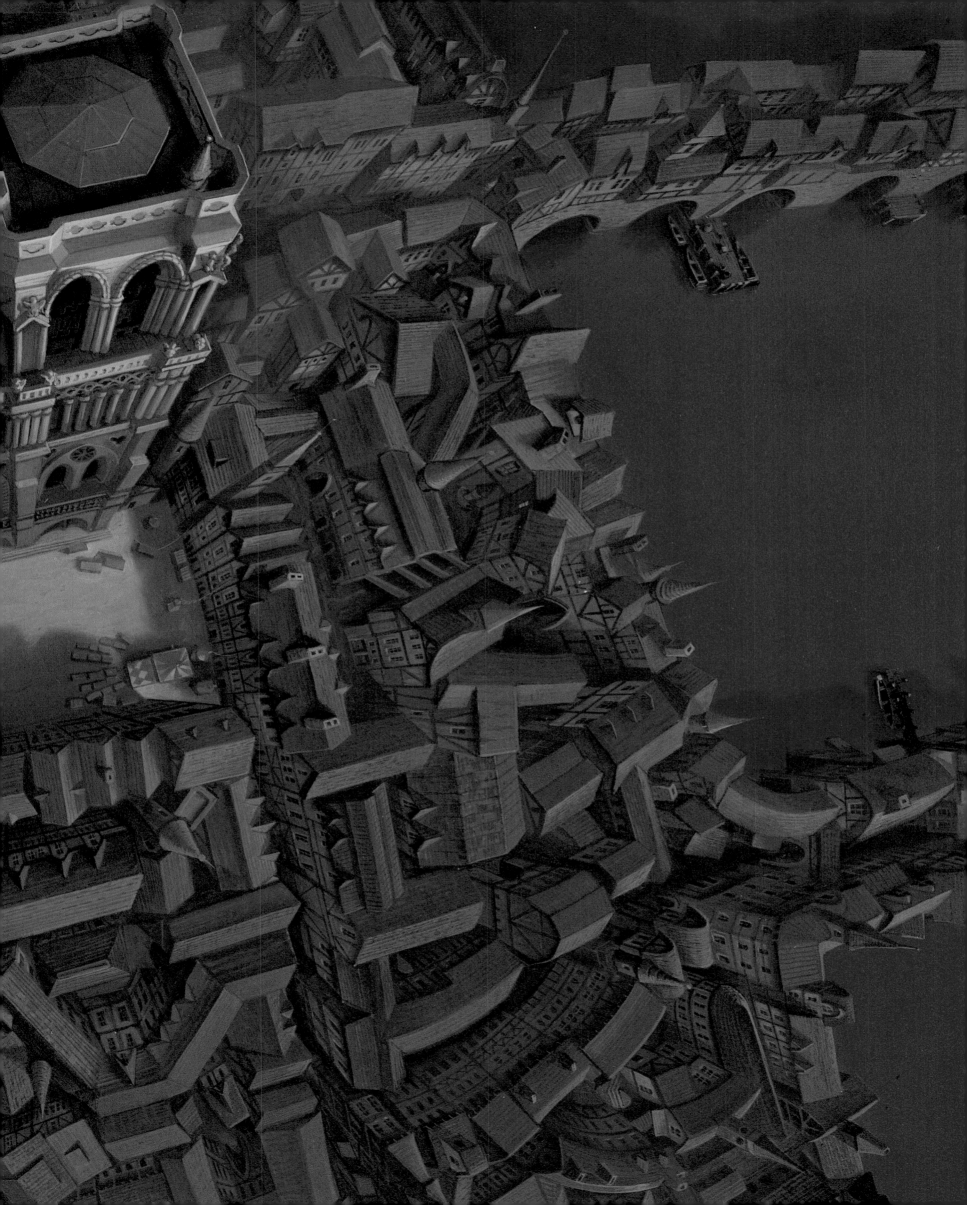

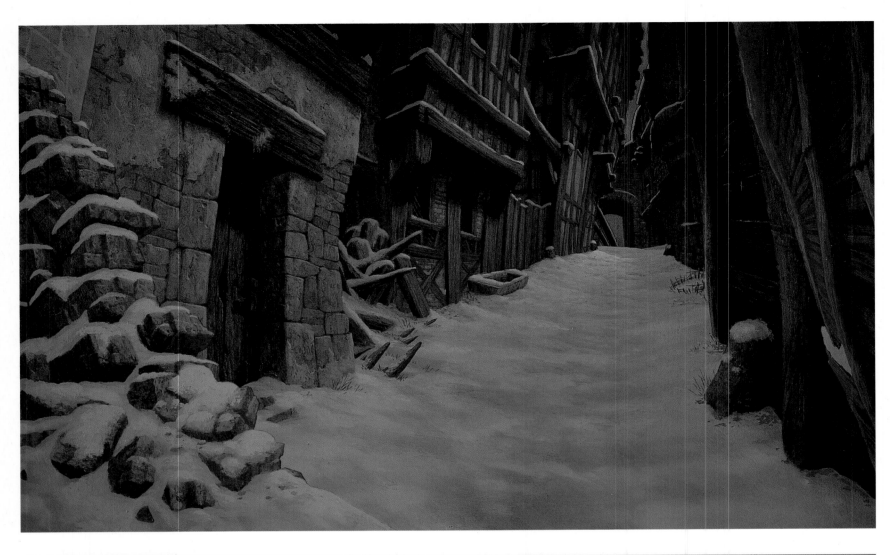

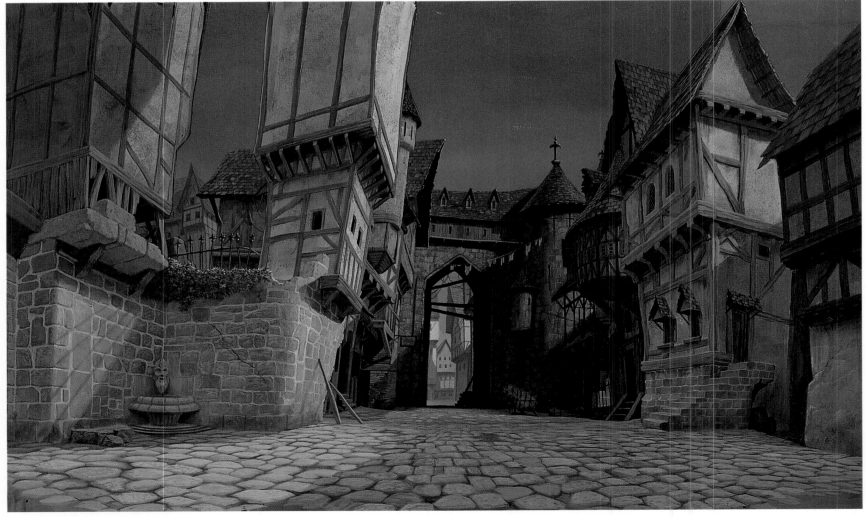

114

effect is achieved in part by accenting the thrusting verticality of Notre Dame and of Paris itself, a stylistic approach that was inspired and informed by Hugo's notion of Heaven awaiting among the clouds, Hell yawning directly beneath the feet of the everyday man, and the half-angel, half-devil known as Quasimodo existing between the two. Art director David Goetz collaborated closely with layout department supervisor Ed Ghertner and with background department supervisor Lisa Keene on stressing the verticality of the architecture to convey what he calls "a feeling of 'urban medieval,' not 'village medieval.' Paris, in that time, while beautiful in many ways, was also a hard, unyielding environment that reinforced to the average man and woman on the street what their place in society was." By increasing the height of the buildings to six or seven stories tall, the Paris streets were made to feel more claustrophobic and forbidding. Similarly the layout artists increased the scale of the cathedral to enhance the feeling of the building's weight and presence. This quality is also played out in the angularity or vertically "stretched" design aspects of such characters as Frollo, Esmeralda, and Phoebus. On the other hand, what computer generated imagery (CGI) supervisor Kiran Joshi calls the "angular, somewhat inflated, saggy, squared-off look of the citizenry of Paris" tempers the dominance of vertical lines.

BELOW: *Background art by Fred Warter, Kathy Altieri, and David Goetz.*
OPPOSITE ABOVE: *Background art by Oliver Besson.*
OPPOSITE BELOW: *Background art by Greg Drollette.*
PRECEDING PAGES: *Background art by Mike Humphries.*
OVERLEAF: *Layout art by Tom Shannon.*

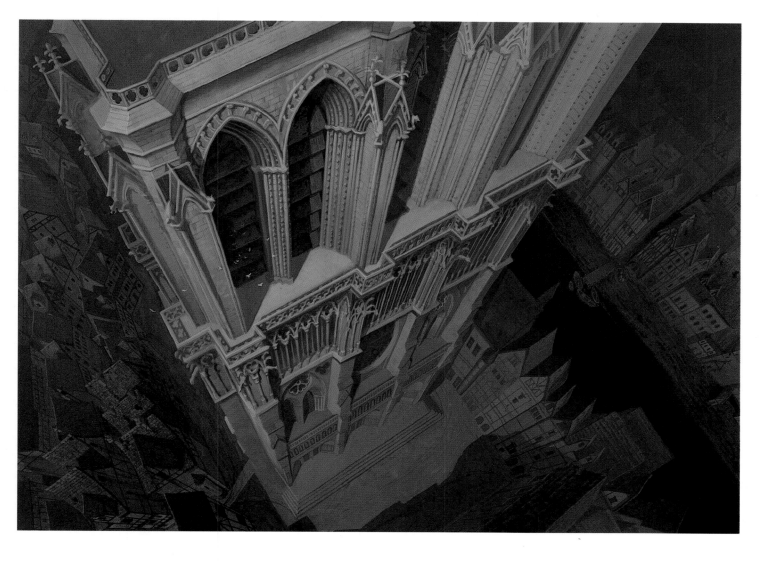

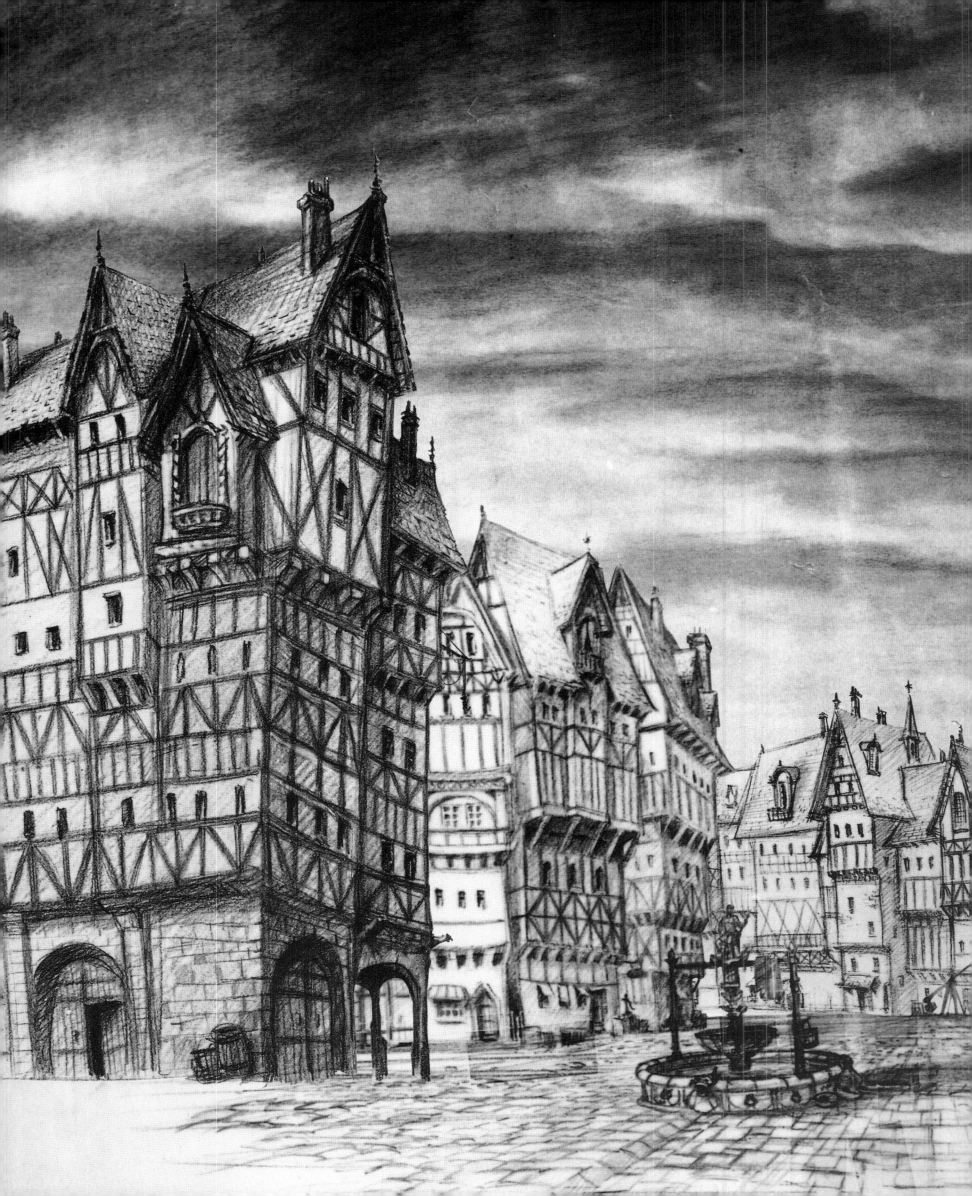

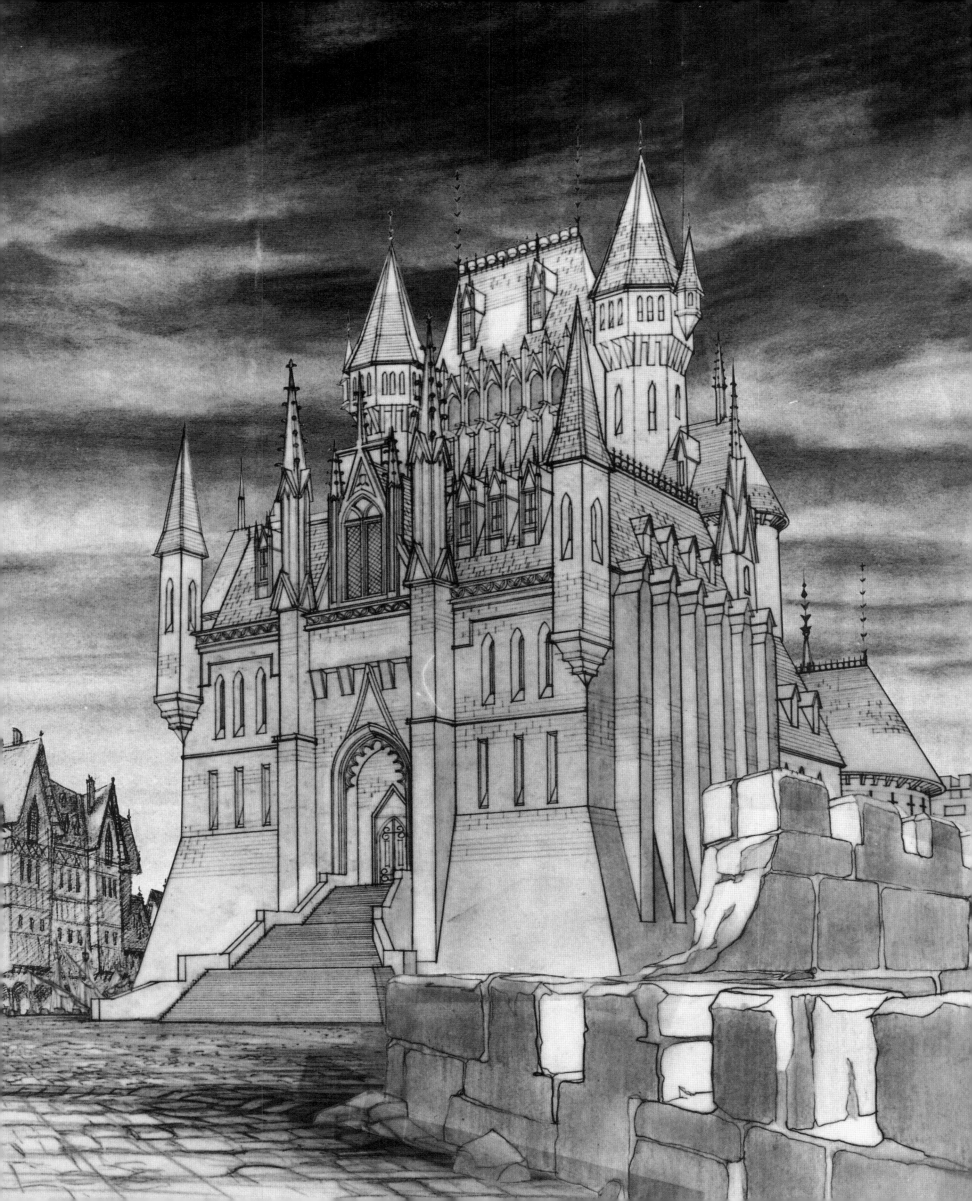

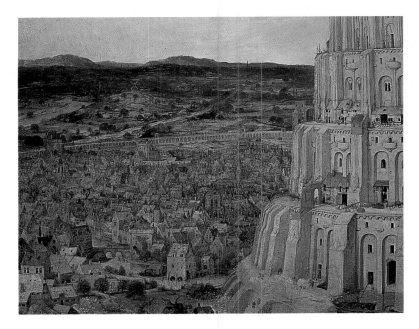

RIGHT: *Detail of* The Tower of Babel *by Pieter Breughel, 1563.*
OPPOSITE: *Development art by Mike Humphries.*

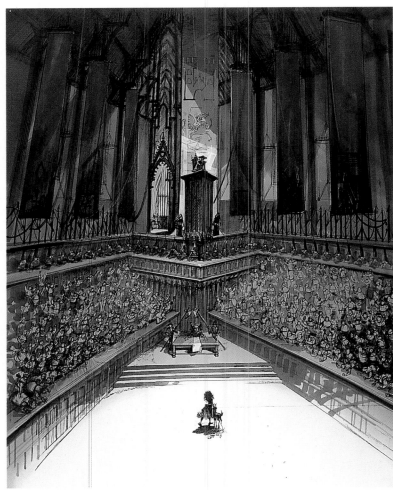

ABOVE: *Etching by Gustave Doré for Book V of* Gargantua and Pantagruel, *by François Rabelais. The book was originally published in 1864.*
ABOVE RIGHT: *Development art by Darek Gogol.*

Throughout the film's production, the walls of the filmmakers' offices and the hallways of the Disney Feature Animation Building were lined with inspirational artwork that included illustrated and photographic depictions of Notre Dame and the city as well as prints of pages from medieval illuminated manuscripts. Also on display were lithographs of paintings by early 20th-century artists showing strong raking lights and shadows, illustrations by Gustave Doré, explosively solitary landscapes of Pieter Breughel, moody Canaletto cityscapes, and the brush-sketch impressionism of Edouard Manet.

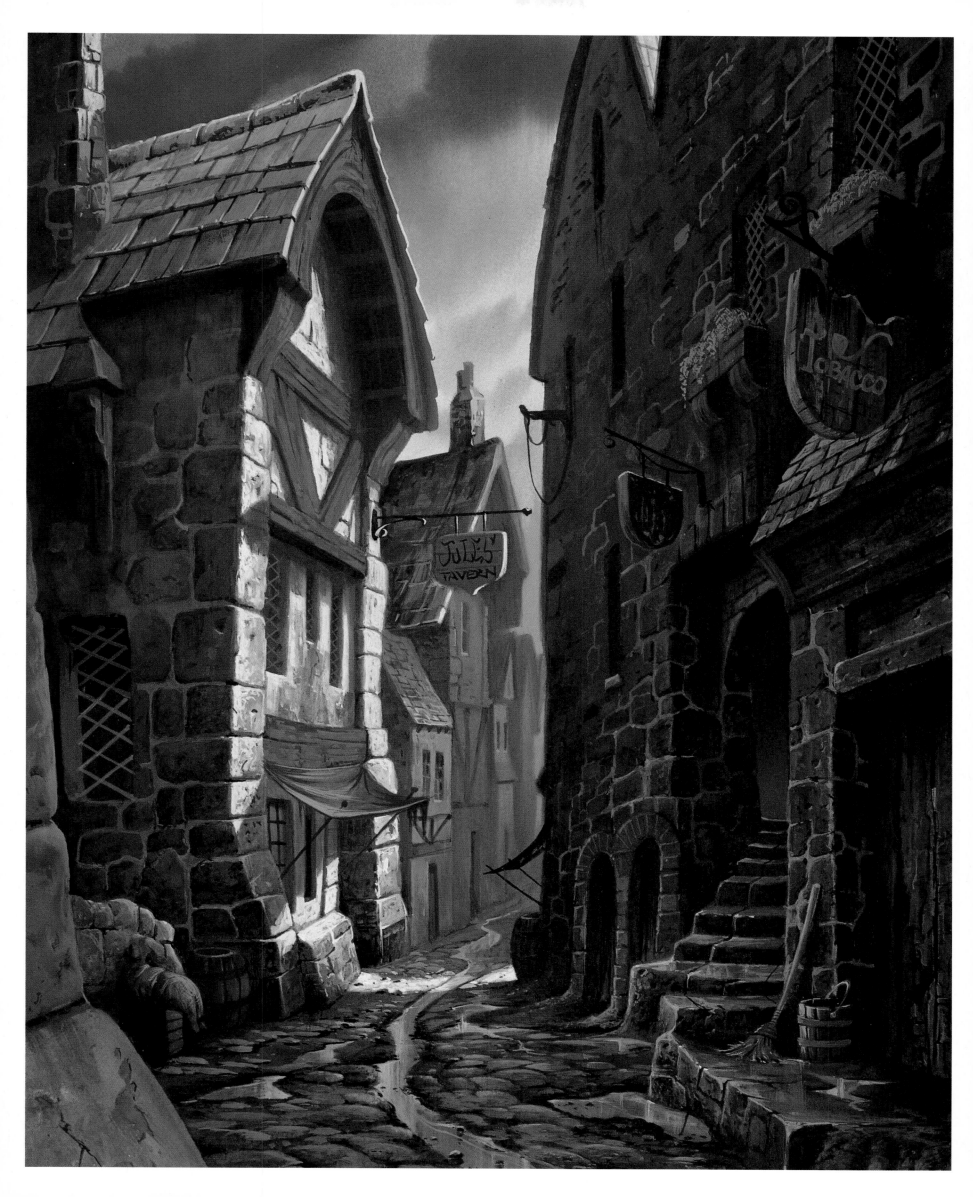

ABOVE: *Le Bourg et le Château de Vianden by Victor Hugo, 1857.*
BELOW: *Layout art by Dave Martin.*
OPPOSITE: *Production still.*

While many of the works displayed dramatic composition, expressive use of light and shadow, and a somber radiance, David Goetz singled out Victor Hugo's paintings as particularly inspirational, "for their brooding, almost macabre graphic quality. In our movie, Hugo's forces of darkness lurk everywhere, so even the buildings, shops, and houses convey a sense of melancholy and impending dread along with their warmth." Lisa Keene declared that the artists of the layout and background departments found particular challenge in the chance "to create the mood, ambience, lighting for the sets that would accentuate Victor Hugo's light versus dark struggle that runs throughout the movie." One artistic means by which to convey this struggle was to juxtapose blacks and heavy dark colors against light colors. Ed Ghertner comments, "Where *Beauty and the Beast* lived in un-reality, *The Hunchback of Notre Dame* is moody and extreme, and lives in a world of reality. Everything is so architectural, we even used computer techniques to replicate the diamond-shaped stonework in the interior walls of the cathedral, so that we don't have to sit there and laboriously draw it." The highly detailed environment and "world" of the movie suggests the unrelenting grittiness of Victor Hugo meeting the golden-hued, welcoming craftsmanship of *Snow White and the Seven Dwarfs* and *Pinocchio.*

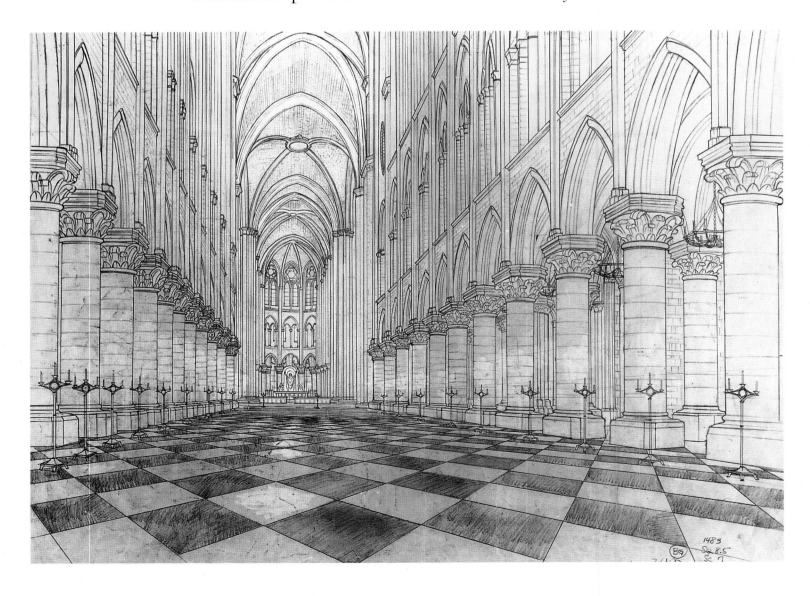

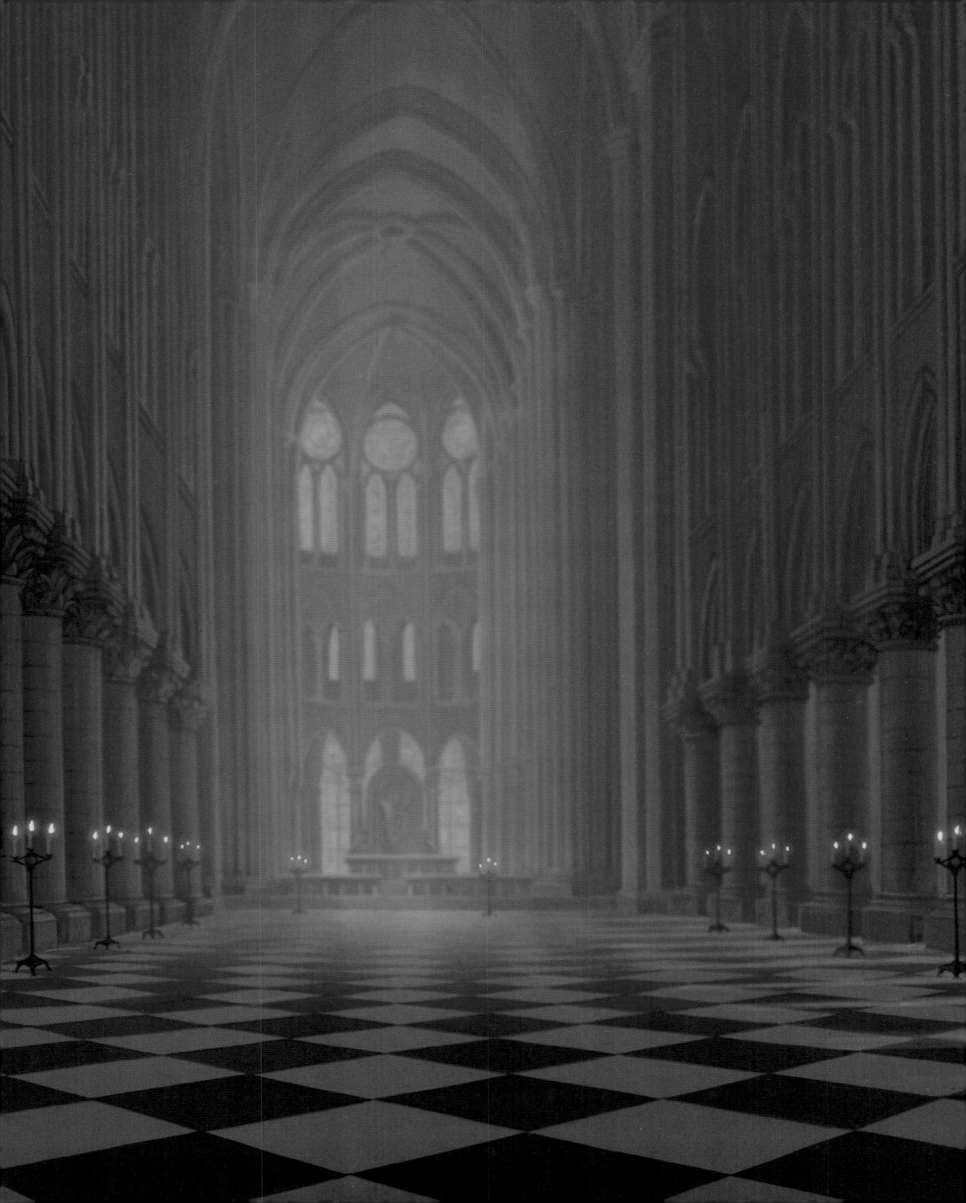

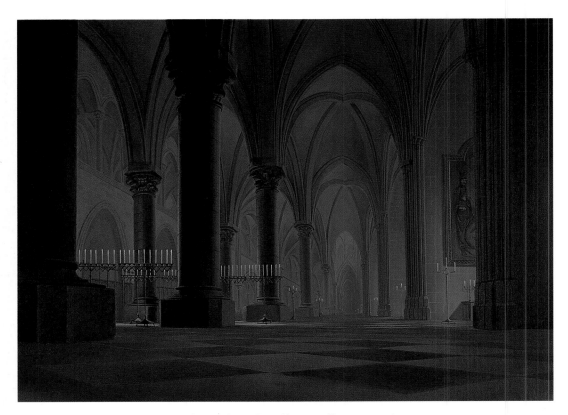

Background art by Allison Belliveau-Proulx.

Saving Notre Dame

Color key by Doug Ball and David Goetz.

The elaborate, quintessentially Gothic descriptions of the cathedral of Notre Dame signal Hugo's intent to create events of operatic scope and to set an epic stage against which to play them. However, these descriptions were also meant to deliver a polemic and to fight an aesthetic crusade. Tastemakers and aestheticians of Hugo's day tended to prefer Romanesque architecture or Classicism to Gothic architecture, the latter style perceived by many to epitomize lack of sophistication and crude vulgarity. Because of this perception, many Gothic structures were either being razed or architecturally diluted.

For Hugo, however, the Gothic spirit and the idea of Romanticism were synonymous. In personifying and making 'human' the cathedral, Hugo's literary style imitates and praises the Gothic, a form of architecture which, for Hugo, represents the common man, caprice, hope, freedom, even rebellion. In his view, the Gothic arch was anti-authoritarian and populist where the rounded Romanesque arch was imposing, oppressive, even tyrannical. His introduction to *Notre-Dame de Paris* sends out this rallying cry: "Let us, if possible,

inspire the nation with the love of national architecture. That, the author declares, is one of the principal objects of this book; that, one of the principal objects of his life."

No structure benefited more from Hugo's preservation campaign than Notre Dame itself. This monument to God, described by Hugo as "a vast symphony of stone" and "the aged queen of French cathedrals," represents, alongside the other cathedrals of Europe, the highest aspirations and greatest achievements of its age. In 1163, Pope Alexander III blessed the first cornerstone for Notre Dame, "Our Lady." Never actually completed, the cathedral, built on the Ile de la Cité, required two hundred years and the combined skills of thousands to build. The necessary funds came from the large portion of France's wealth which from the middle of the 11th century to the middle of the 14th was dedicated to the Virgin.

The cathedral was not only a center for pilgrimage but also housed, at times in its history, a library, a morgue, a museum, a burial chamber, an art gallery, a stage and an auditorium. To step into it today is to feel humbled, awestruck, on the threshold of the infinite. Once inside Notre Dame, the outside world falls away, and contemplation of the inner world, the life of the spirit, begins. The overwhelming impression of darkness and gloom is relieved by the famed stained glass rose window, the intent of which is to create awe and spiritual uplift in the beholder. To citizens of the Middle Ages, the rose window, due in part to its elegant geometry and symmetry, marked the purest, most artistic expression of the stained glass window. Such windows symbolized mankind's desire to attain order and coherence; a

Layout art by Scott Caple.

rose window represented a veil, a prism through which God's light and the hereafter could be glimpsed by man.

Hugo's intervention in the fate of Gothic architecture came none too soon. Baroque modernizations in the style of faux imperial Rome had already destroyed much of the harmony of the original designs. But, even among those who cared little for the novel, *Notre-Dame de Paris* sent out such a forceful wake-up call for architectural integrity that the citizenry and influential city planners came to revere and actively champion the preservation and restoration of the city's pre-Renaissance buildings. Hugo, who was active in a conservancy drive that led to ordinances forbidding the demolition or alteration of such historical landmarks, came to be called the "initiator and the prophet of architectural preservation."

From 1845 to 1864, thanks largely to Victor Hugo and *Notre-Dame de Paris*, the cathedral was radically and painstakingly restored by Jean-Baptiste Lassus and Eugène Viollet-le-Duc.

IV.

Shadow and Light

"Hugo created a cinematic language of light and shadow which we re-created on screen. Describing a shaft of light as it passed through stained glass, or the twisted soul inside Frollo's upright pious body, he metaphorically invoked the paradoxes he imagined existed in Quasimodo's world. There evil masquerades as good, and ugliness conceals hidden depth of spirit."

—CHRIS JENKINS, Head of Effects

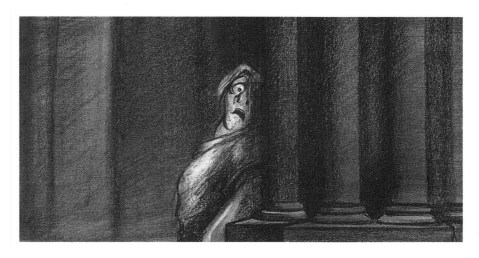

ABOVE: *Storyboard art by Paul Brizzi and Gaëtan Brizzi.*
OPPOSITE: *Production still.*

ntithesis fascinated Hugo. The visual and moral scheme the novelist laid out in *Notre-Dame de Paris* hinges on contrast. In describing a character's plight, the novelist, for instance, writes: "He was about to be trapped between fire and water." He also contrasts "the shouting and the laughter and the tramp of thousands of feet" with the reverential hush of the interior of the cathedral. The dizzying heights of the belltower scaled by Quasimodo demand the contrast of the narrow, twisting streets below. Just before the siege on the cathedral, Quasimodo stares out uneasily over a dark city because "in those days, the city was scarcely lighted at all," then, "an instant later seven or eight torches were shaking their tufts of flame in the darkness." The surface normalcy, power, and respectability of Claude Frollo, "a man of some distinction," hides a twisted, deformed soul. The murkily mysterious Court of Miracles,

125

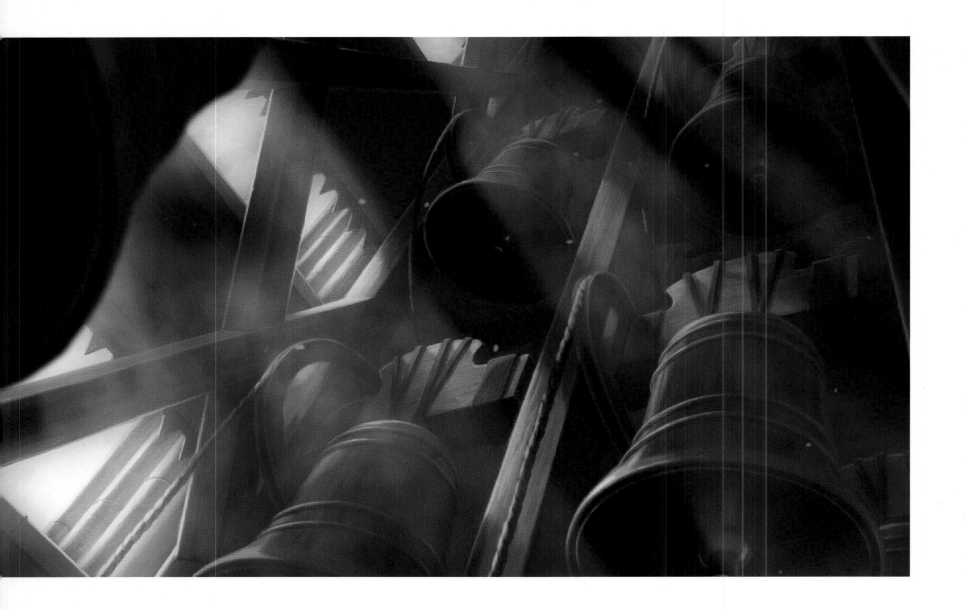

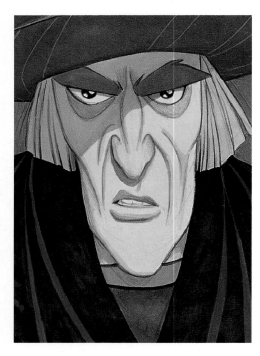

the lair of thieves, charlatans, and lowlifes, may in fact be "no more than a tavern, but a tavern of brigands, as red with blood as with wine." In the Court of Miracles, the clash between appearance and reality is particularly potent. There the apparently blind are revealed as fully-sighted fakers. Amputees who beg by day, once in the seclusion of the Court, suddenly sprout legs hidden under their garments; pitiful "sores" miraculously heal with a splash of water and soap. Hugo, in the climax of the story, appears to take special delight in pitting the fiery, almost Satanic glow of peasants' torches against the black sky and silhouette of the cathedral. In describing the interior of the cathedral, Hugo writes, "In the depths of the darkness, there twinkled the great cross of silver, scattered with a few points of light, like the Milky Way of this sepulchral night. Above the black drapes the tips of the tall lancet windows of the choir showed and a ray of moonlight, passing through the stained glass, lent it the doubtful colors of the night."

This richly conceptualized, consistent image system inspired the Disney moviemaking team to create a universe of darks and lights. The key design motif in the film is the straight shaft of light, which can be glimpsed

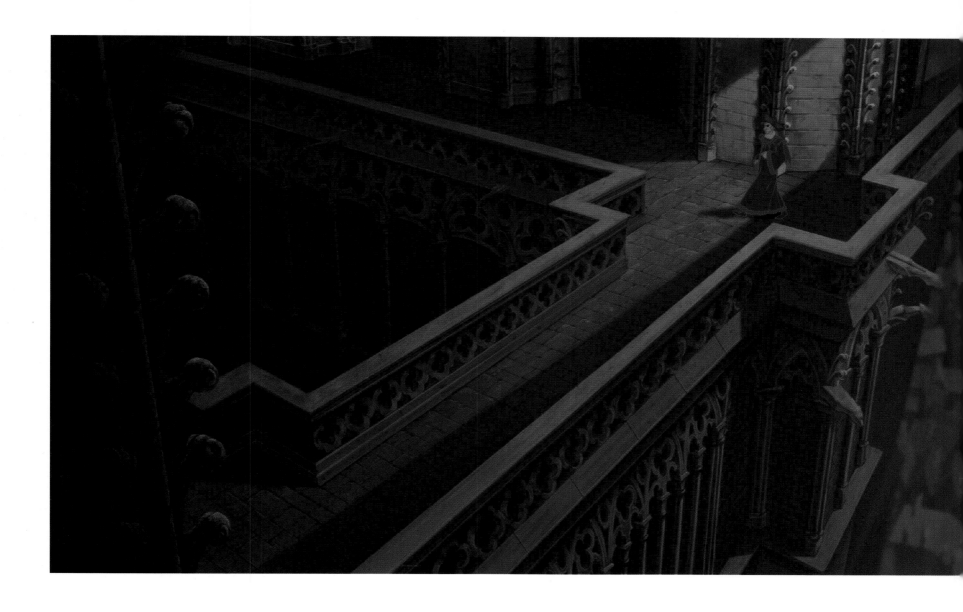

pouring through the stained glass windows of the cathedral, and through the beams of the belltower where Quasimodo lives. Significant action from scene to scene involves a character walking into or out of the light. "In a cathedral or very old building you don't really see shadows move over you, but you can feel them," says head of effects Chris Jenkins. "We want the audience to feel the play of light over the characters just as if they themselves were walking through that environment."

Paris-based Paul Brizzi and his brother Gaëtan not only led the French unit during production of the film, the storyboards they created for several sequences, including the prologue and "Heaven's Light/Hellfire," influenced the production strongly. Paul Brizzi asserts that he and his brother "saw the movie in terms of 'monochromatic color,' which is why we put long shadows into the boards that complement the black mood of the book." Gaëtan Brizzi likened the mood and look they sought to achieve to black-and-white, Hollywood movies of the 1940s, "in which light was used to dramatize and heighten the characters, situations, and themes."

The light and shadow motif was also informed by the moviemakers' research trips to Paris. At the Bibliothèque Nationale, the creative team

ABOVE: *Value study by Tom Shannon.*
TOP: *Effects animation by Philip Vigil.*
OVERLEAF: *Storyboard art by Paul Brizzi and Gaëtan Brizzi.*

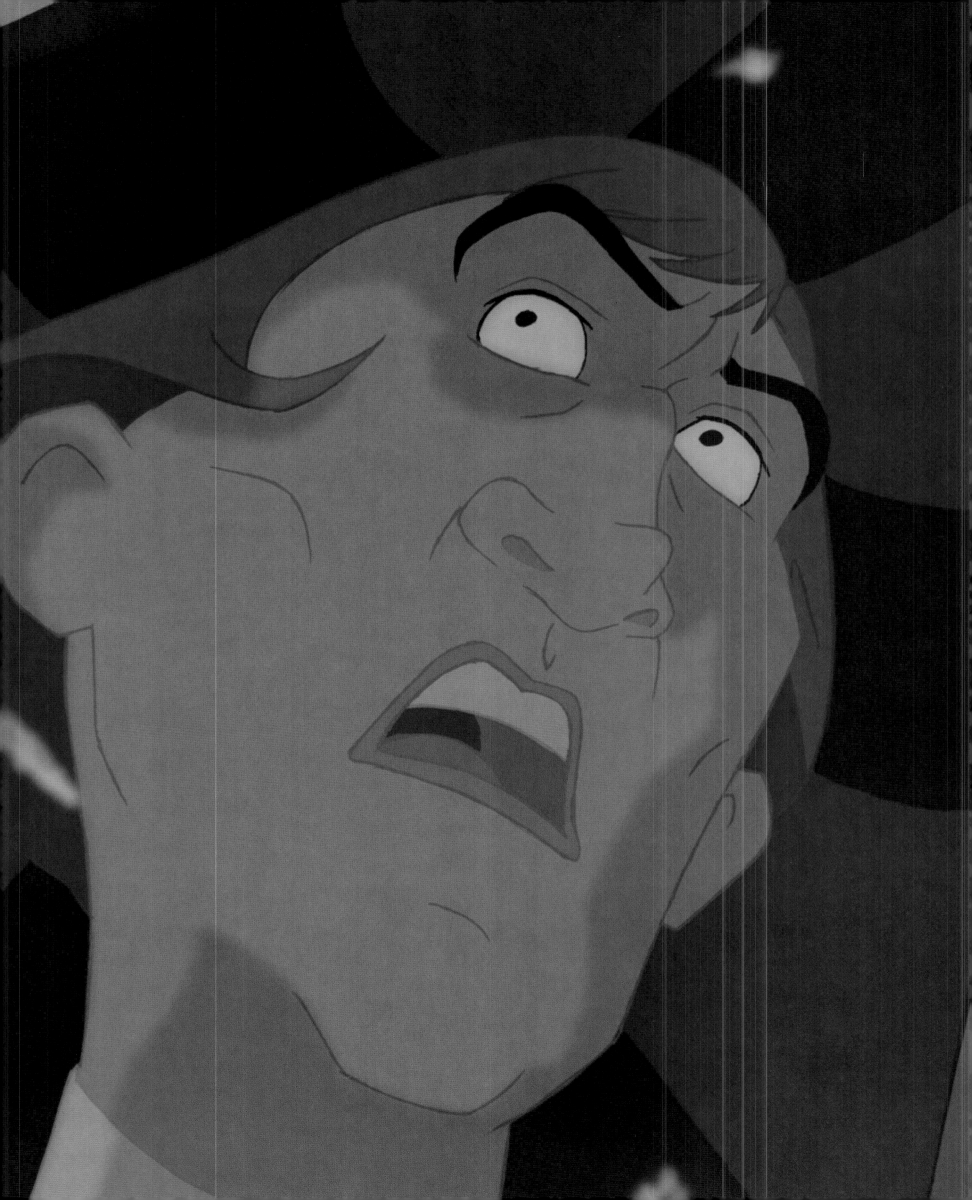

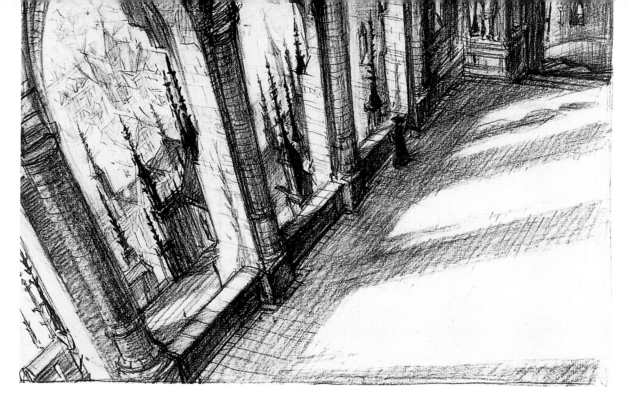

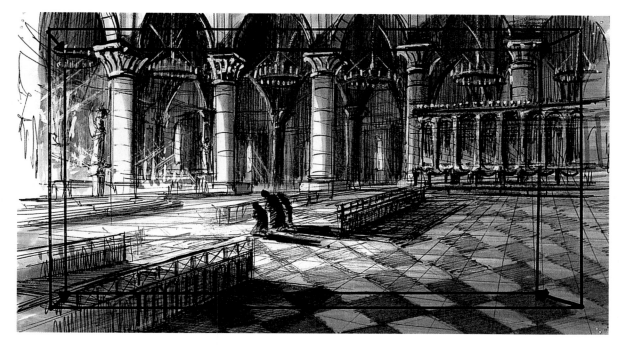

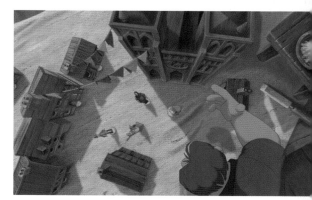

studied images by Victor Hugo himself as well as 19th-century illustrator Gustave Doré. "All of the images were strong graphic statements and had the same kind of raking lights and darks that we had already been experimenting with," David Goetz enthused. "Because we wanted to honor Hugo's legacy, I remember looking at those illustrations and thinking, 'We're on the right track.'"

For *The Hunchback of Notre Dame*, the moviemakers worked to approximate the impression of direct light casting shadows on and over objects. They also wanted to immerse audiences in an environment that evokes a cold, often rainy European city. Striving for what Goetz calls "duality everywhere," the artists attempted to achieve what he terms "'the symbolic landscape,' or a 'visual subtext' because we tried to catch the feeling in the lights and darks and in the architecture, of what is going on, symbolically, in the narrative."

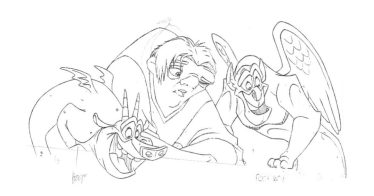

Light and Levity

The essential darkness of Hugo's tale presented a challenge to the filmmakers, who sought to balance the highly dramatic tone of the story with moments of emotional light. According to Thomas Schumacher, the decision to make humor an important part of the story begins with Quasimodo and his own lust for life: "The directors brought a level of wit and charm that acknowledges Quasimodo's compassion and humanity. By allowing us to laugh with him we see he's a complete person, not just a figure of fear."

As an expression of Quasimodo's humor, directors Trousdale and Wise suggested making the gargoyles of Notre Dame into friends and confidantes for him. The directors' notion of talking gargoyles is, in some ways, suggested by Hugo in the novel: "The other statues, the ones of monsters and demons, felt no hatred for Quasimodo. . . . The saints were his friends and blessed him; the monsters were his friends, and protected him. Thus he would pour out his heart at length to them."

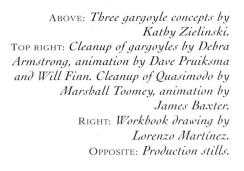

ABOVE: *Three gargoyle concepts by Kathy Zielinski.*
TOP RIGHT: *Cleanup of gargoyles by Debra Armstrong, animation by Dave Pruiksma and Will Finn. Cleanup of Quasimodo by Marshall Toomey, animation by James Baxter.*
RIGHT: *Workbook drawing by Lorenzo Martínez.*
OPPOSITE: *Production stills.*

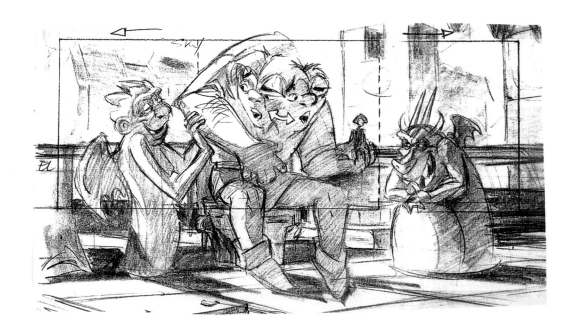

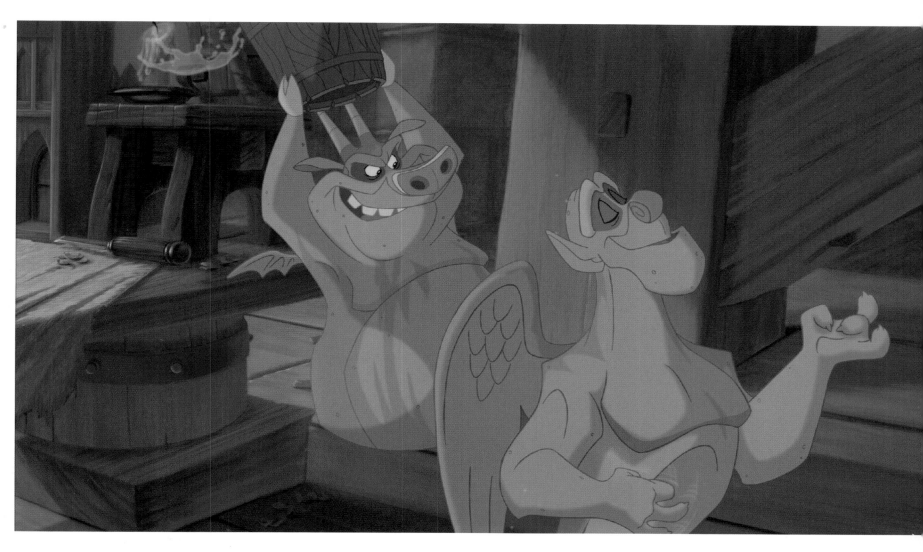

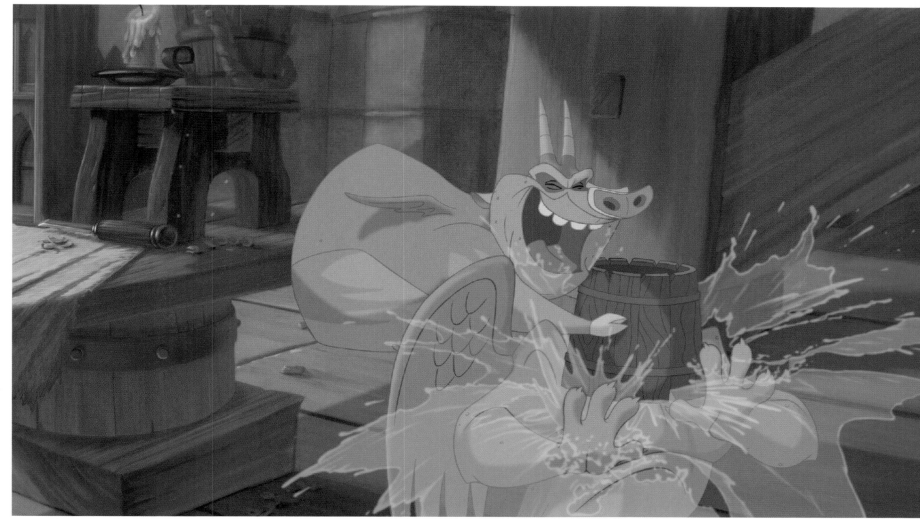

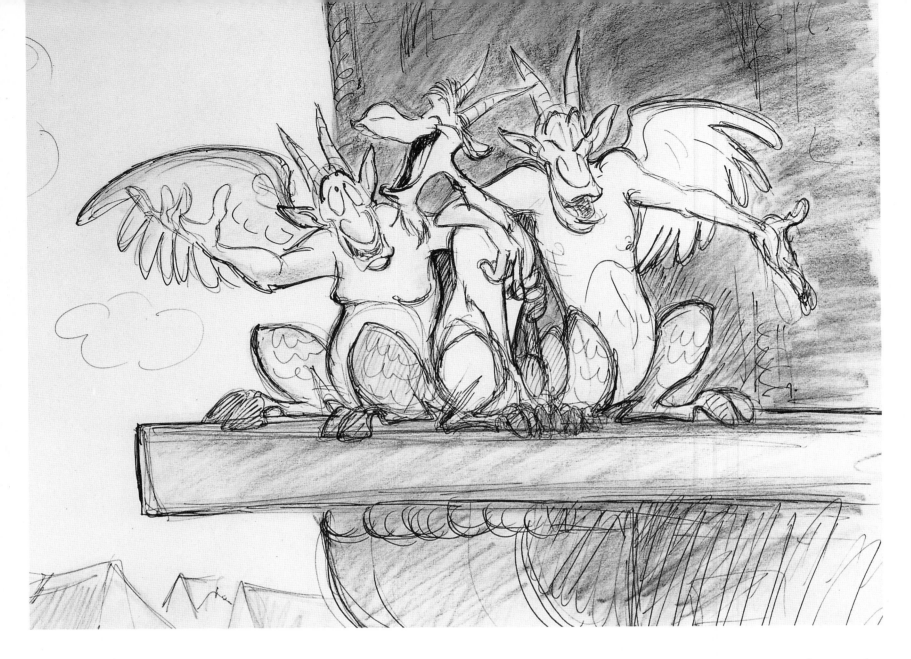

Imparting an element of fantasy very much in the Disney tradition, the gargoyles, says supervising animator Dave Pruiksma, are "the fantasy glue that holds together the film and helps tell the story with humor and lightness." Yet, the moviemakers made a conscious choice not to have real magic; instead they envisioned the gargoyles as creatures of Quasimodo's imagination. Will Finn, who headed the story department and, later, acted as supervising animator for Laverne, the salty elder stateswoman of the three, likens the trio to *Pinocchio*'s Jiminy Cricket because "they express aspects of Quasimodo's inner conscience: one, the wild side that wants to go out there and do crazy things, another the straight-shooting, wisdom side, the third the stiff stuffed shirt side."

ABOVE AND RIGHT: *Gargoyle concept art by Geefwee Boedoe.*
TOP: *Concept art by Will Finn.*
OPPOSITE: *Concept art by Thom Enriquez.*

The crazy side is expressed in "A Guy Like You," sung by the gargoyles to cheer and embolden the dispirited Quasimodo in his misguided pursuit of Esmeralda. As his three muses try to cheer Quasimodo into thinking Esmeralda will soon return to the belltower, they

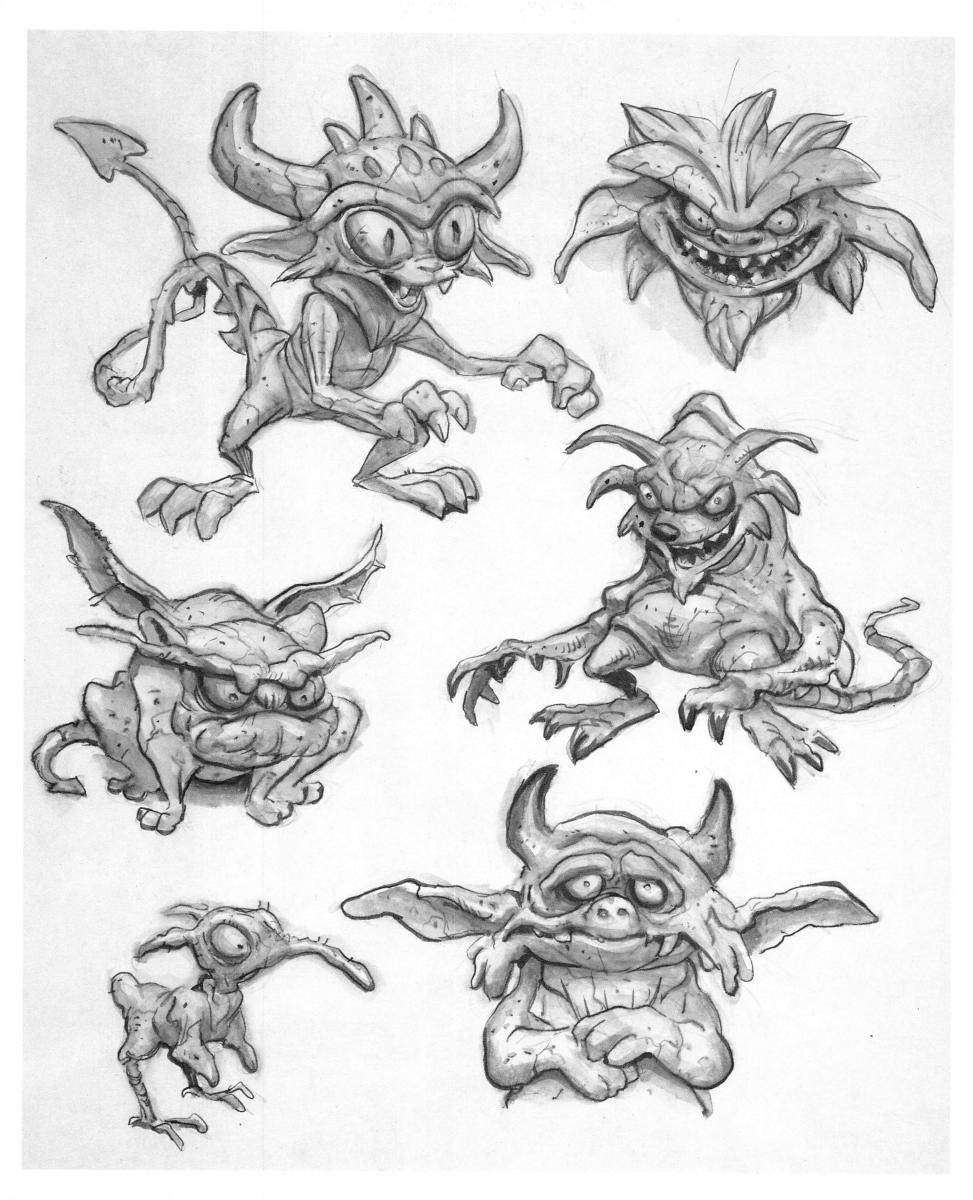

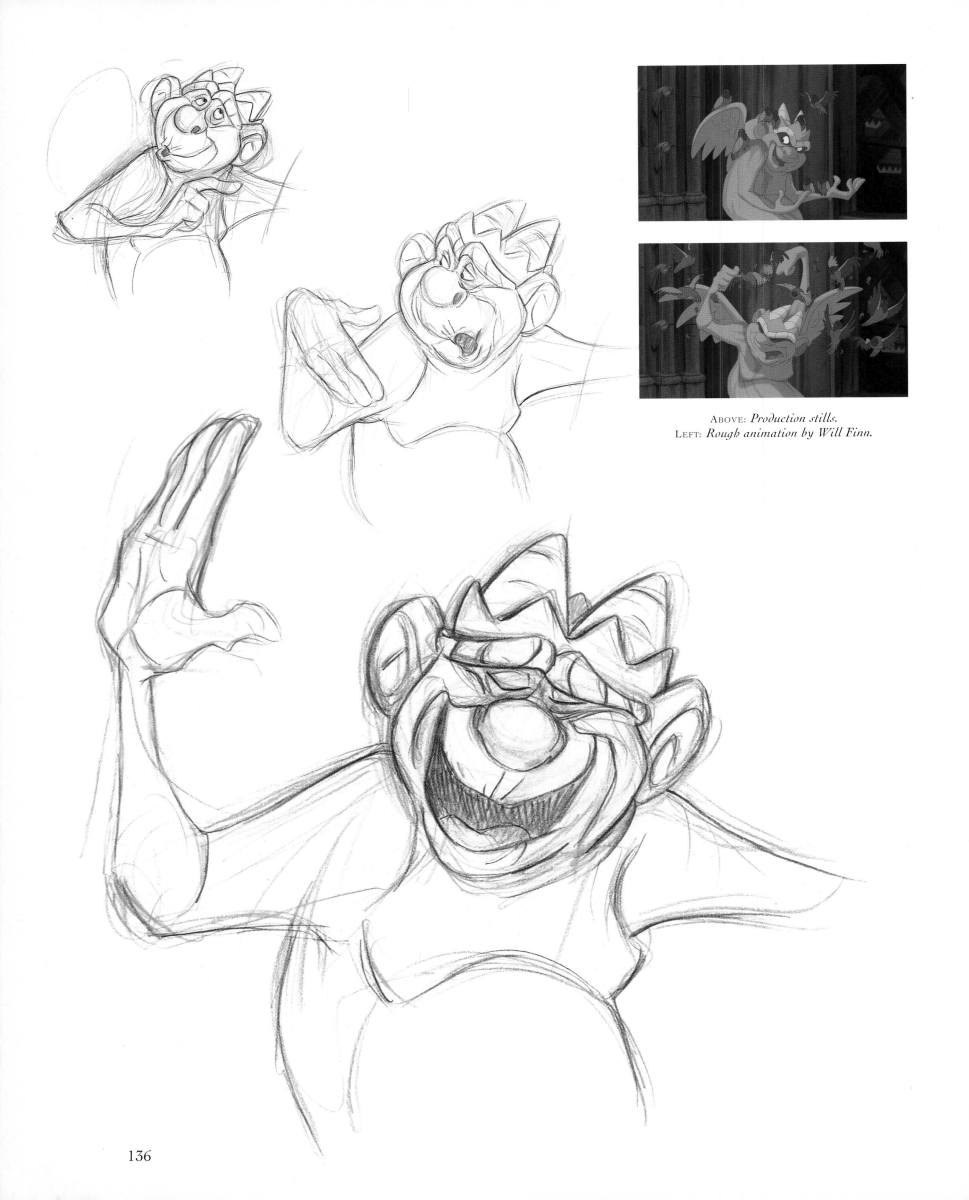

ABOVE: *Production stills.*
LEFT: *Rough animation by Will Finn.*

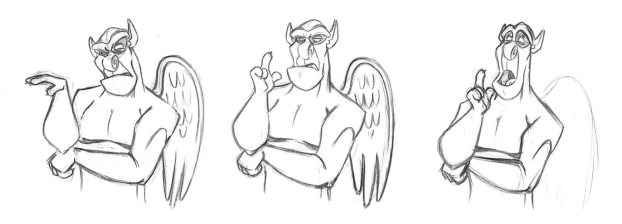

adopt the roles of a flamboyant, piano-playing romancer, a seductive lounge singer, and a ladykiller, encouraging Quasi to see these aspects in himself. Lyricist Stephen Schwartz asserts that "the joke of the song is a spin on the notion that beauty is in the eye of the beholder. Since the gargoyles are the beholders, the fun comes from the way they view Quasimodo's character as opposed to the traditional, man-on-the-street way of viewing him." This musical sequence, says Will Finn, "allows the movie to go nicely crazy for a welcome two-and-a-half minutes," and acts as a bridge to the action-packed final act of the movie.

ABOVE: *Rough animation by Dave Pruiksma.*
BELOW: *Production still.*

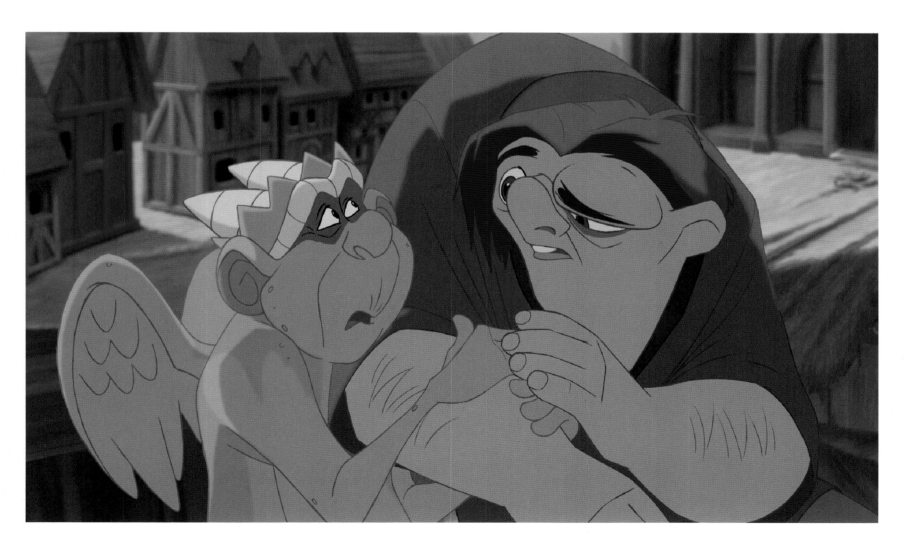

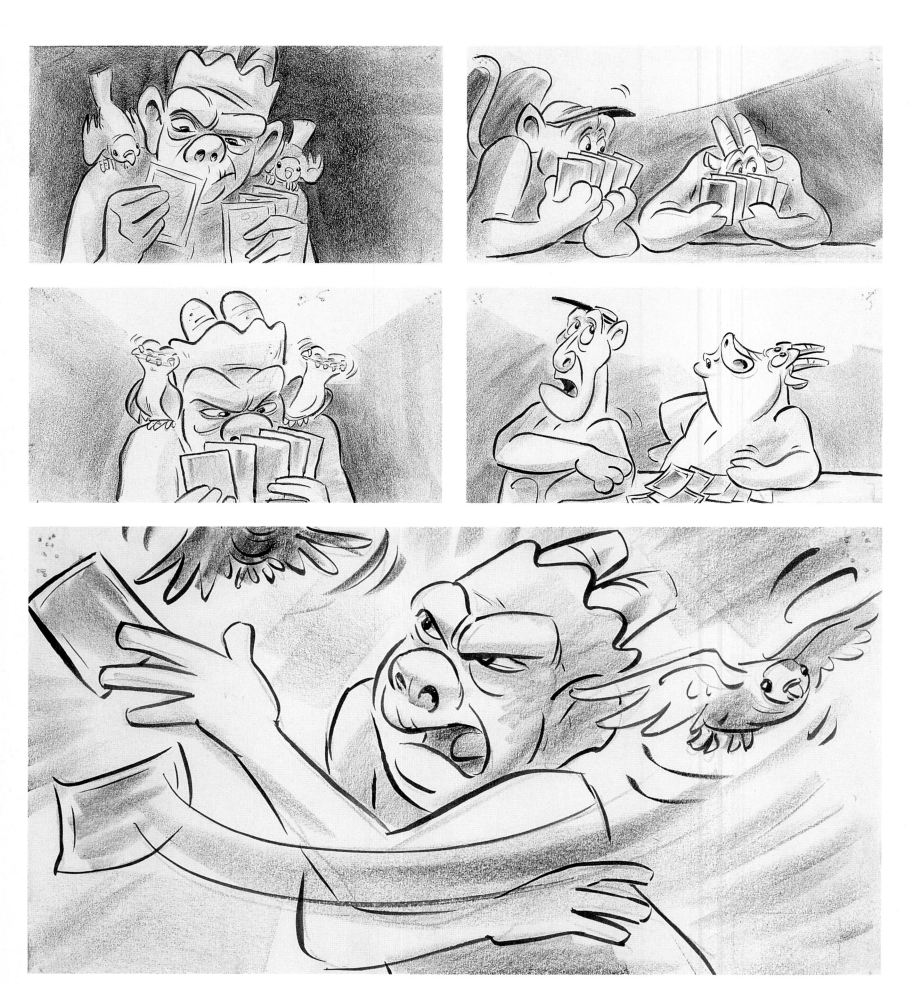

THIS PAGE: *Finding the right touch of humor required its share of trial and error.*
This card game between the gargoyles was one idea which did not make it to the final cut. Storyboard art by Ed Gombert.
OPPOSITE: *Production still.*

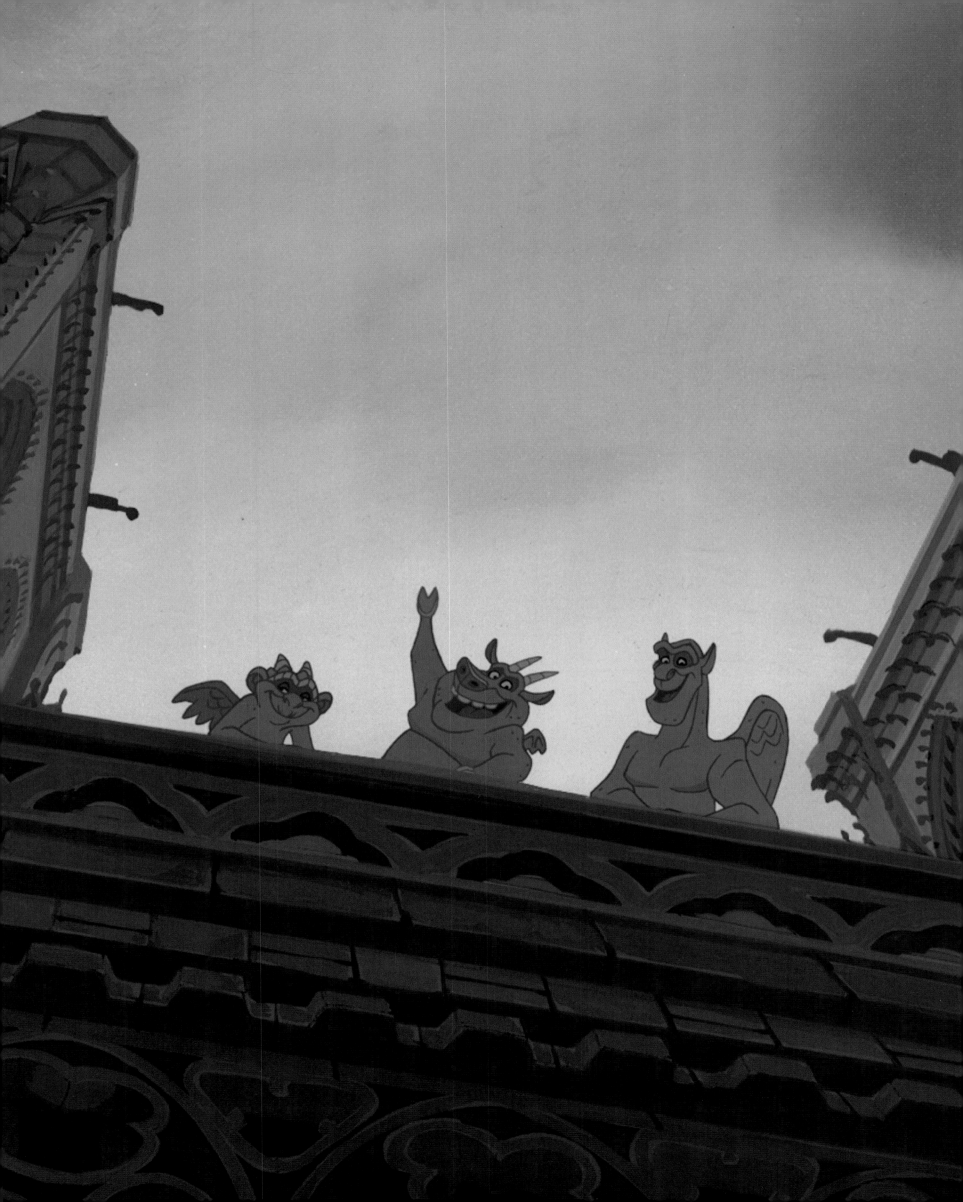

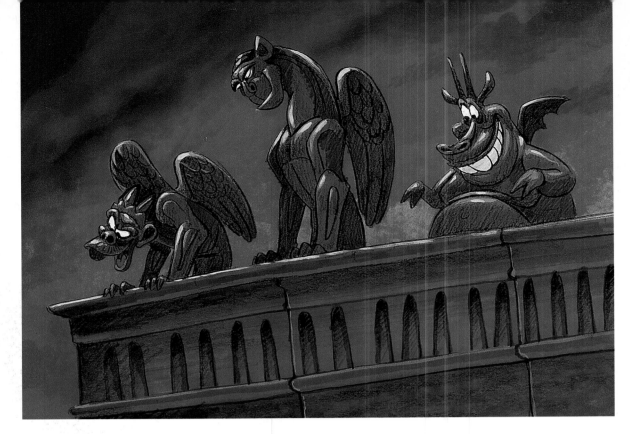

Though the gargoyles are the most prevalent purveyors of comic relief in the movie, elements of humor and lightness are threaded into the story by many of the supporting characters, including Phoebus, Clopin, Djali, and even Esmeralda, who each subtly oppose the somber stiffness and rigidity that Frollo represents. The directors used Esmeralda's companion Djali to take the edge off the darkness of the storytelling. According to supervising animator Ron Husband, "When you're dealing with the serious subject matter of Esmeralda and her feelings for Phoebus or Frollo's desire for Esmeralda, Djali's presence leavens a situation that would otherwise be very melodramatic, just the way bringing a baby into the room changes the conversation." Phoebus, too, brings "a light heart to the film, just doing his job and falling in love," says Russ Edmonds.

ABOVE: *Four rough animation sketches by Dave Pruiksma.*
TOP RIGHT: *Concept art by Kathy Zielinski, painted by Lisa Keene.*
RIGHT: *Storyboard art by Kevin Harkey.*

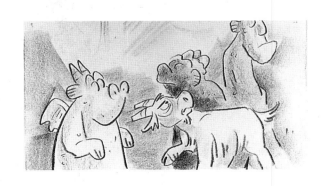

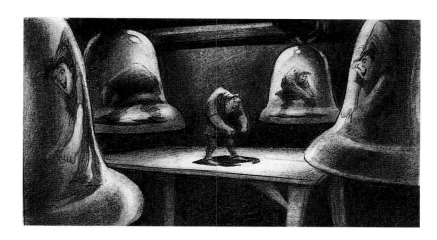

ABOVE: *Rough animation of Victor by Jamie Oliff.*
LEFT: *Value studies by Fred Craig.*
TOP: *Rough animation by Dave Hancock.*

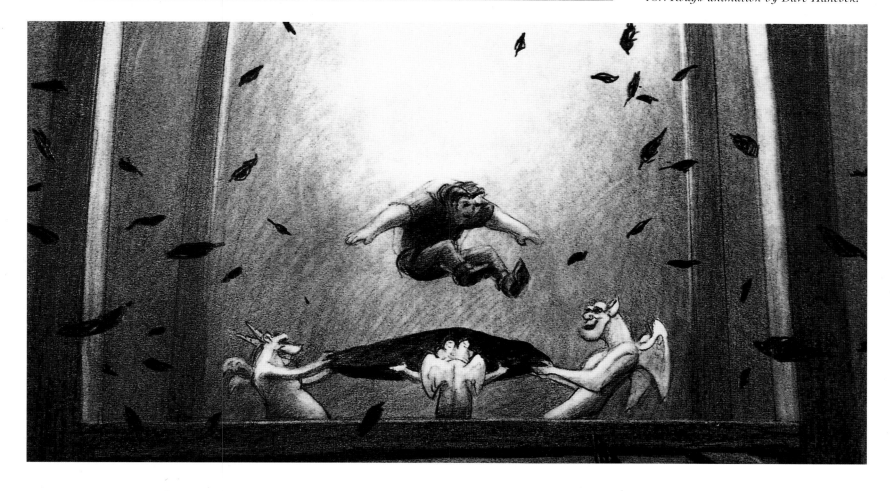

141

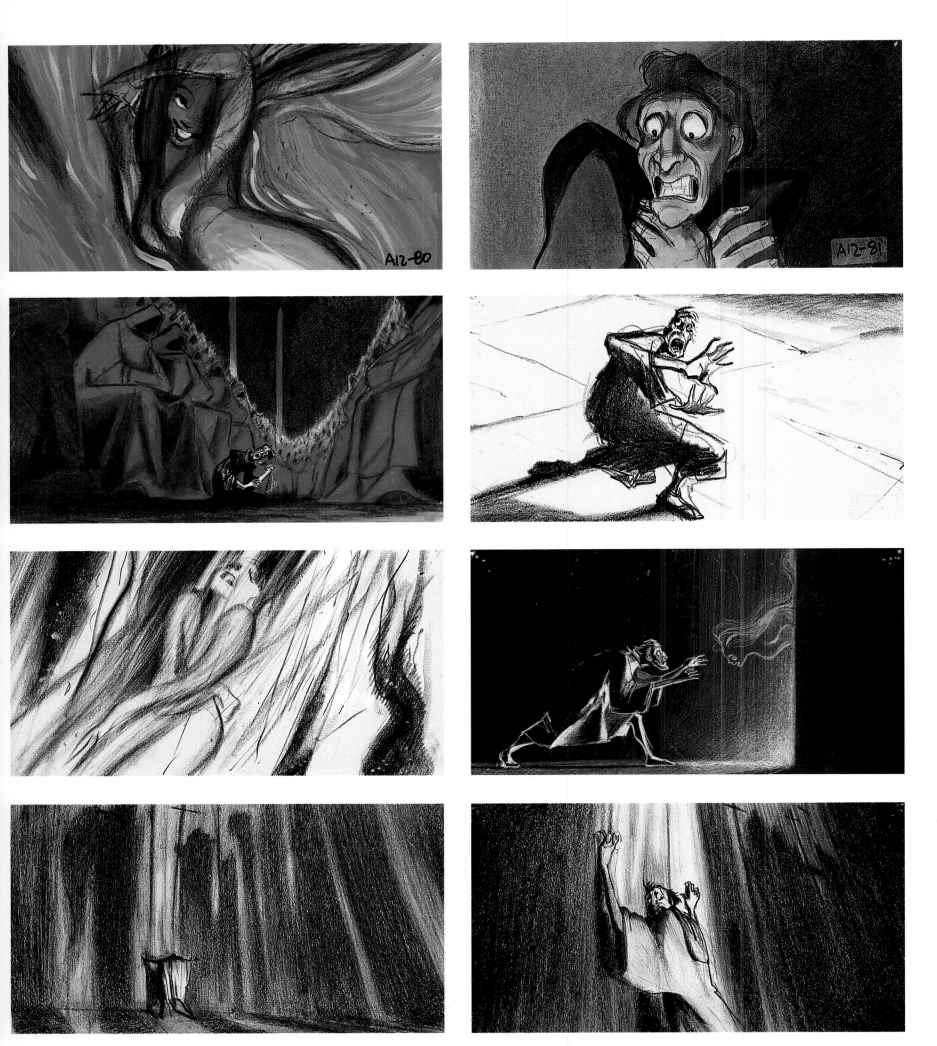

THESE PAGES: *"Hellfire."* Storyboard art by Paul Brizzi and Gaëtan Brizzi.

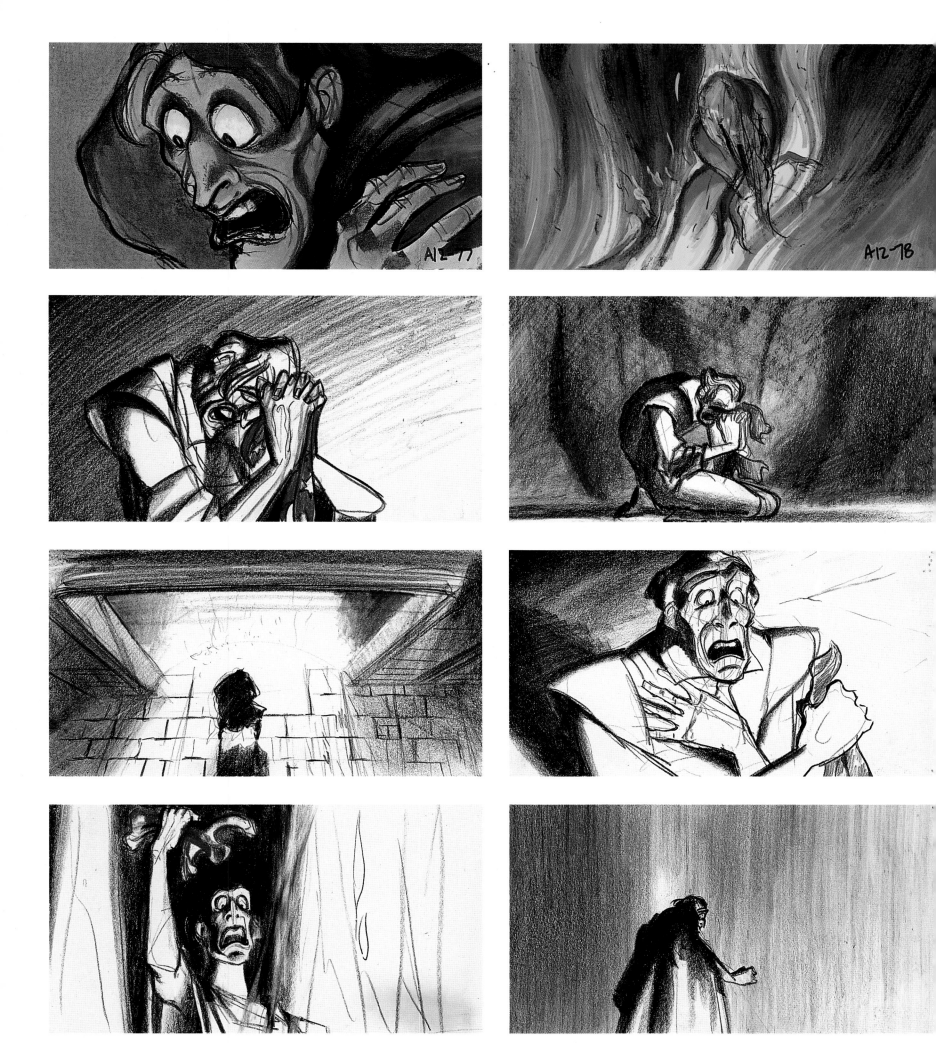

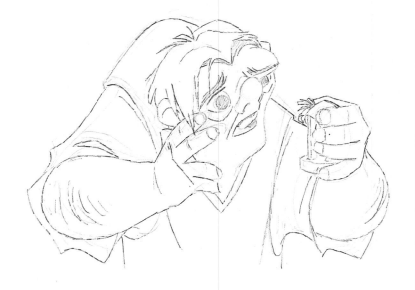

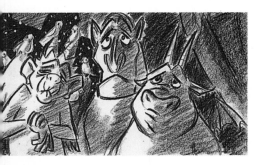

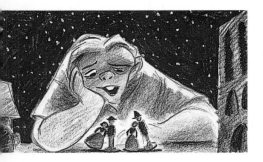

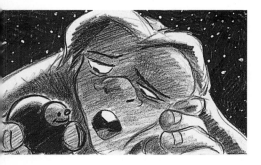

ABOVE: *Storyboard art by Brenda Chapman.*
TOP RIGHT: *Rough animation by James Baxter.*

Heaven's Light and Hellfire

The powerful dynamics of light and shadow find expression in several musical sequences. The most dramatic of these is designed around Quasimodo's song, "Heaven's Light," and its dramatic counterpoint, "Hellfire," sung by Frollo. The scoring for the number not only incorporates original instruments of the Middle Ages but also makes reference to the Latin Mass, chant, and Ecclesiastical themes. The sequence begins with Quasimodo entertaining sweet hopes that Esmeralda might, against all odds, harbor tender feelings for him. It addresses the pain and frustration that Quasimodo expresses in the novel, on glimpsing the terrible contrast between himself and Esmeralda. In the book, he says:

> When I compare myself to you, I can't help feeling sorry for myself, miserable monster that I am. I must seem like some kind of beast to you. As for you, you're a sunbeam, a dewdrop, the song of a bird! But I'm something hideous, neither a man nor an animal, something harder, more unshapely, more trampled on than stone.

In the movie, he sings:

> But suddenly, an angel has smiled at me
> And kissed my cheek without a trace of fright
> I dare to dream that she
> Might even care for me
> And as I ring these bells tonight
> My cold dark tower seems so bright
> I swear it must be heaven's light . . .

The camera swoops down through the cathedral where evening Mass is being celebrated, then, moving across the square, finds Frollo in a cold, sterile chamber in the Palace of Justice. Unable any longer to contain his turbulent passions for Esmeralda, he stands before a fireplace. In a hallucinatory chapter of the novel titled "Fever," Frollo laughs

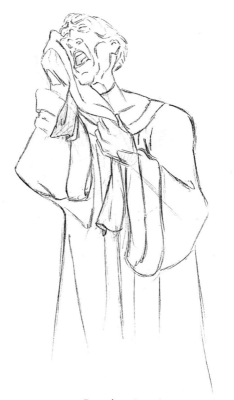

... hideously, then turned pale again as he considered the most sinister side of his fateful passion, of that corrosive, venomous, hateful and implacable love which had led to the gallows for one person and to hell for the other; she was condemned to death, he was damned.

In a wildly imaginative, unsettling sequence of the film, Frollo sings:

Beata Maria
You know I'm so much purer than
The common, vulgar, weak, licentious crowd
Then tell me, Maria
Why I see her dancing there
Why her smold'ring eyes still scorch my soul . . .
Like fire, Hellfire . . .
This fire in my skin
This burning desire
Is turning me to sin.

ABOVE: *Rough animation by Kathy Zielinski.*
BELOW: *Production still.*

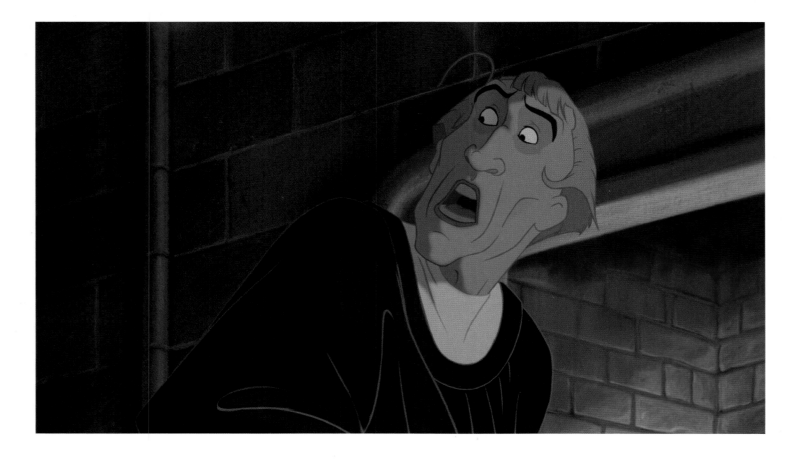

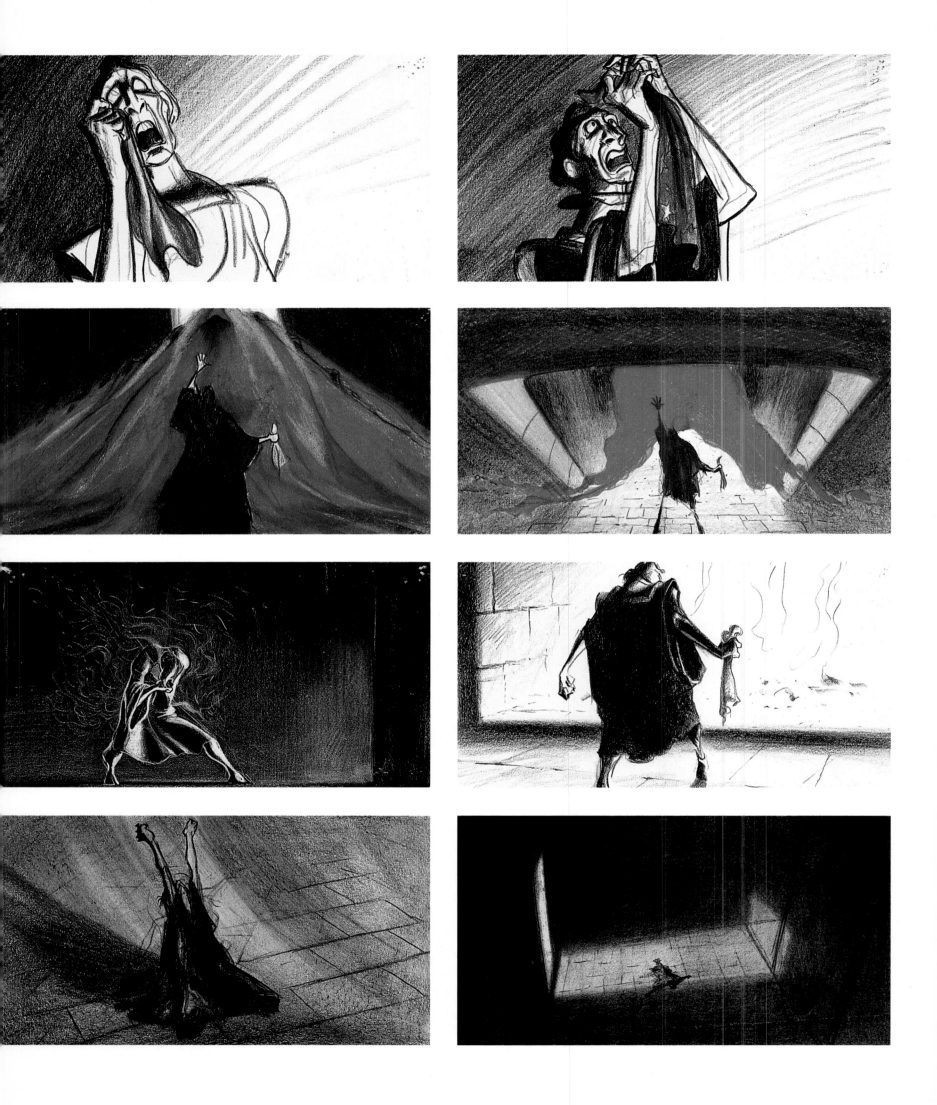

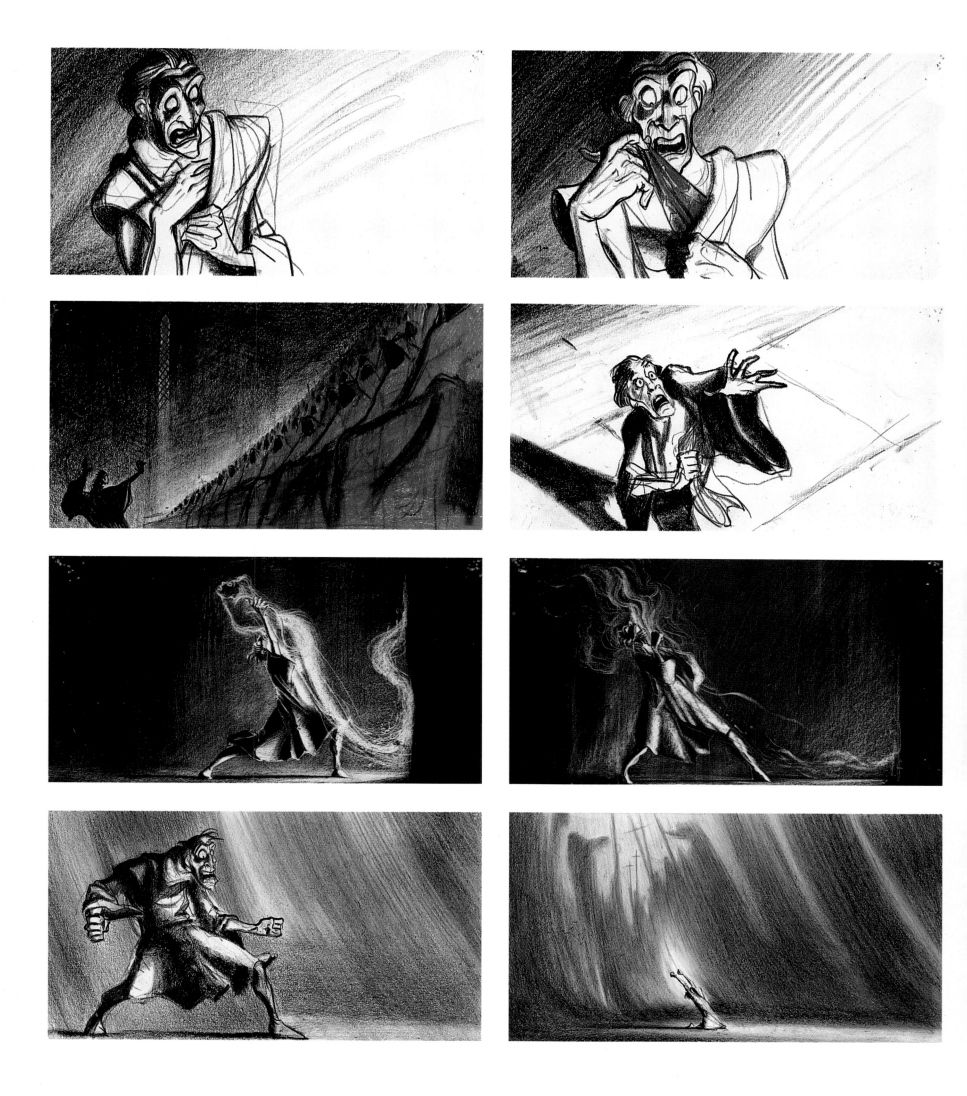

RIGHT: *Workbook page.*
BELOW: *Effects animation by Chris Jenkins.*
Rough animation of Esmeralda
by Dave Kupczyk.

According to art director David Goetz, the moviemakers determined that "Hellfire" would be the one place where they would "very consciously retain the sexual tension around which the book seems to revolve." As Frollo stands before a hearth, singing his confession of wild, obsessive thoughts for Esmeralda, whose scarf he caresses, the imagery becomes progressively more nightmarish, distorted, surreal. In the fireplace Frollo sees visions of a lascivious, dancing Esmeralda. From beneath his feet spring rows of faceless, menacing, hooded, monk-like figures who unnerve Frollo, much as the holy statuary of Notre Dame had earlier. By the end of a sequence that marks the further disintegration of Frollo, he decides that Esmeralda will either succumb to him or burn at the stake.

Special effects supervisor Chris Jenkins says that suggesting the dancing Esmeralda in spectral form within the flames of a fire is "the essence of animation—moving shapes and flickers of light to so engage the audience that you suggest in their minds many things at once: a literal fire, a dance, a character, a feeling of sensuality." According to Goetz, "In a sense, the third act of our movie is all about Frollo torching the city and countryside because he can't face his feelings for Esmeralda." Supervising animator Kathy Zielinski views the character as "someone who believes what he is doing is right when what he's doing is evil." Stephen Schwartz found the key to writing the "Hellfire" lyrics in Hugo's prose and in his observations of contemporary society. The lyricist asserts that Frollo "projects his guilt onto others anytime he does something vile; to him, it's Esmeralda who is making him feel the madness that consumes him."

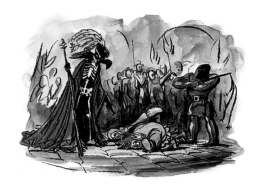

The Gypsies' Lair

Another shade of darkness comes into play in a sequence set in "The Court of Miracles," which is informed by Hugo's perceptions of the gypsies as wildly colorful, nefarious, freedom-loving creatures who might well lurk in the subterranean hideouts of Paris, wearing ominous disguises to trap the unsuspecting. Hugo writes of the notorious Court: "There was a tavern in the lower room, amusement of another kind on the upper floors. This tower was the most vital and consequently most repulsive spot in the entire truantry. It was a sort of monstrous beehive, which buzzed both night and day."

In the Disney film, the geometry and layout of the sequence diverge pointedly from Hugo's description. This Court of Miracles is secreted away in what appears to be old Roman ruins hidden under the streets of Paris, a choice of locale that suggests how dogged and persecuted by Frollo the gypsies are. "The gypsies have been literally forced underground to a place that isn't very nice, but they've made it home," says editor Ellen Keneshea. The art direction for the sequence, which recalls memorably stylized and frightening moments and sequences in *Snow White and the Seven Dwarfs*, *Fantasia*, and *Pinocchio*, reflects the chaotic but human nature of the

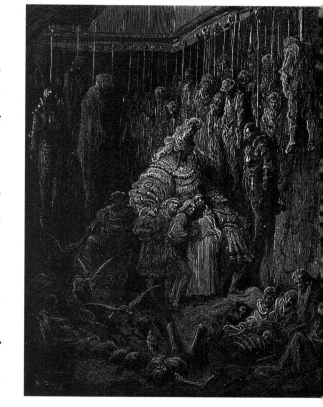

ABOVE: *Etching by Gustave Doré from a 19th-century edition of François Rabelais's* Gargantua and Pantagruel.
ABOVE LEFT: *Concept art by Vance Gerry.*
BELOW: *Concept art by Rowland Wilson.*
OVERLEAF: *Concept art of the Catacombs by Marek Buchwald.*

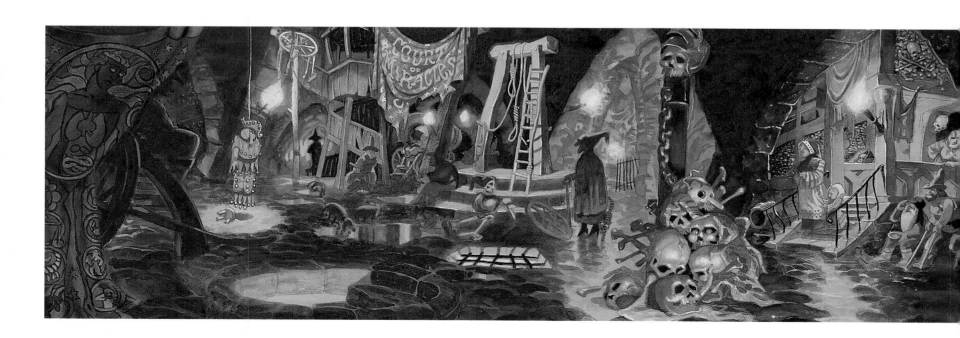

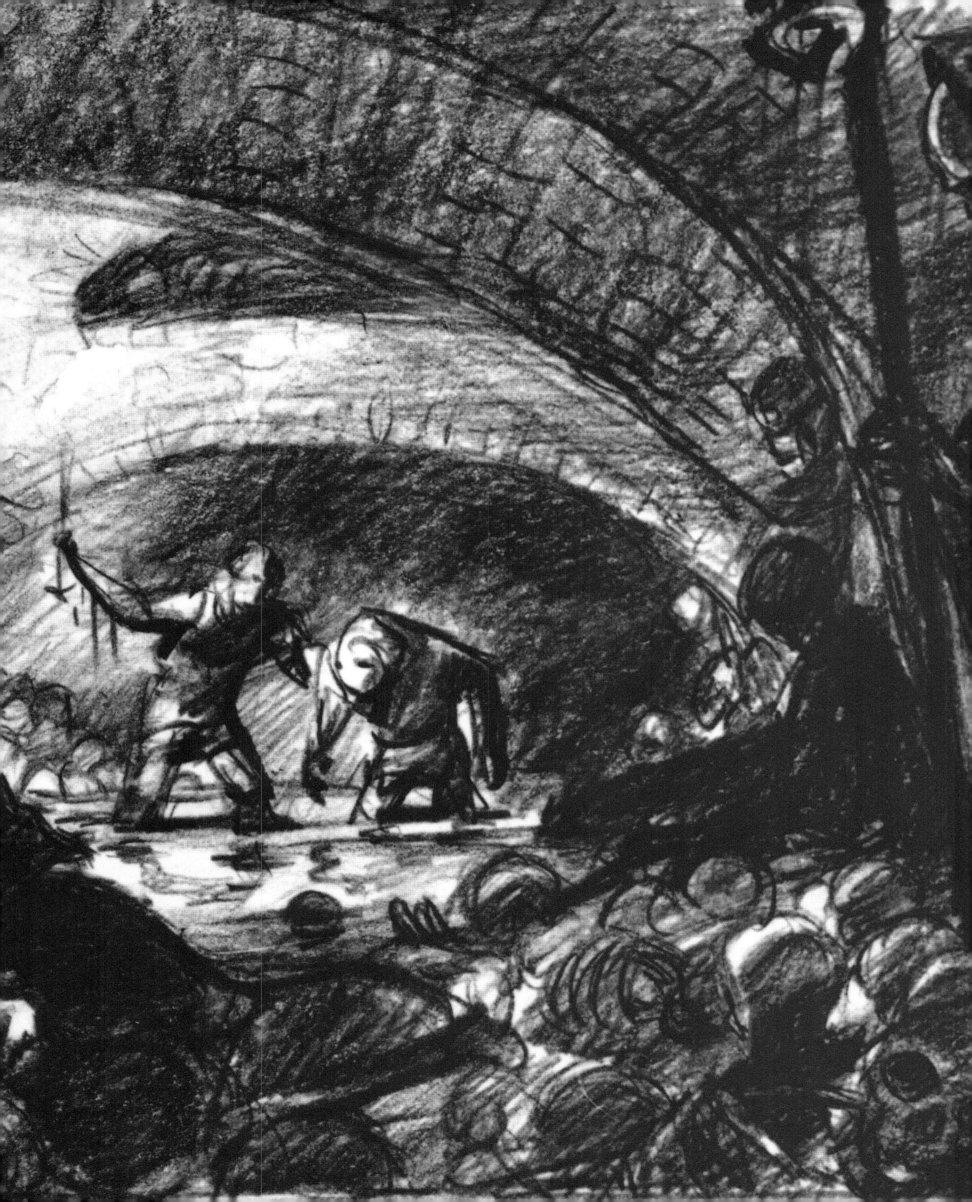

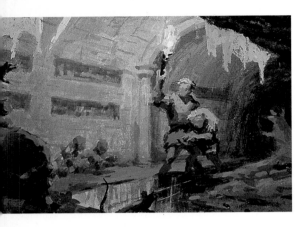

Gypsies' home: "The Gypsies have brought their life and color to this Roman ruin they're forced to live in and even though there aren't any real trees or living things, they've created an organic-feeling space," says artistic coordinator Randy Fullmer. "Even though they're forced to live in a condemned area of the city, they've brought humanity to it; they've hung tapestries everywhere, and the soft circular shapes make this a welcoming place in spite of its being underground," adds David Goetz.

The action of the scene begins with Quasimodo and Phoebus descending together into this underworld to liberate Esmeralda. The setting of the sequence and its placement in the dramatic arc of the film come at a time when both characters have taken major steps toward turning their backs on their former lives. Quasimodo has voluntarily left the cathedral to help his friends Esmeralda and Phoebus, taking another step away from being a shunned recluse. Phoebus has broken away from the path of a dutiful soldier. Their descent is as symbolic as it is literal. Only by confronting directly the disturbing, spooky underbelly of the city (and, by extension, human nature) can freedom be won. Based on the catacombs under Paris, the approach to the Court of Miracles is a forbidding place. "The gypsies are survivors. They need to be very secretive and hide themselves because they know they are wanted. They have little traps for people," says director Kirk Wise.

As Quasimodo and Phoebus are captured by the gypsies, thieves, and other outcasts, Clopin sings an eerily macabre little ditty:

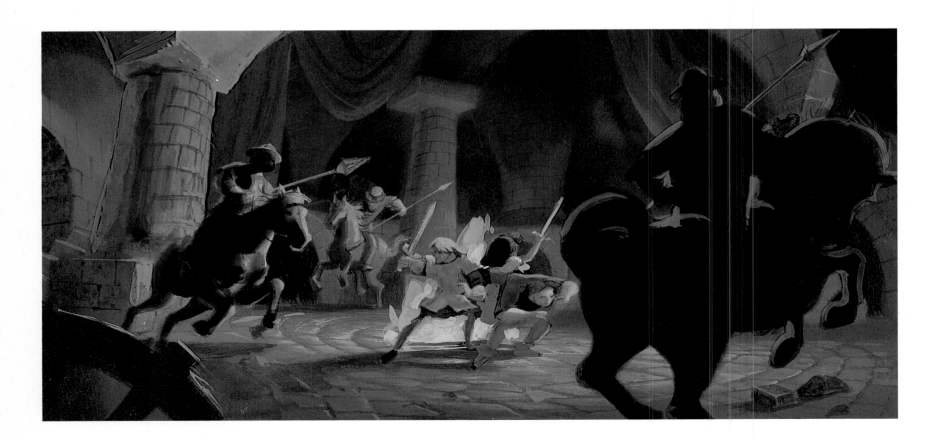

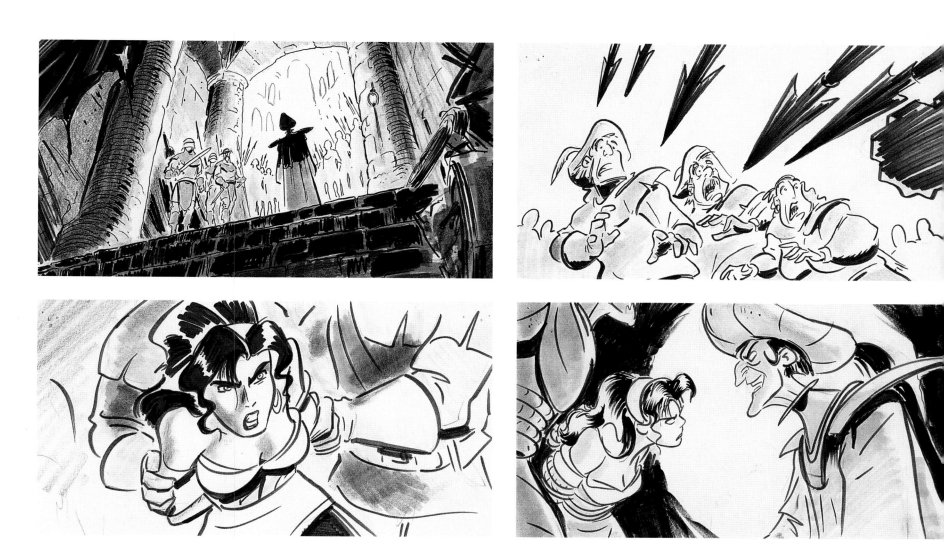

Maybe you've heard of a terrible place
Where the scoundrels of Paris collect in a lair
Maybe you've heard of that mythical place
Called the Court of Miracles, hello, you're there.
Where the lame can walk
And the blind can see
But the dead don't talk
So you won't be around
To reveal what you found.

"We split the edge between humor and seriousness during this sequence," says Randy Fullmer. "When the Gypsies are getting ready to hang Quasimodo and Phoebus on the scaffold, they're pretty ruthless, but at the same time they're still the Gypsies. They approach this execution, like everything else, with a sense of celebration." This is even reflected in the art direction of the scaffold, explains David Goetz: "The sequence is rich and colorful and exotic and the scaffold is decorated in brightly colored banners. So it's an execution but it's also a party."

Rough animation of Clopin by Michael Surrey.

God Help the Gypsies

"And I'm sure their teeth are long enough to eat children," remarked Gervaise. "In fact, I wouldn't be surprised if Esmeralda took a little bite now and then. And her white goat knows so many malicious tricks that I'm sure there's something unholy at the bottom of it."

—VICTOR HUGO, Notre-Dame de Paris

To merely utter the word "Gypsy" is to conjure up superstition-fueled images of palm reading, begging, child-snatching, lying, and hoodwinking. Nomadic, and little understood, Gypsies traditionally suggest, on their simplest level, magic and the occult—wrapped in searing color, accompanied by the jangle of golden earrings, tambourines and the fiery blaze of violins. In *Notre-Dame de Paris*, Gypsies, as personified by Esmeralda, Clopin, and their faction, are outcasts, tribal wanderers. Enjoying no rights, the Gypsies are objects of fascination, misinformation, and persecution. As embodiments of mystery, the exotic, the supernatural, they are part of Hugo's fascinations as a Romanticist.

Notre-Dame de Paris presents many medieval superstitions and misconceptions about gypsies. In a chapter titled "The Story of a Cake," three women are on their way to deliver a charity cake when they hear Esmeralda's tambourine. Immediately, one of the women grabs the arm of her son, saying: "God preserve me from her! She'd steal my child!" and proceeds to demonize the Gypsies as excommunicants from Egypt whose women are "even uglier and darker than the men" and whose children "would have frightened a monkey." She repeats rumors that they "stole children, cut purses, and ate human flesh."

Information about Gypsies is not easy to pin down and contemporary accounts by non-Gypsies are often unreliable. As a people, they may have originated on the plains of northern or

central India; some scholars have suggested that they settled in parts of the Byzantine Empire. Believed to be of mixed ancestry, Gypsies are speculated to have had roots in Afghanistan before the Islamic and Iranian invasions. Historians assert that in France, as early as 1388, Gypsies, the Tinguerys of Abbeville, held positions of high political prominence, yet most lived on the edge of society and their relations with mainstream French society were difficult at best.

On the outskirts of Paris, Gypsies appear in documents dated as early as August 17, 1427. A contemporary wrote of them: ". . . their children, boys and girls, were as clever as could be; all had both ears pierced, and a silver ring or two in each. . . . The women were the ugliest that could be seen and the blackest; all had hair as black as a horse's tail. . . . In short, they were the poorest creatures ever seen coming to France within the memory of man; and in spite of their poverty there were witches in this company who looked into people's hands and told what had happened to them, or what would happen."

The same account reported that the Gypsies claimed to be Christians of Lower Egypt who had been vanquished by enemies, become Saracens again and "denied Our Lord." As penance, the Pope had commanded them to "roam the earth for seven years without sleeping in a bed." There were tales of Gypsies falsely reporting infidelities of Parisian wives and husbands, of their picking pockets, of rifling through the property of French peasants.

How much of this reportage was reality and how much based on prejudice? Medieval Gypsies are now thought to have been skilled in such fields as metalwork and smithing. Unable to obtain work in these fields because of the guild system, they turned to entertainment and fortunetelling. In Medieval times, nomadic Gypsies, the "Tsiganes," existed outside the normal bounds of class and feudal ties, paying no church tithes, nor knowing any allegiance to kings or national boundaries.

The French populace, armed with pitchforks, cudgels, and hunting dogs, drove some Gypsies to the north of France, others to Spain. Louis XII issued an edict in 1504 ordering every officer of the kingdom to hang any Gypsy who refused to leave. Another edict, in 1561, put a price on the head of every Gypsy; a 1675 edict enjoined Gypsies to be "exterminated by fire and sword." Out of desperation, some Gypsies went into hiding, while others committed acts of vandalism and violence.

Considered an affront to the established order, they were often displaced from a series of deserts and wastelands by successive waves of invaders. Arriving in country after country and sometimes accepted at first as refugees, they were usually later perceived and treated as thieves, sorcerers, and anti-Christians and, as such, met with hostility, suspicion, and outright, frequently violent, persecution. Through it all, the Gypsies never stopped roaming.

THESE PAGES: *Gypsy model sheet drawings by Joe Moshier.*

155

V.

The Feast of Fools

"Quasi's first interaction with the world is the day he gets up the courage to sneak out and be part of the Feast of Fools. Instead of encountering the fantasy world he's been dreaming about, he runs smack into the reality of what people can be. That's the moment it becomes his story—how does he deal with that? It's his own personal journey—it's not about pleasing the crowd, which you can never really do, but learning to believe in yourself."

—RANDY FULLMER, Artistic Coordinator

ABOVE: *Rough animation by James Baxter.*
OPPOSITE: *Explosions of computer-generated confetti, animated by Peter De Mund and Kevin Sheedy, heighten an atmosphere of festivity throughout "Topsy-Turvy."*

In fiction, as in life, beginnings are everything. Hugo began the action of *Notre-Dame de Paris* in January, 1482, with "the tumultuous clanging of all the bells in the city" to commemorate "the double holiday of the Epiphany and the Festival of Fools." The yearly celebration, also known as Topsy-Turvy Day and the Feast of Asses and often centered in cathedrals and in collegiate churches, was a socially approved opportunity for members of society—particularly subdeacons and lower clergymen—to switch roles, ridicule the mighty, mock society's most revered conventions, and flout propriety.

This human kaleidoscope, festive and irreverent, inspired the makers of *The Hunchback of Notre Dame* to tap the spirit of the Feast of Fools in a sequence built around "Topsy Turvy," a madcap musical number that brings to Disney animation a carnival-like ambience and the slightly surreal touch of Federico Fellini.

Informed and inspired by Hugo and by

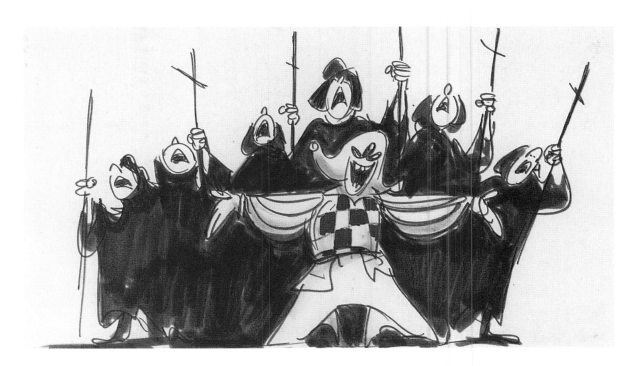

RIGHT: *Storyboard art by Kevin Harkey.*
BELOW: *Production still.*

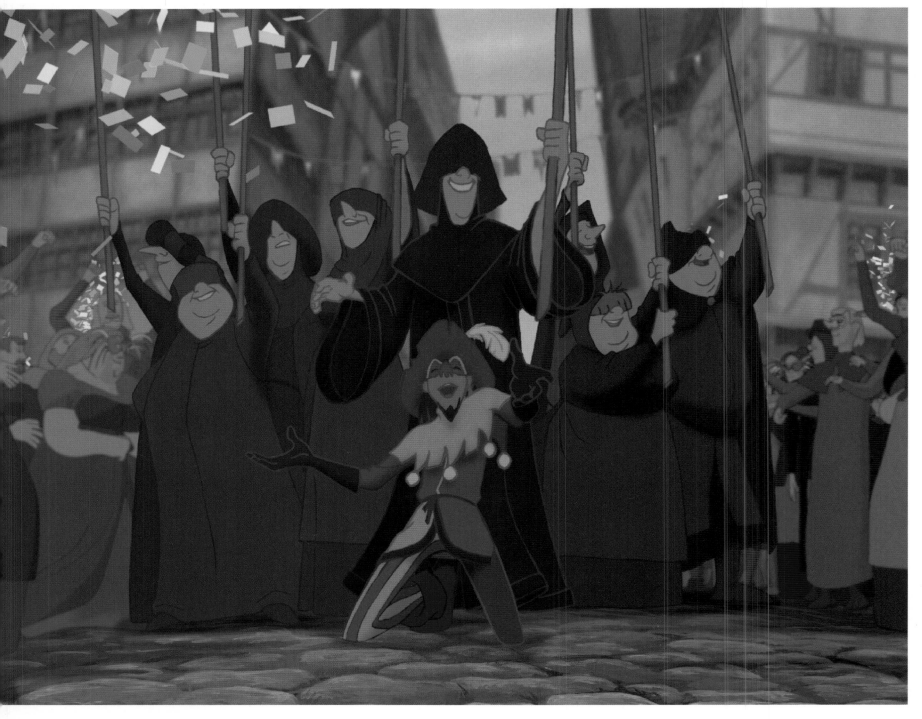

158

historical reality, the sequence explodes with circus colors, barely contained mayhem, and playfully off-center imagery. A dog trots by yanking a man on a leash. A horse with two rear ends prances by. A giant angry fish chases a fisherman in a rowboat.

Directors Trousdale and Wise recall that story artist Kevin Harkey suggested many of these antic, kaleidoscopic impressions in devising inspirational storyboards for the sequence. In fact, according to coproducer Roy Conli, "the great whimsy, style, and true comic/tragic underpinnings of Kevin's storyboards greatly influenced the tone of the whole film." Upon Menken and Schwartz's completion of the song, the storyboards were further refined and amplified in response to certain lyrics and images. Although

ABOVE: *Concept art by Geefwee Boedoe.*
ABOVE LEFT: *Storyboard art by Kevin Harkey.*
LEFT: *Concept art by Geefwee Boedoe.*
OVERLEAF: *Production stills.*

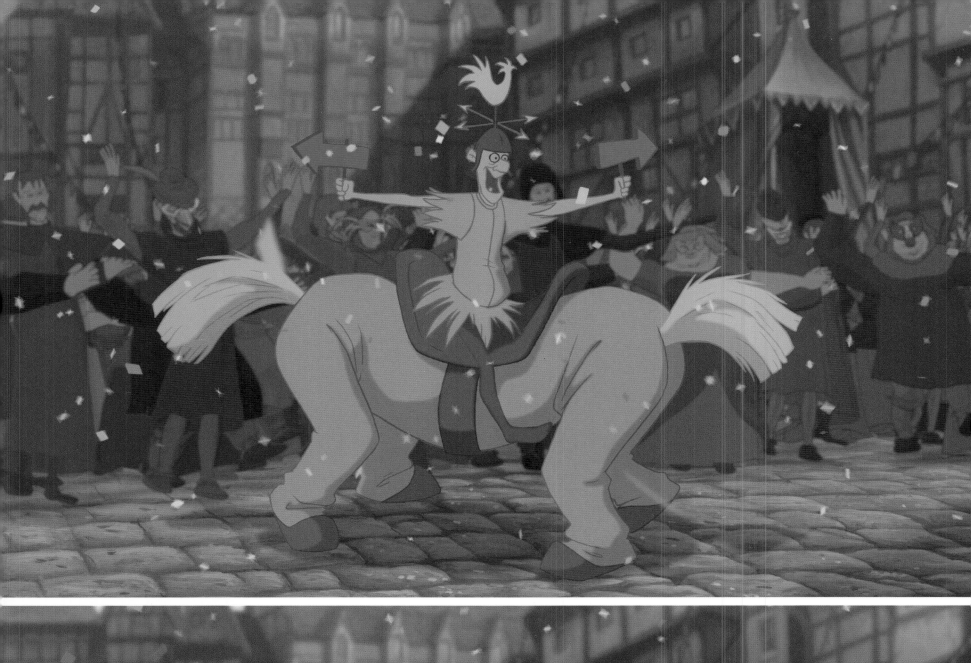
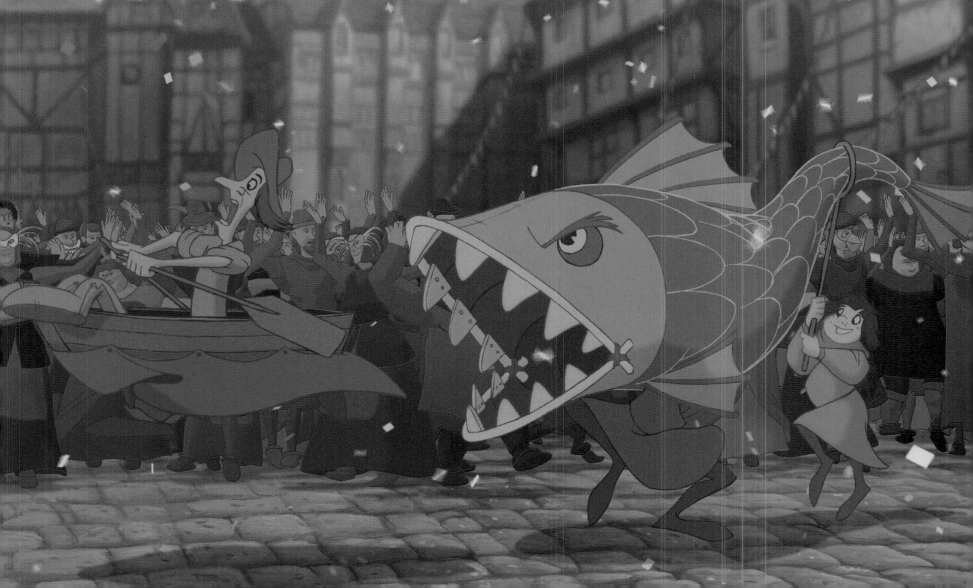

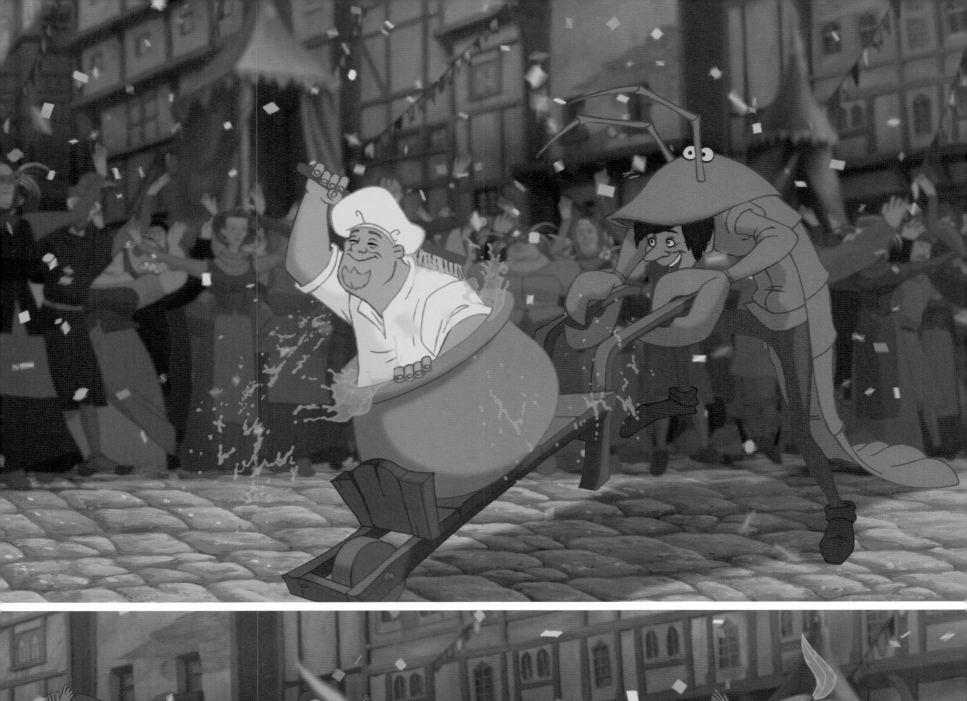
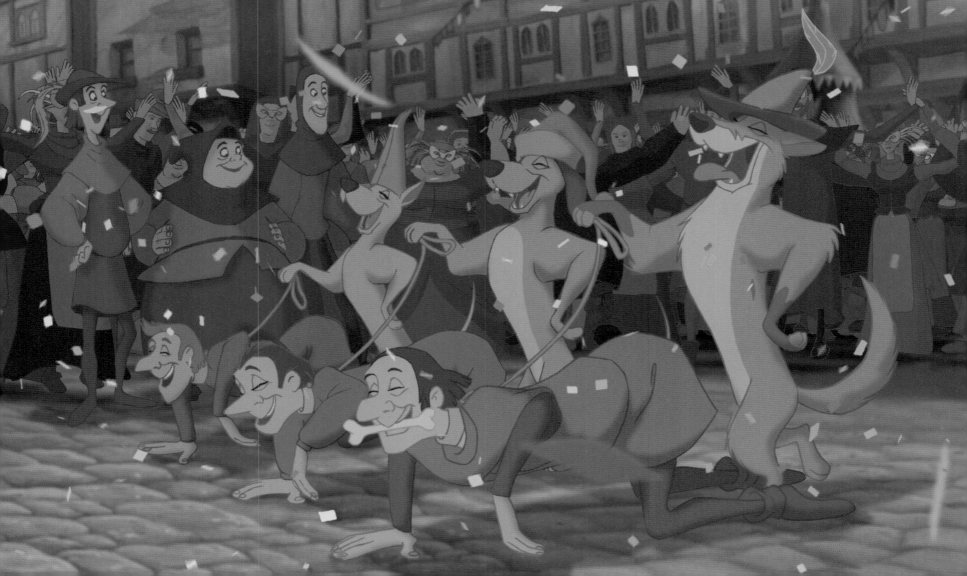

codirector Trousdale characterizes the film's overall musical score as "liturgical, influenced by chants, hymns, music one would hear in a cathedral," the orchestration for "Topsy Turvy" by Michael Starobin, known for his work on Broadway shows by composer-lyricist Stephen Sondheim, appropriately stresses bells and organs and circus parade, oom-pah-pah rhythms. Sung by Clopin, the song is orchestrated with such lively, historically accurate instrumentation as fiddle, glittern, shawms, trumpets, and drums:

> Once a year we throw a party here in town,
> Once a year we turn all Paris upside down,
> Ev'ry man's a king and ev'ry king's a clown,
> Once again it's topsy turvy day.
> It's the day the devil in us gets released,
> It's the day we mock the prig and shock the priest,
> Ev'rything is topsy turvy at the Feast of Fools!

ABOVE: *Concept art by Marek Buchwald.*
TOP: *Concept art by Jean Gillmore.*
BELOW: *Concept art by Rowland Wilson.*

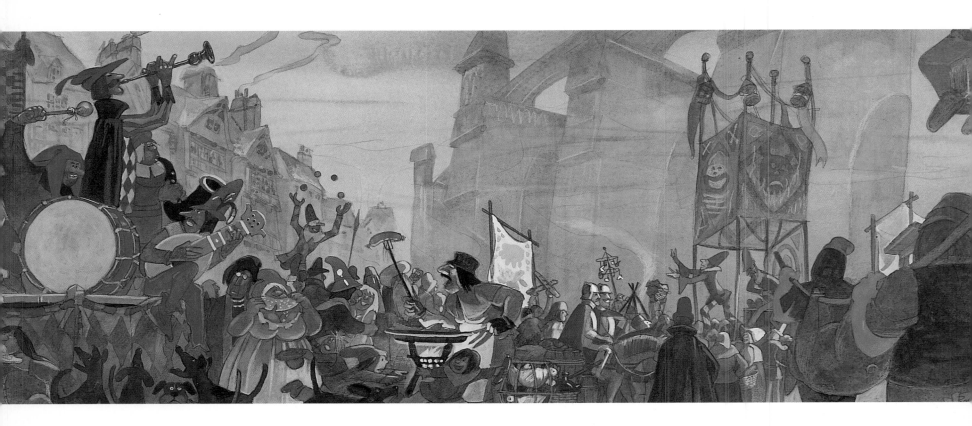

Producer Don Hahn asserts that particularly because the song is "the most zany and light hearted in the film, it was important that, like the other songs, it seems entirely motivated by the action of the film. It's as if the characters must sing these feelings because there is no other way to express them. 'Topsy Turvy' stems from the great need of the populace to go completely wild every once in awhile." Kirk Wise believes the song demonstrates well "how particularly good Alan and Stephen are at musicalizing story material. They allowed us to be able to portray in song the whole action of the festival, as well as Quasimodo's crowning as King of Fools and his first meeting with Esmeralda. It's our no-holds-barred, cut loose, crazy sequence, but it also encompasses much of the most touching, sympathetic story material about Quasimodo, because it shows him venturing for the first time out in the world and the ridicule he gets because of it." Alan Menken believes that Trousdale and Wise were, as directors, "perfect on something like 'Topsy Turvy' because they're wildly inventive and

Quasimodo's world turns upside down after being crowned King of Fools.

ABOVE: *Production still.*
TOP: *Storyboard art by Kevin Harkey.*
OVERLEAF: *Production still.*

163

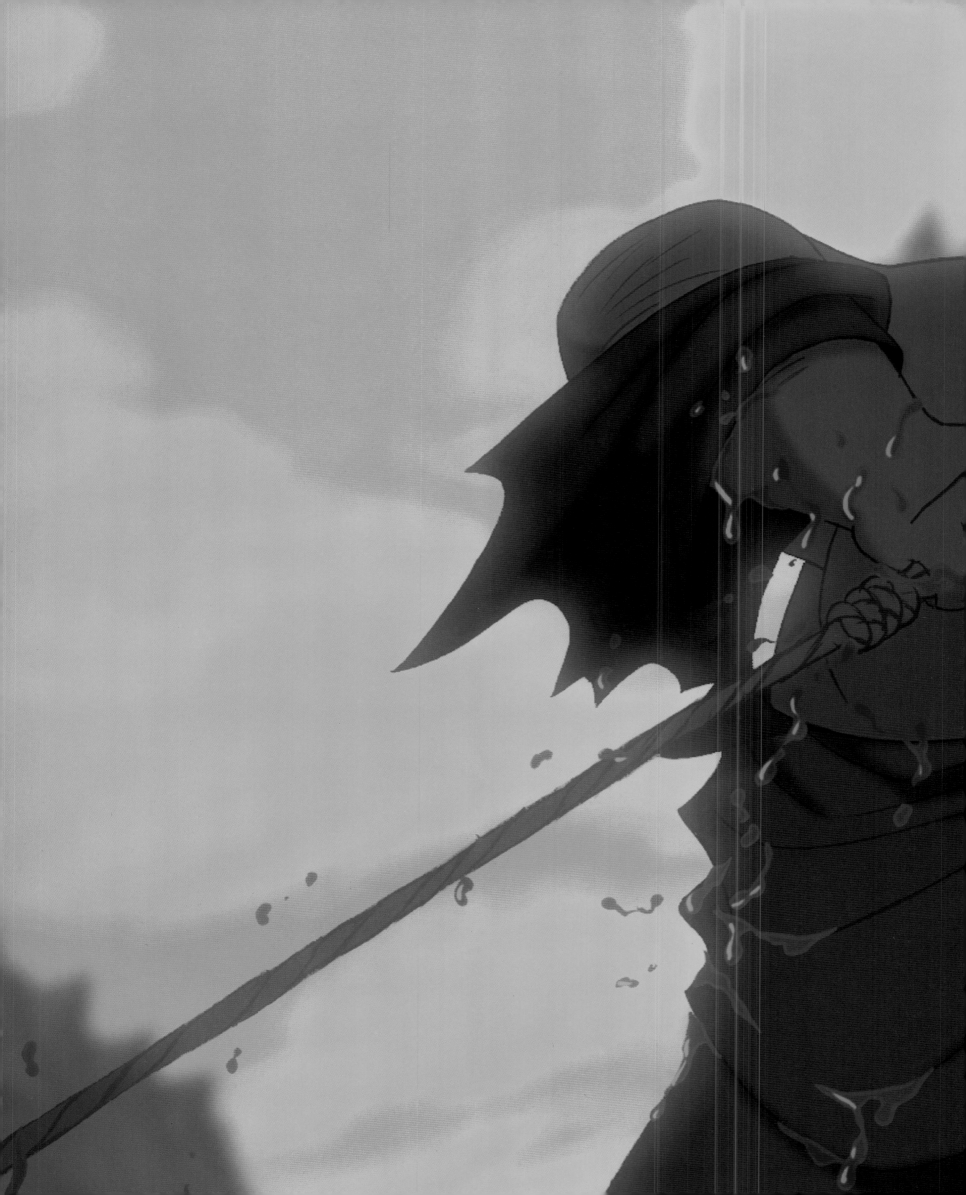

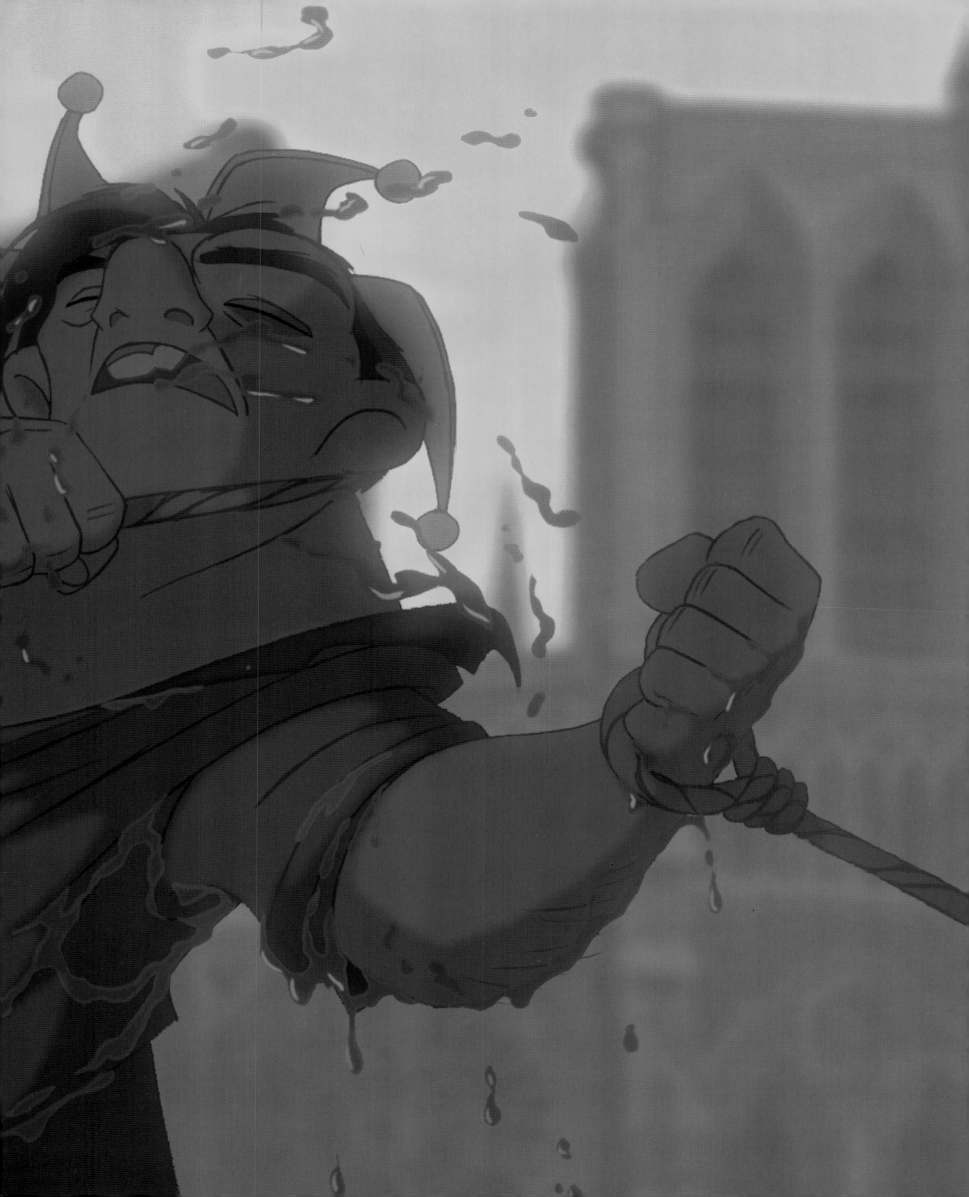

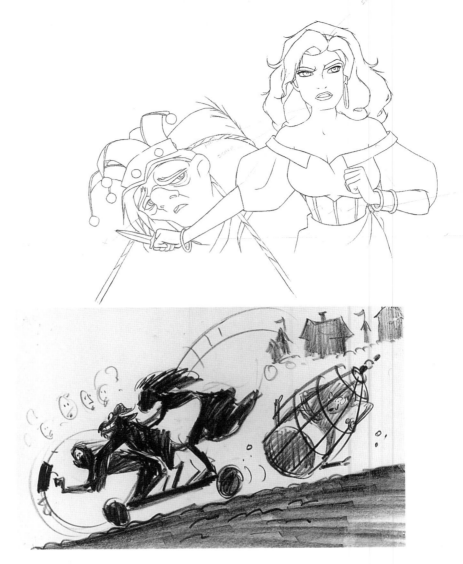

ABOVE: *Production stills.*
TOP RIGHT: *Cleanup of Quasimodo by
Marshall Toomey, animation by Tony Fucile.
Cleanup of Esmeralda by Ginny Parmele,
animation by Tony Fucile.*
RIGHT: *Storyboard art by Kevin Harkey.*
BELOW: *Cleanup by Brian Clift, animation
by Dave Brewster.*

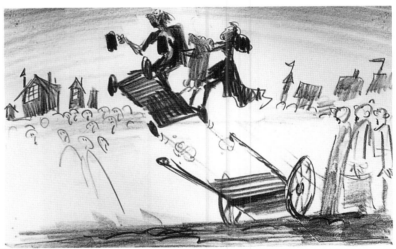

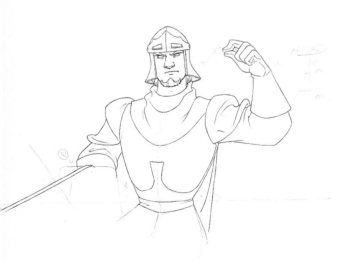

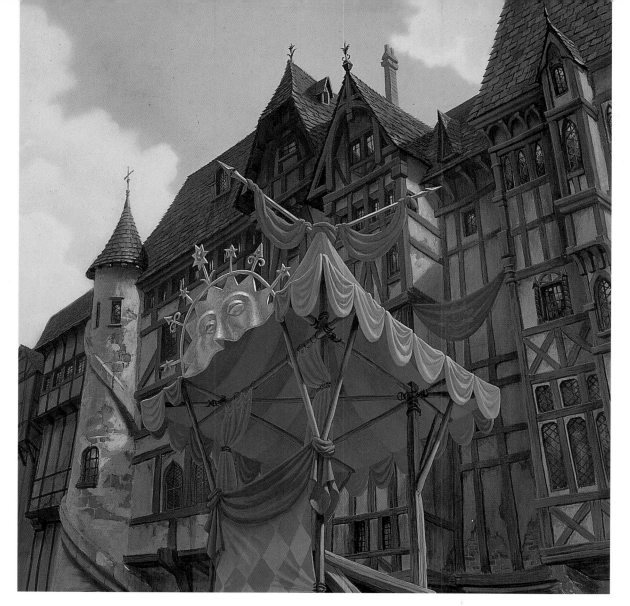

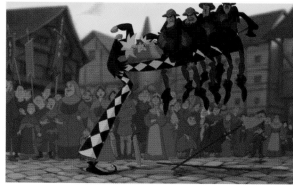

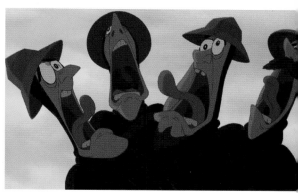

ABOVE AND BELOW: *Production stills.*
LEFT: *Background art by Greg Drollette.*

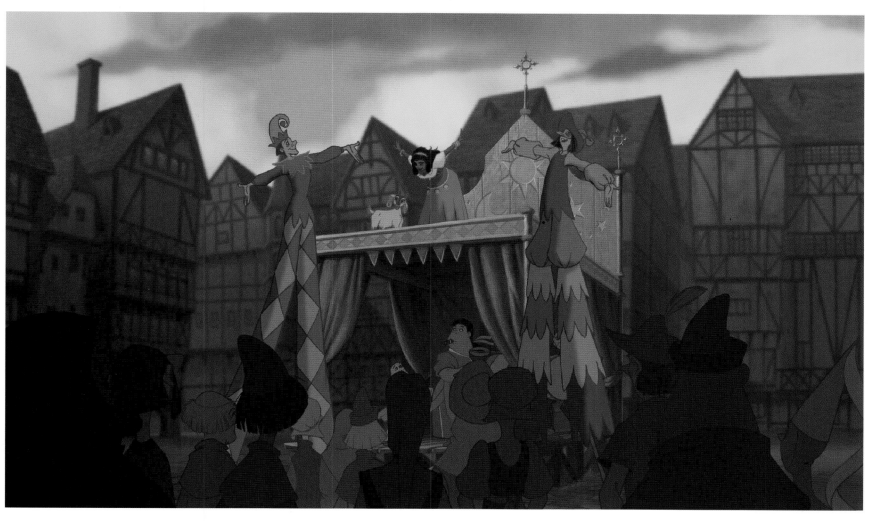

167

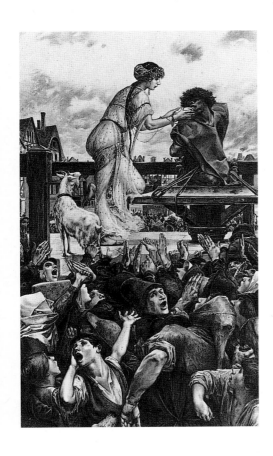

joyful, and like the holiday itself—you have to rein them back or they'll just go wild."

The roughly eight-minute sequence also boasts whirling, multicolored, computer-animated confetti pouring down on a computer-assisted animated cast of thousands who, variously, jump up and down, wave, and ambulate. These latter characters, developed by CGI supervisor Kiran Joshi and his team, "help give the scene and the whole movie the feeling of the vast multitudes of people that Don, Gary, and Kirk wanted, to match the scale of the novel." The crowd is a palpable force in this film, and to give the sense of the power of that force and its potential for chaos, it was necessary to make the crowd "real and lifelike in reflecting not only how individuals might behave but also how a mass of people might behave as a body, to show the evil possible with crowds" according to Joshi. Crowds are

LEFT: Le Pilore (The Pillory). *Lithograph by Luc-Olivier Merson from a 19th-century edition of* La Esmeralda.
BELOW: *The chaos of medieval crowds depicted in such scenes as the* Fight between Carnival and Lent (1559) *by Pieter Brueghel helped inspire the filmmakers' depiction of the festival crowd.*

168

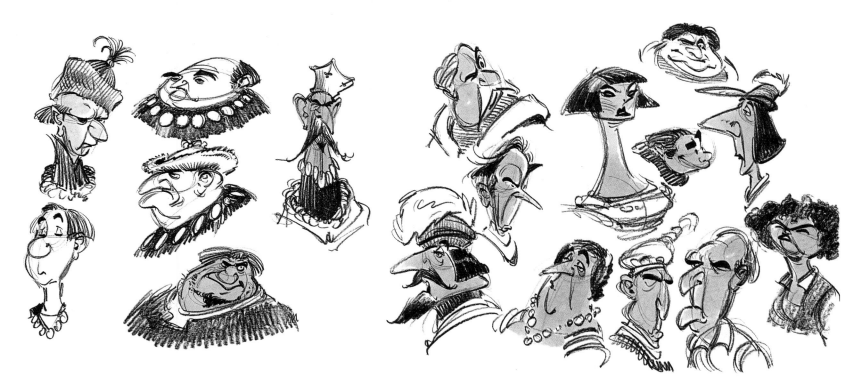

ABOVE: *Character concept art by Rick Maki.*
BELOW: *Production still.*

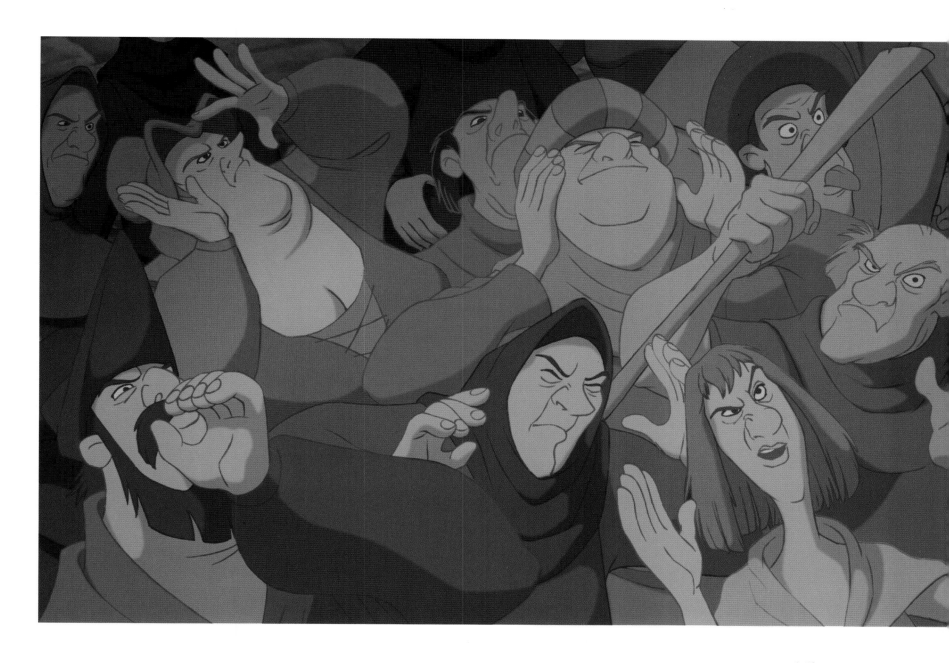

169

fickle and the Topsy Turvy Parisians are no exception. Lisa Keene believes "the colors in themselves almost tell the story of this sequence. The emotional jolt for Quasi of being at the mercy of this fickle crowd was emphasized through shifts in color." Explains Randy Fullmer, "One minute Quasimodo is seen as evil and the next minute Clopin proclaims him King of Fools and instantly people are celebrating. The color on Quasi builds and gets brighter and brighter through the scene. When the first soldier throws a tomato, there are gasps from the crowd, and the color starts to dial down a bit. For a moment, you can see the crowd is perplexed about what to do, then all of a sudden the evil momentum builds and they're just all jumping in to be part of it."

David Goetz calls "Topsy Turvy" "the moment during which we could most push the 'dirty pageantry' idea, the grungy, lived-in medieval look we were all after. We went for a highly saturated fall palette—orange, rust, yellow ocher—everything with a burnt smokiness to it, punched up with reds and violets." Background department supervisor Lisa Keene elaborates,

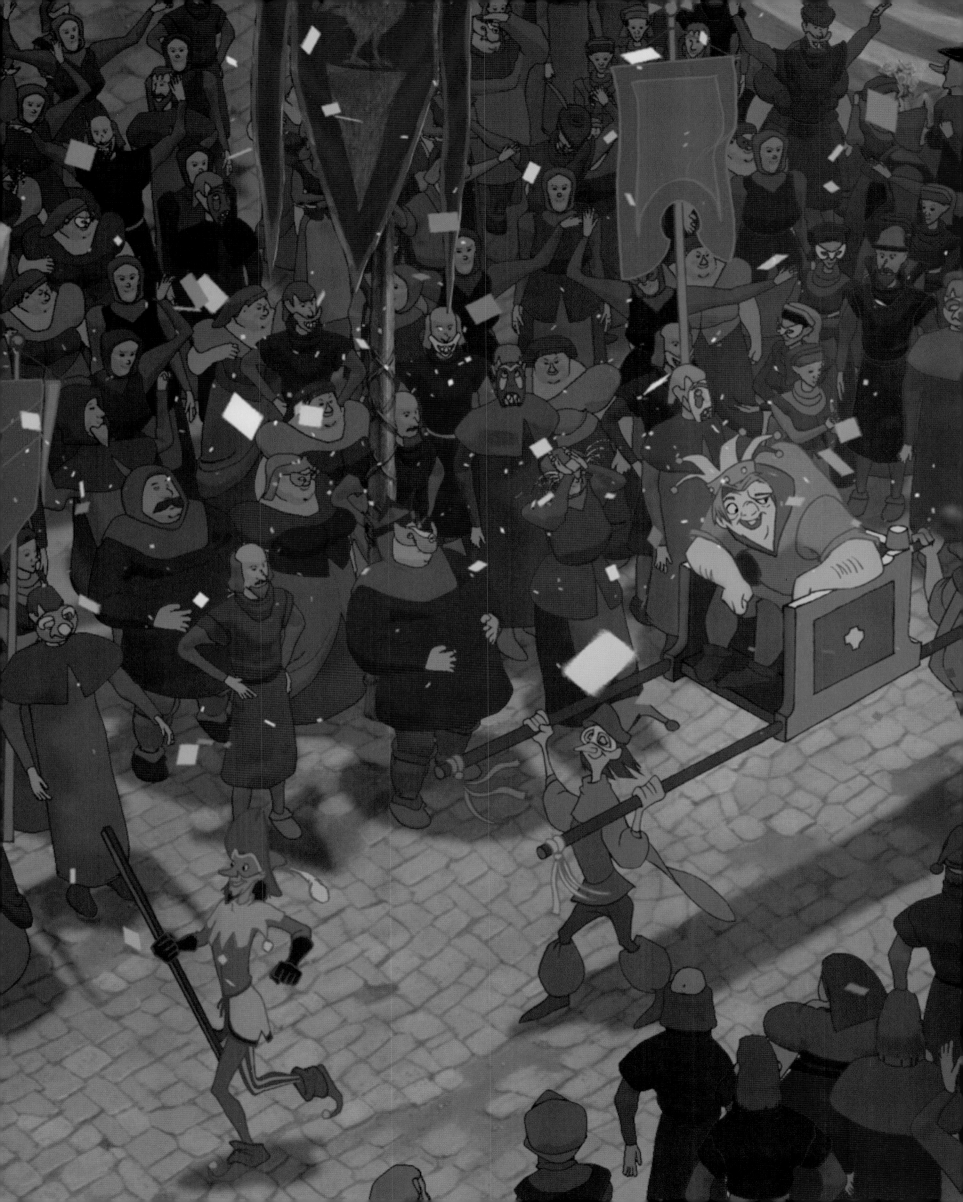

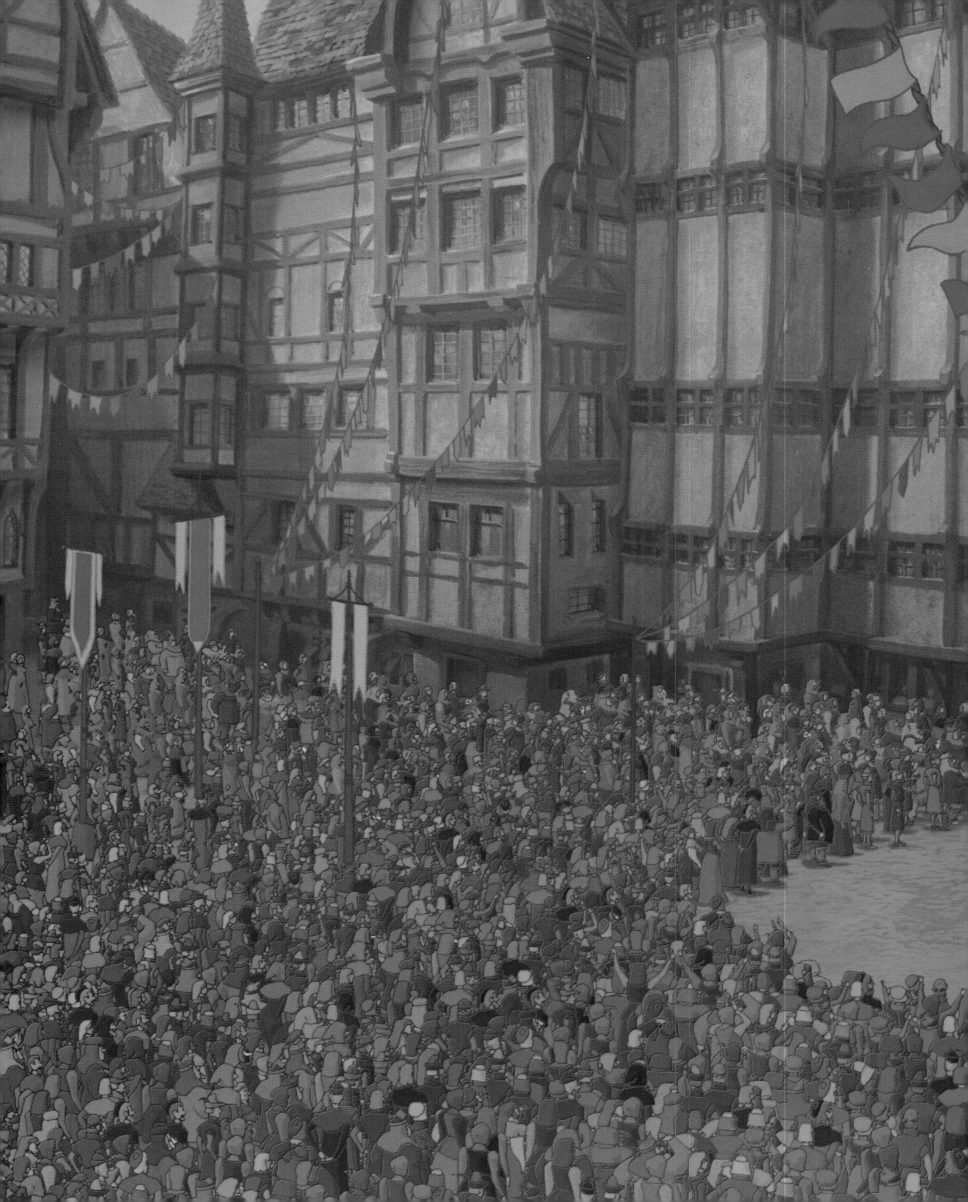

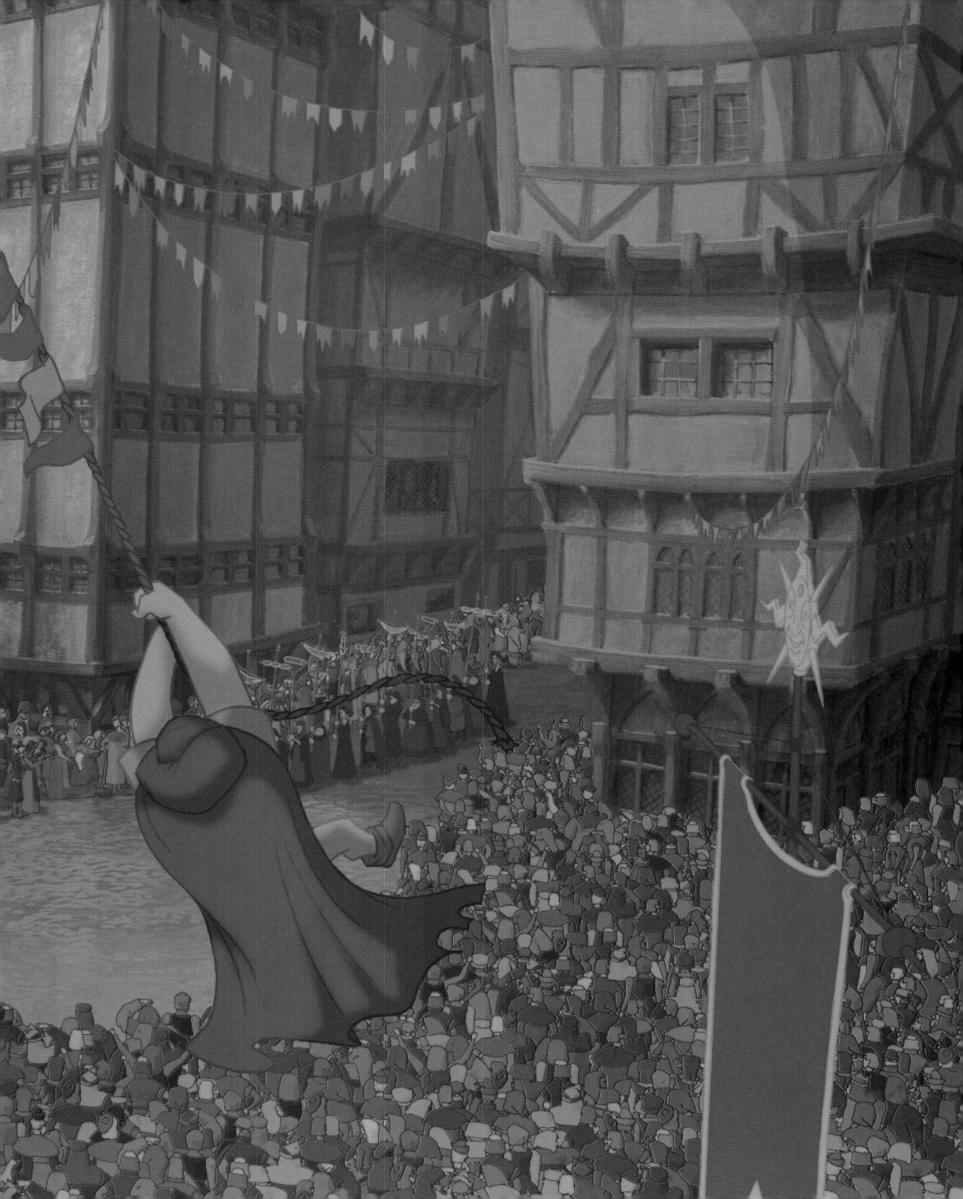

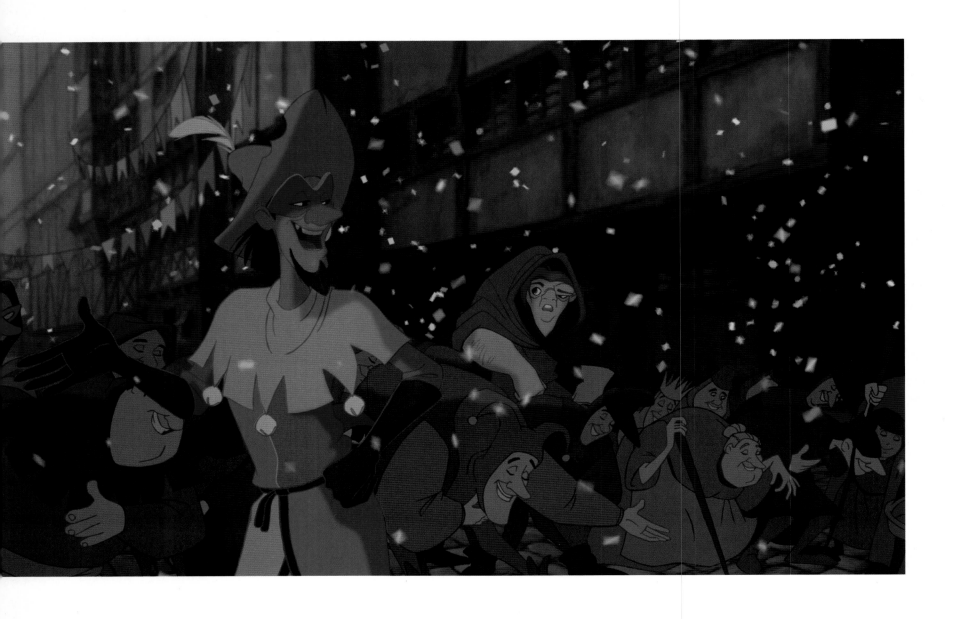

"The color palette was carefully worked out in terms of what each charac-
ter would wear and what kind of environment they are in. It's a party, a
time of year when the townspeople get to cut loose a little. The Gypsies are
all in festive colors and the townspeople are in a
range of colors with browns and siennas all influ-
enced by earth tones. In contrast, Frollo is very dark
and oppressive and repressed. He's not about to
wear anything colorful or have his tent
be colorful, so it's all reds and blacks
and grays—very regal and subdued
and completely different from everyone
around who is celebrating. It's the exact
opposite of Esmeralda's tent, which is
entirely bright and alive."

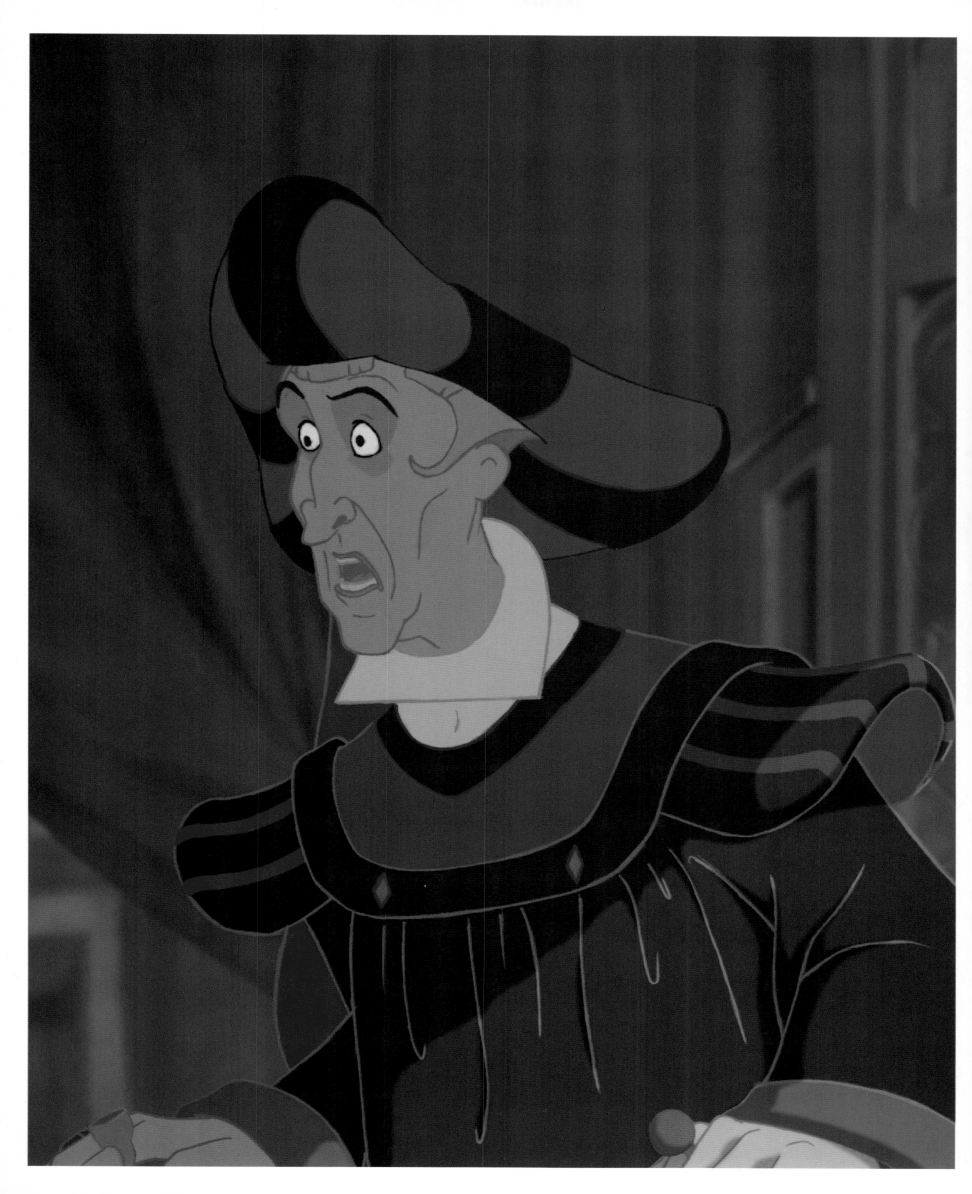

A Moveable Feast

The Feast of Fools fulfilled an important function in medieval times. In a rigidly stratified feudal system in which the rank, station, and aspirations of every member of society were tightly proscribed, political, religious, sexual, and social tensions fairly seethed. In addition, medieval society boasted a highly developed sense of merriment and play. Expressions of that spirit include the day's popular miracle plays, jesters, fairs, even the frightening and fanciful gargoyles that grimace from the heights of Europe's grand cathedrals.

ABOVE AND OPPOSITE: *Production stills.*
TOP: *Concept art by Marek Buchwald.*

Topsy Turvy Day, also known as the Feast of Asses and the Festival of the Flight into Egypt, was marked by participants at Mass being prompted to bray on cue while a donkey was brought into a church. The importance of the donkey as an icon was to celebrate the role played by the ass in the flight into Egypt and Christ's arrival in Jerusalem. Festival participants in Rouen and Beauvais marked the Feast with short plays about the biblical prophet Balaam and his wondrous talking ass.

Fifteenth-century accounts of such fetes tell of priests and clerks cavorting in the Choir in the clothes of women and of minstrels, singing bawdy songs. The religious men often wore torn vestments and ate puddings and sausages at the church altar, while the celebrant said Mass. Dice were rolled at the altar and incense made from filthy shoe soles burned. Clerics ran rampant through churches, blowing ashes from the censers, turning somersaults, making animal sounds. Around town, they sang bawdy songs and hurled excrement and indecent gestures at passersby as they tooled around in carts. Masses

were conducted in screeches and gibberish, accompanied by brays, burping, and flatulence. Choirs and prayer responses were screeched and sung dissonantly or backwards. Prayer books were held upside down.

During the Feast of Fools, the celebrants often crowned a king to preside over the ribaldry, who went by such names as Mock King, Boy Bishop, Lord of Misrule, and Abbot of Fools Three buckets of water and a hood or else a crown of leaves marked his coronation. Underpinning the merriment was the subversive, if utterly valid philosophy that power, privilege, even laws are arbitrary; that the occasional expression of sensuality, freedom, license is beneficial. It is not difficult to see in the Feast of

Fools the forerunner of Halloween and New Year's Eve, Mardi Gras, and such 20th-century entertainment as political cabaret shows and theater pieces.

Not surprisingly, the Bishop of Paris in 1199 tried in vain to tone down the Feast of Fools at Notre Dame; The Council of Basel, in fact, outright condemned such fetes in 1431. Although the Feasts persisted well into the 16th century, society lost its taste for ridiculing the things it held most sacred, at least within the context of the Feast of Fools. The age of Reformation and Counter-Reformation made it so; goals, industry, thrift, sobriety were hallmarks of the Protestant era. Unfortunately, there's always someone ready to rain on one's parade.

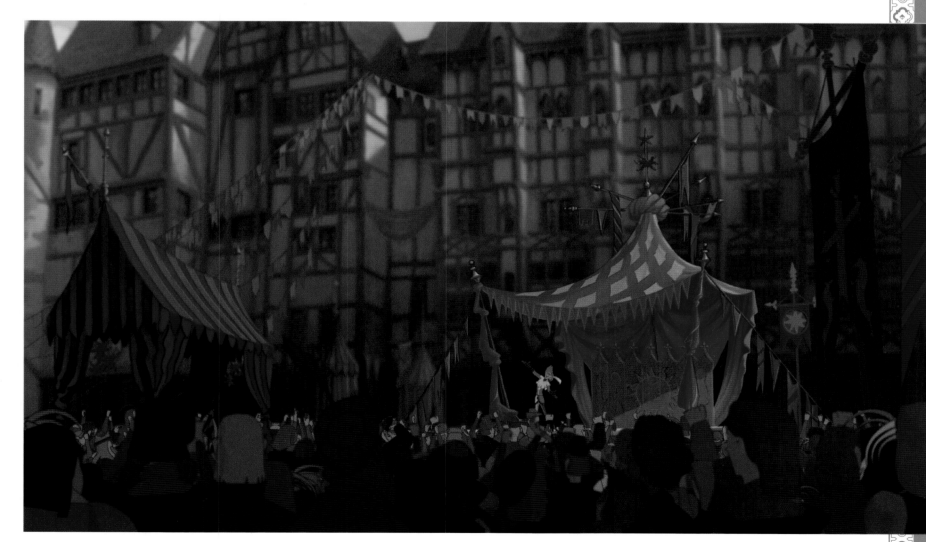

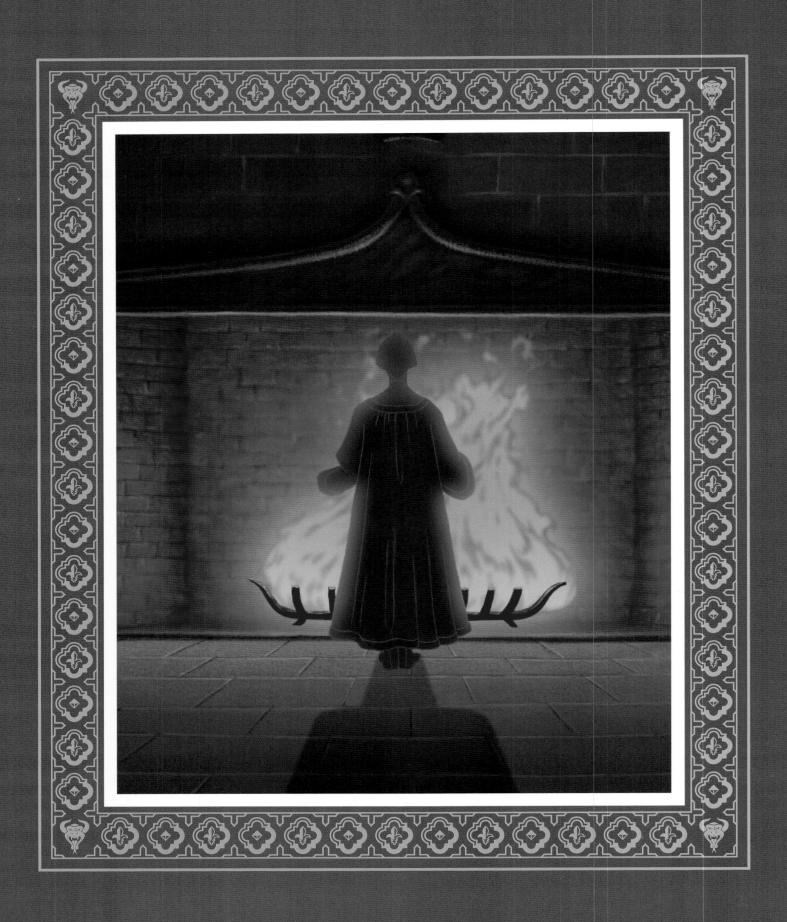

VI.

City on Fire

"Quasimodo's battle on the parapets of Notre Dame is more than just a battle, it's his moment of truth when he at last fights for what he loves and what is right. When Quasimodo goes down into the street, he doesn't step into the hellish place Frollo has made it out to be. He steps into the world, a place of great complexity and possibility, as a complete person who can now believe in himself and in others, and step into the light."

—DAVID GOETZ, Art Director

ABOVE AND OPPOSITE: *Production stills.*

A udiences have grown to expect Disney animated films to serve up a world of visual wonders, from flying elephants and dancing hippos to dancing dinnerware and charging wildebeests. To realize on film the finale of Hugo's *Notre-Dame de Paris* demanded epic scope and sweeping action as a cast of six thousand vagabonds led by Clopin storm the cathedral to rescue Esmeralda, only to be confronted by the full, savage brunt of troops of soldiers, Quasimodo hurling wooden beams and pouring molten lead on them, and the wrath of "an enchanted old church," as Hugo puts it. Throughout the film, we have seen Quasimodo emotionally and, at times, symbolically imprisoned in the cloistered belltower, roped and shackled on the pillory, and finally, bound in chains from which, like Prometheus, he must break

179

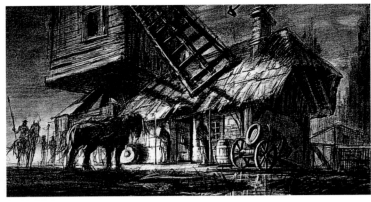

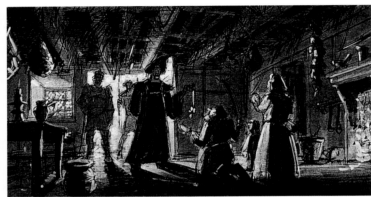

Frollo's smoldering desire for Esmeralda ignites the spark which will result in the burning of all Paris.

ABOVE: *Background art by Colin Stimpson.*
RIGHT: *Value studies by Sam Michlap.*
BELOW: *Fire effects animation by Ed Coffey.*

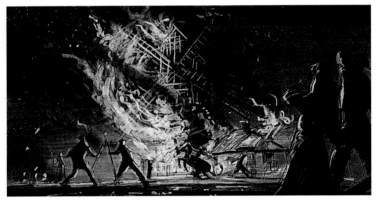

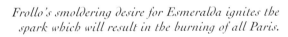

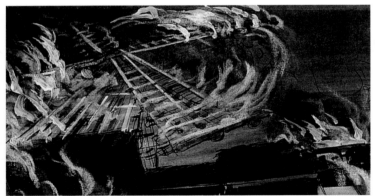

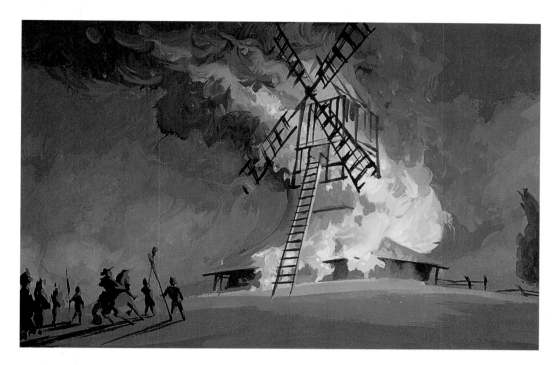

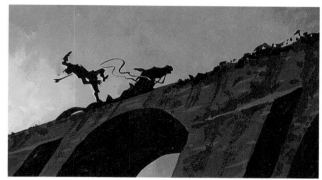

LEFT AND ABOVE: *Color keys by Colin Stimpson.*
BOTTOM: *Production still.*

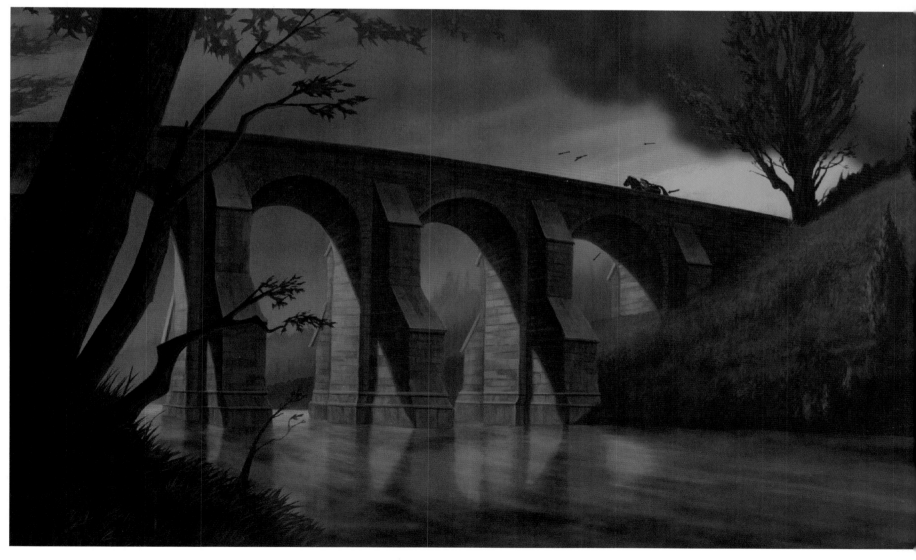

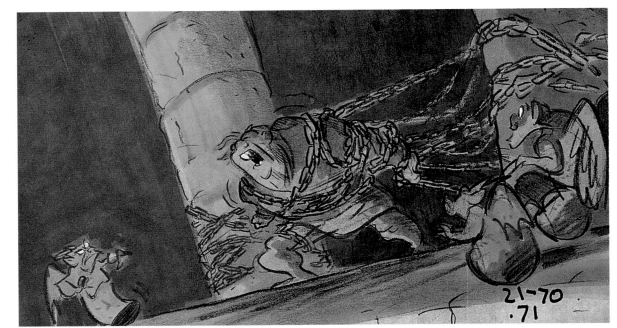

21-70
.71

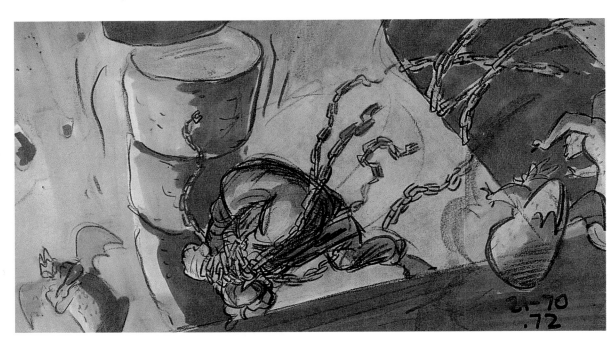

21-70
.72

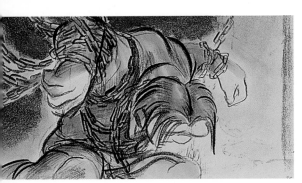

THIS PAGE: *It is only through the triumph of his own spirit that Quasimodo can break free of the chains, both literal and figurative, that hold him back. Storyboard art by Jeff Snow. Color by Francis Glebas.*

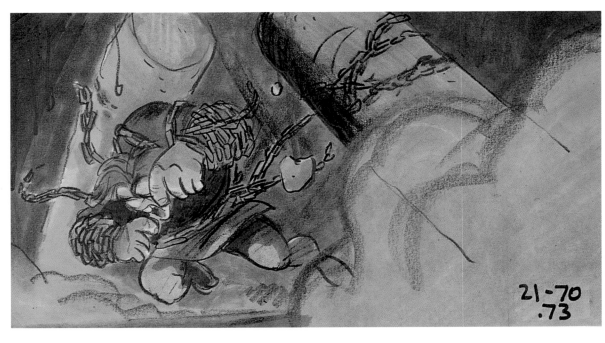

21-70
.73

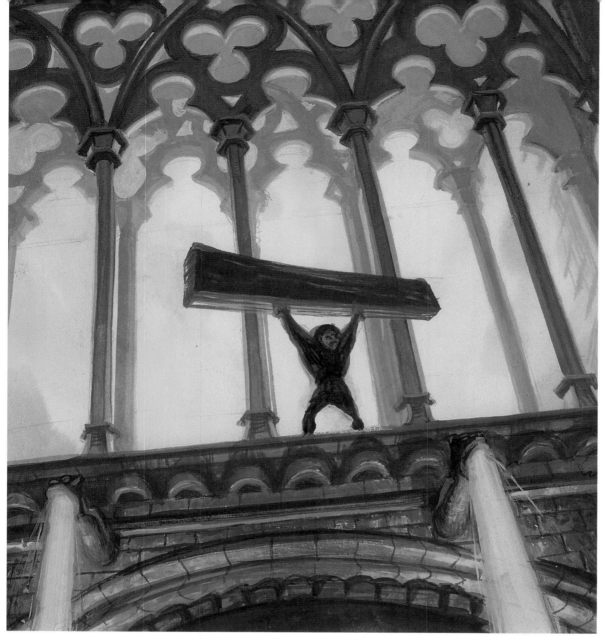

Concept art by David Goetz.

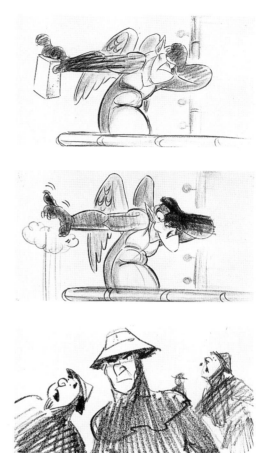

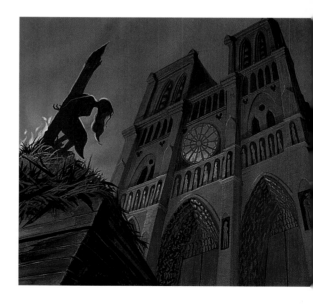

loose. By the end of the sequence of the storming of Notre Dame, Quasimodo will be confronted with the unrepentant evil of his surrogate father Frollo, vanquish that evil, and set himself free.

In a novel justifiably famed for its set pieces, Hugo conjures the finale with forceful emotions and images. The attacking mob "armed with sickles, pikes, pruning-hooks and halberds, . . . [and] black pitchforks," spurs Quasimodo's decision to "fight to the death on the threshold of Notre Dame." Against the onslaught, even the statuary of Notre Dame rebels. "The innumerable sculptured demons and dragons of the two towers rising above the flames took on a formidable aspect. The flickering light made them move their eyes. There seemed to be dragons laughing, gargoyles yelping, salamanders blowing into the fire and griffins sneezing in the smoke."

The Disney filmmakers sought to capture and even enhance the scope, spectacle, and emotional resonance of these memorable scenes in a battle which plays out on multiple levels. As Randy Fullmer describes it, "We

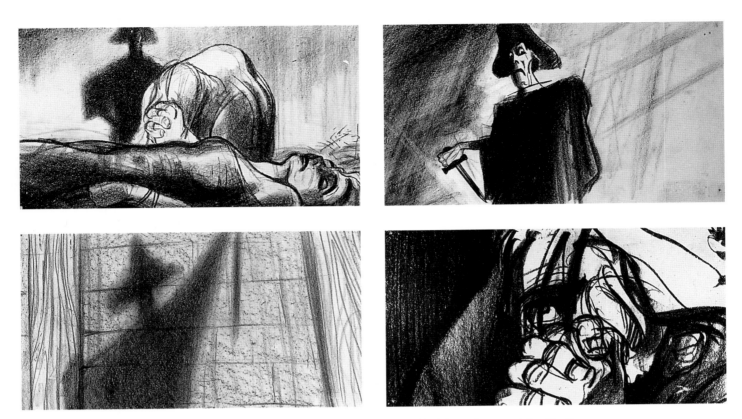

ABOVE AND OPPOSITE: *Quasimodo confronts and ultimately vanquishes Frollo.*
Storyboard art by Paul Brizzi and Gaëtan Brizzi.
BELOW: *Color key by Colin Stimpson.*

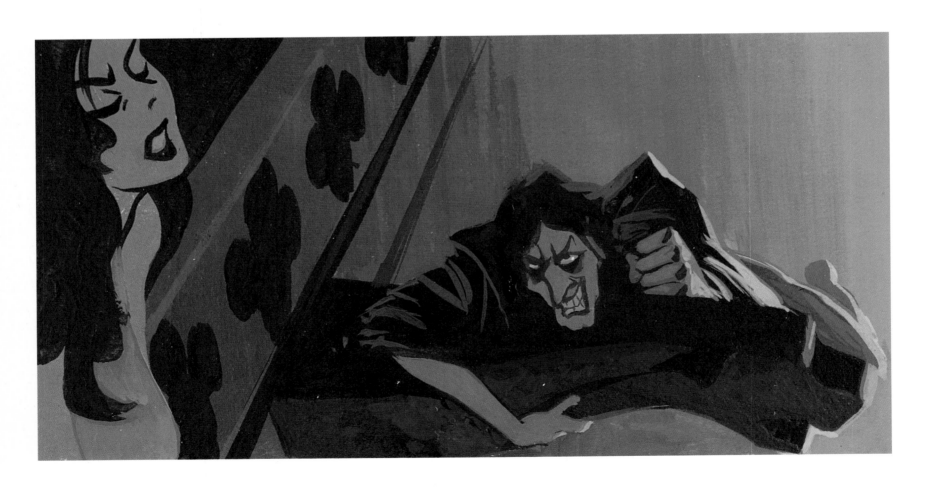

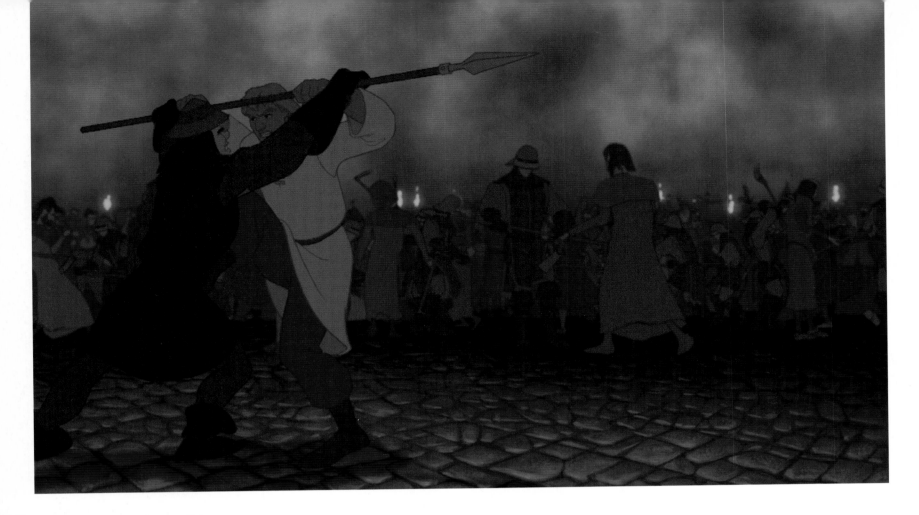

The battle movement of the computer-generated crowd was created by observing live action fight choreographers and generating a set of fight behaviors based on their movements.

ABOVE: *Individual wireframe figures are brightly colored to help animators distinguish each character when choreographing the action.*
TOP: *CGI-animated figures are combined with hand-drawn animation in the foreground.*
BELOW: *Fight-stance CGI animation.*

have a wacky, silly fight going on with the gargoyles, and a serious death struggle, we have an internal struggle for Quasimodo—his maturing as a human being as he finally breaks through his psychological shackles. There's the death of Frollo. It's all there compressed into about eight minutes of really intense film." The effect of multi-layered, dimensional storytelling was enhanced through careful attention to the pacing of the scenes. Says editor Ellen Keneshea, "Intercutting Phoebus, the serious fight, and the many comic touches created an extra dimension of dramatic impact and suspense to the storytelling."

According to Kiran Joshi, "This sequence called for *Ben-Hur*-style epic shots of charging crowds and masses of people and soldiers engaged in intense fighting." To achieve the dimensions of what director of technology Paul Yanover terms "a big, golden years of Hollywood-style epic," the battle scenes, which would have been nearly impossible to animate solely by hand, were assisted by the CGI team. These artists handled animation, staging, battle choreography, lighting, and rendering for three-dimensional models of crowd members and soldiers which had to mesh seamlessly in shots with traditional two-dimensional animated figures.

Codirector Wise explains, "This is the first Disney movie where mass movements of people and fight scenes had to be choreographed just as if they were live action. Additionally, the central figures of Quasimodo and Phoebus executing various actions, for instance, were hand-drawn, while the soldiers and mob are like moving wallpaper behind them. The computer keeps track

186

of each of those six thousand people, keeping straight such details as the movement of the sword and the color of the shoes and trousers." The technology used in the siege of Notre Dame is absolutely cutting edge. "Our goal in those scenes was to crash the computer," joked Gary Trousdale. "We never did." As Paul Yanover stresses, "Disney has made a tremendous commitment to technology. Every film that comes out drives us and motivates us to create a new piece of technology that goes into the filmmaking in such a way that the audience has no idea." Adds associate producer Philip Lofaro, "That a piece of this movie was hand-drawn, partially hand-drawn, partially computer-generated is just not an issue. It's all about telling you a story. It's all part and parcel of making the movie. There's magic behind the magic."

Asserts producer Don Hahn, "First and foremost we are storytellers, but beyond that we try to put images on the screen that can dazzle the

In addition to making scenes with masses of people possible, CGI technology also allowed the filmmakers to choreograph complex camera movements. Here the camera tracks Quasimodo as he rescues Esmeralda and carries her to sanctuary atop Notre Dame.

ABOVE: *Rough animation of Quasimodo and Esmeralda by James Baxter, camera animation by Mike Merell, crowd animation by James Griffith, rendered and lit by George Katanics.*

audience—show them something that they've never seen before." Accordingly, in this sequence, the animators, art director, background, layout, and effects artists, and computer animators conspired to suggest, through blazing, inferno-style colors and images of panic and fury, the devastating consequences of Frollo's racism, thwarted passion, and hypocrisy. "Choose me or the fire," Frollo warns Esmeralda, as he is about to condemn her to death. She spits in his face. The twisted logic becomes clear: if he cannot have Esmeralda, she will burn to her death; when her rescue prevents his burning her, he's willing to avenge himself by setting loose hellfire on Notre Dame and the whole city. Flames spew from the mouths of the gargoyles, firelight flickers across the visages of the Notre Dame statuary, lending them almost human expressions.

Fire, like water, can pose exciting challenges for animators. According to special effects supervisor Chris Jenkins, the approach taken for *The Hunchback of Notre Dame* is distinct in adding believability and a heightened sense of emotion to the film. Says Jenkins, "The fire in *Hunchback* is more European than Japanese in style. It is dimensional and forceful and at the same time suggestive, subliminal, more like a surge of energy than other animated fire we've done. This fire has a tone and a sense of movement all its own."

Awesome special effects are expected of Disney. But, ultimately, at the heart of the story is the sense of triumph felt by Quasimodo. This is what the

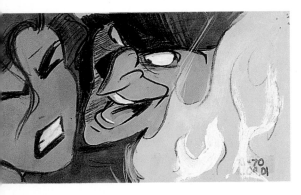

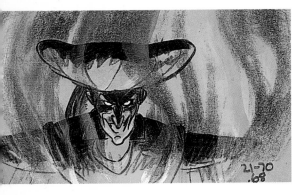

ABOVE: *Storyboard art by Jeff Snow, color by Francis Glebas.*
RIGHT: *Cleanup of Quasimodo by Miriam McDonnell, animation by John Ripa. Fire effects animation by Dan Lund.*

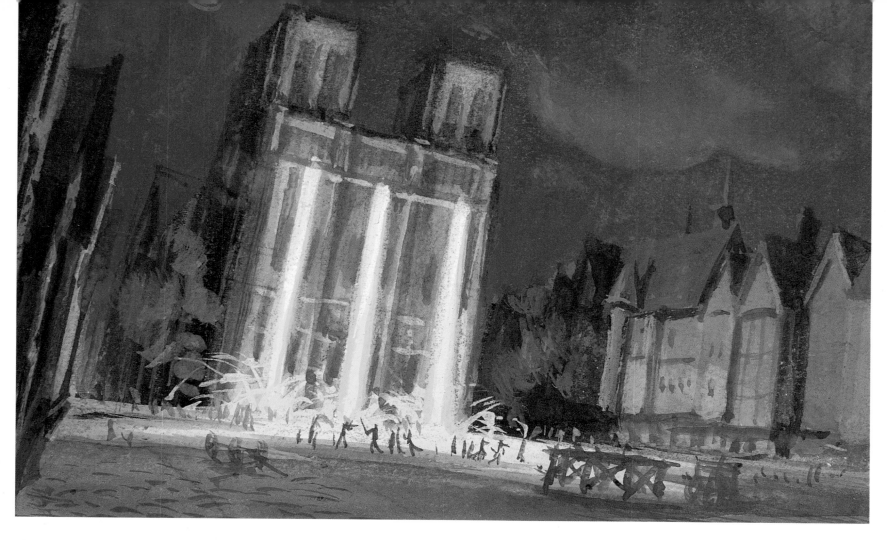

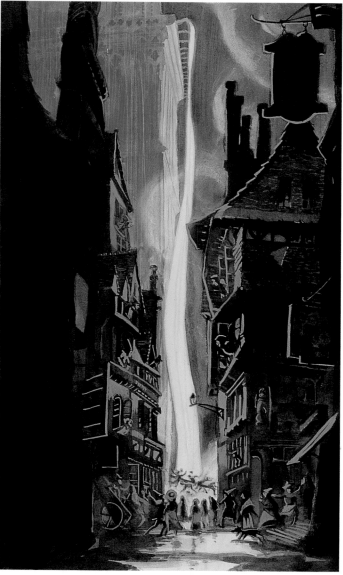

ABOVE: *Color key by David Goetz.*
LEFT AND BELOW: *Concept art by Rowland Wilson.*
OVERLEAF: *Concept art by Dave Martin.*

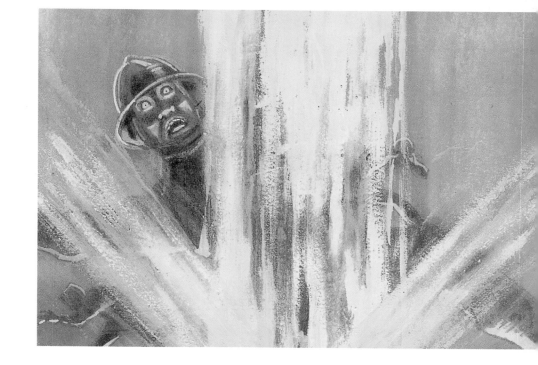

189

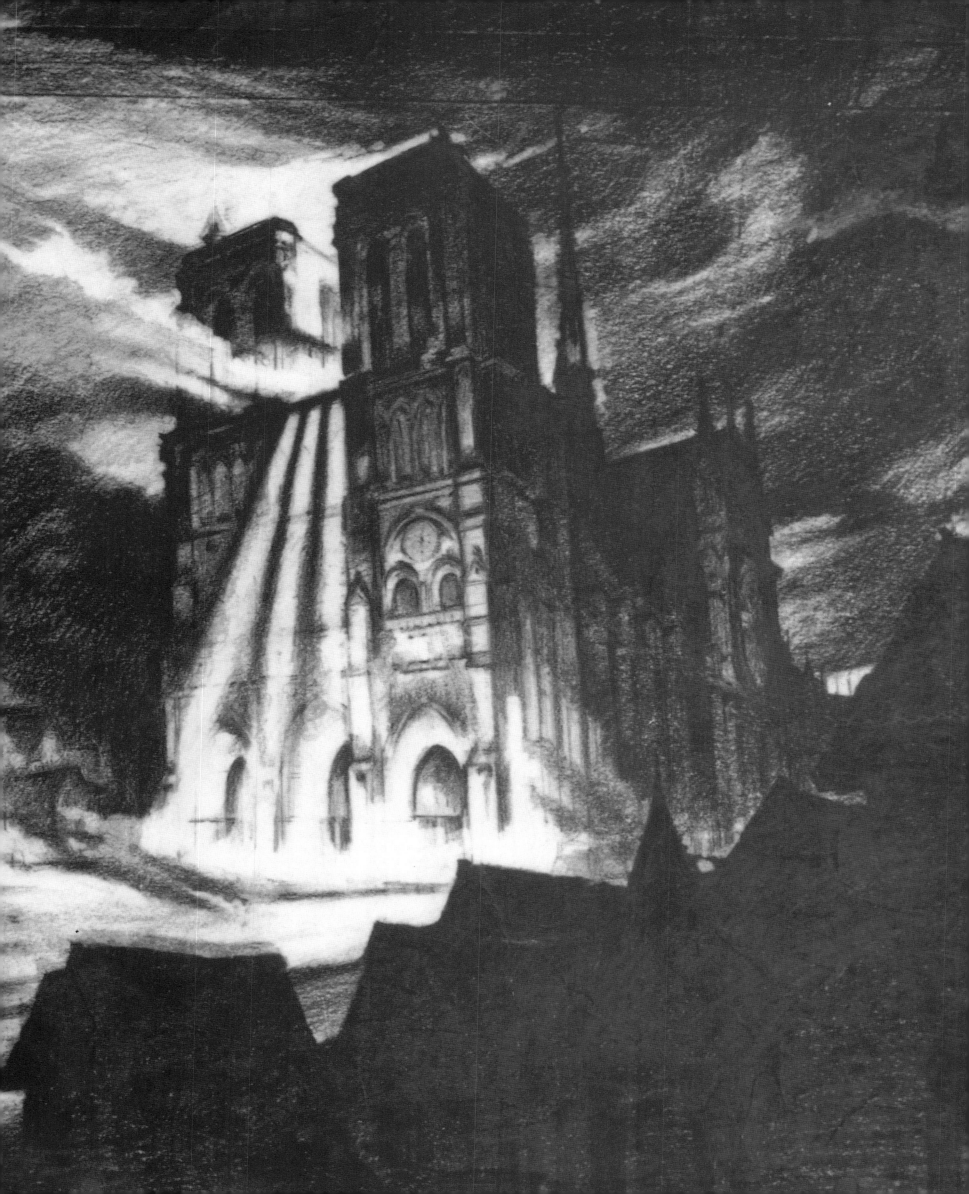

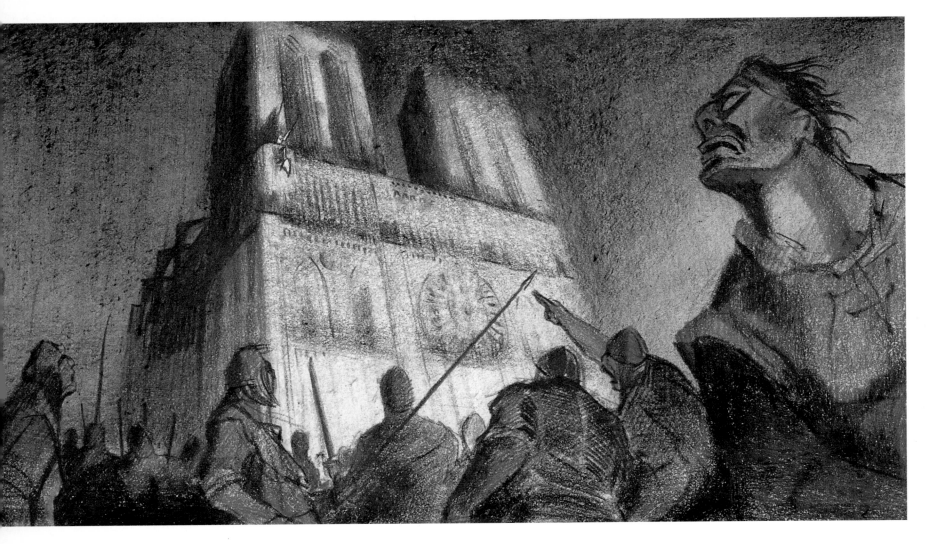

ABOVE: *Storyboard art by Paul Brizzi and Gaëtan Brizzi.*
BELOW: *Color key by Lisa Keene.*

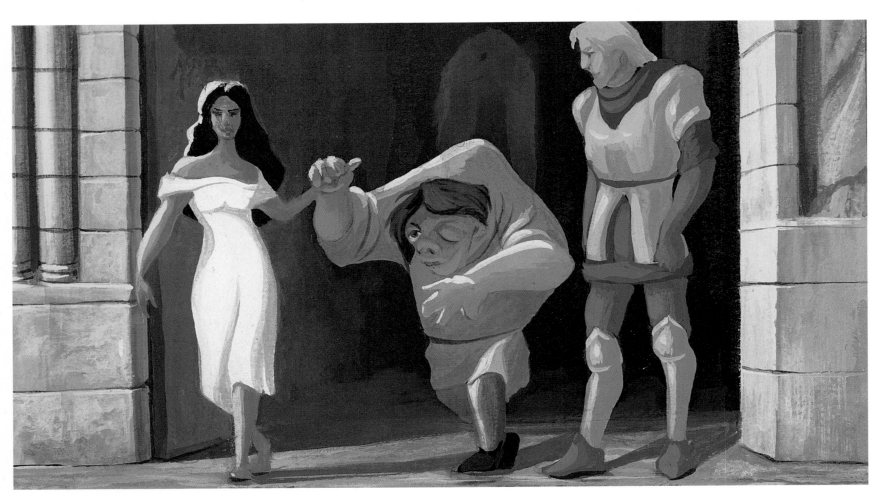

192

journey of the film has been all about. "There's no special magic that makes the world right in this movie. This movie is a triumph of Quasimodo and what he is able to do. The power that heals the world and heals our hero comes from his heart, from his soul in a very real way," says Kirk Wise. "This movie says you believe in yourself and you can conquer the world. And Quasi does it with his own force of character and his own might. That's very powerful," concurs Gary Trousdale.

Perhaps no other moment in the movie is quite as powerful as the incident at its close. Quasimodo has at last broken and shed the shackles of years of belittling and cruelty that have kept him subjugated. For now, there are no more chains, metaphorical or otherwise. The ultimate abusive father has been vanquished. Urged on by his friends, Esmeralda and Phoebus, Quasimodo emerges tentatively into daylight from the shadows of the only home he has known, the battered cathedral. The crowd murmurs. A little girl approaches him. Will she jeer? Hide her head in fear? She touches his face and regards him with an expression of nonjudgmental acceptance. Quasimodo, cheered by the crowd that once shunned and abused him, is finally and irrevocably "out there," ready to find his place in a world that is bigger, more frightening, yet more welcoming than he had known.

THIS PAGE: *Storyboard art by Paul Brizzi and Gaëtan Brizzi.*
OVERLEAF: *Color key by Lisa Keene.*

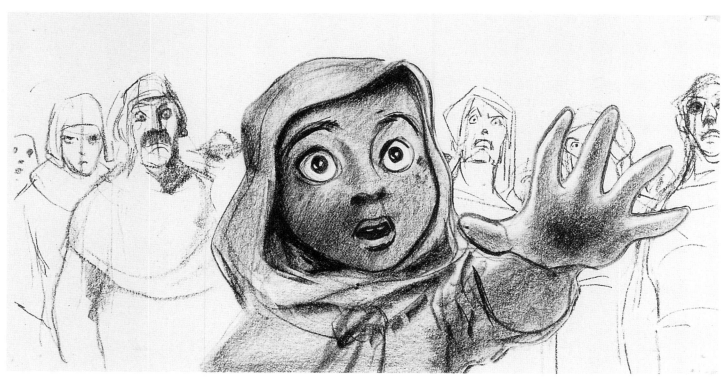

193

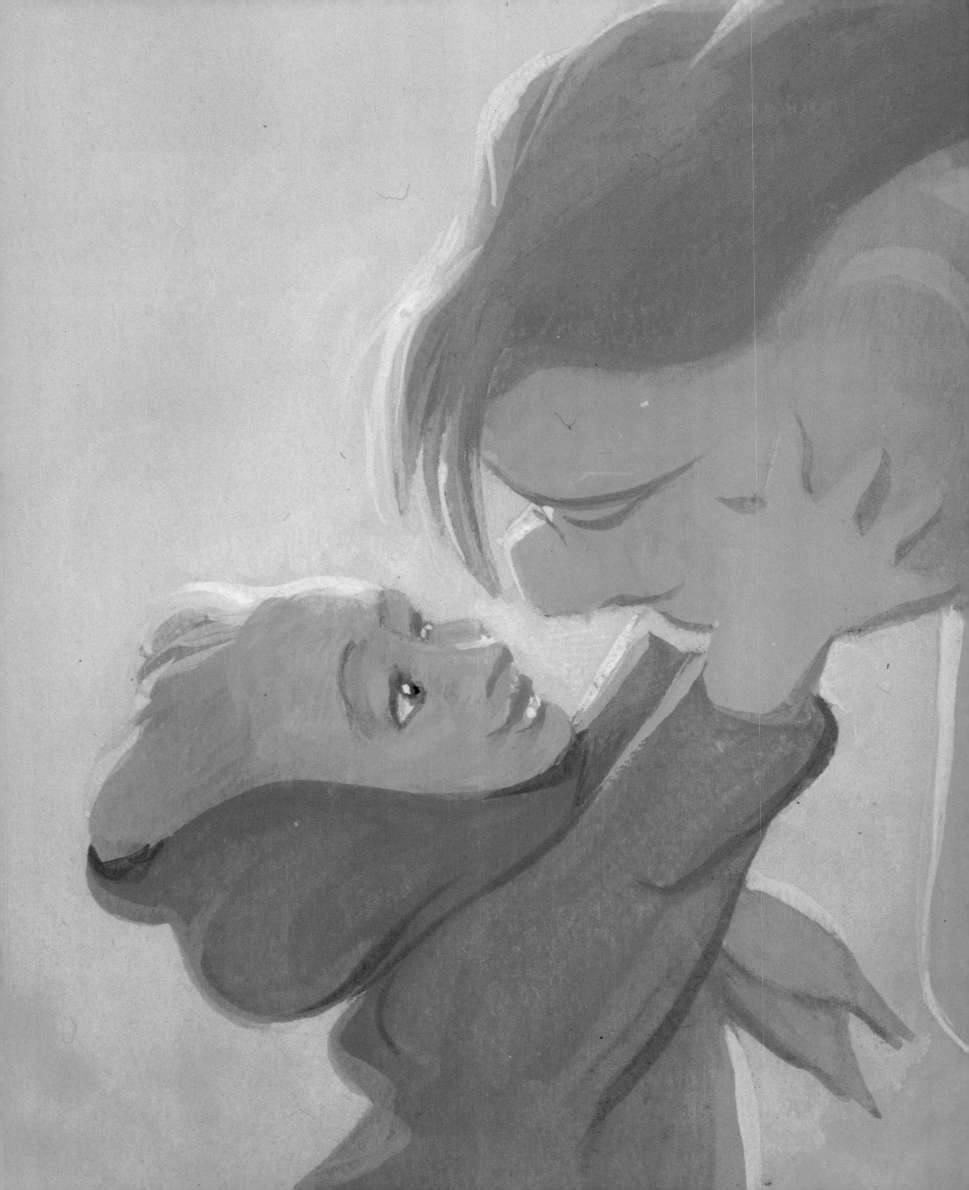

Index

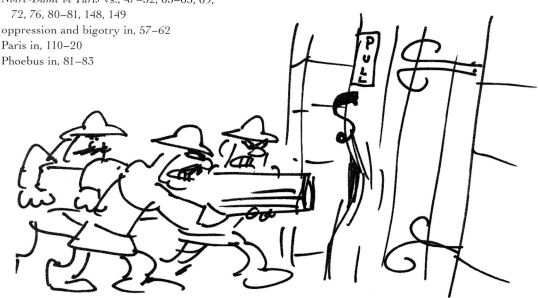

PAGES 196–199: *The artists working on* The Hunchback of Notre Dame *let off steam by making fun of the film's characters in "gag" sketches.*
OVERLEAF: *Storyboard art by Ed Gombert.*

Acknowledgments

The prospect of writing this text was made pleasurable due largely to the inspiring pride in their work demonstrated by the remarkable people who help put the magic in Disney Feature Animation. I must particularly single out Roy E. Disney, Howard Green, Peter Schneider, Thomas Schumacher, and David Stainton for generously giving of their time, enthusiasm, and support. Very special thanks, too, to Don Hahn, Roy Conli, Gary Trousdale, and Kirk Wise who, despite their frantic schedules, made me feel that nothing and no one was more important than this book nor my ceaseless questions about it.

The many talented others who graciously and seemingly effortlessly revealed so much about the passion, inspiration, and power of great art and storytelling include Gretchen Albrecht, Scott Anderson, Jason Alexander, Debra Armstrong, Doug Ball, James Baxter, Gaëtan Brizzi, Paul Brizzi, Janet Bruce, David Burgess, Hortensia Casagran, Brian Clift, Karen Comella, Margie Daniels, Peter DeSève, Russ Edmonds, Thom Enriquez, Will Finn, Tony Fucile, June Fujimoto, Randy Fullmer, Vance Gerry, Ed Ghertner, Jean Gillmore, David Goetz, Ron Husband, Tony Jay, Chris Jenkins, Joe Jiuliano, Kiran Joshi, Paul Kandel, Lisa Keene, Ellen Keneshea, Charles Kimbrough, Vera Lanpher, Philip Lofaro, Rick Maki, Irene Mecchi, Alan Menken, Tab Murphy, Sue Nichols, Ginny Parmele, Dave Pruiksma, Jonathan Roberts, Robyn Roberts, Randy Sanchez, Carmen Sanderson, Stephen Schwartz, Michael Starobin, David Ogden Stiers, Michael Surrey, Marshall Toomey, Ann Tucker, Bob Tzudiker, Noni White, Rowland Wilson, Mary Wickes, Paul Yanover, and Kathy Zielinski.

Katie Alexander showed herself to be never less than gracious and organized in shepherding this book through its many stages from scheduling interviews to locating and organizing artwork. Thanks, also, to Patti Conklin, Ed Oboza, and Dee Haramia for their patience and help. I must express thanks to Hiro Clark, Ellen Mendlow, Gregory Wakabayashi, and Rachel Balkcom for constantly challenging assumptions and for pushing always for substance and style. Thanks to them, and to the fine photography of Michael Stern, this is a beautiful book. Wendy Lefkon proved to be not only a new friend, but also an editor of taste and discretion, a person of serene civility. A bow of gratitude as well to Lige Rushing who fact-checked the manuscript, to Bérangère Frésard of the Paris Studio for her assistance with the art from France, and to Monique Peterson, whose exhaustive research proved invaluable to writing this book.

Grateful acknowledgment is also due to Robert Stemwell for tirelessly pulling artwork, to J.R. Russell of compositing, and Tim Lewis and Andy King of the creative computing division of Disney consumer products for their good humor and efficiency in providing digital artwork and assisting in all our computer needs.

—STEPHEN REBELLO

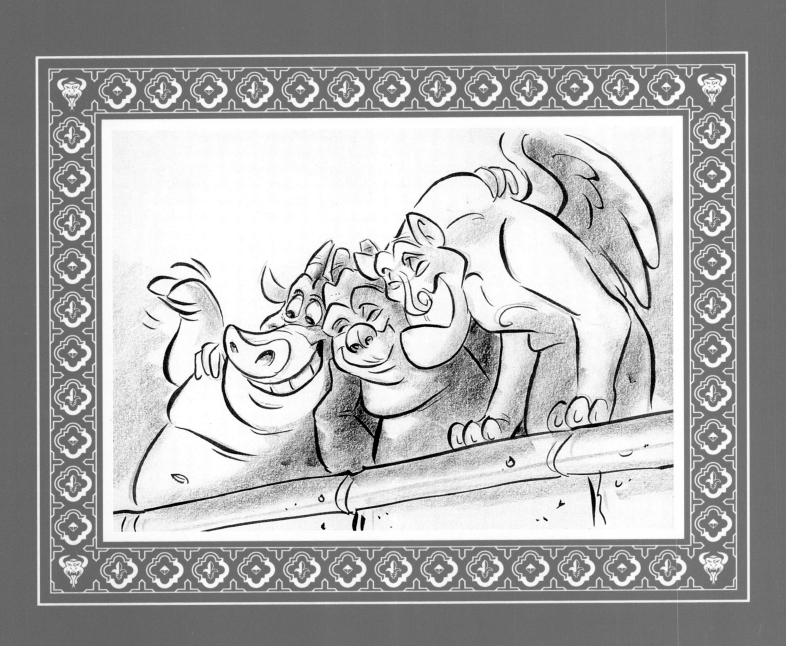

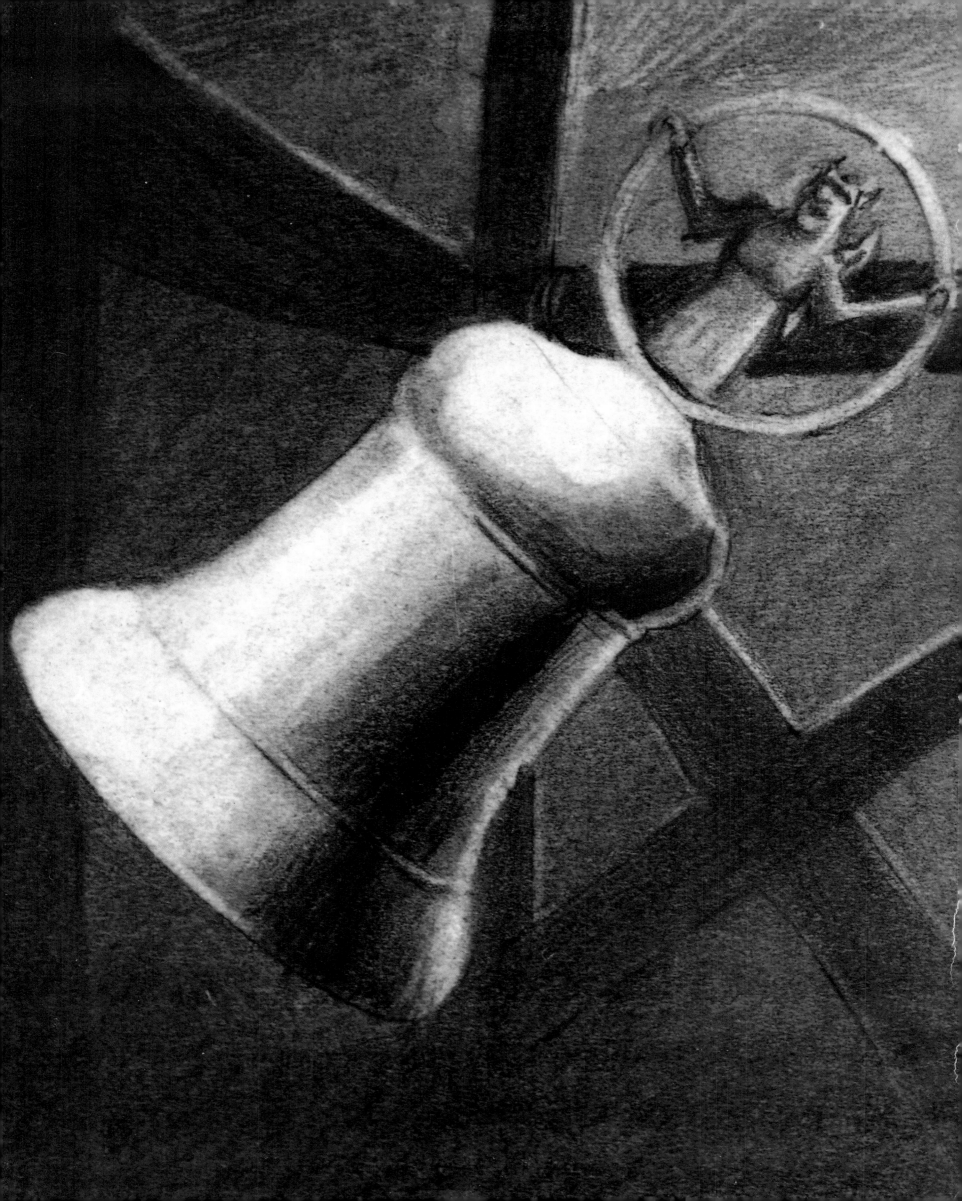